HUMANKIND

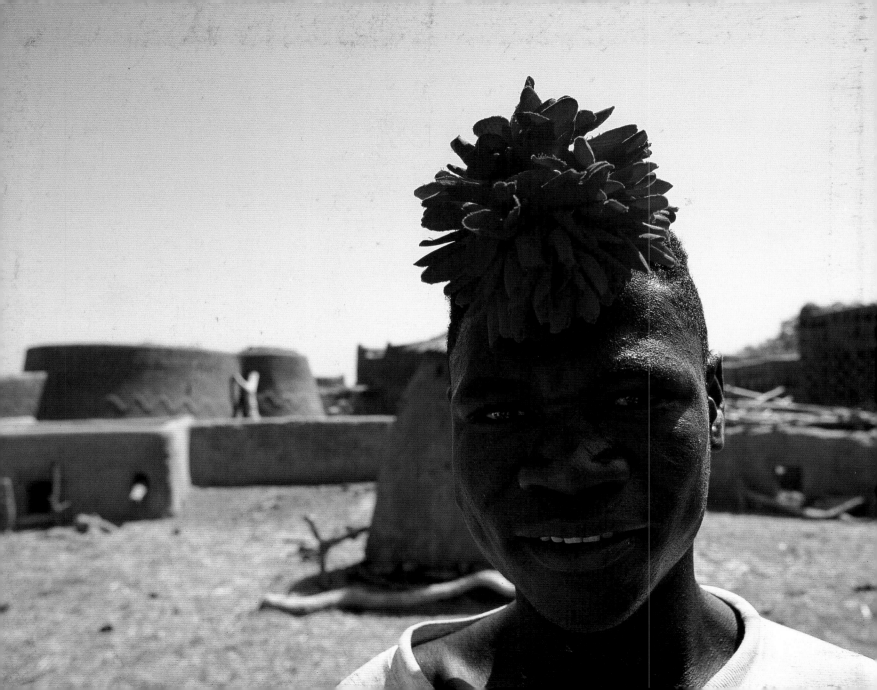

HUMAN KIND

YOSHIO KOMATSU · EIKO KOMATSU

GIBBS SMITH

Gibbs Smith, Publisher
Salt Lake City

First Edition
10 09 08 07 5 4 3 2

Text © 2006 by Eiko Komatsu
Photographs © 2006 by Yoshio Komatsu

Published by
Gibbs Smith, Publisher
P.O. Box 667
Layton, Utah 84041

Orders: 1.800.748.5439
www.gibbs-smith.com

Designed by Axiom Design
Printed and bound in Hong Kong

Library of Congress Control Number:
2006922734

ISBN 10: 1-58685-825-4 ISBN 13: 978-1-58685-825-4

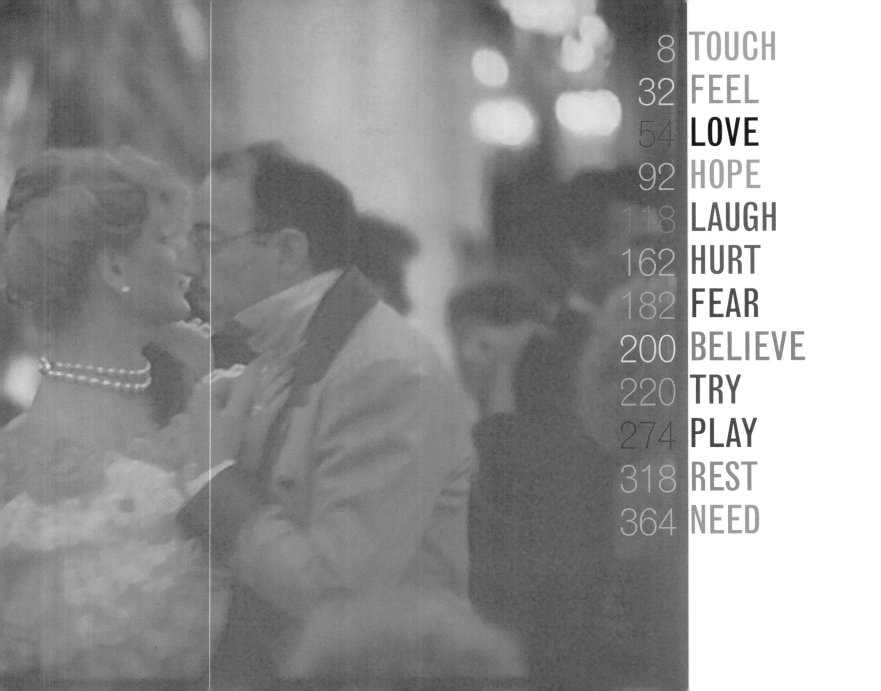

Eiko and I have been photographing people in their environments all over the world for more than 35 years.

Our first book with Gibbs Smith, Publisher, entitled *Built by Hand: Vernacular Buildings Around the World*, explored the handcrafted architecture and living spaces of people far and wide. *Humankind* became an emotional journey for us, taking "home" a step farther, showing us the feelings, emotions and basic needs of those within those walls.

During our journeys, we looked for an answer to the question "What is humankind?" In searching, it has been a pleasure to meet those who live strongly with tough will, including children of all ages and families. From them we have learned that being part of humanity means experiencing many of the same things, no matter where or how we live. We all touch, feel, love, hope, laugh, hurt, fear, believe, try, play, rest, and need.

It is said that the journey is the destination. *Humankind* is a record of our journey—a collection of photographs from around the world meant to captivate, educate and hopefully motivate you to realize that we really aren't that different from one another, that we can have increased tolerance and understanding for others. Since land is about one-third of the earth's surface and seven billion people are moving and living on the surface, it is our hope that we can all live peacefully together.

It is our delightful honor to invite you to open this book and enjoy this emotional journey with us.

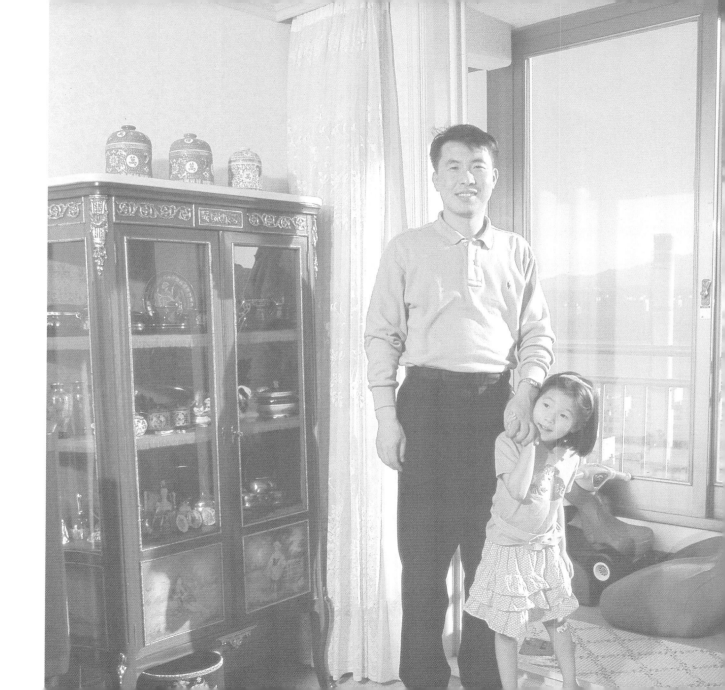

TOUCH

"Without touch, a baby dies, the human heart aches, and the soul withers."—Phyllis Davis, Licensed Professional Counselor.

Positive touch is not only a biological need but also a language that expresses love more powerfully than words. It is communication on the most basic level. Shaking hands, touching another's arm or shoulder, hugging, and walking arm in arm are all ways of communicating with each other. The sense of warmth engendered by affectionate touch is one of the best feelings in the world.

The touch of the hand can also act as a creative influence, as seen in the many stone and earthen houses we've seen all over the world or in the piece of thread in the hands of a skilled worker that gets transformed into beautiful fabric. When we see beautiful works, we acknowledge touch as a magical element, a special power that turns something ordinary into something marvelous.

Touch the earth, love the earth, honour the earth, her plains, her valleys, her hills, and her seas; rest your spirit in her solitary places.
Ernest Dimnet

Tangassoko, BURKINA FASO

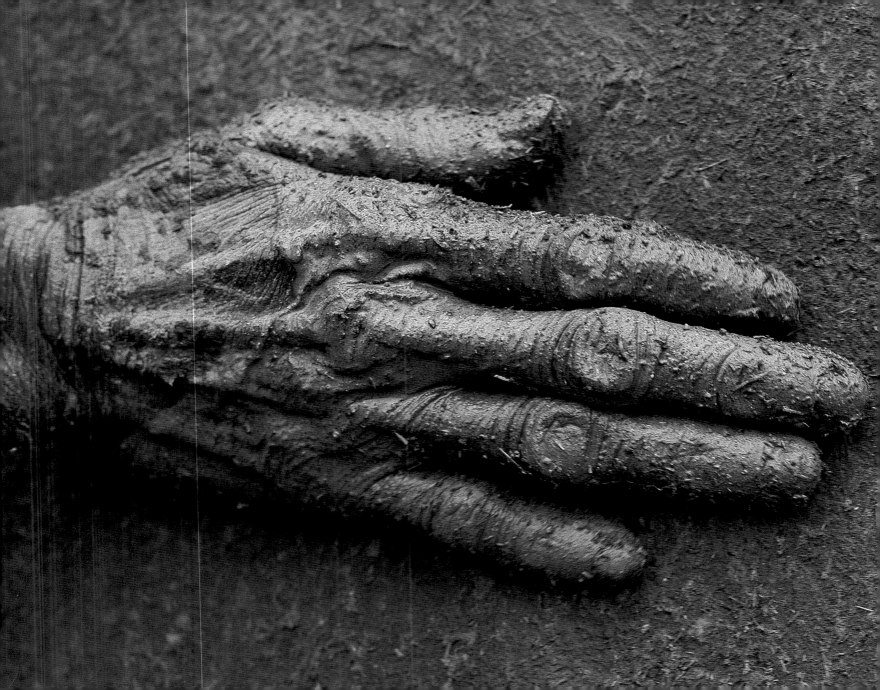

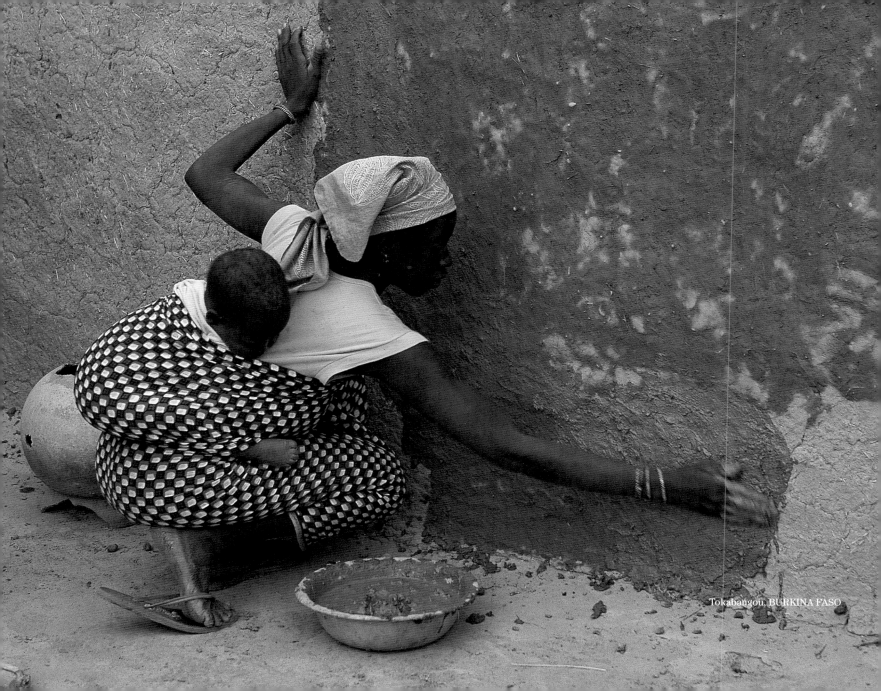

Tokabangou, BURKINA FASO

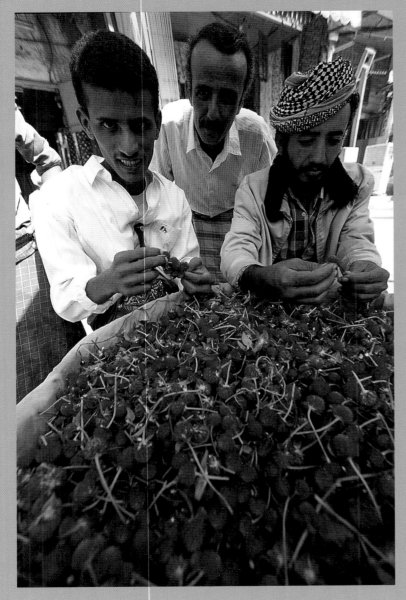

Ta'izz, YEMEN

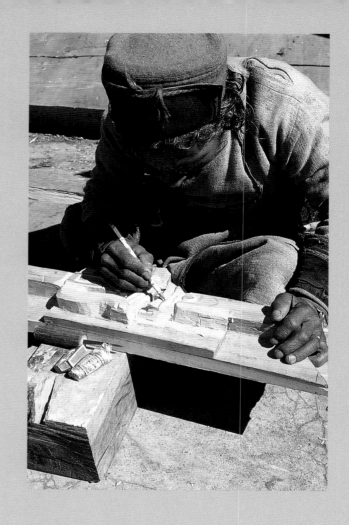

Kinnaur Region, INDIA

Ollantaytambo, PERU

Korhogo, IVORY COAST

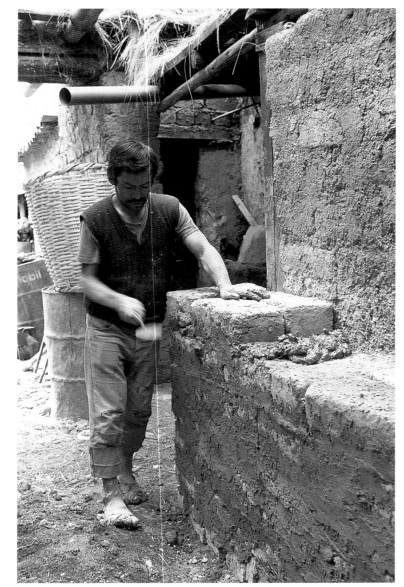
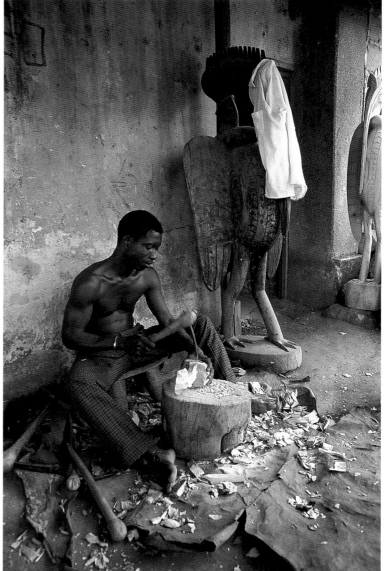

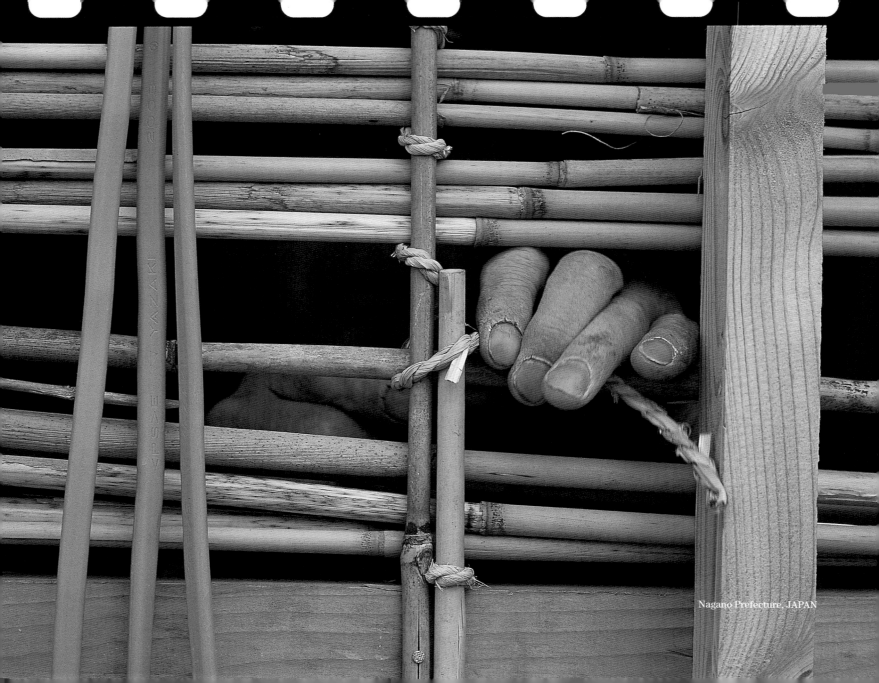

Nagano Prefecture, JAPAN

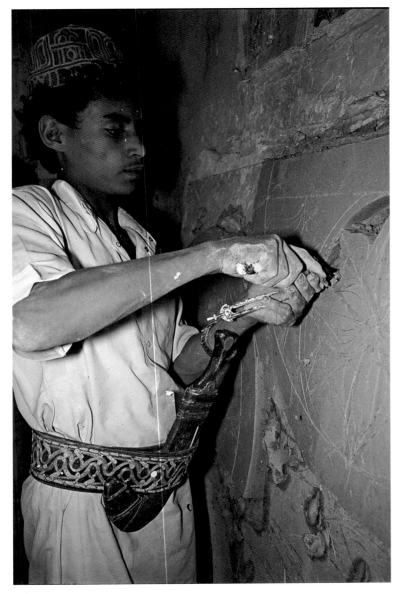

Sanaa, YEMEN

TOUCH

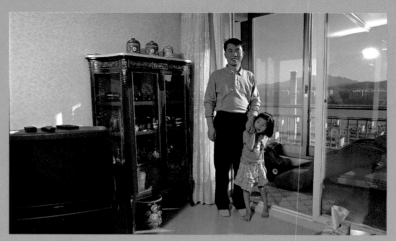

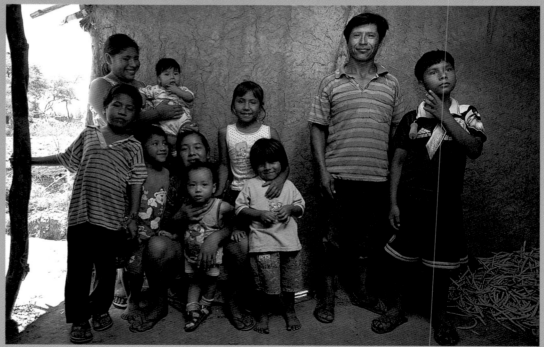

Near Seoul, SOUTH KOREA

Chiclayo, PERU

A child's hand in yours —
what tenderness and power it
arouses. You are instantly the very
touchstone of wisdom and strength.
Marjorie Holmes

Do you know what friendship is...
it is to be brother and sister;
two souls which touch without
mingling, two fingers on one hand.

Victor Hugo

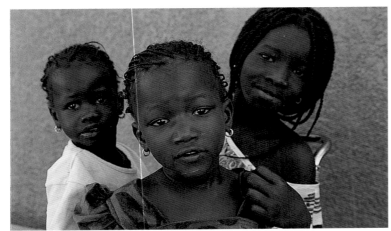

MAURITANIA

IRAN

PAPUA NEW GUINEA

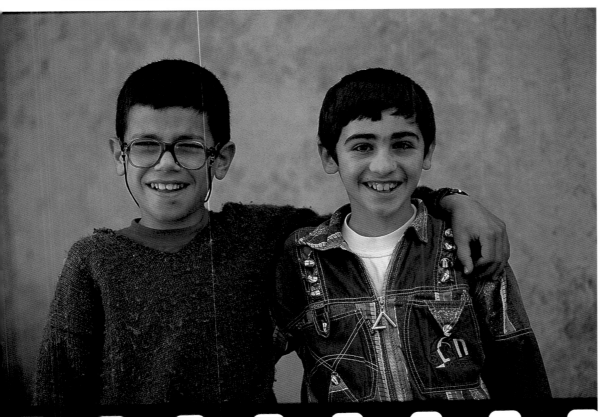

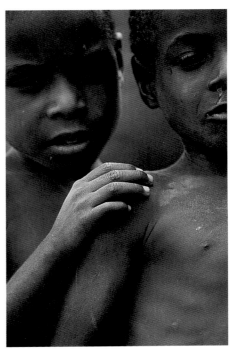

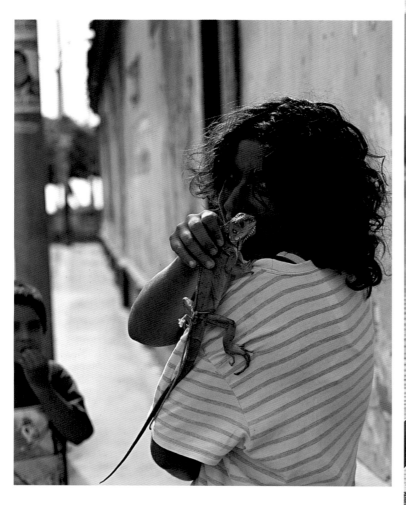

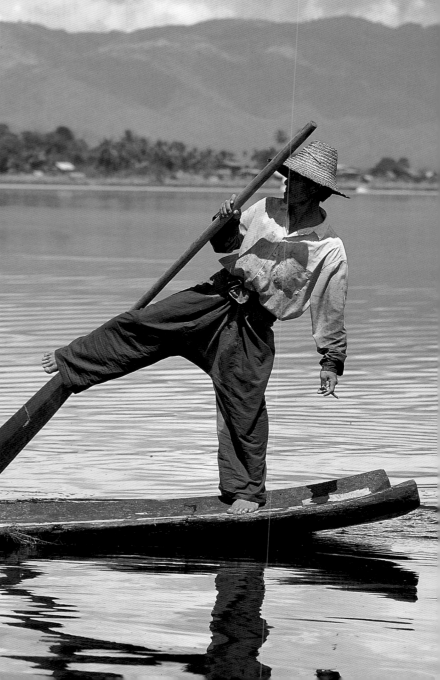

Trujillo, PERU

MYANMAR (formerly BURMA)

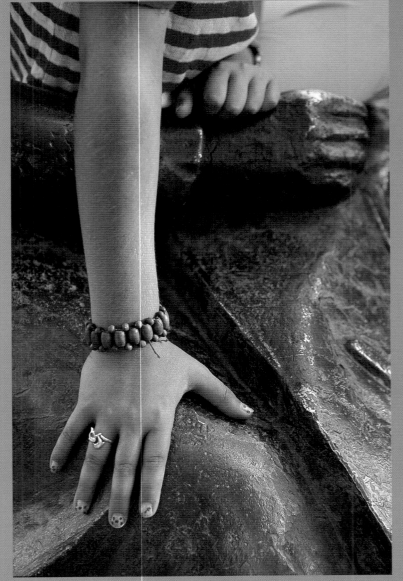

Tryavna, BULGARIA

TOUCH

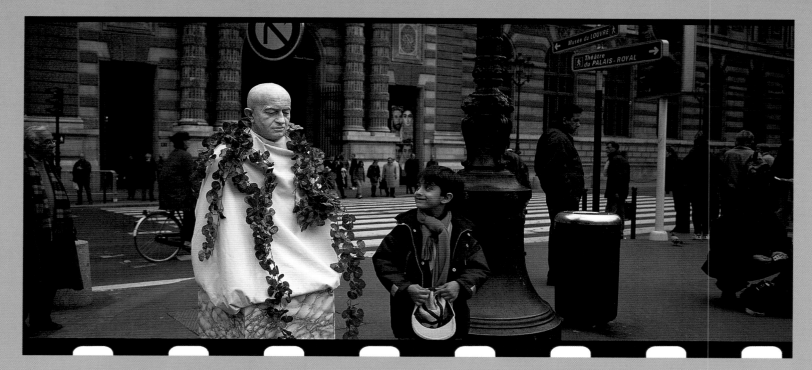

Paris, FRANCE

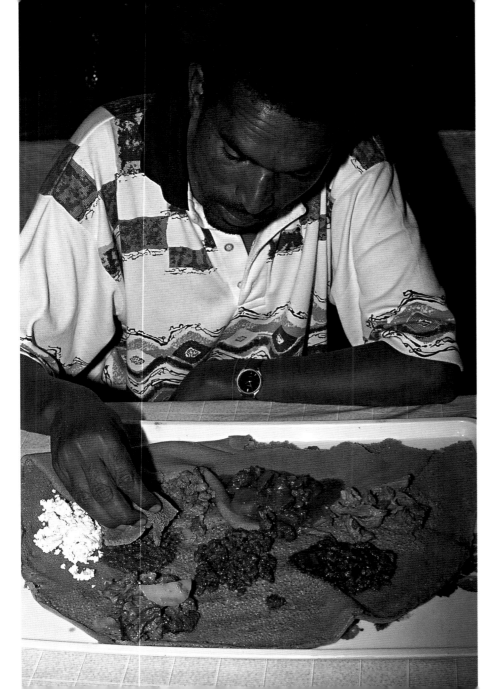

ETHIOPIA

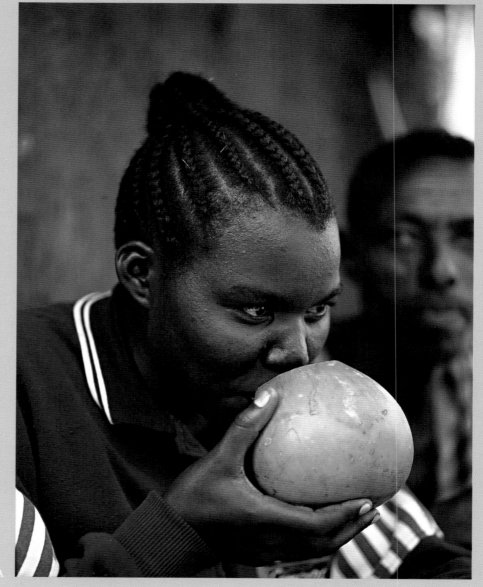

ETHIOPIA

One touch of nature makes the whole world kin.
William Shakespeare

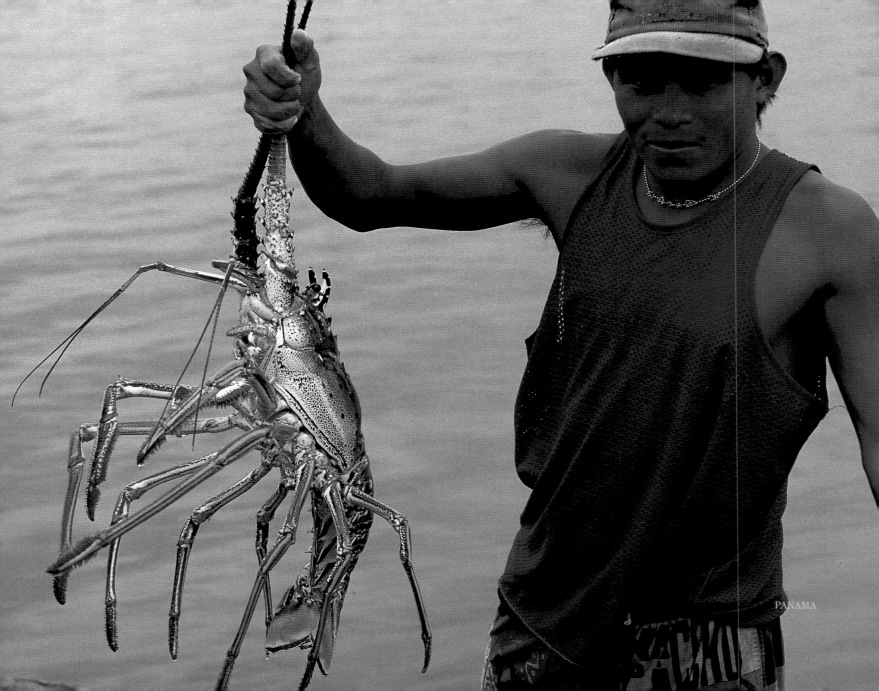

PANAMA

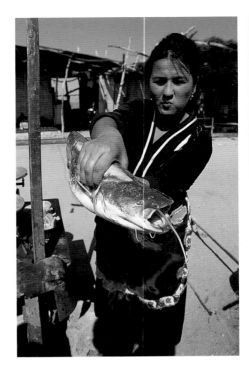

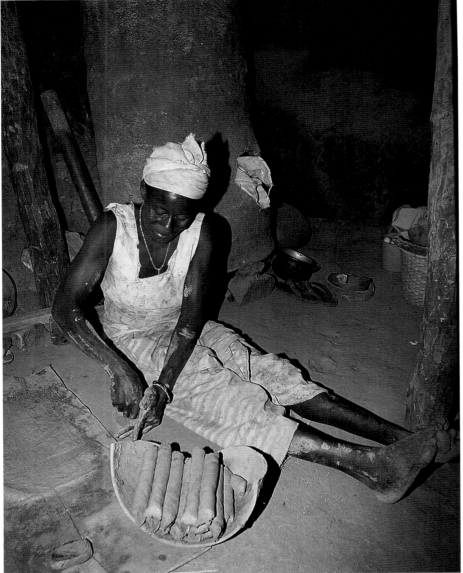

UZBEKISTAN

Koro, BURKINA FASO

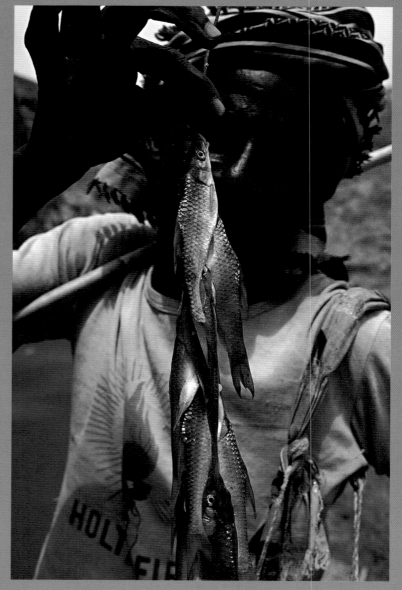

Tihama, YEMEN

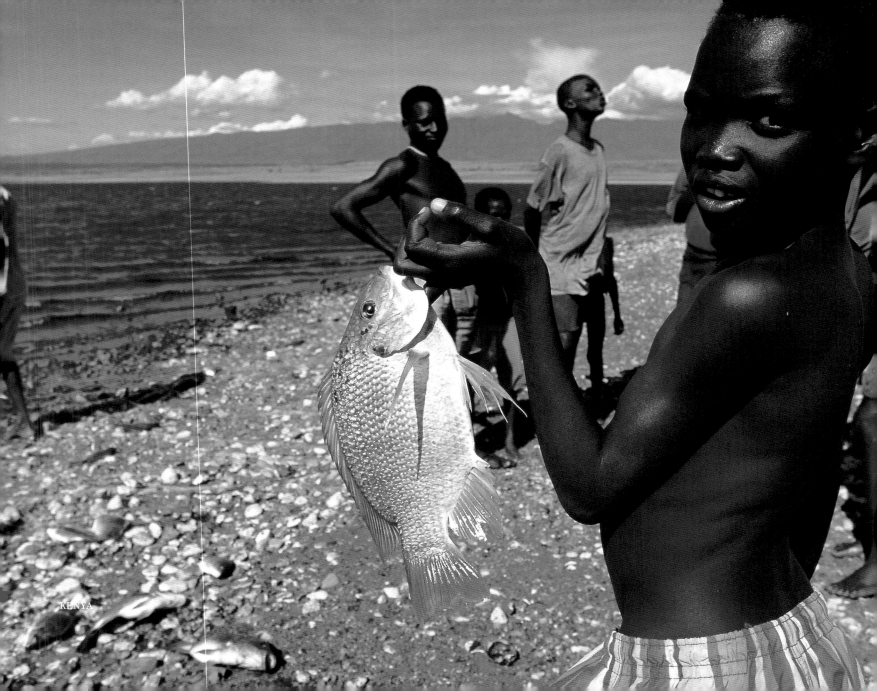

KENYA

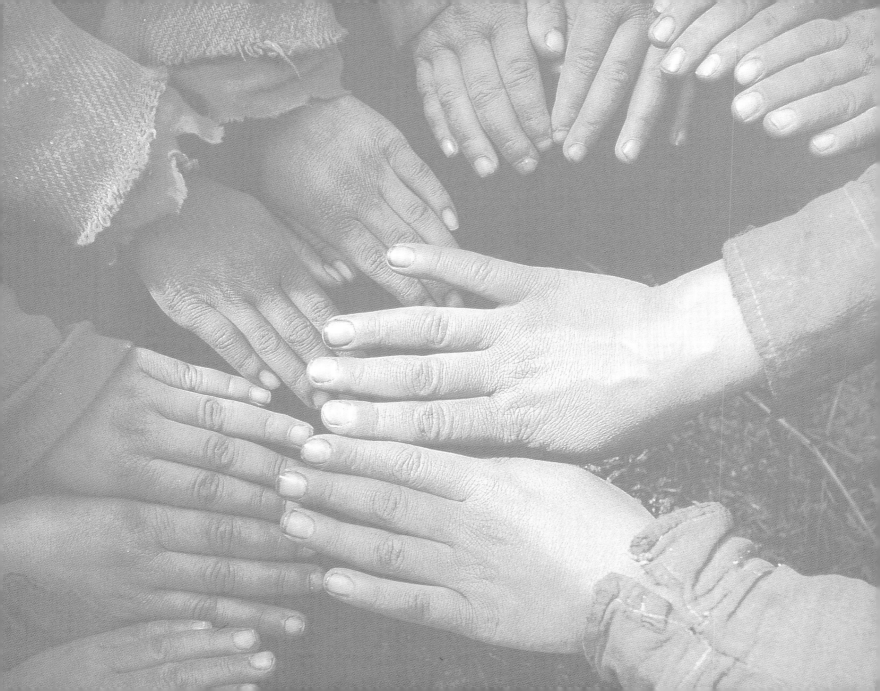

FEEL

Feel has many connotations. It can be a physical sensation, an awareness, an emotional state or reaction, a susceptibility to impression, or the overall quality of one's awareness. It can also include the capacity to respond emotionally to the many different characteristics of a region or place.

One thing we have documented in our journeys is the concept of home around the world. As part of our discoveries, we have learned that home is more than just shelter: it is a feeling that helps nurture the inhabitants' emotional well-being. Like a bird's nest offers a place for a bird to grow up in safety, home is a space of comfort and relaxation, a place that encompasses all the emotions experienced by the heart of humankind.

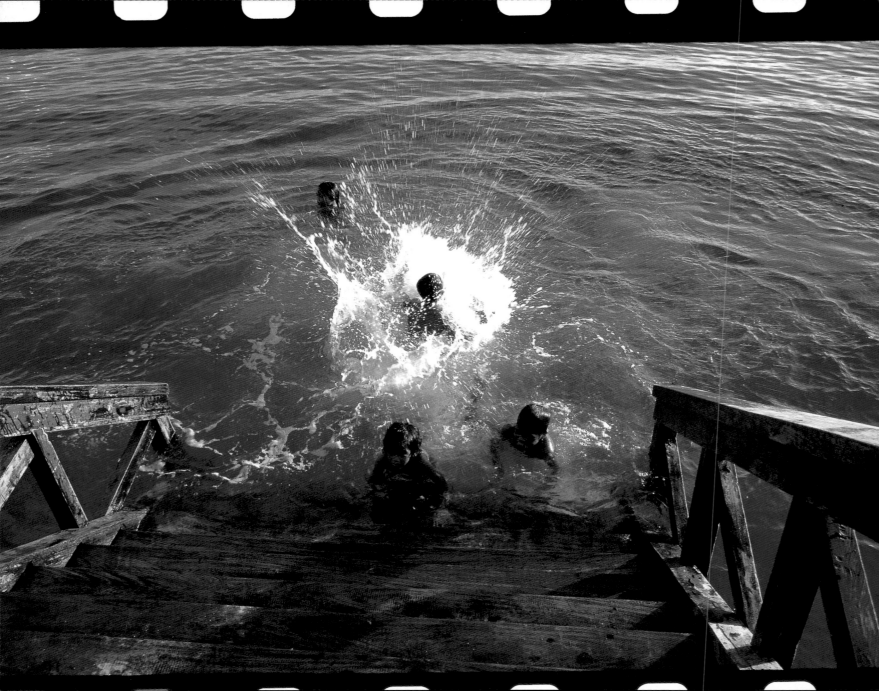

A lake carries you into recesses
of feeling otherwise impenetrable.
William Wordsworth

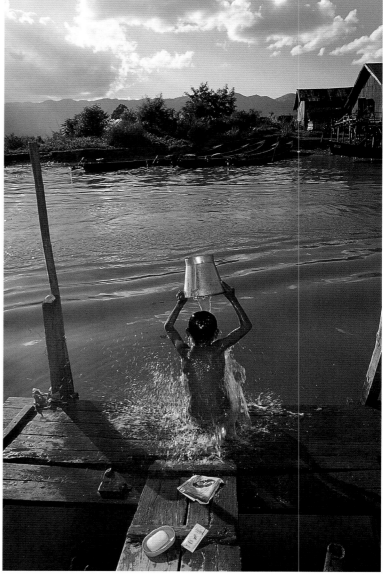

Near Creel, MEXICO

Inle Lake, MYANMAR
(formerly BURMA)

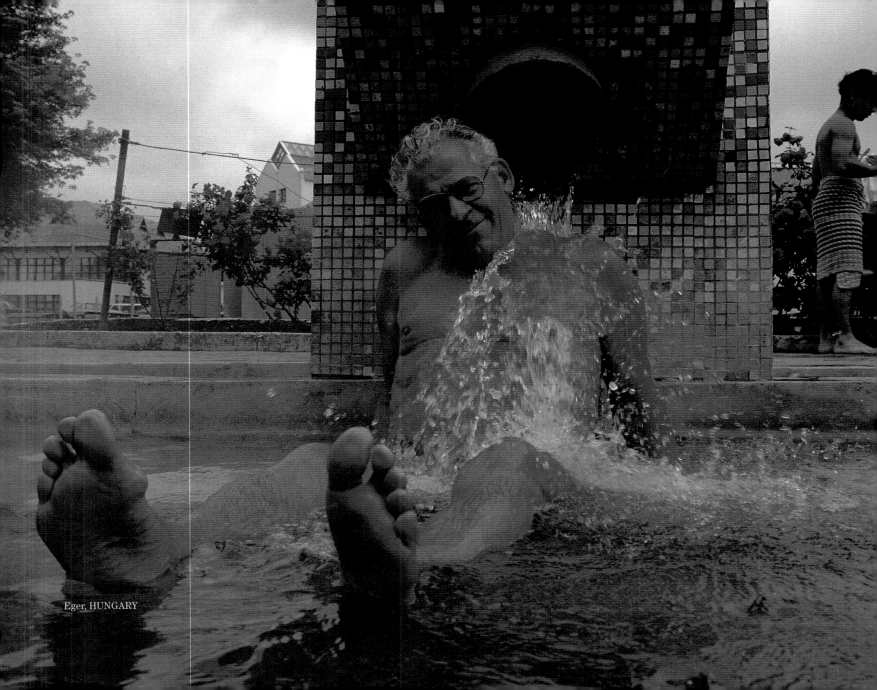

Eger, HUNGARY

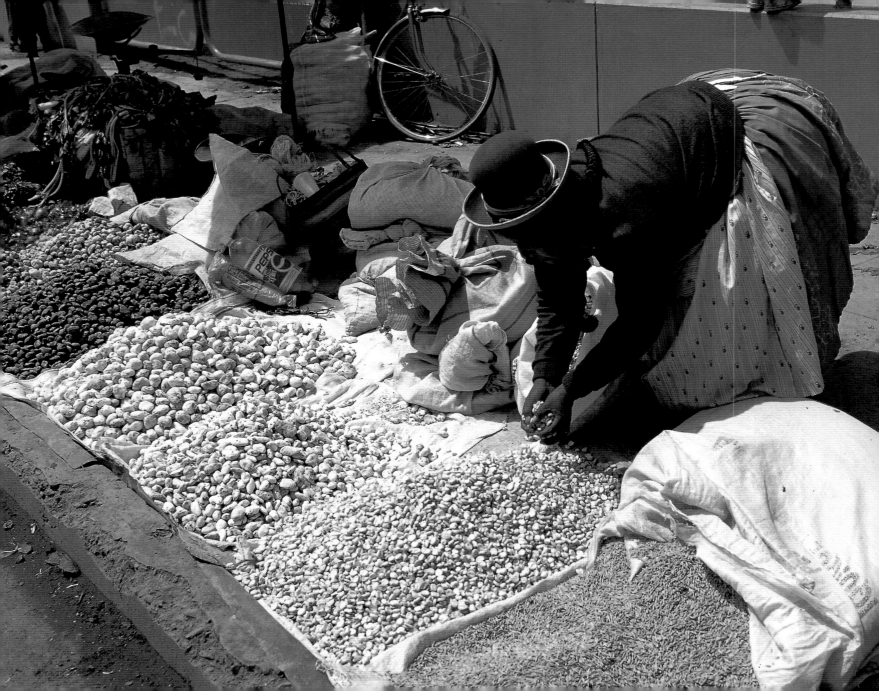

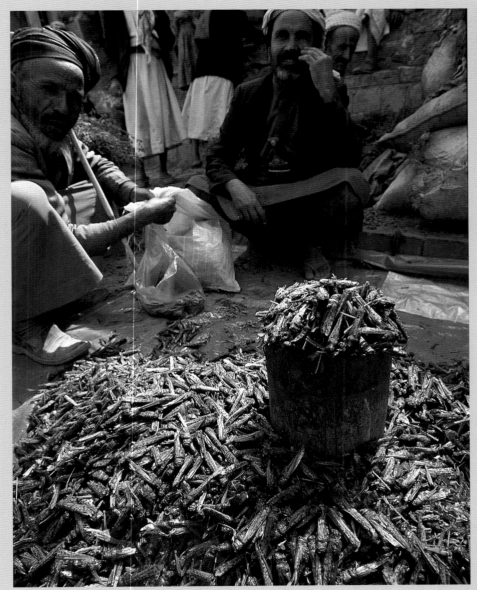

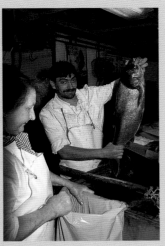

PERU

YEMEN

HUNGARY

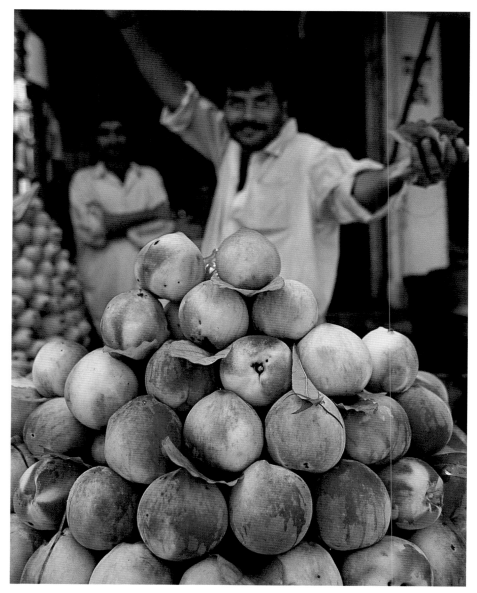

PAKISTAN

PAKISTAN

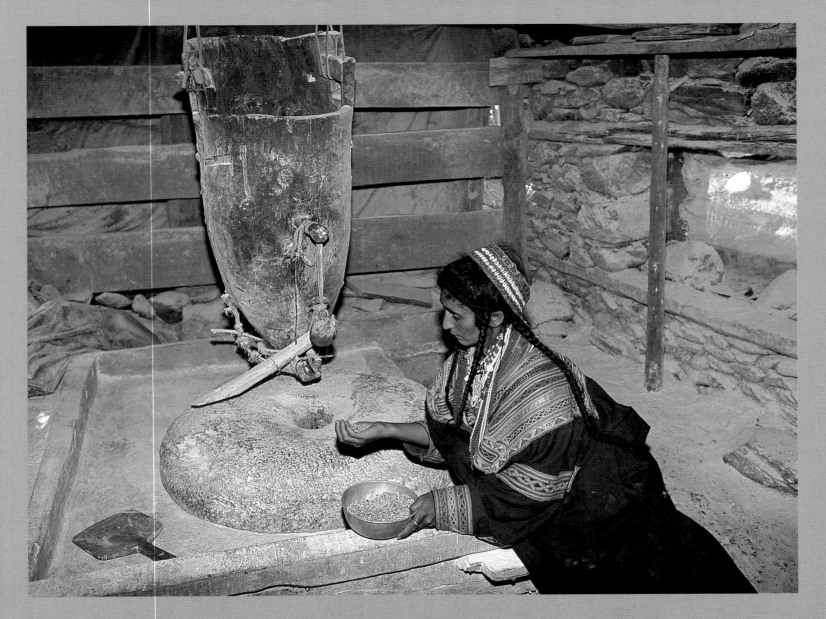

"I perfectly feel even at my finger's end."
John Heywood

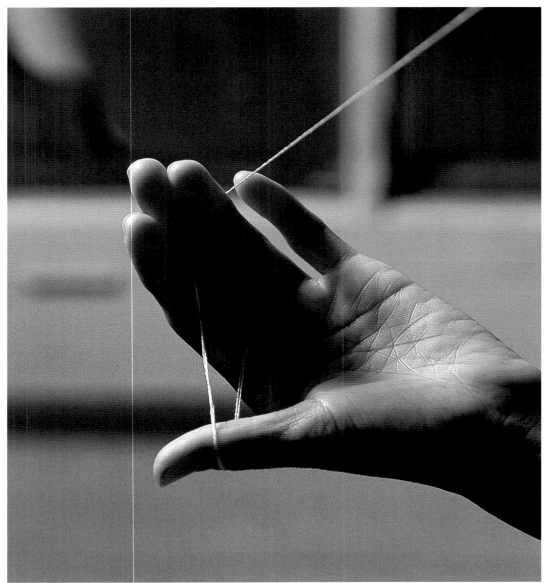

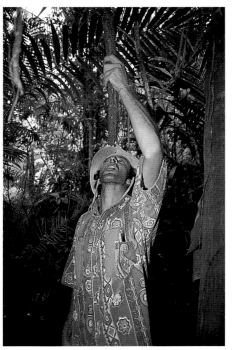

Paro, BHUTAN

VENEZUELA

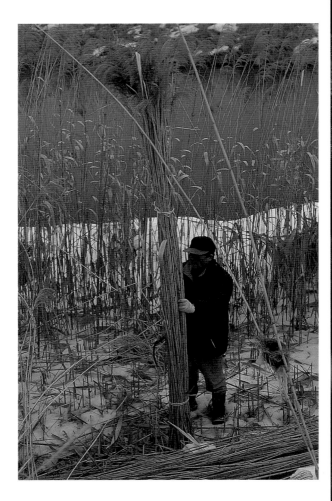

Nagano Prefecture, JAPAN

Shimshal, PAKISTAN

No man can feel himself alone
The while he bravely stands
Between the best friends ever known
His two good, honest hands.
Nixon Waterman

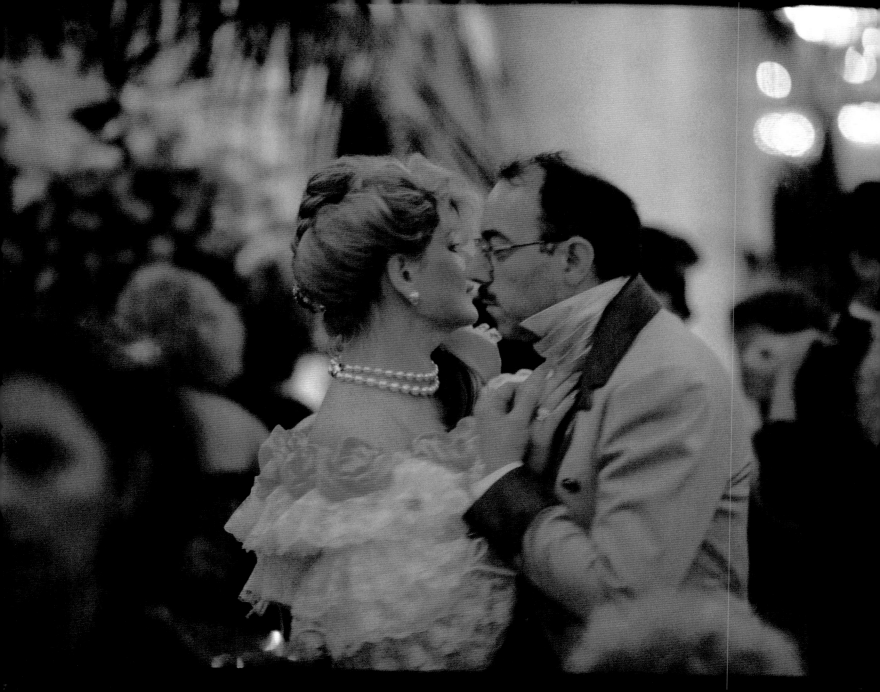

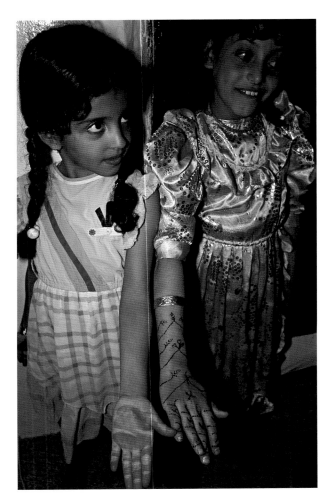

Vienna, AUSTRIA

Sanaa, YEMEN

FEEL

Some feelings are to mortals given With less of earth in them than heaven.

Sir Walter Scott

SLOVAKIA

SENEGAL

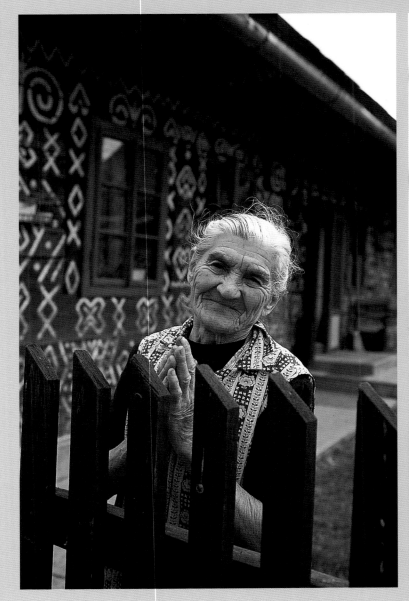
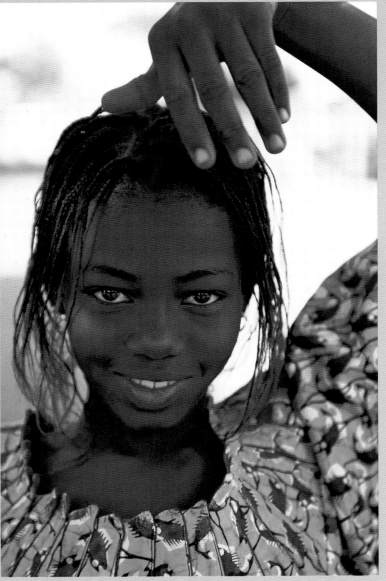

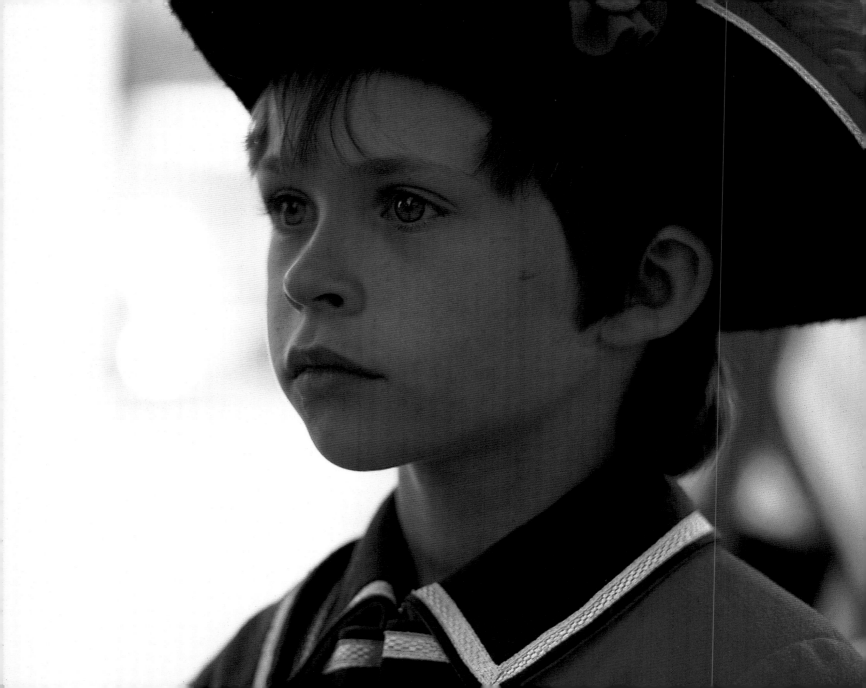

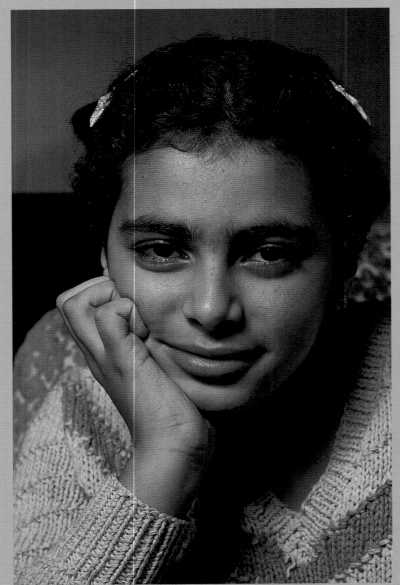

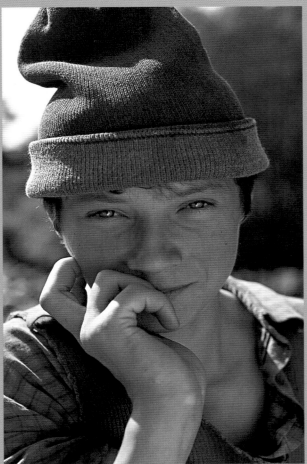

GERMANY

EGYPT

ROMANIA

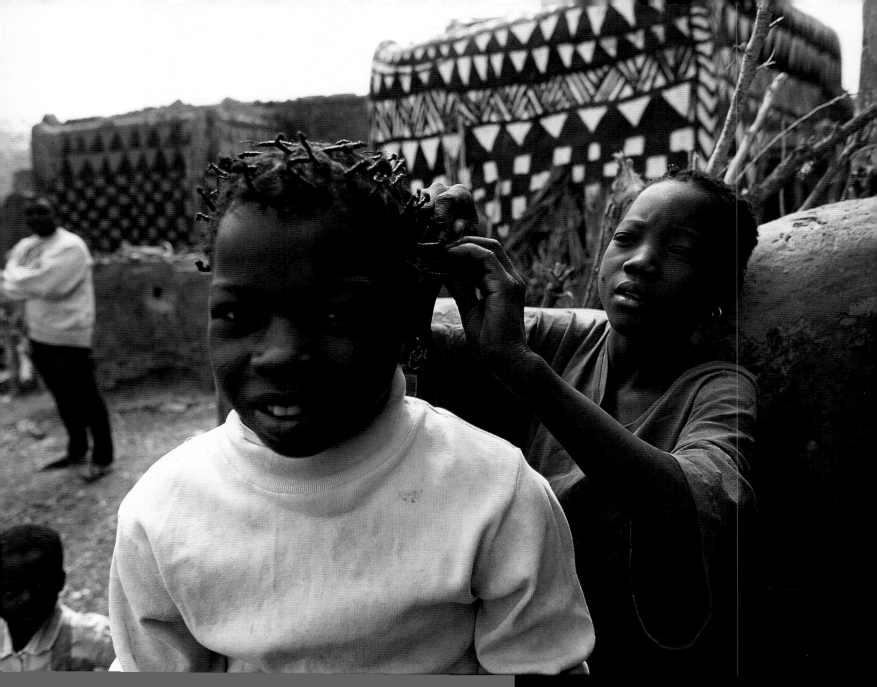

When is man strong until he feels alone?
Robert Browning

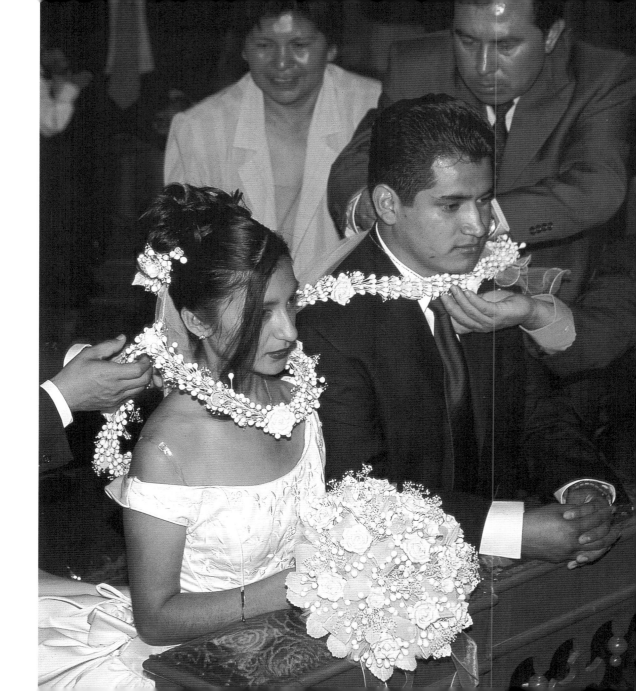

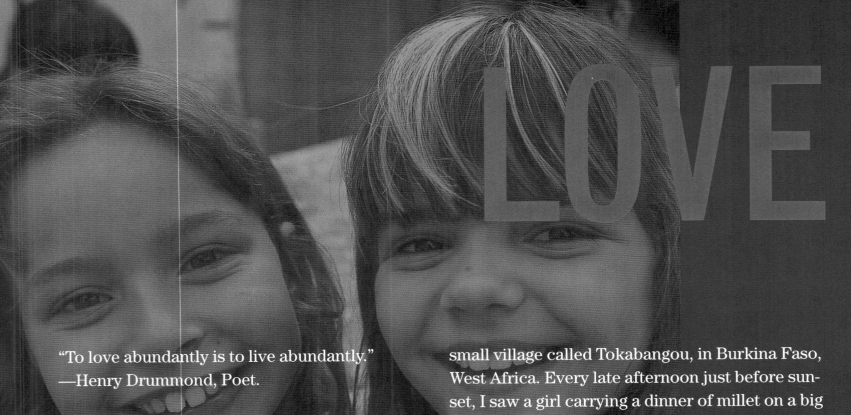

LOVE

"To love abundantly is to live abundantly."
—Henry Drummond, Poet.

The child who grew up feeling loved will have a gentle heart. Love demands understanding and compromise.

Love has been an easy thing to notice during our travels. One of my favorite memories was in a small village called Tokabangou, in Burkina Faso, West Africa. Every late afternoon just before sunset, I saw a girl carrying a dinner of millet on a big plate to her grandfather, who was living outside the village. She stayed and talked with her grandfather until he finished supper. The scene was heartwarming and filled with love and devotion between two generations.

Come live with me, and be my love;
And we will all the pleasures prove
That hills and valleys, dales and fields,
Woods or steepy mountain yields.
Christopher Marlowe

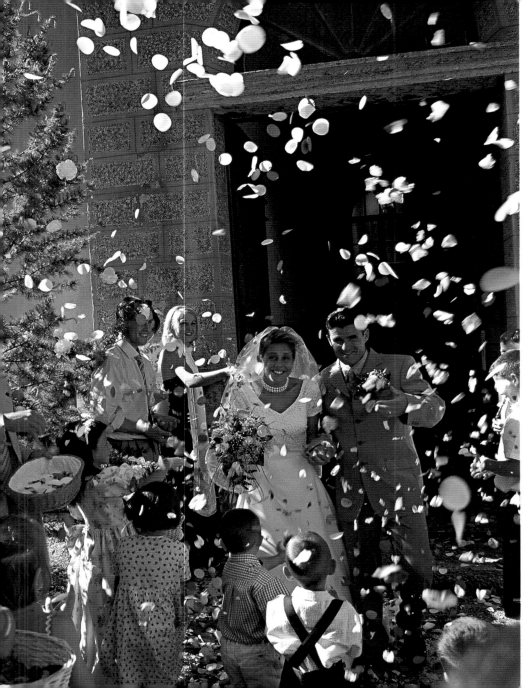

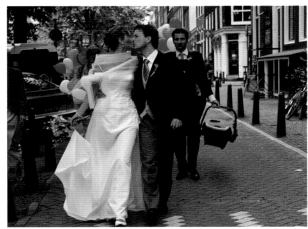

Near Grenoble, FRANCE

Amsterdam, HOLLAND

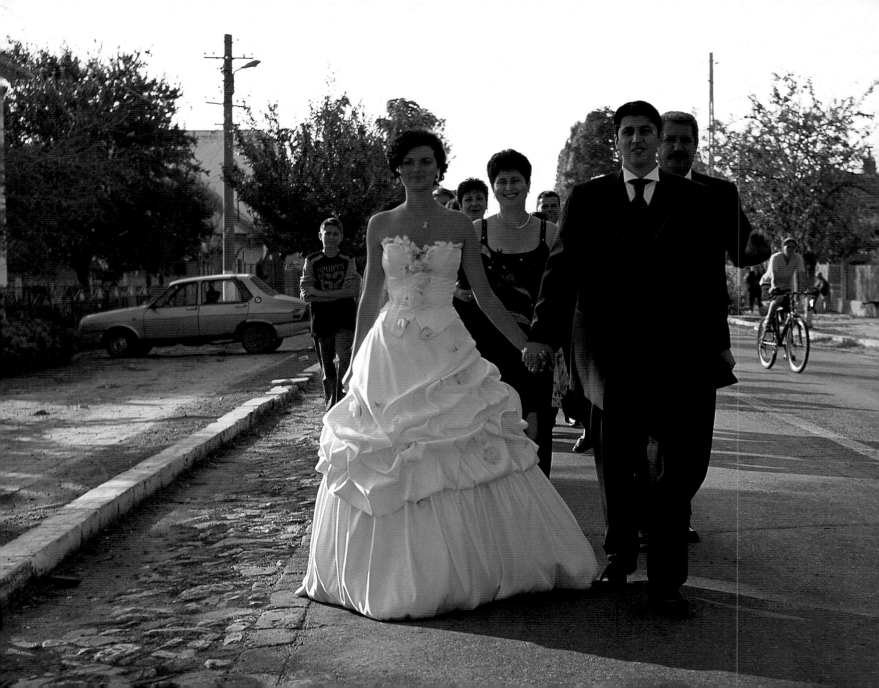

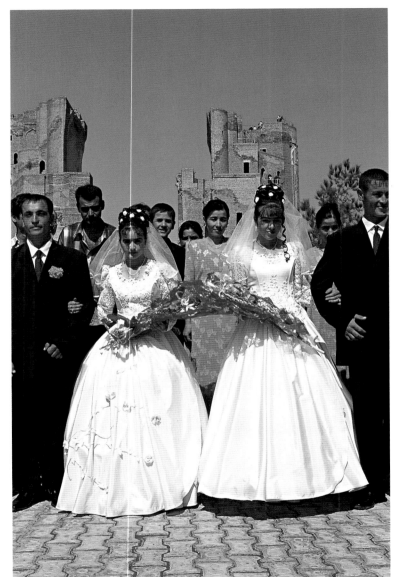

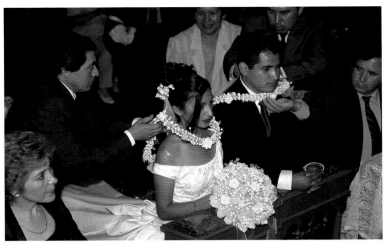

Shakhrisyabz, UZBEKISTAN

Tlaxcala, MEXICO

Love is Nature's second sun,
Causing a spring of virtues where
he shines.

George Chapman

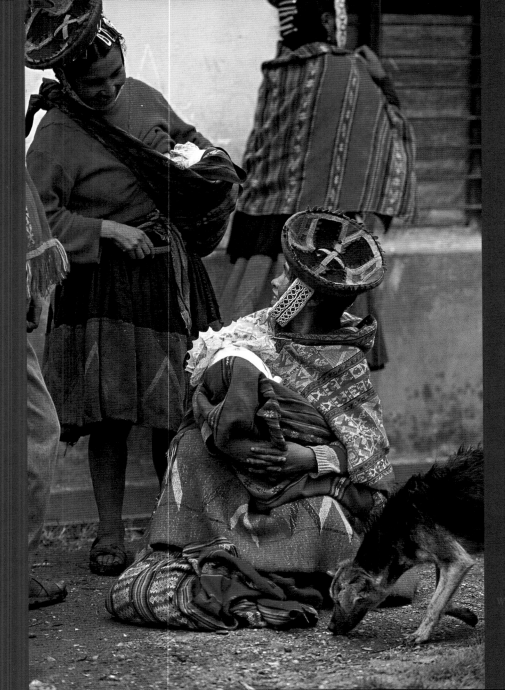

Wuillo, PERU

LOVE 61

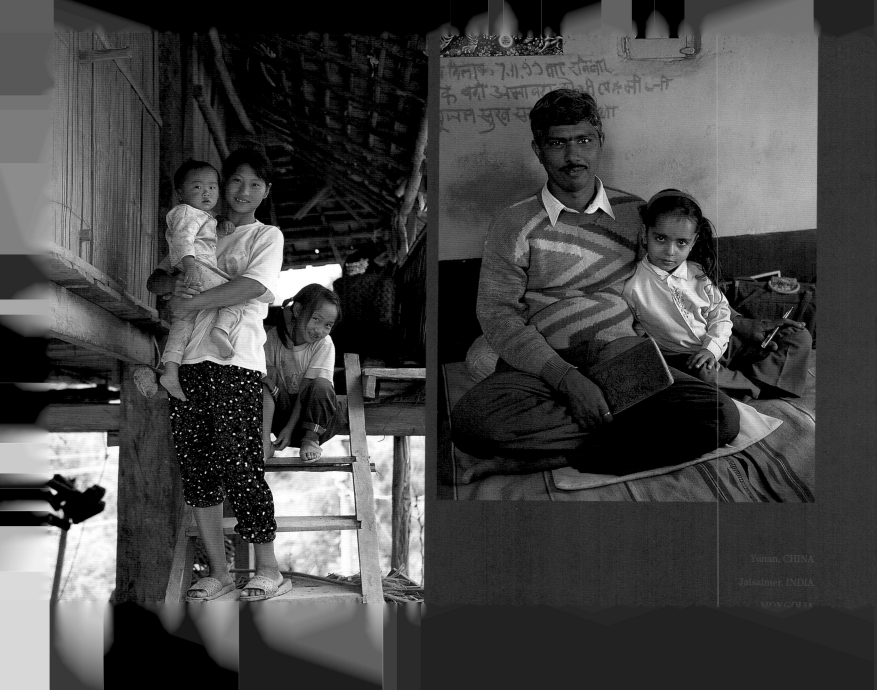

Yunan, CHINA

Jaisalmer, INDIA

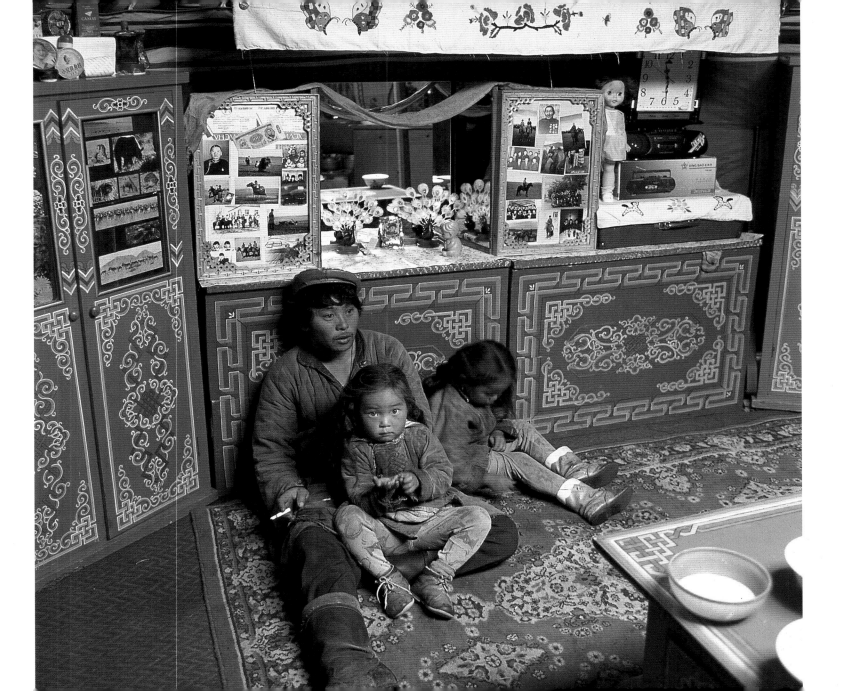

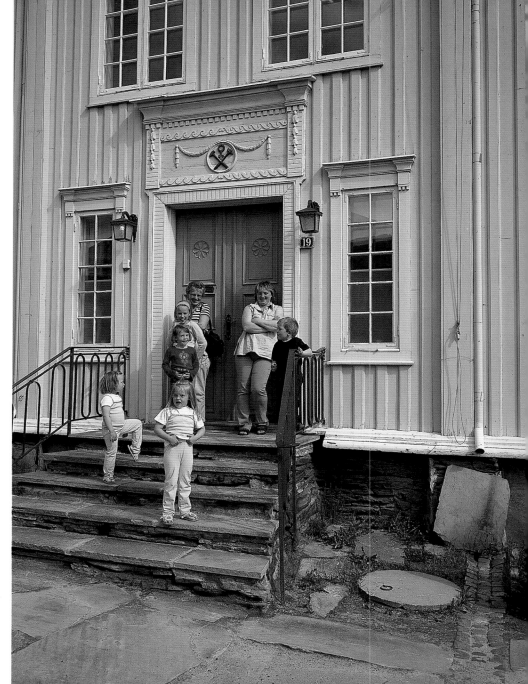

Røros, NORWAY

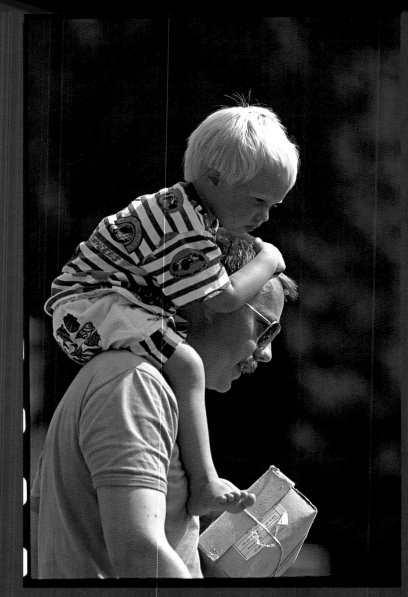

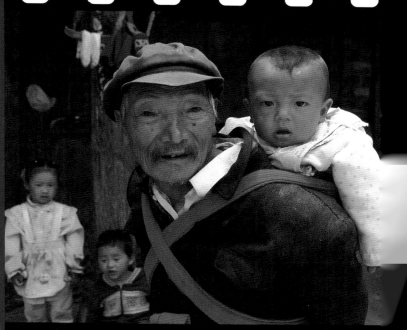

SLOVAKIA

Near Lijang, CHINA

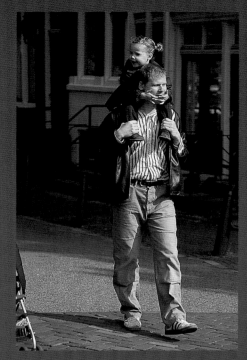

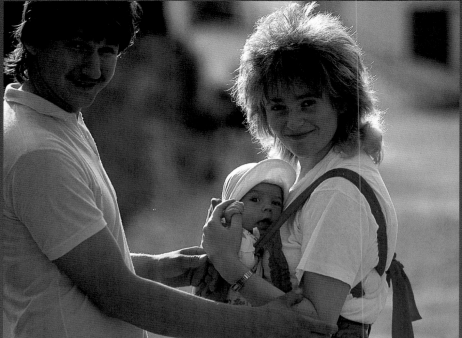

Amsterdam, HOLLAND

Hollókő, HUNGARY

Amsterdam, HOLLAND

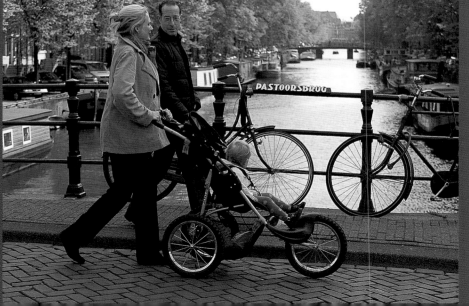

It is a wise father that knows his own child.
William Shakespeare

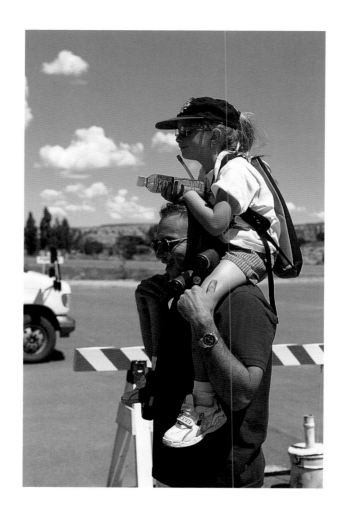

UNITED STATES

Røros, NORWAY

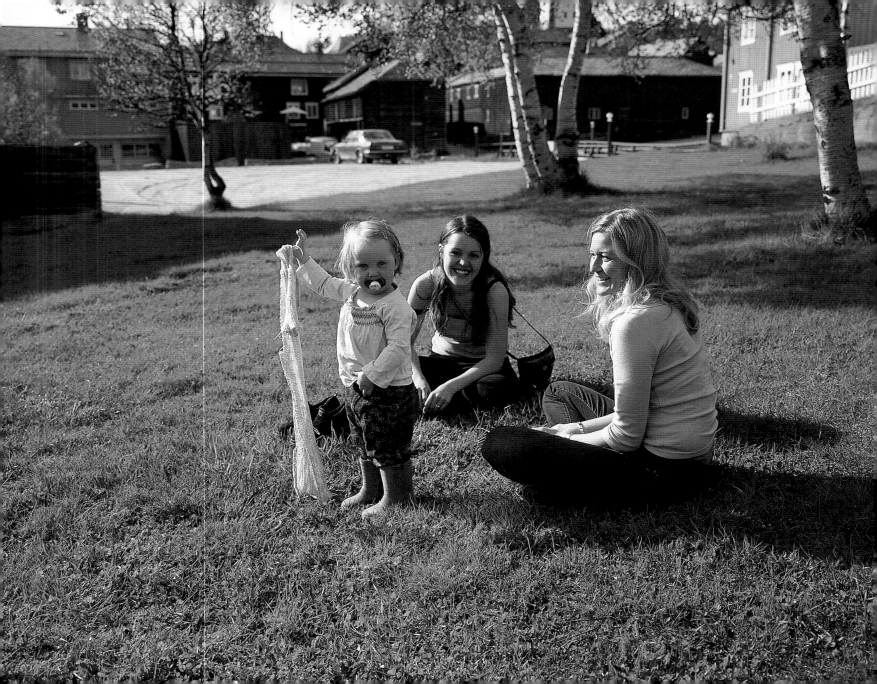

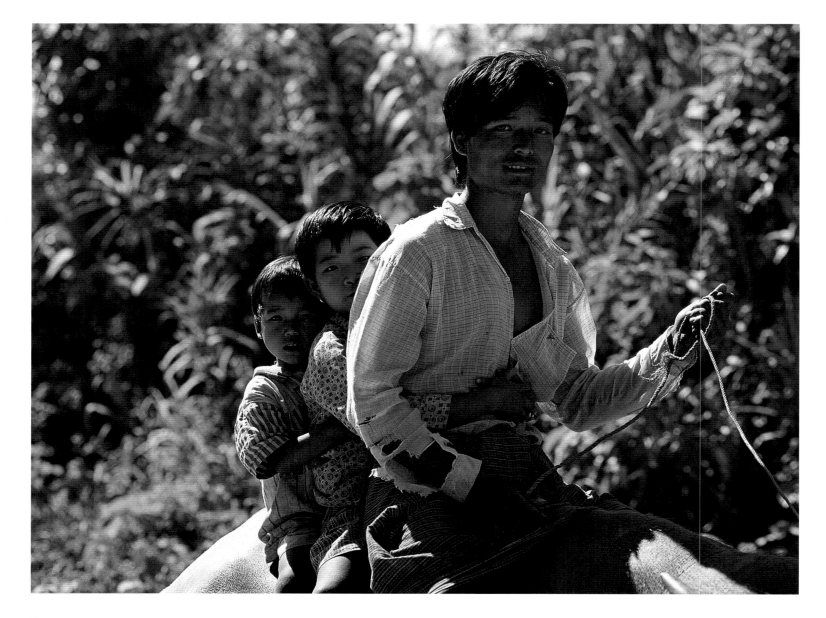

A friendship that like love is warm;
A love like friendship, steady.
Thomas Moore

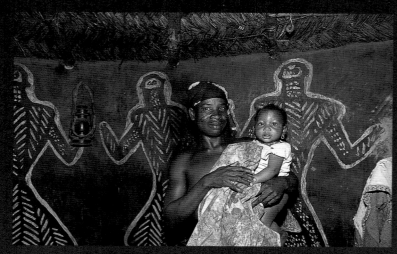

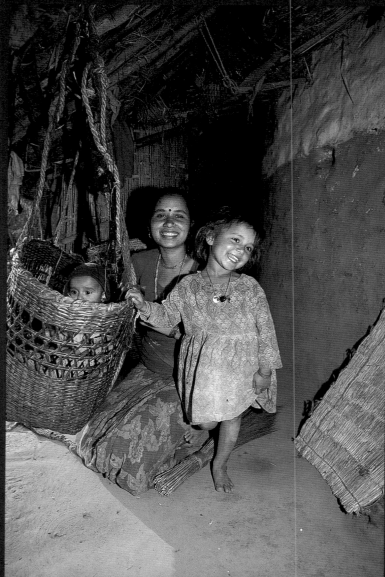

Zbila, GHANA

Suikhet, NEPAL

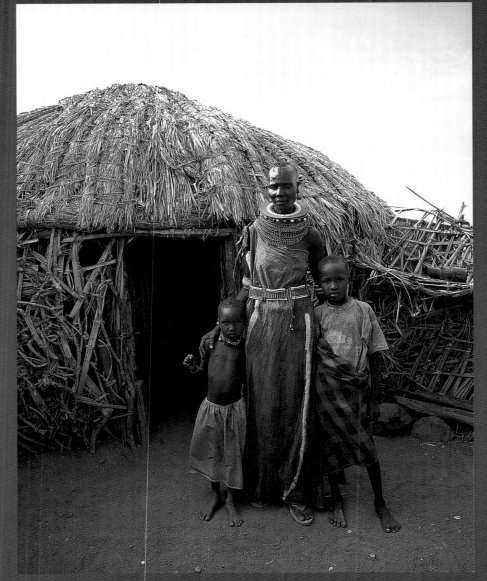

Loyangalani, KENYA

LOVE

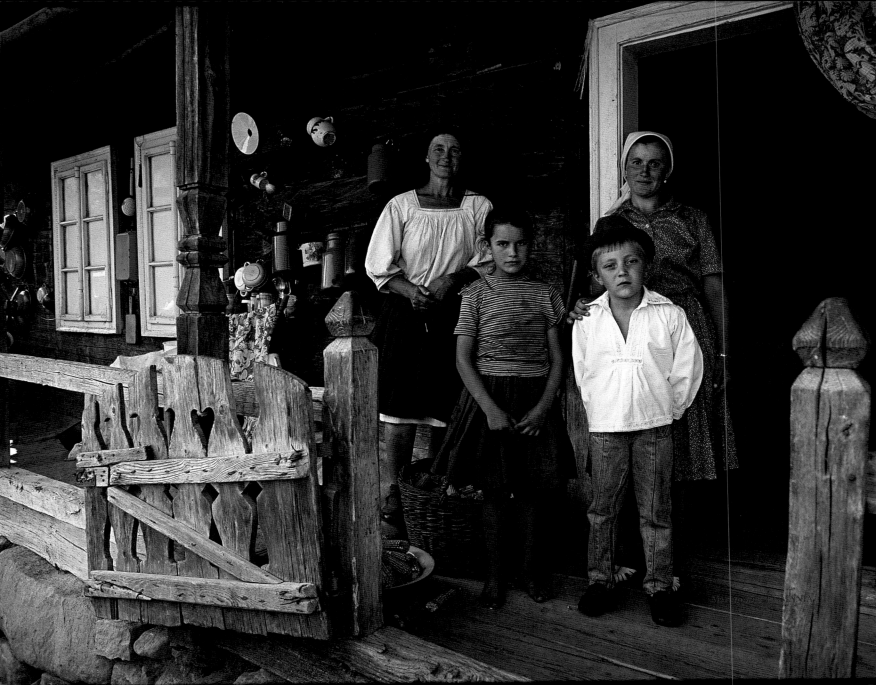

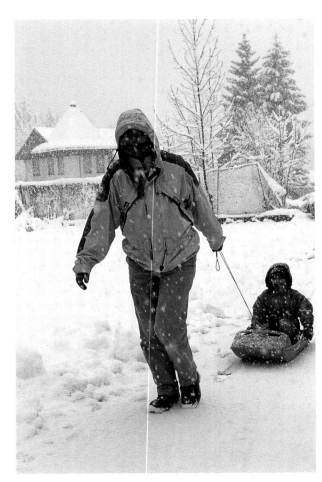

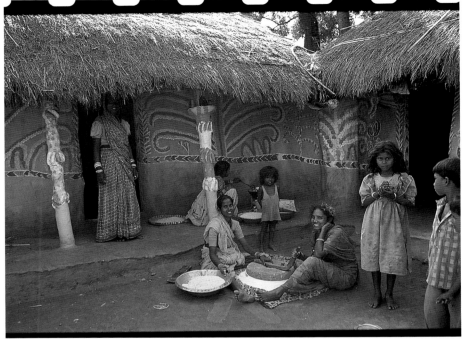

Northern ITALY

Near Janakpur, NEPAL

That best portion of a good man's life,
His little, nameless, unremembered acts
Of kindness and of love.

William Wordsworth

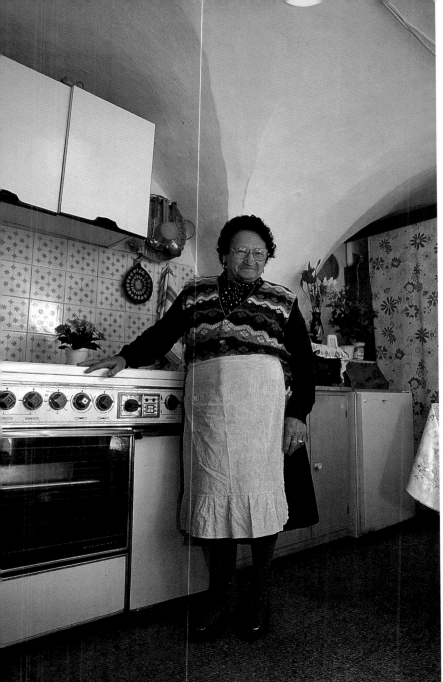

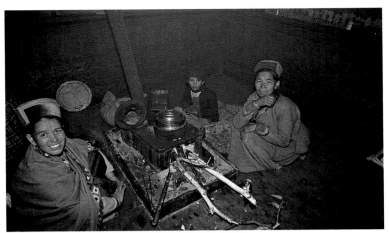

Cisternino, ITALY

Chitkul, INDIA

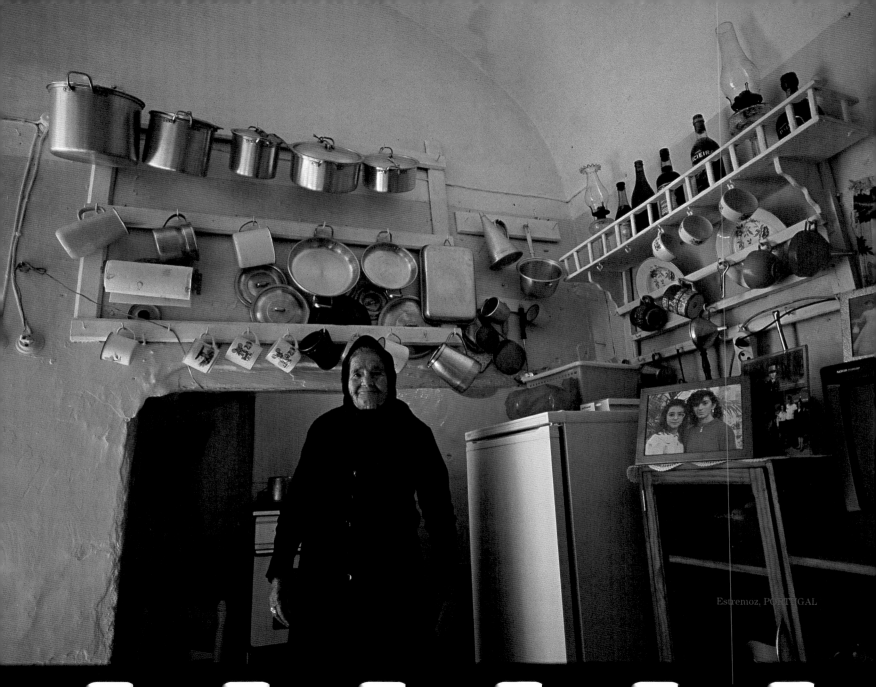

Estremoz, PORTUGAL

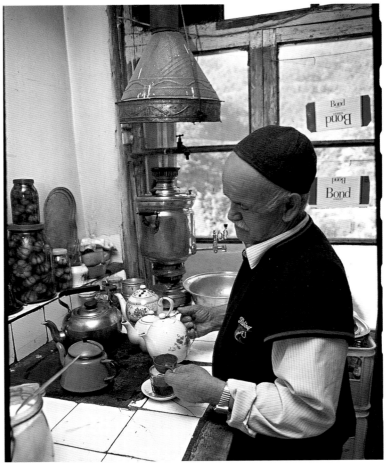

Antwerp, BELGIUM

Masule, IRAN

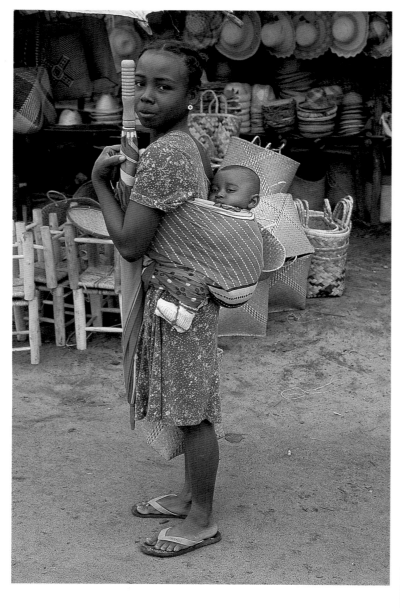

HUMANKIND

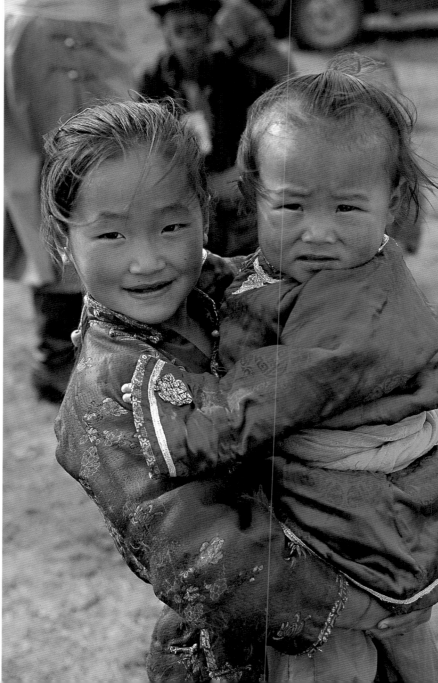

Little deeds of kindness, little
words of love,
Help to make earth happy like
the heaven above.
Julia A. Fletcher Carney

MADAGASCAR

MONGOLIA

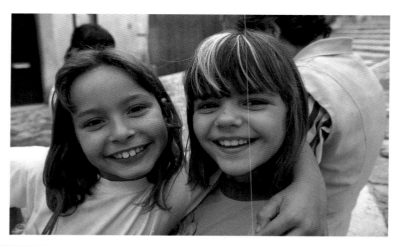

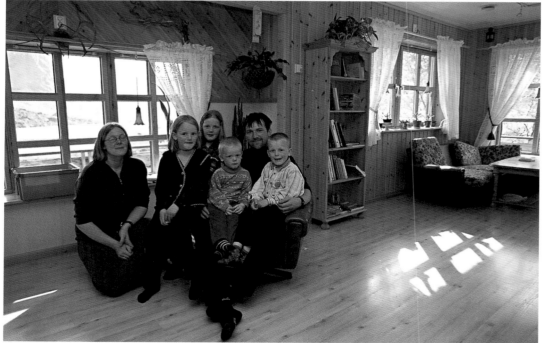

PORTUGAL

Lofoten, NORWAY

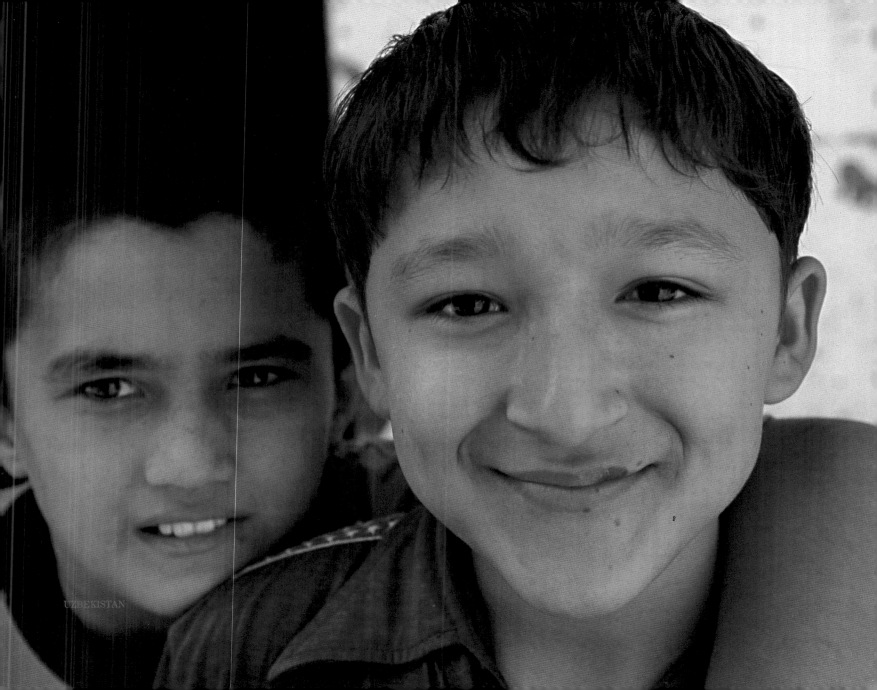

UZBEKISTAN

Animals are such agreeable friends —they ask no questions, they pass no criticisms.
George Eliot

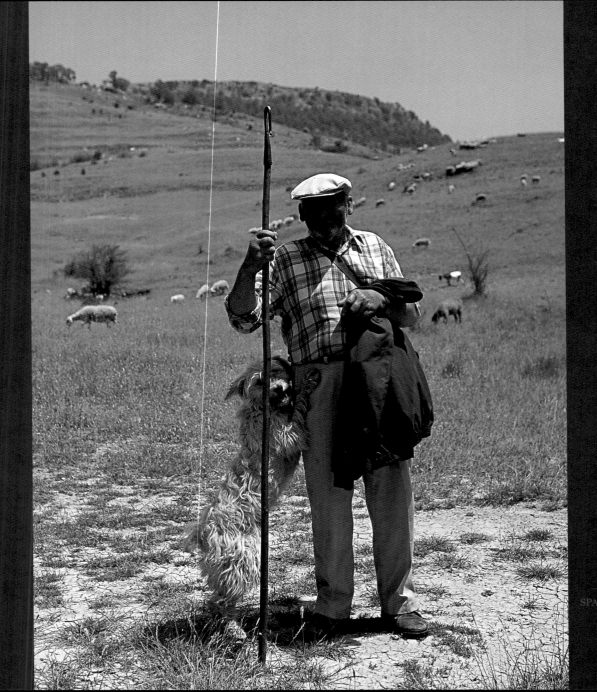

LOVE

SPAIN

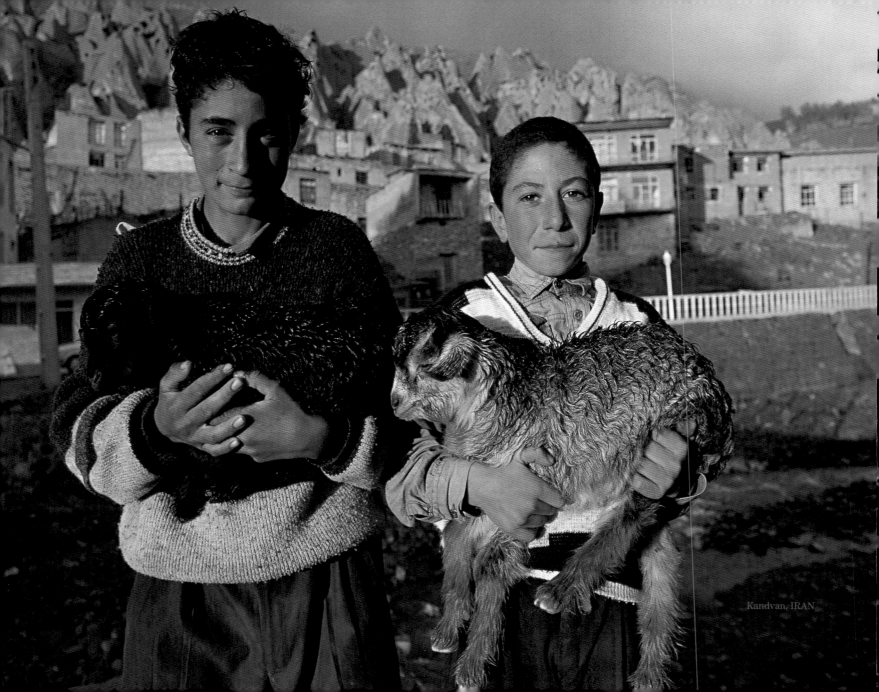
Kandvan, IRAN

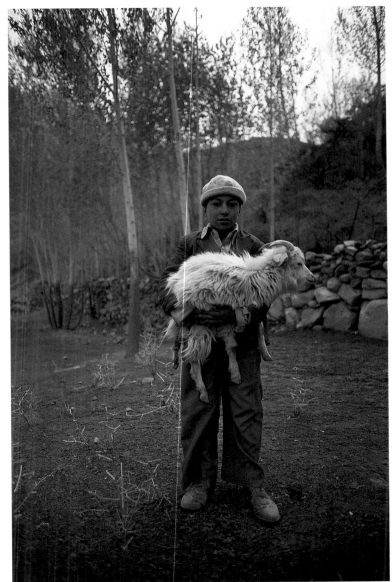

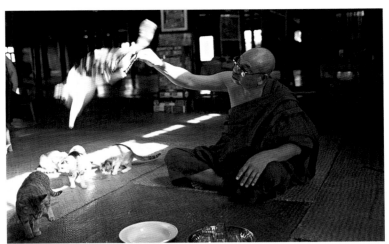

PAKISTAN

MYANMAR (formerly BURMA)

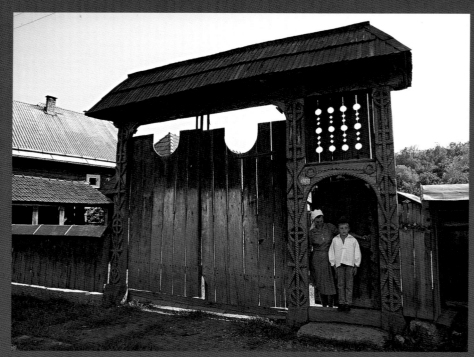

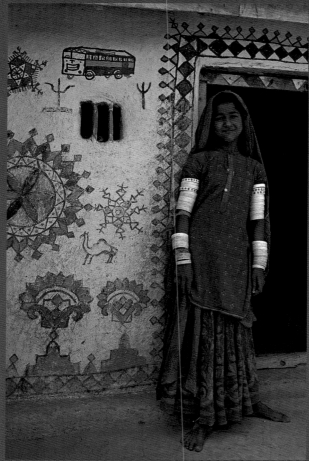

Maramures, ROMANIA

Gujarat, INDIA

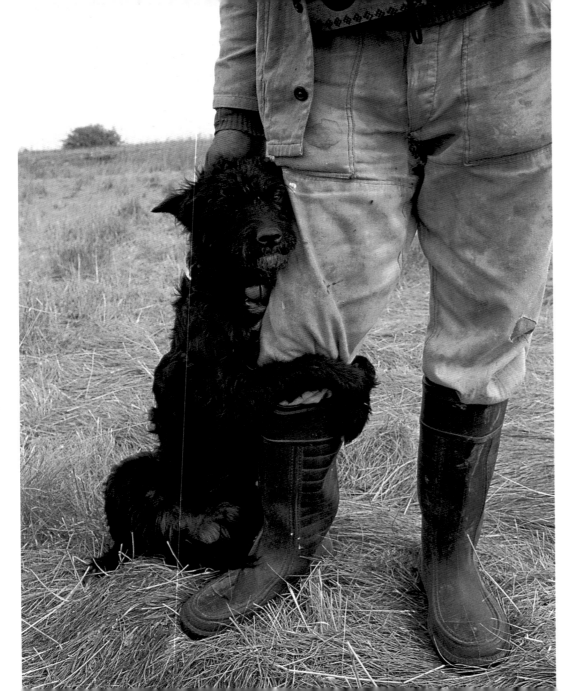

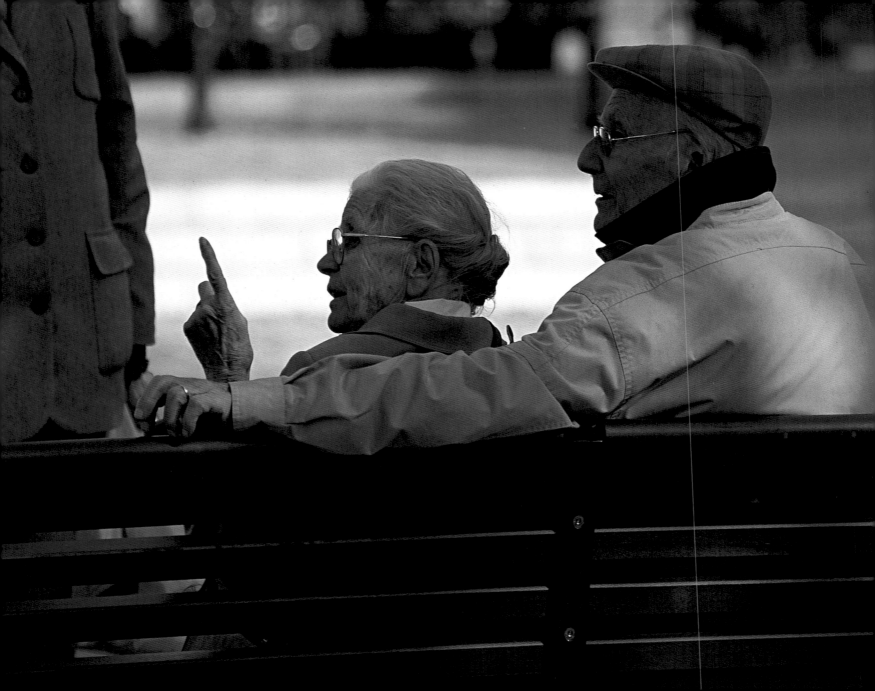

We have lived and loved together
Through many changing years;
We have shared each other's gladness,
And wept each other's tears.
Charles Jefferys

Colmar, FRANCE

HOPE

Hope implies trust and reliance on things that may or may not be under one's control.

I was born a few months after the end of World War II. Many people died in the war; the economy was a mess, and people all over the world were exhausted. Many people felt hopeless and wondered if they could effect change in such an environment. In 1955, ten years after the war had ended, hope came in the form of a humanistic photo exhibition held at New York's Museum of Modern Art. Organized by Edward Steichen, the title was "Family of Man," and it toured many countries. It was a beam of hope that influenced my heart and left me hopeful for a simpler, more natural life.

I laugh, for hope hath happy place with me …
William Ellery Channing

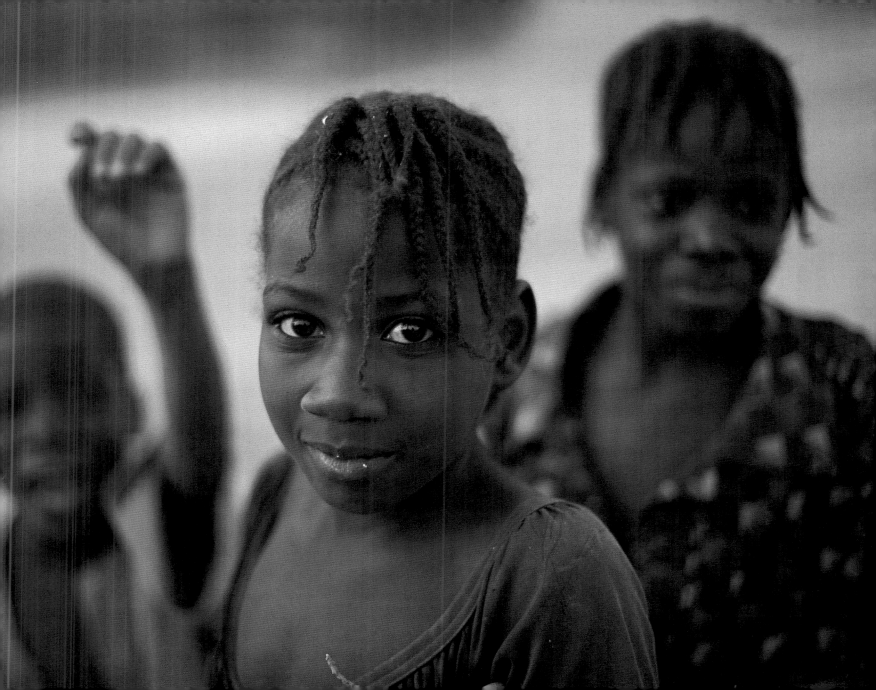

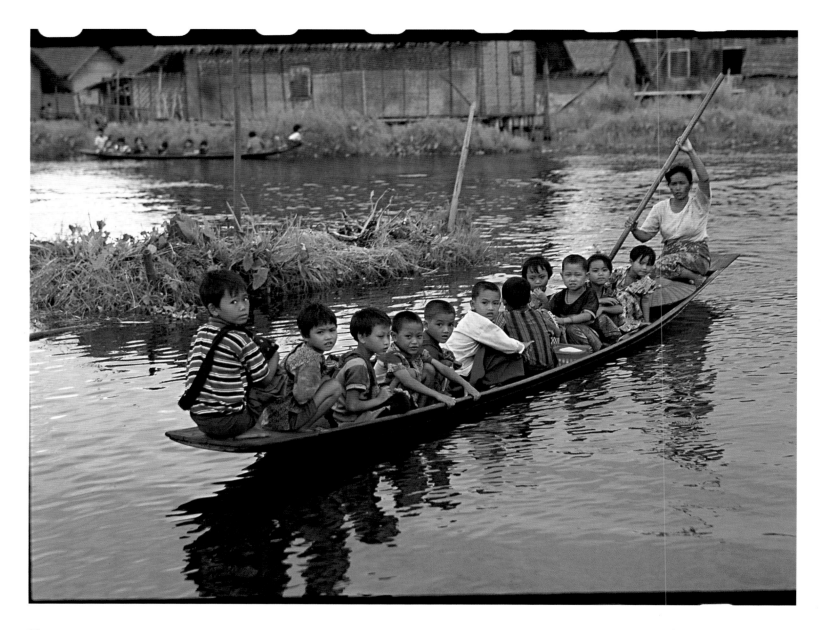

Inle Lake, MYANMAR (formerly BURMA)

MOROCCO

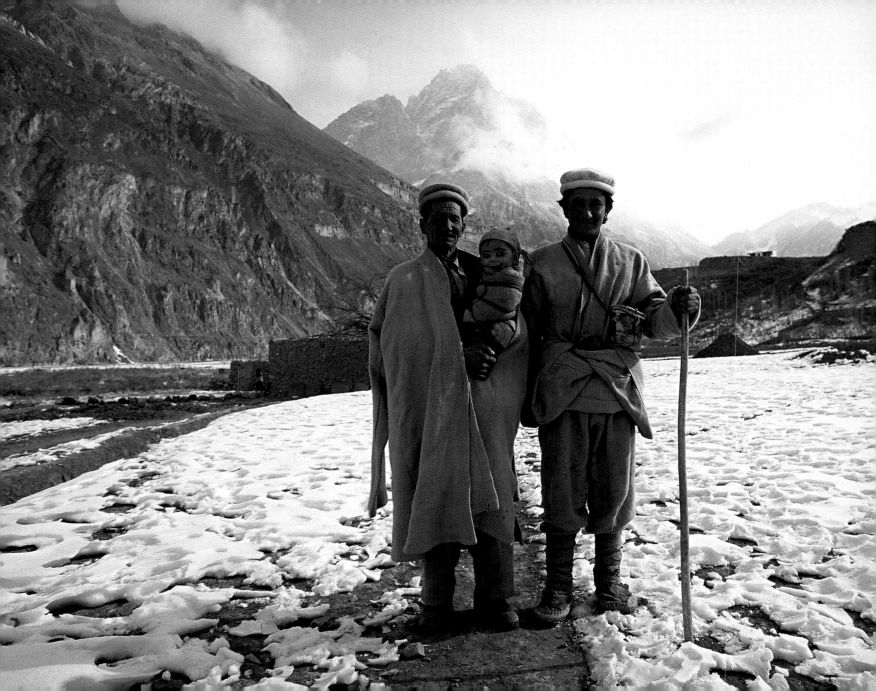

HOPE

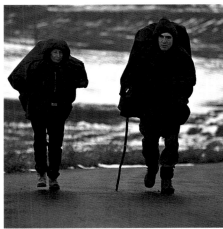

Shimshal, PAKISTAN

SPAIN

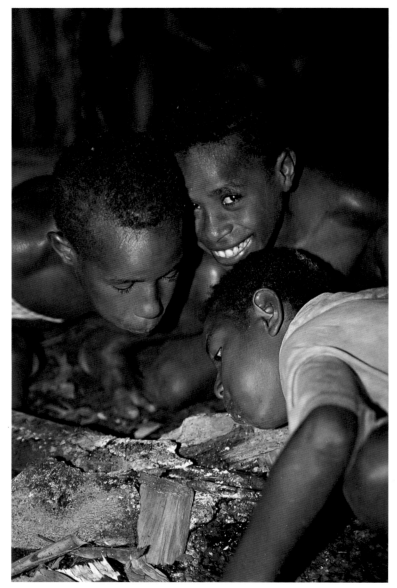
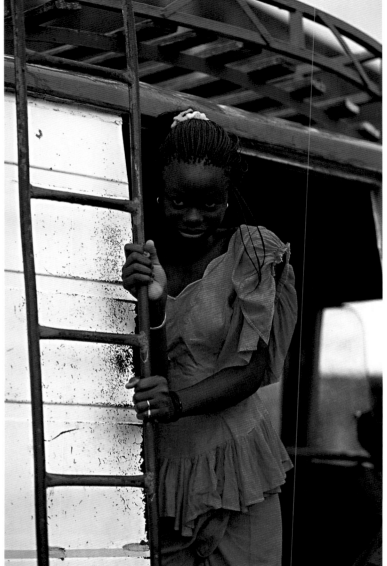

Hope, like the gleaming taper's light,
Adorns and cheers our way.

Oliver Goldsmith

PAPUA NEW GUINEA

Ziguinchor, SENEGAL

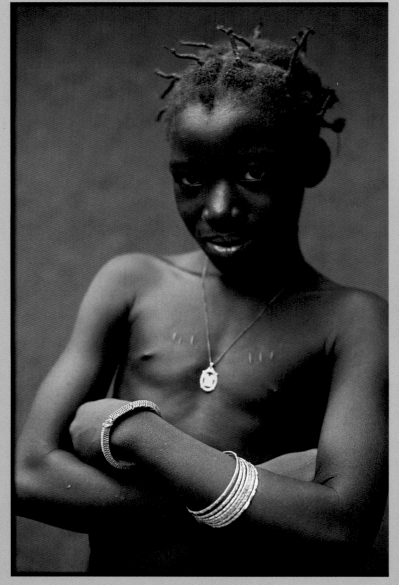

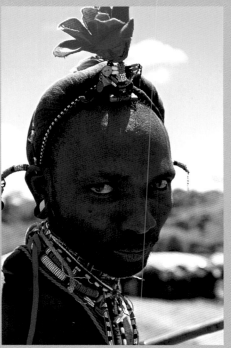

IVORY COAST

KENYA

VENEZUELA

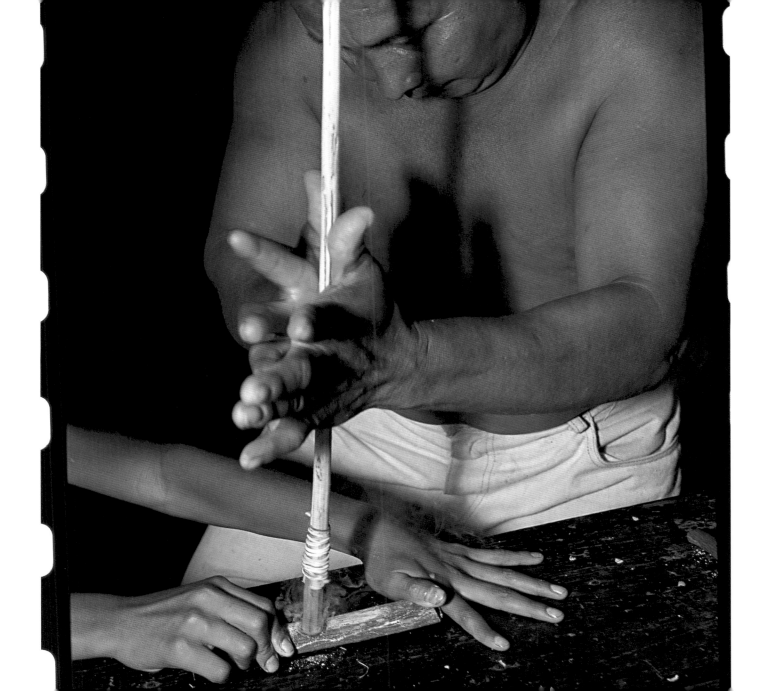

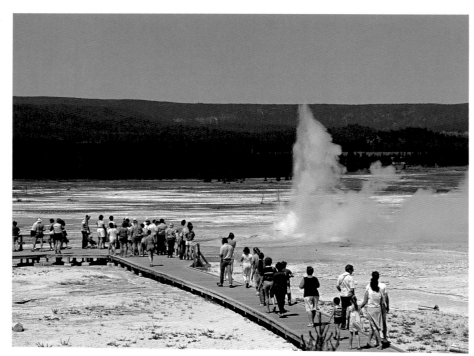

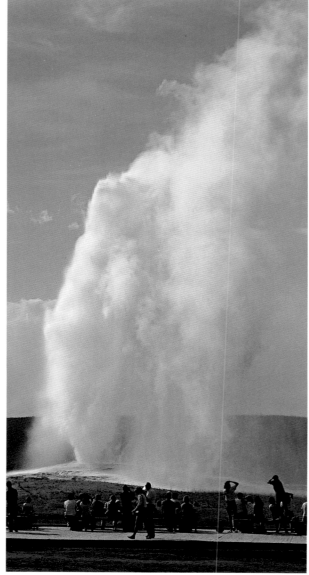

UNITED STATES

Hope springs eternal in the human breast...
Alexander Pope

Celebrating Friendship

Arizona, UNITED STATES

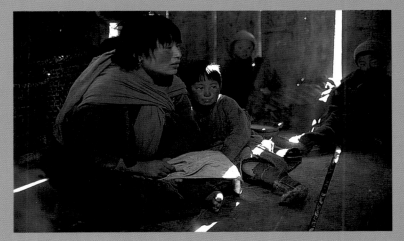

HOPE

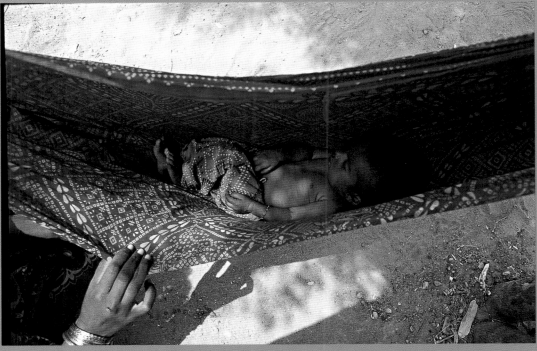

BHUTAN

Gujarat, INDIA

If a profound gulf separates my neighbor's belief from mine, there is always the golden bridge of tolerance.

Anonymous

Dublin, IRELAND

Nabusimake, COLOMBIA

SWITZERLAND

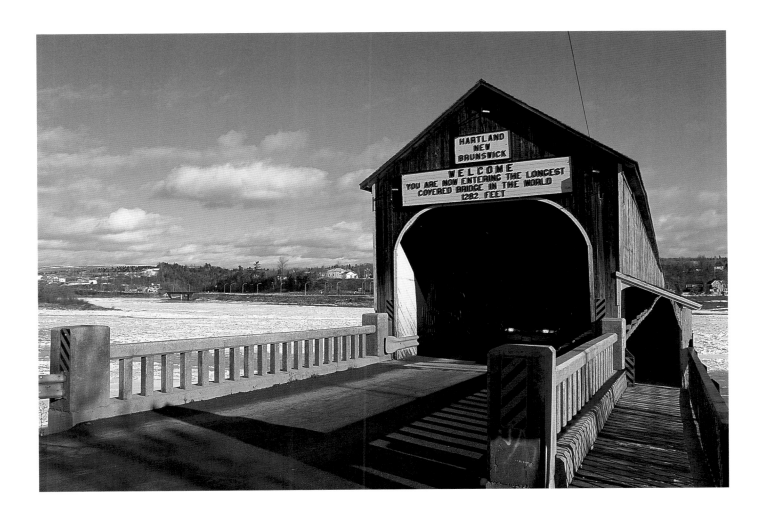

New Brunswick, CANADA

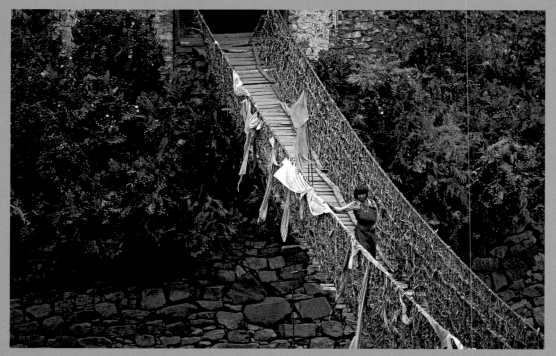

Lhuntshi, BHUTAN

SENEGAL

CURAÇAO (Netherlands Antilles)

Go to the truth beyond the mind. Love is the bridge.
Stephen Levine

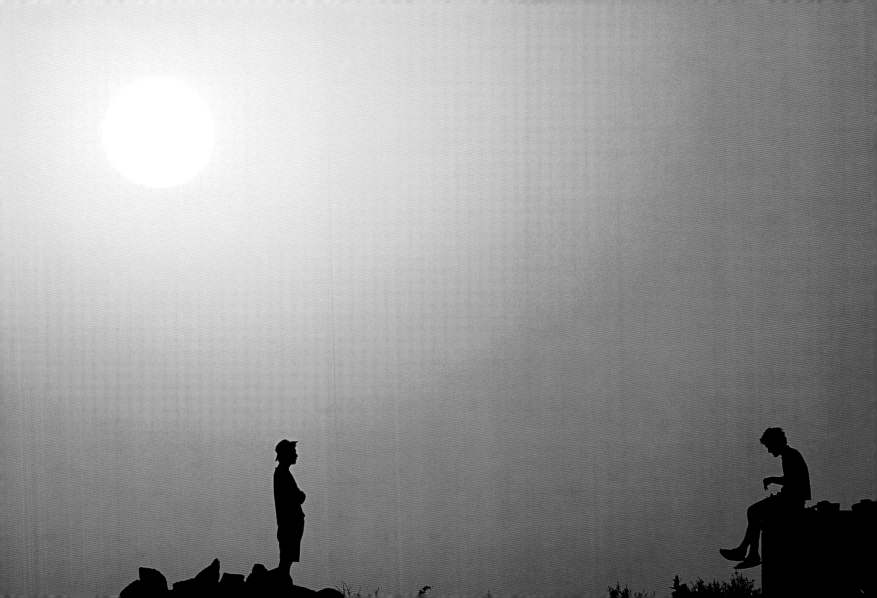

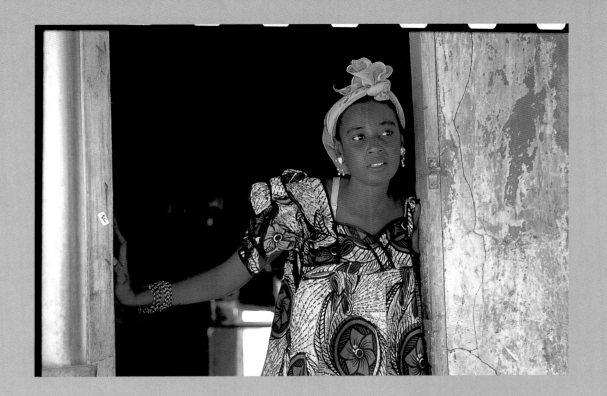

HOPE

Vienna, AUSTRIA

Sélibabi, MAURITANIA

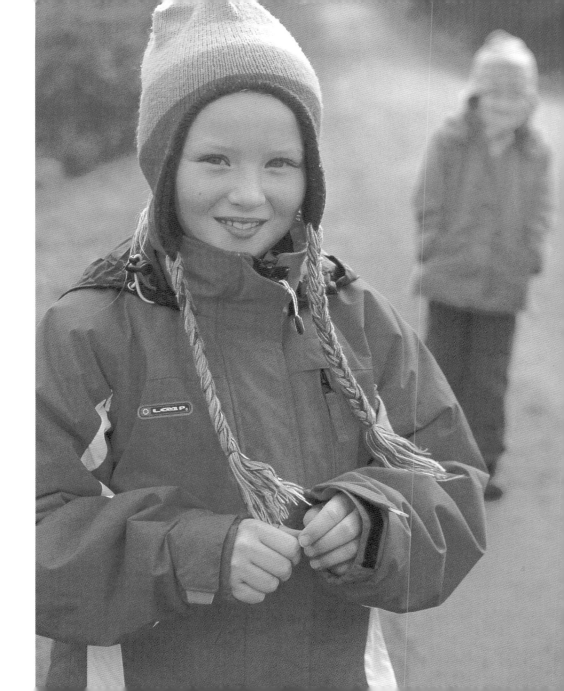

LAUGH

Laughter is a strong way to communicate with others. There is a wide variety to laughter: young girls often giggle over nothing; boys grin mischievously; men smile knowingly; older people chuckle as if they are remembering something funny.

Laughter helps people overcome difficulties. It is one of Nature's cures. It instills an eagerness to live and opens the door to miraculous healing.

On a hot afternoon on the small island of Lifou in New Caledonia, which is situated in the Pacific Ocean, I saw girls walking home from school. They were smiling at me because I was gesturing with my camera and talking to them about the funny handmade hats they were wearing. Gradually, the smiles moved to an explosion of laughter, which made the day even warmer.

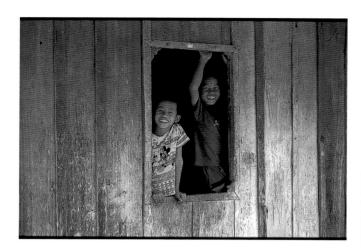

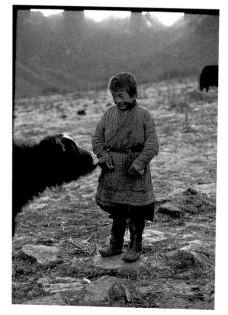

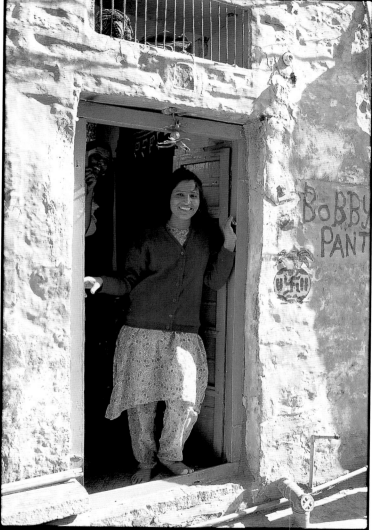

One inch of joy surmounts of grief a span, Because to laugh is proper to the man.
François Rabelais

Ban Nangang, LAOS

BHUTAN

Jaisalmer, INDIA

Laughter is the closest thing to the grace of God.

Karl Barth

Kalpa, INDIA

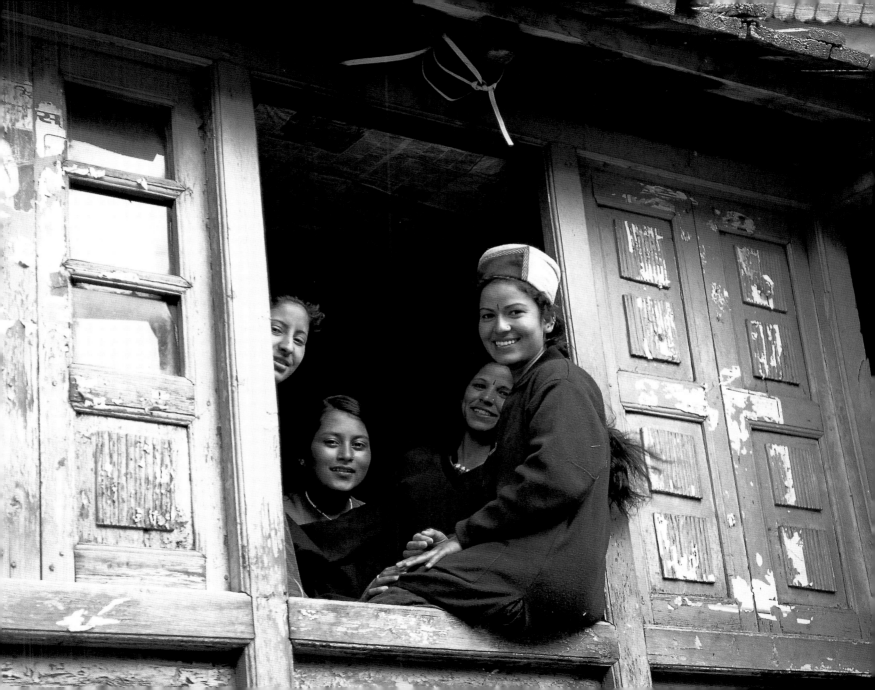

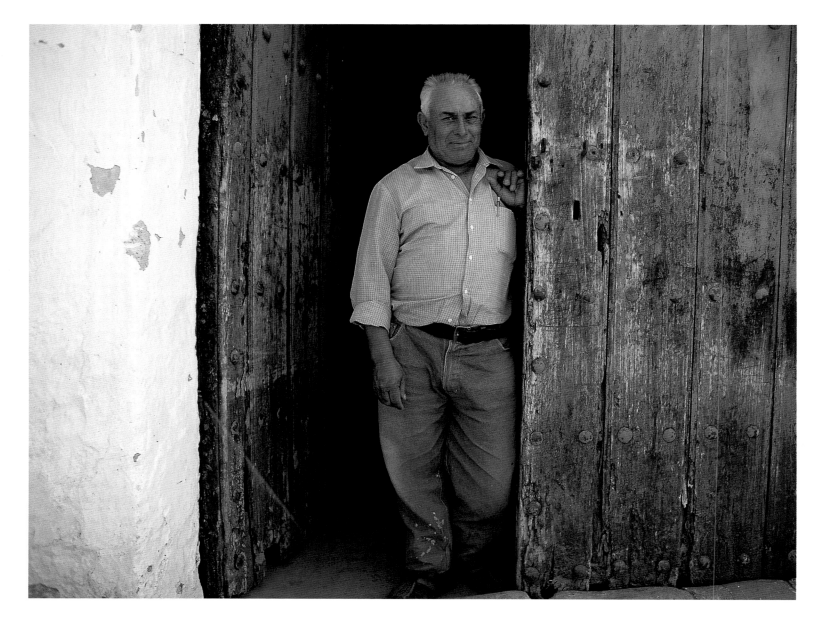

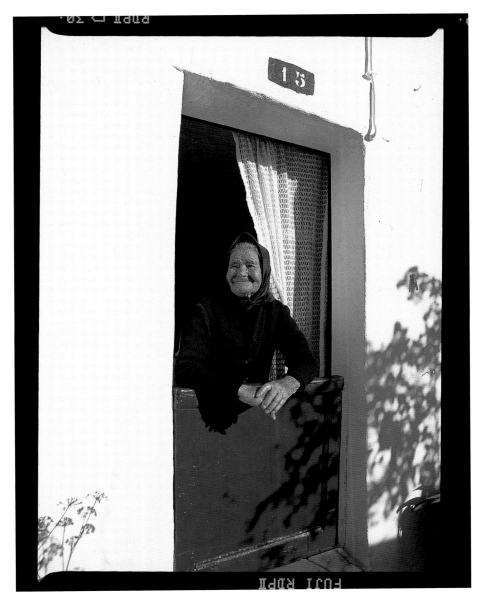

LAUGH

Ronda, SPAIN

PORTUGAL

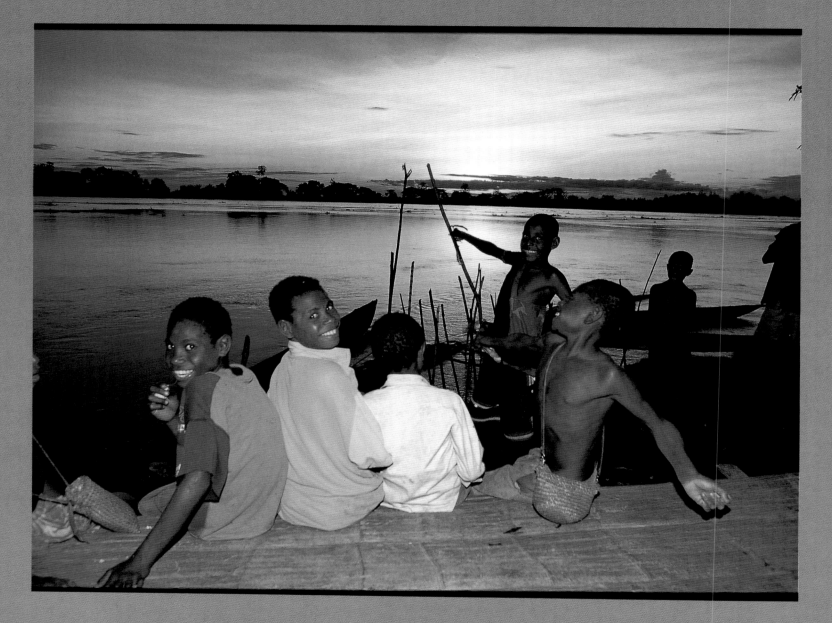

Laughter is day, and sobriety is night; a smile is the twilight that hovers gently between both, more bewitching than either.

Henry Ward Beecher

PAPUA NEW GUINEA

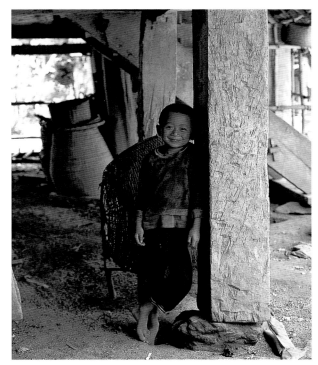

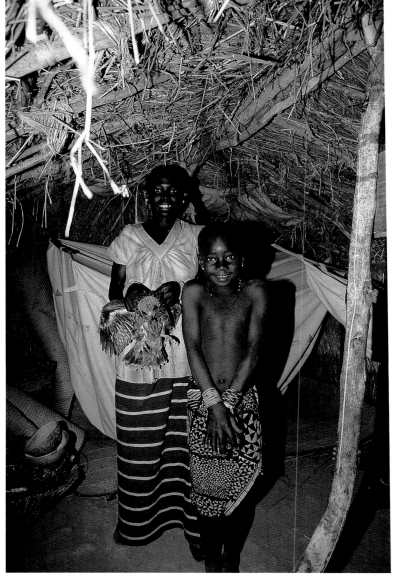

LAOS

MALI

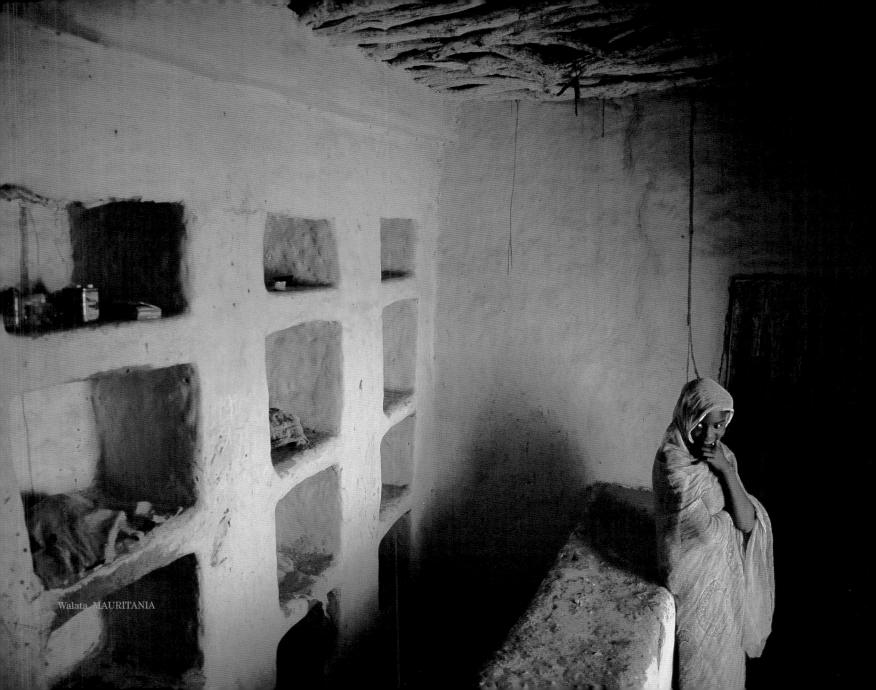
Walata MAURITANIA

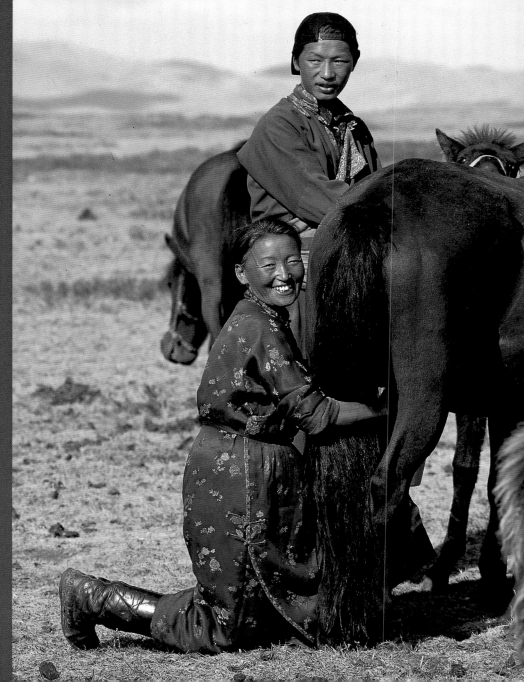

Estremoz, PORTUGAL

LAUGH

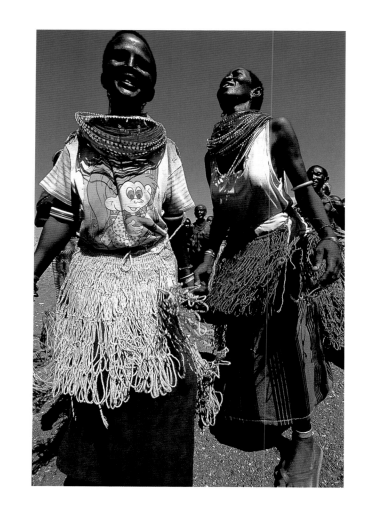

KENYA

ETHIOPIA

TOGO

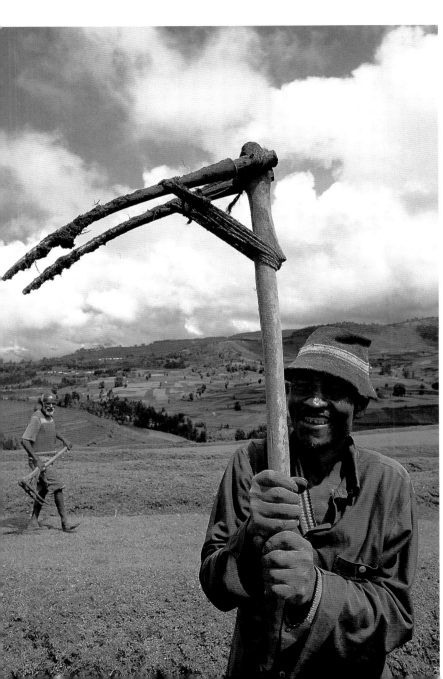
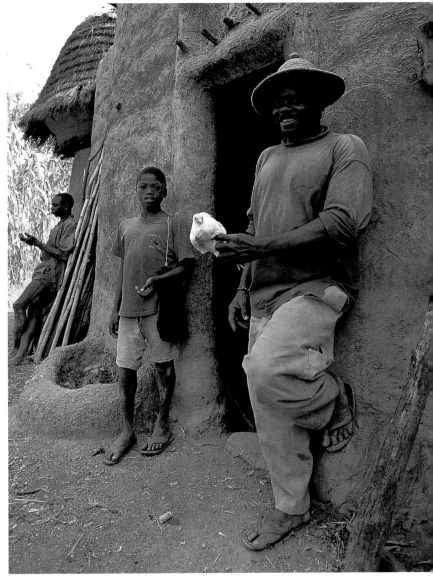

Most smiles are
started by another smile.
Frank A. Clark

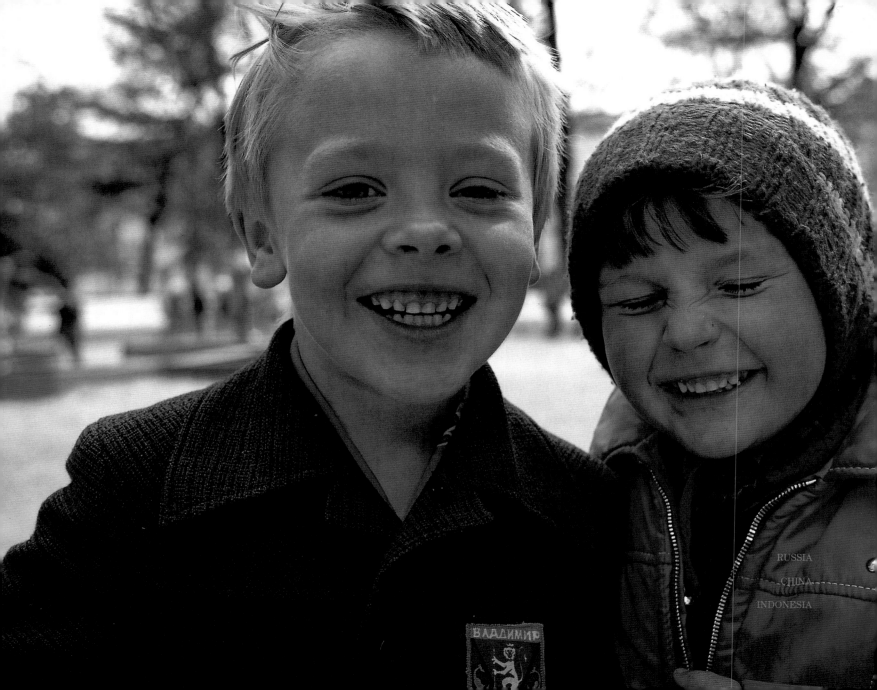

ВЛАДИМИР

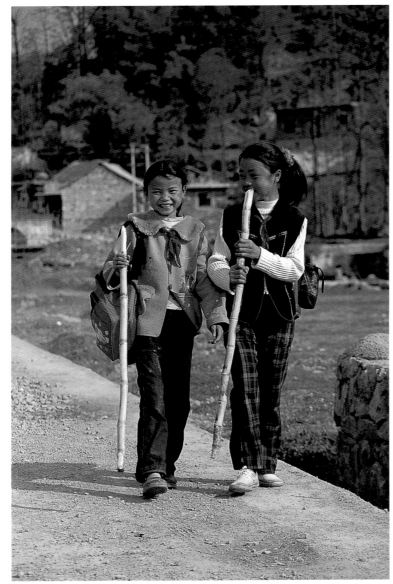
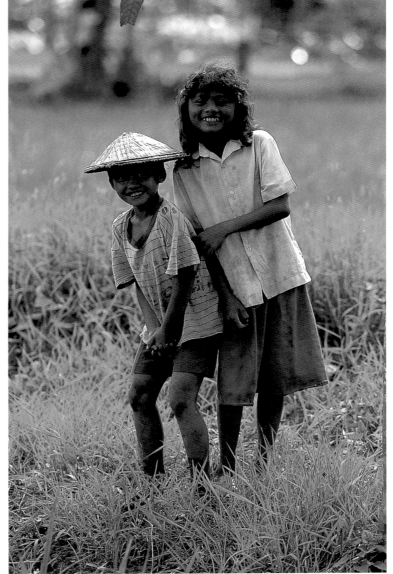

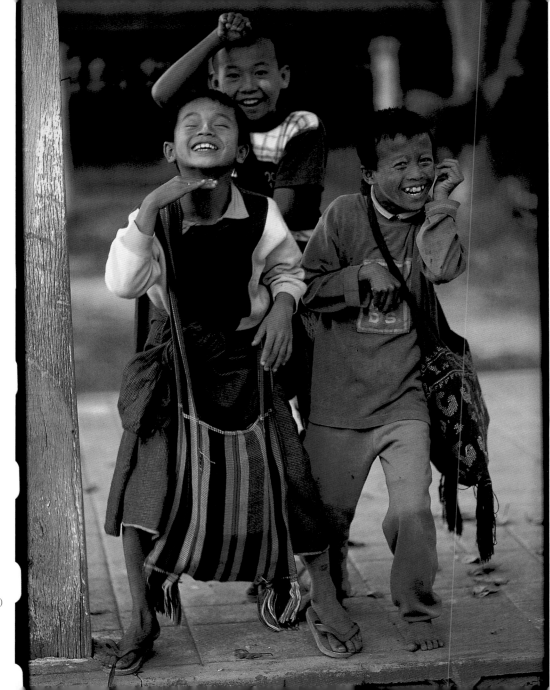

Inle Lake, MYANMAR (formerly BURMA)

Laughter is the shortest distance between two people.
Victor Borge

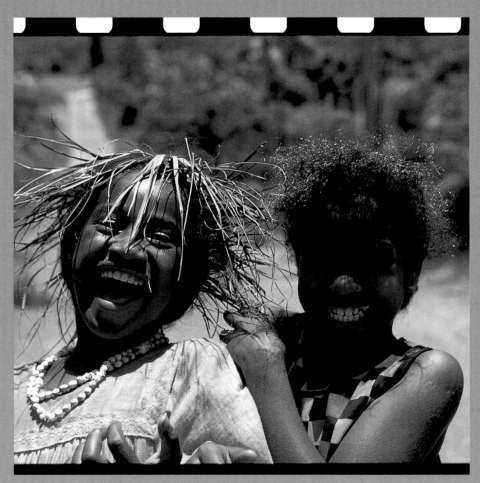

NEW CALEDONIA

Jaisalmer, INDIA

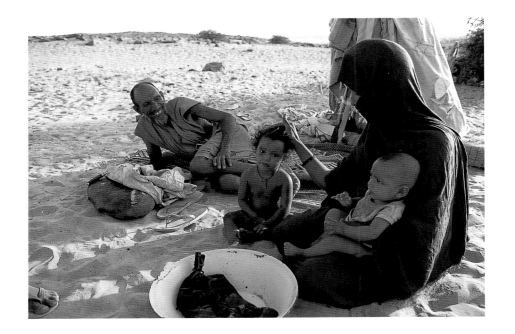

Near Oualata, MAURITANIA

LAUGH

Wrinkles should merely indicate where smiles have been.
Mark Twain

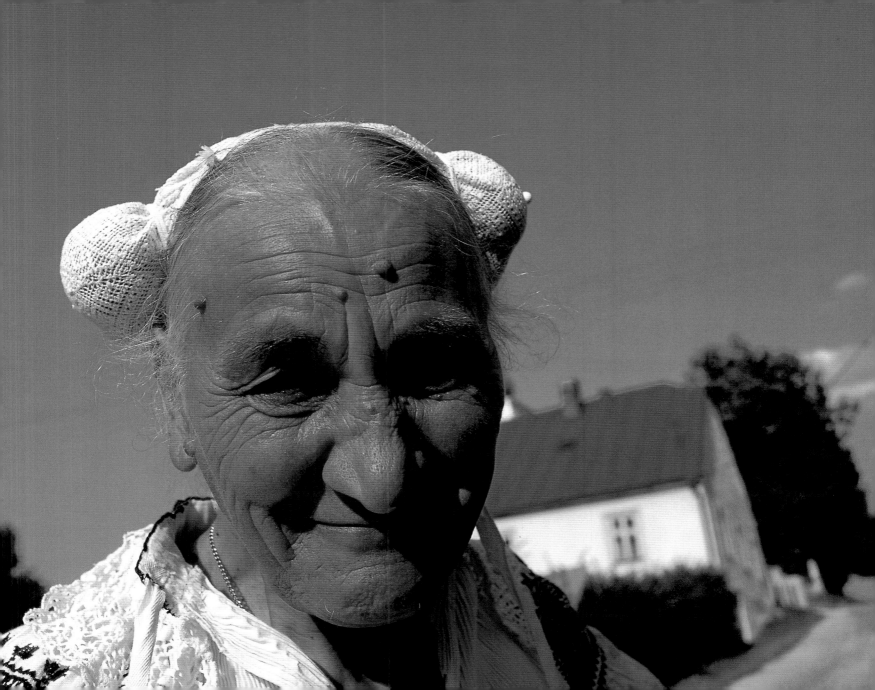

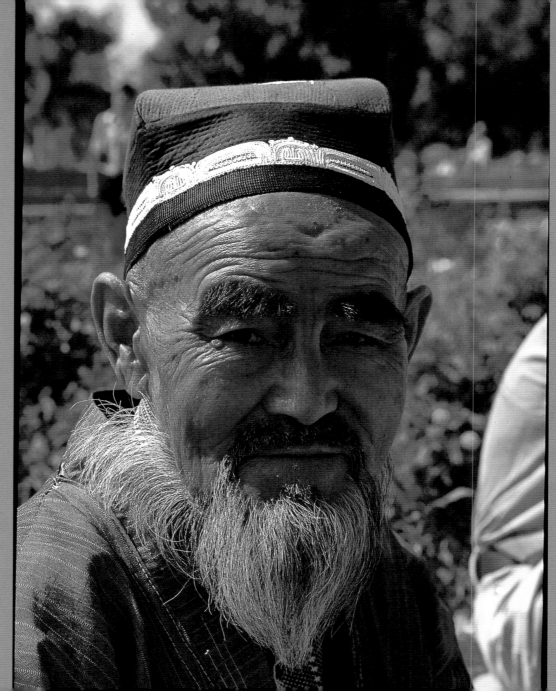

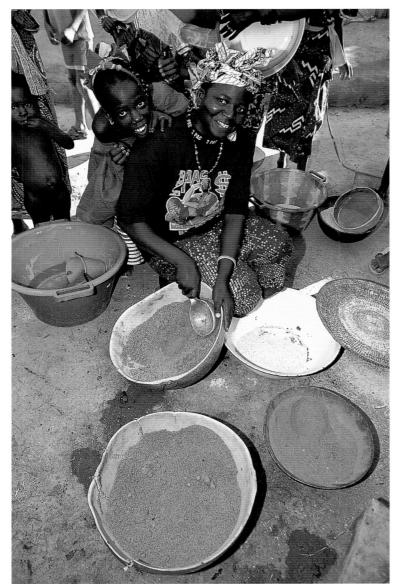

MAURITANIA

AUSTRIA

A smile cures the wounding of a frown.

William Shakespeare

TOGO

TUNISIA

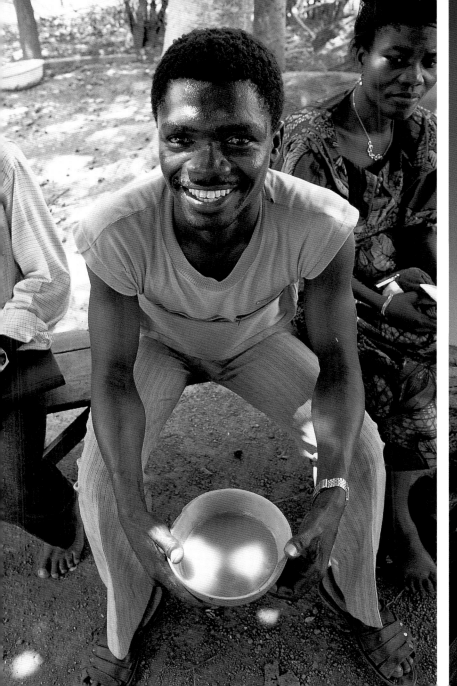
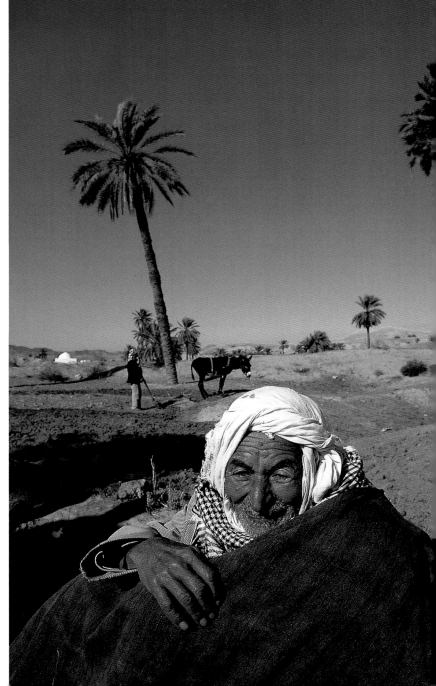

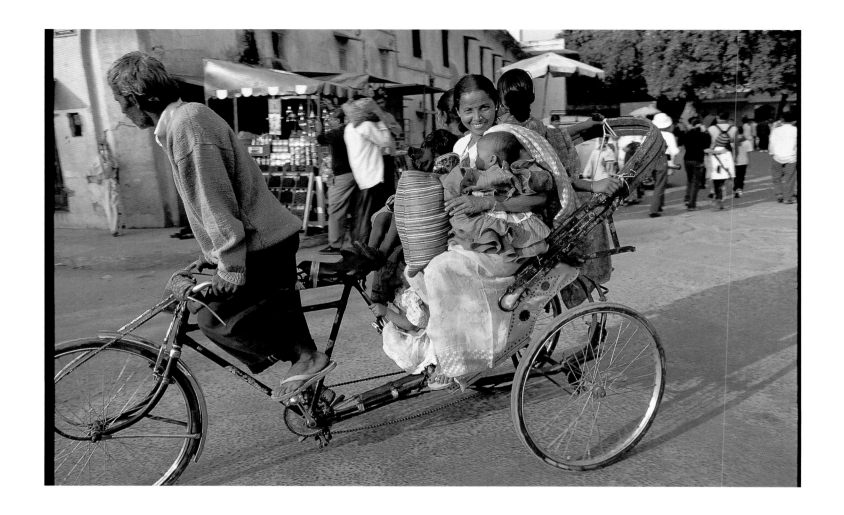

INDIA

Coober Pedy, AUSTRALIA

UNITED STATES

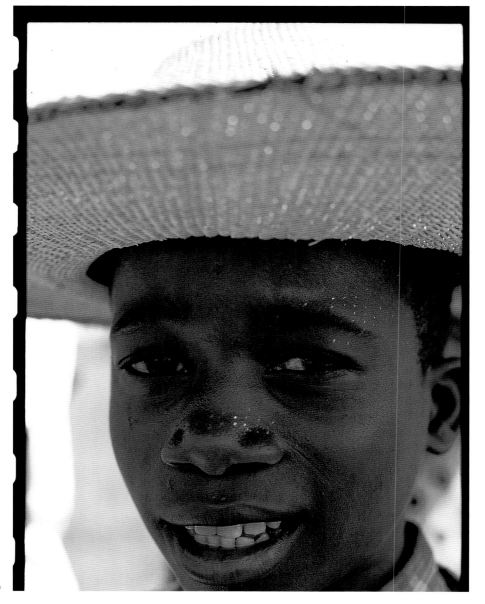

TOGO

A warm smile is the universal language of kindness.
William A. Ward

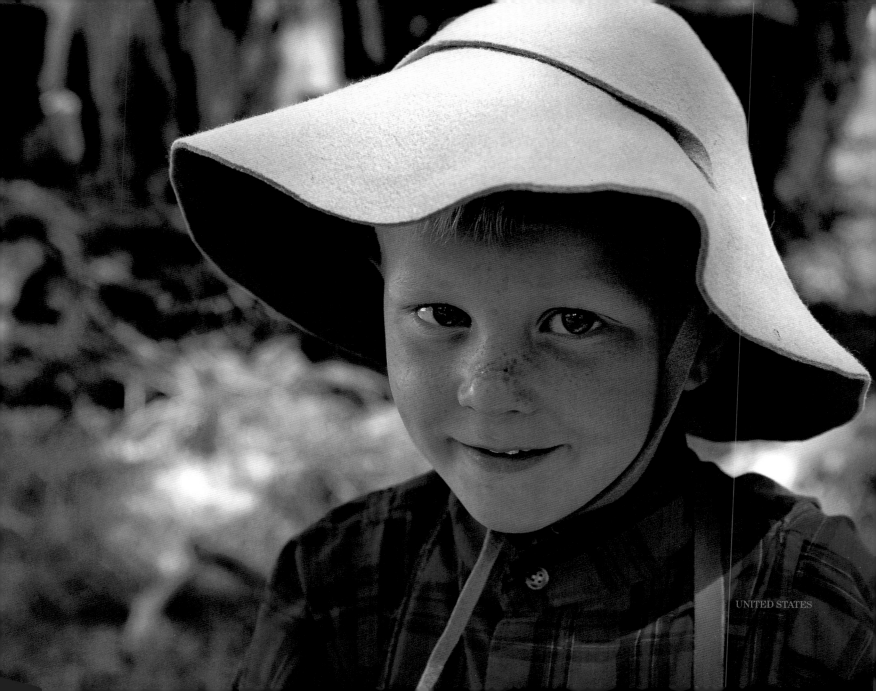

UNITED STATES

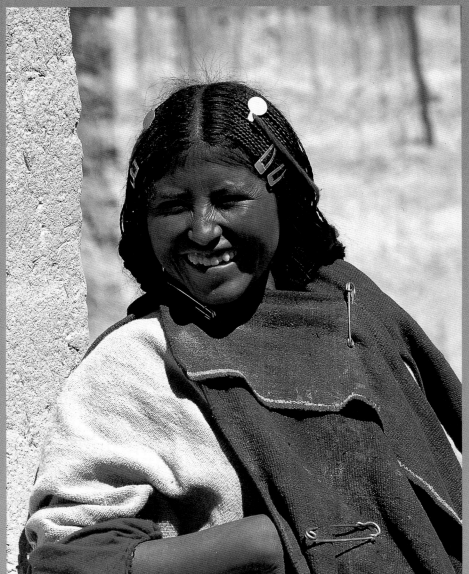

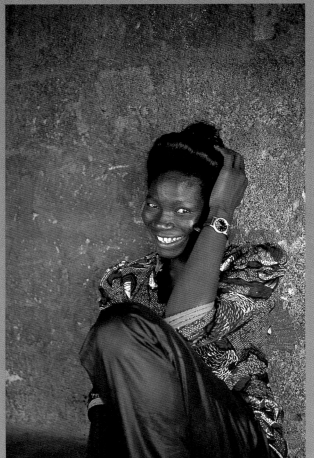

BOLIVIA

TOGO

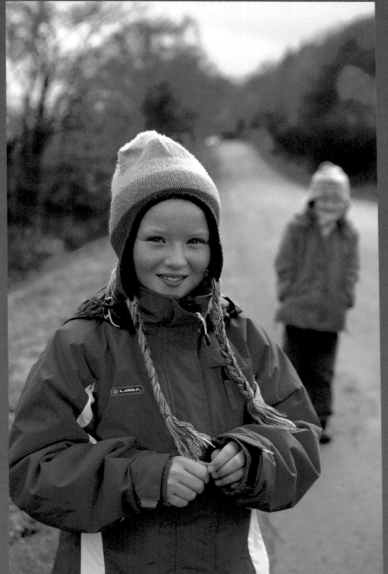

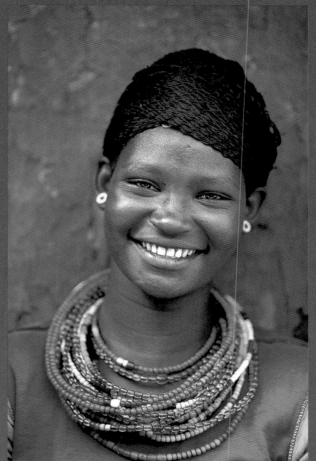

CZECH REPUBLIC

ETHIOPIA

Ollantaytambo, PERU

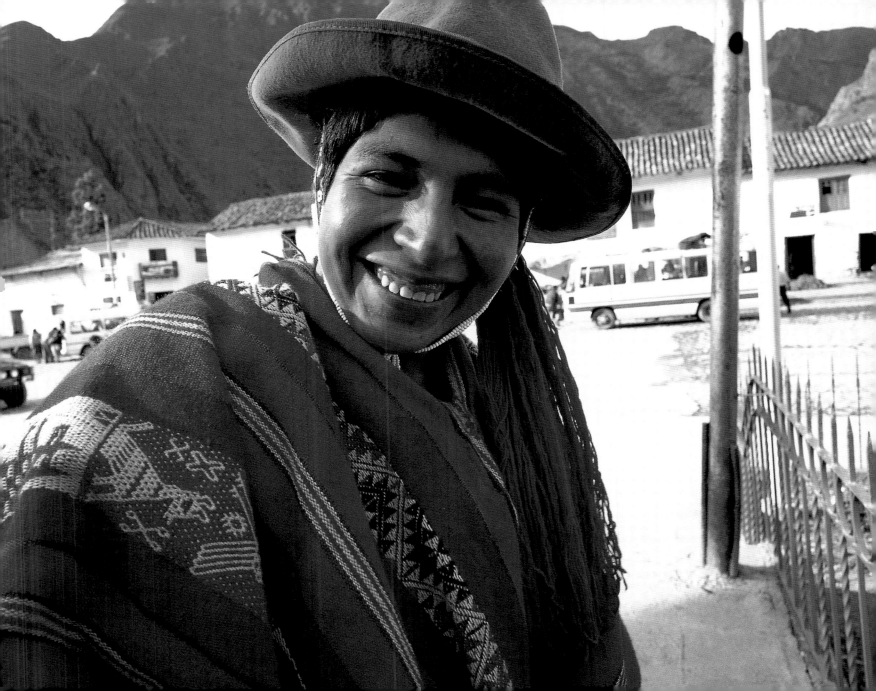

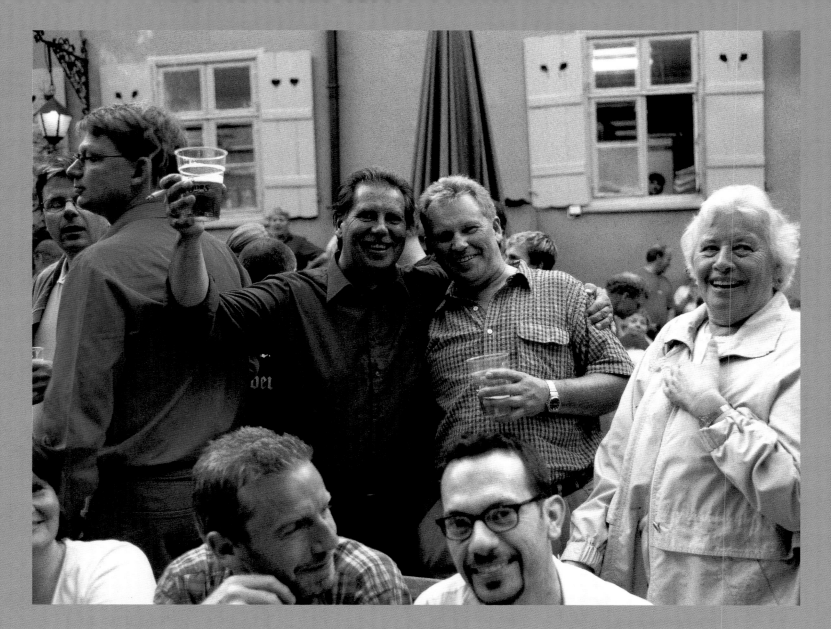

Laughter is taken as a sign of strength, freedom, health, beauty, youth, and happiness.

Martin Grotjahn

Oslo, NORWAY

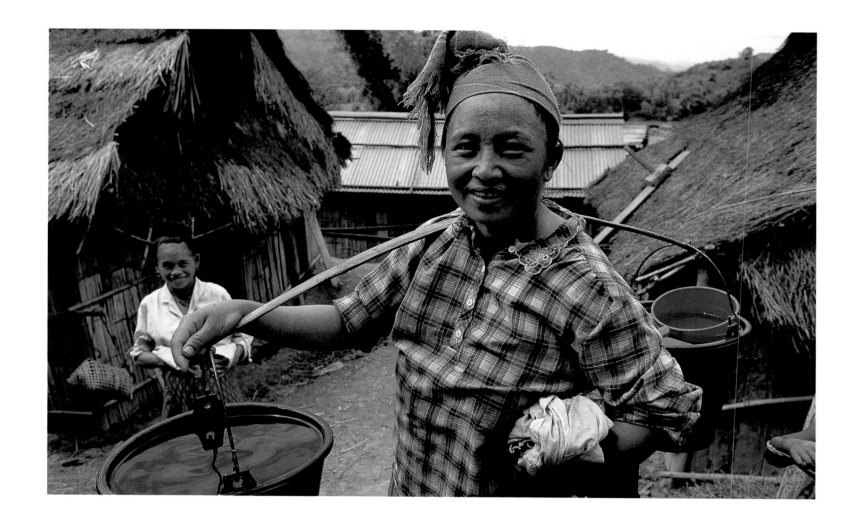

LAOS

MALI

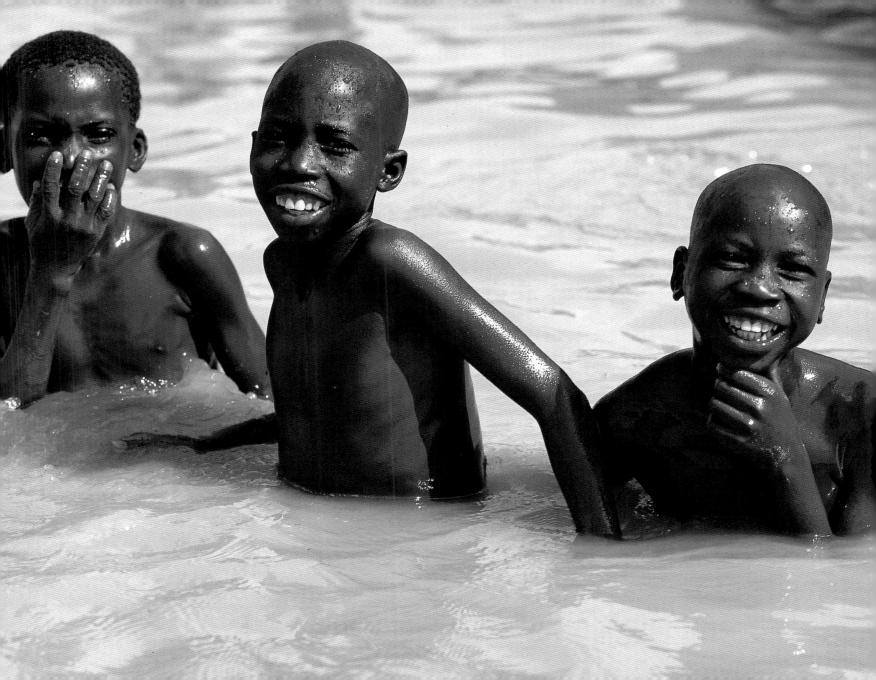

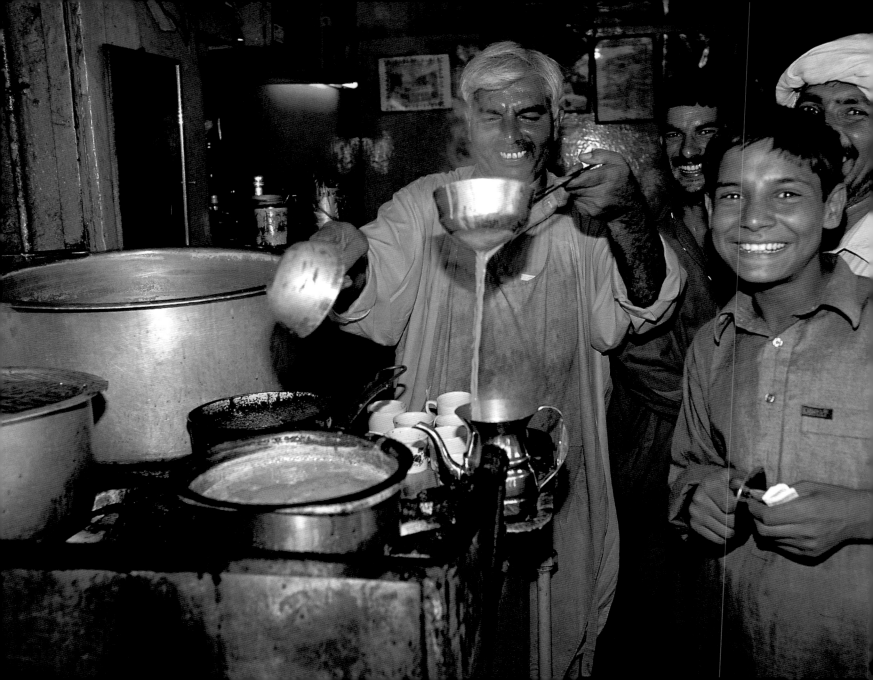

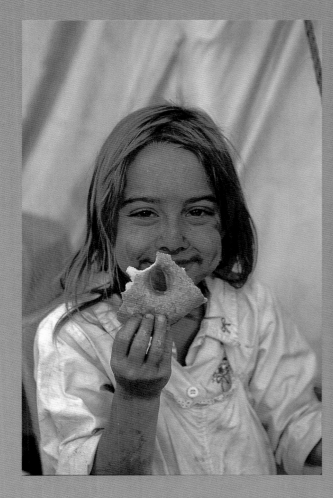

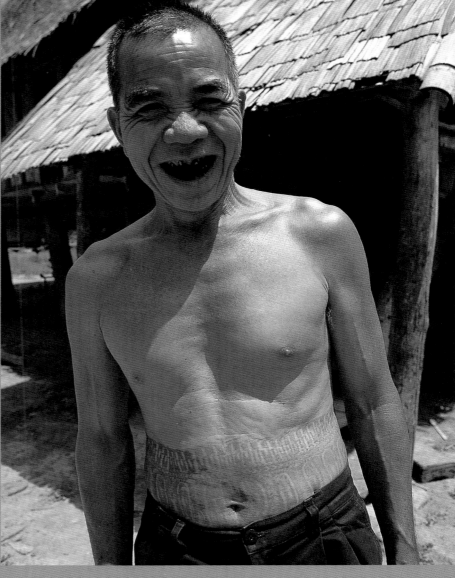

PAKISTAN

UNITED STATES

Ban Nangang, LAOS

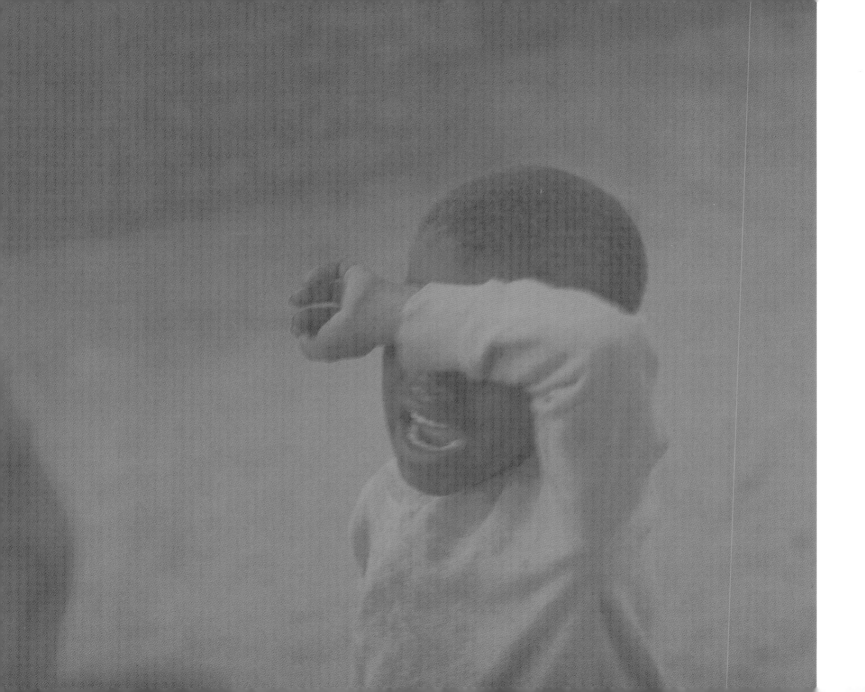

HURT

Hurt is at the core of humankind. At any moment, there are many who hurt—whether emotionally, physically, or mentally. To hurt someone is to wound, damage, offend, or hamper.

War is something that causes much hurt. Its effect ripples out far beyond those who are wounded physically or mentally from battle. Hearts ache as a result of war, when loved ones are separated and lives trampled.

Our character is molded by how we experience and react to hurt.

The tears of the world are
a constant quality.
For each one who begins to weep,
somewhere else another stops.
Samuel Beckett

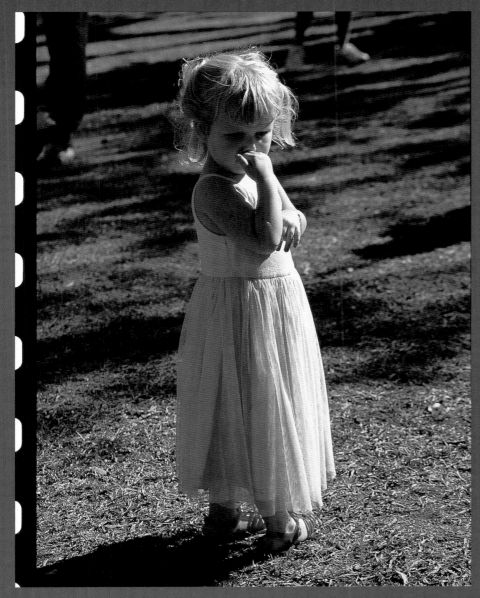

AUSTRALIA

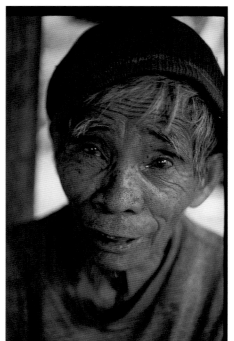

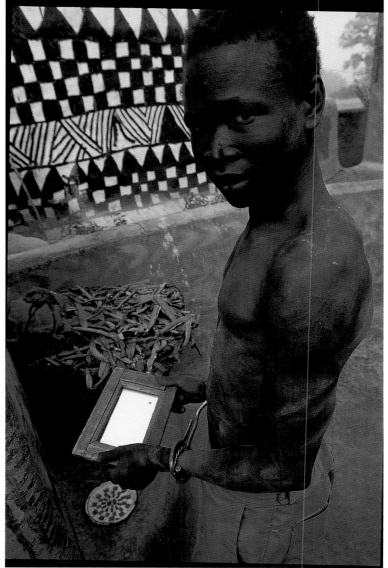

PHILIPPINES

BURKINA FASO

BHUTAN

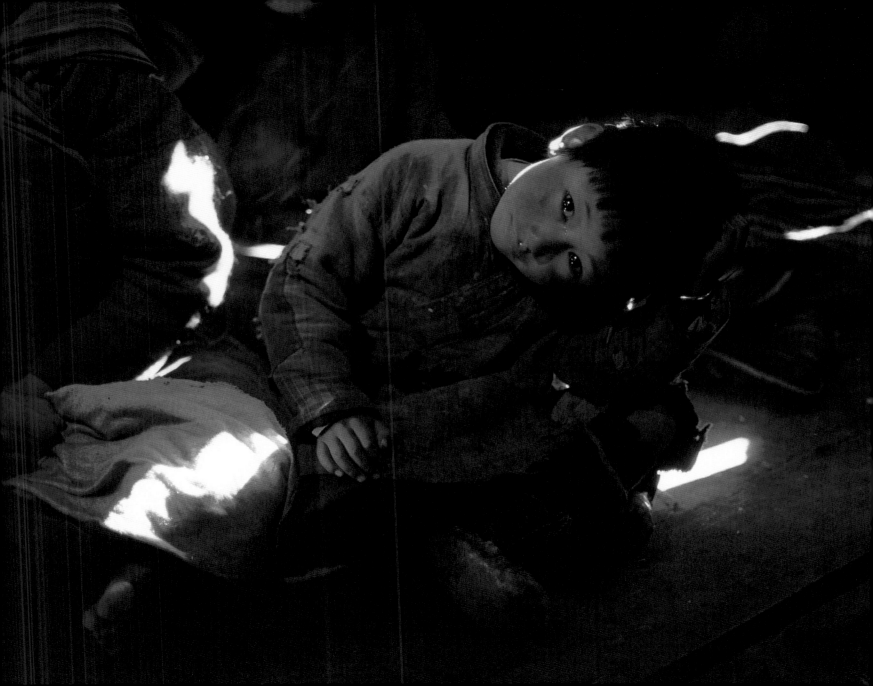

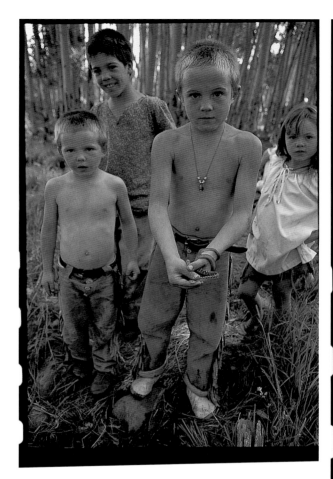

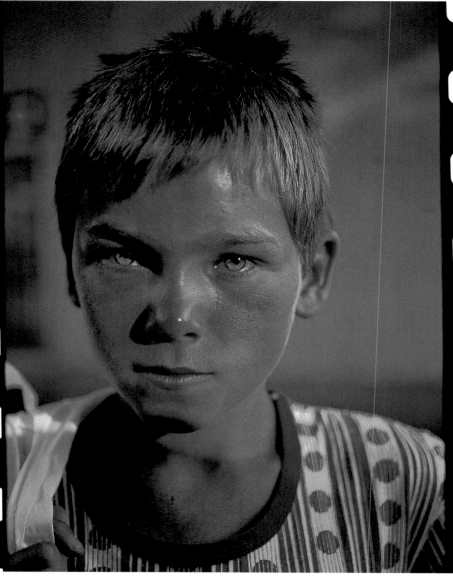

UNITED STATES

SLOVAKIA

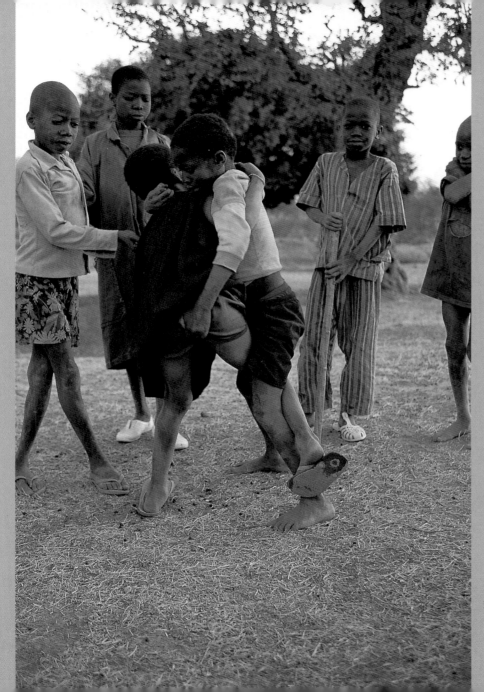

BURKINA FASO

HURT

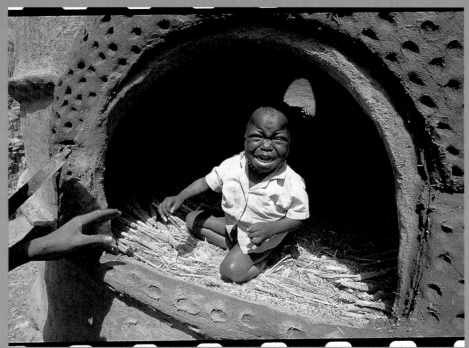

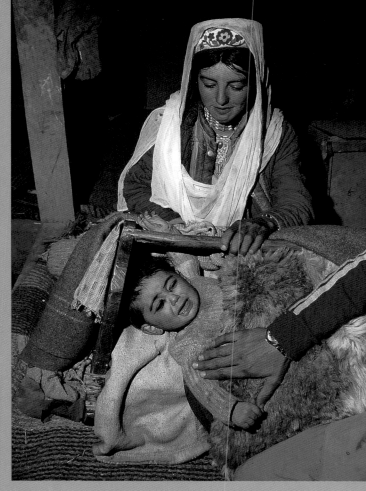

NIGER

BURKINA FASO

Shimshal, PAKISTAN

Child of mortality, whence comest thou?
Why is thy countenance sad, and why are thine eyes red with weeping?
Anna Letitia Barbauld

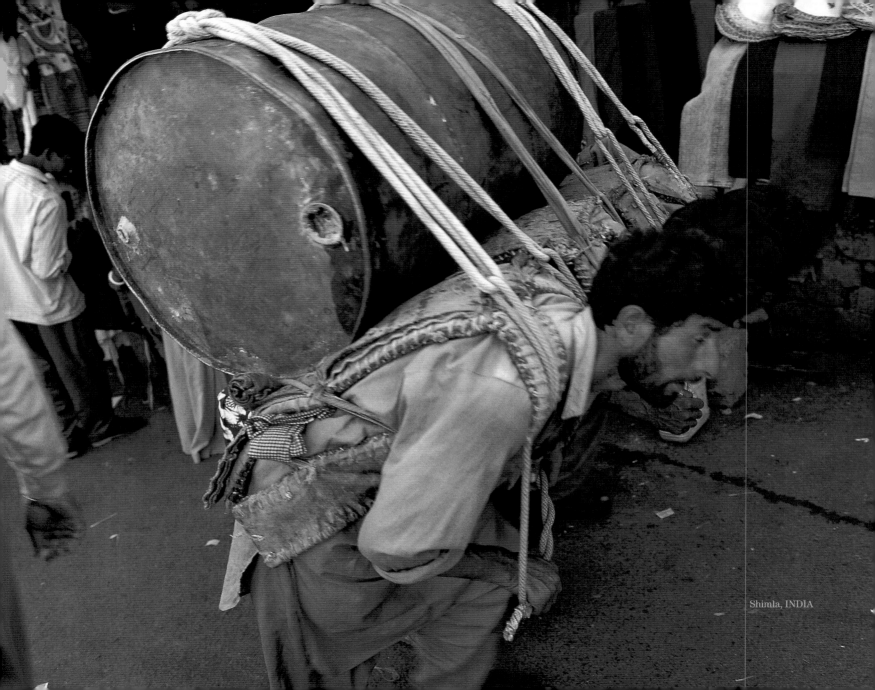

Shimla, INDIA

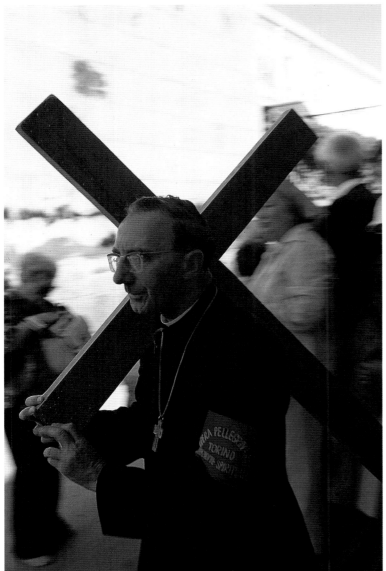

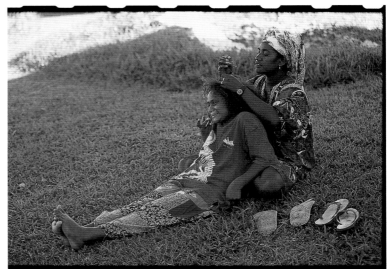

Jerusalem, ISRAEL

Lifou, NEW CALEDONIA

We need never be ashamed
of our tears.
Charles Dickens

Nancy, FRANCE

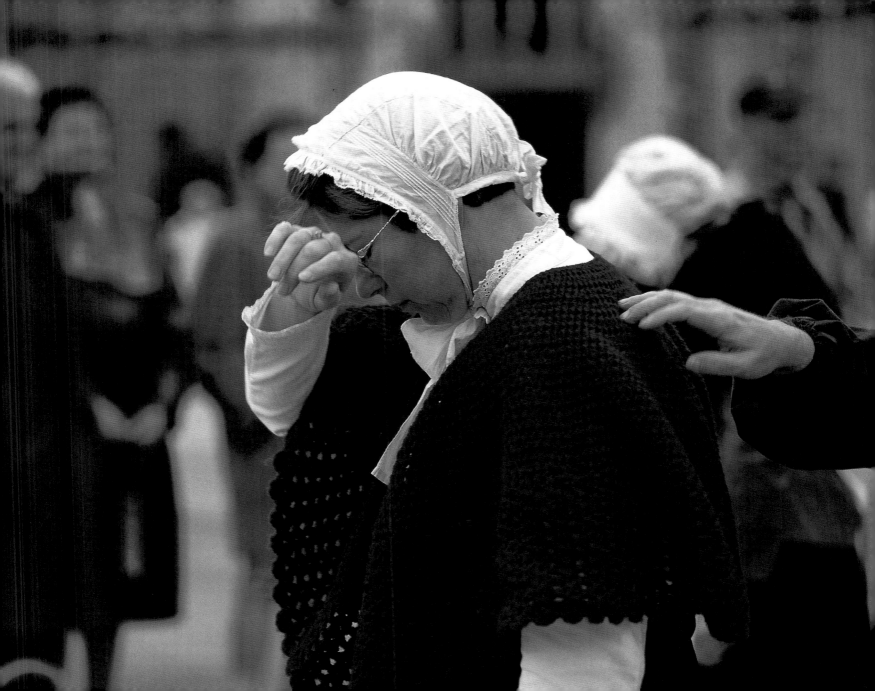

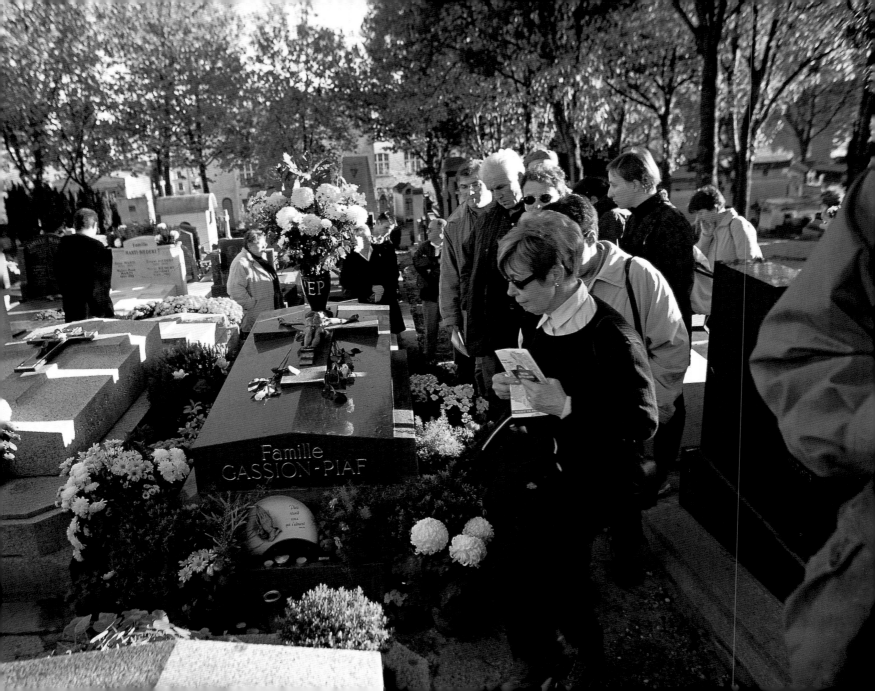

Everything hurts.
Michelangelo

Paris, FRANCE

There are times when God asks nothing of his children except silence, patience and tears.
C. S. Robinson

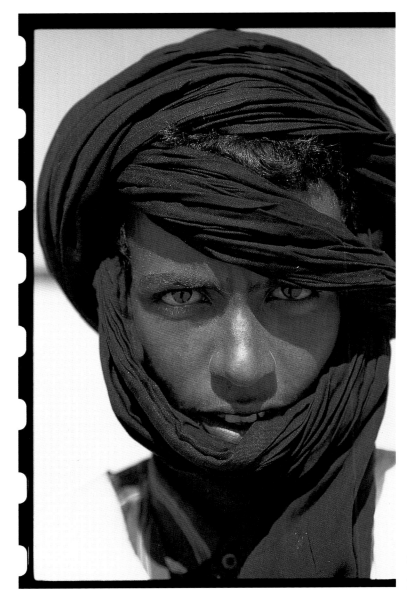

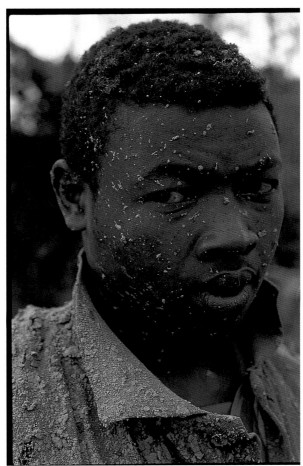

MAURITANIA

MADAGASCAR

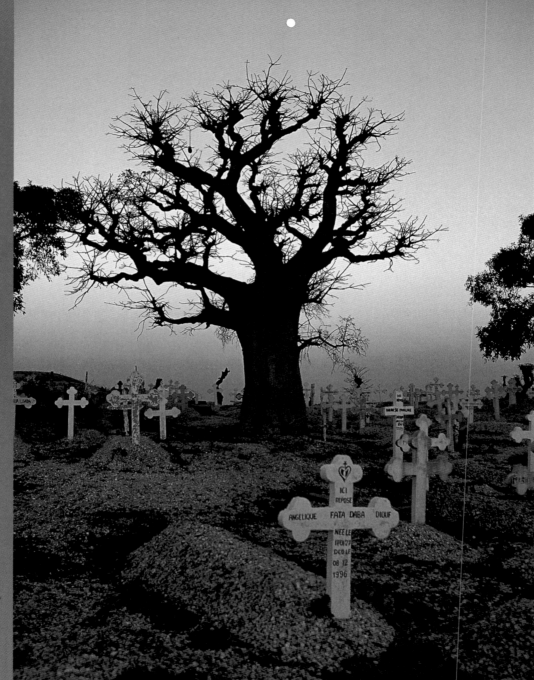

SENEGAL

The bitterest tears shed over graves are for words left unsaid and deeds left undone.
Harriet Beecher Stowe

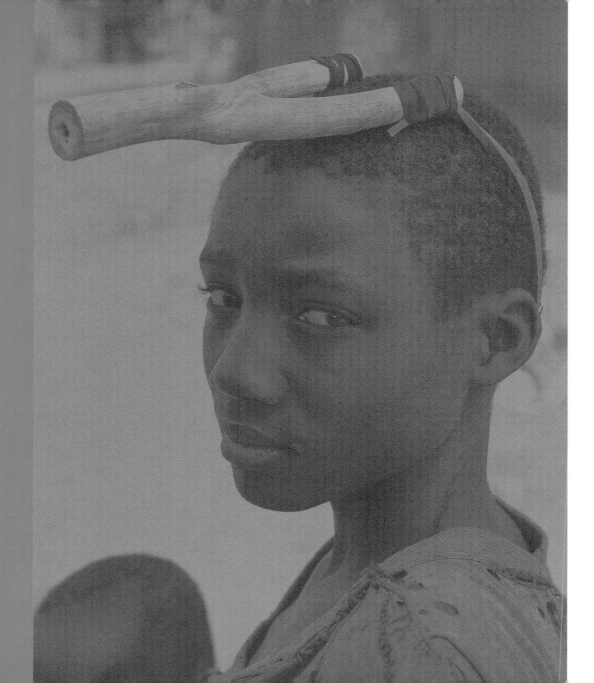

FEAR

Fear can be a negative force in the world. Sadly, many people live in circumstances that are fearful.

Fortunately, some fears can be overcome, such as fear of the unknown or fear of doing something new and difficult the first time. I experience fear of the unknown when I travel, whether it is to a new city or on the face of K2. As a young camera-man, I was faced with climbing K2 as part of an assignment. I had a strong feeling of fear at the prospect of climbing to such high altitudes with-out any special mountaineering training. Because of this, I tried to climb the rock three times and failed three times. But finally, on the fourth try, I overcame my fear and met success. This journey was a remarkable one for me because it gave me great confidence in myself.

It is true that fear can be a negative force, but it can turn positive if it is used as a mechanism for change and growth.

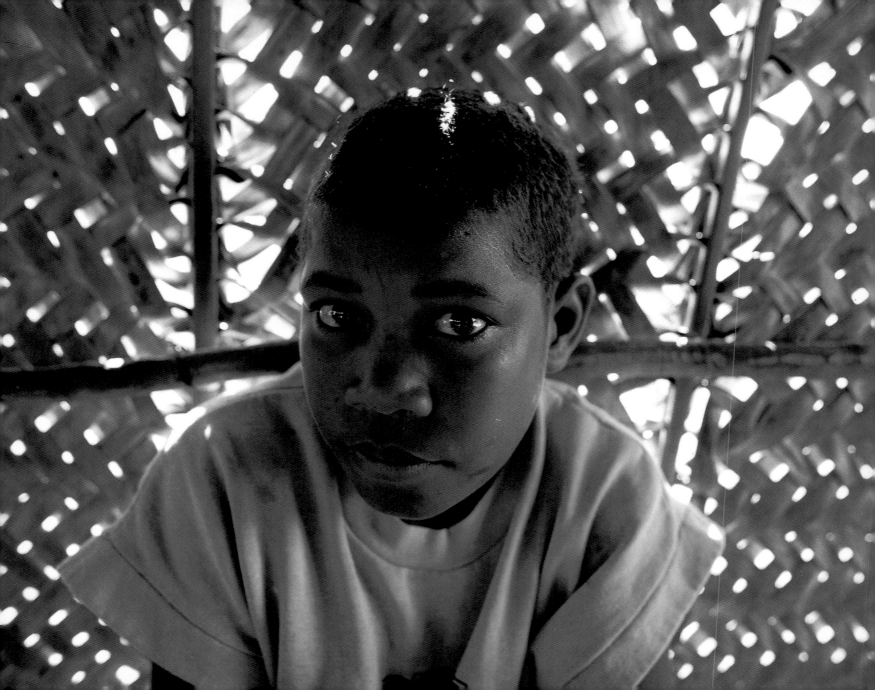

God made all the creatures, and gave them our love and our fear, To give sign we and they are his children, one family here.
Robert Browning

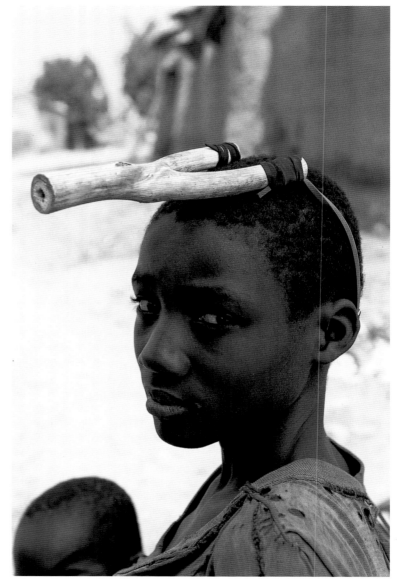

CHAD

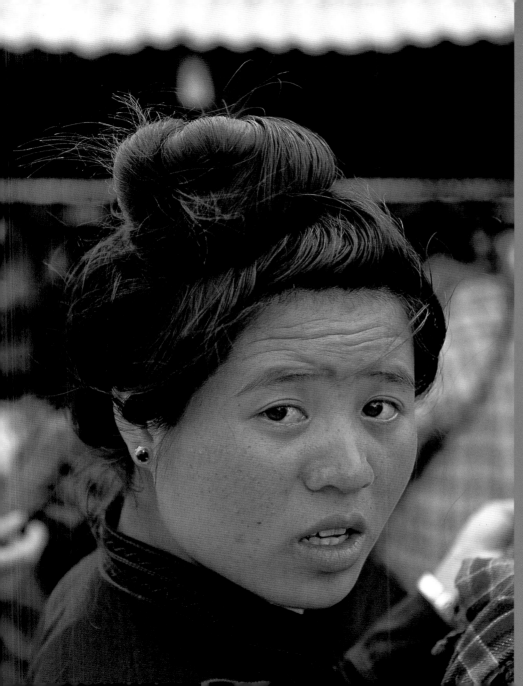

FEAR

MYANMAR (formerly BURMA)

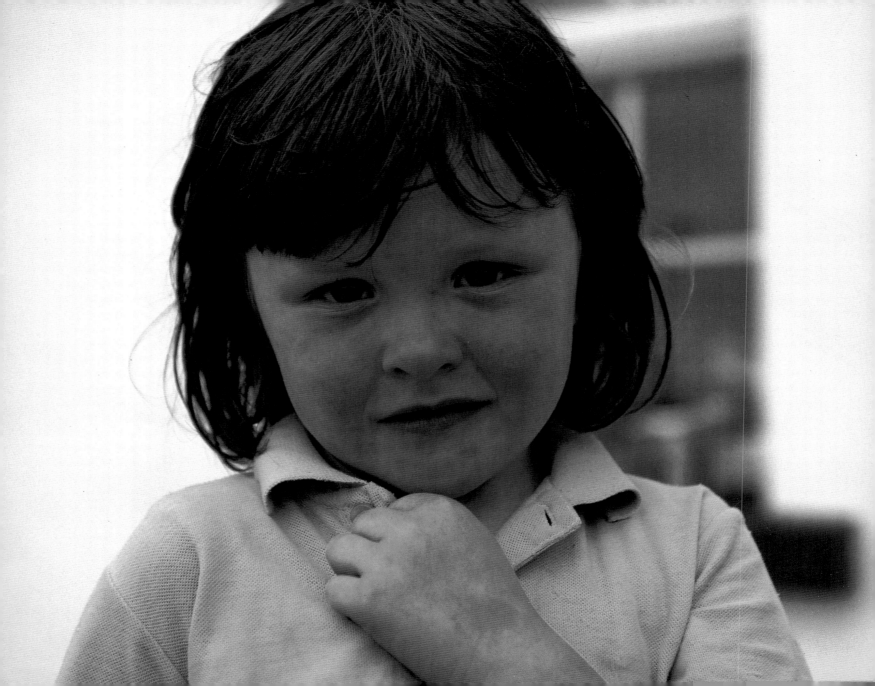

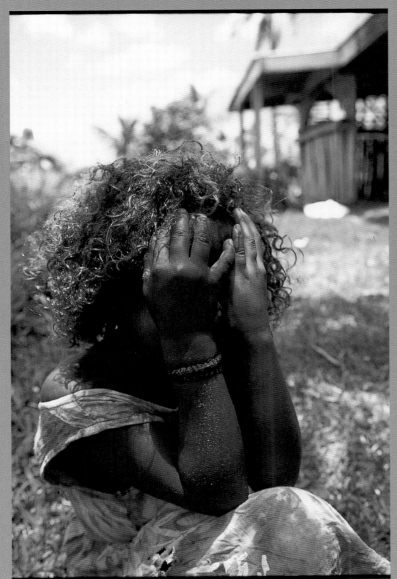

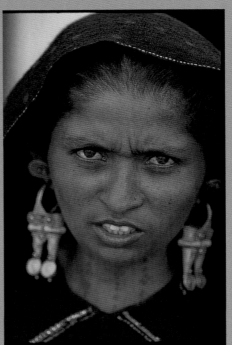

IRELAND

Lifou, NEW CALEDONIA

Gujarat, INDIA

The rose is fairest when 't
is budding new,
And hope is brightest when
it dawns from fears.
Sir Walter Scott

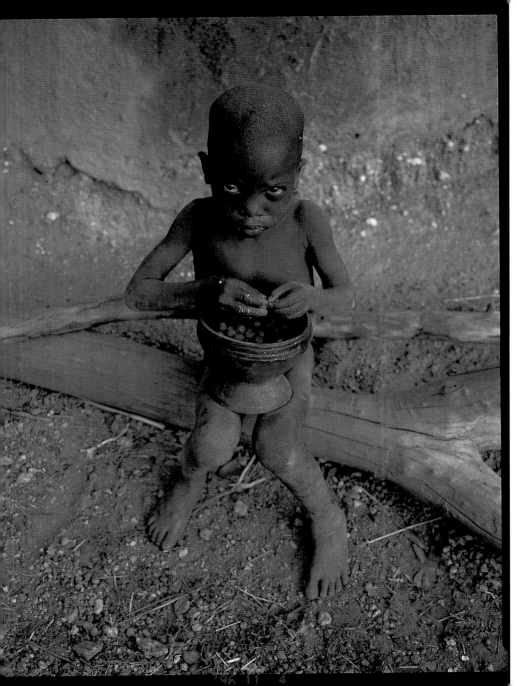

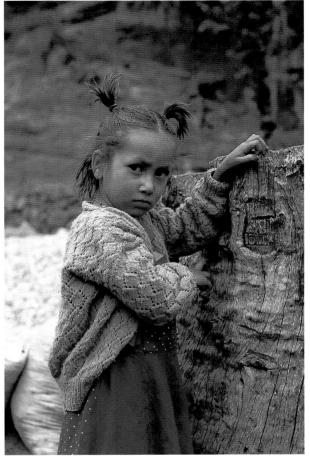

TOGO

Old Manali, INDIA

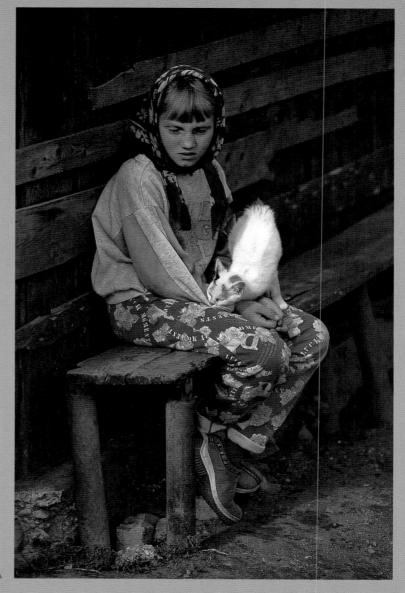

ROMANIA

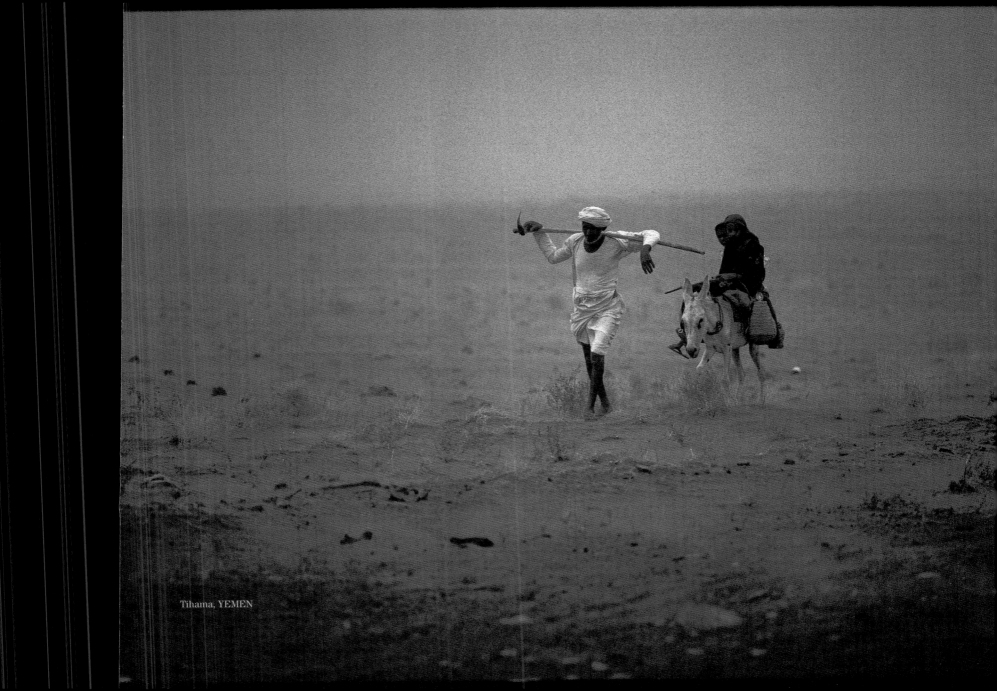

Tihama, YEMEN

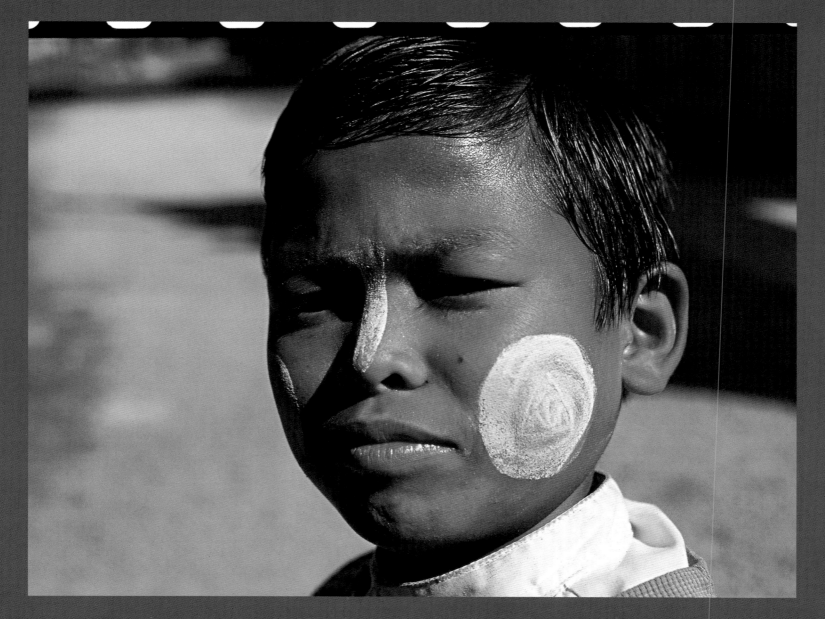

Deep into that darkness peering, long
I stood there, wondering, fearing …
Edgar Allan Poe

MYANMAR (formerly BURMA)

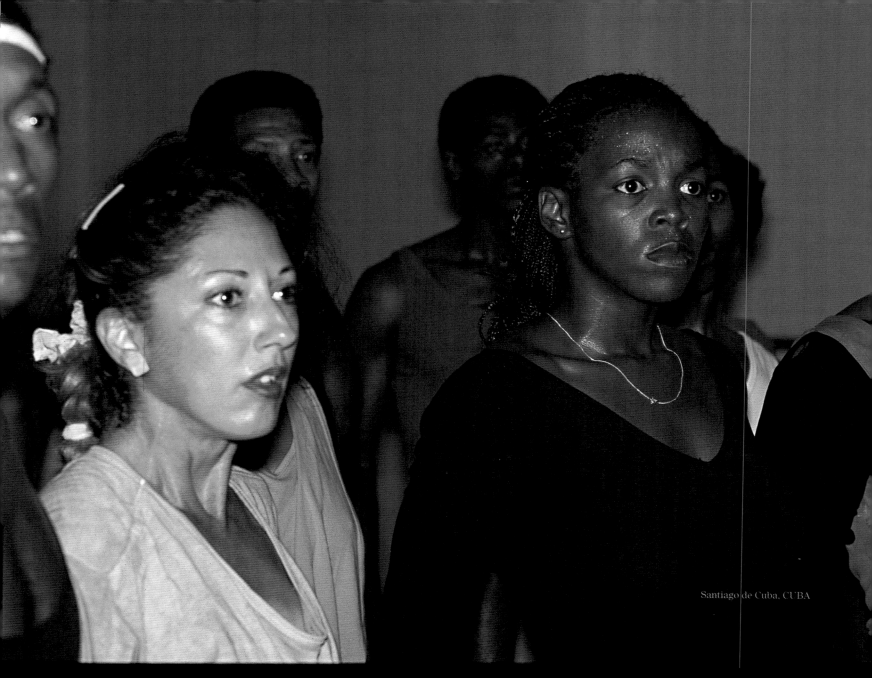

Santiago de Cuba, CUBA

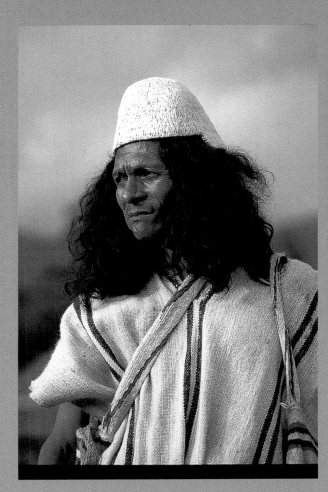

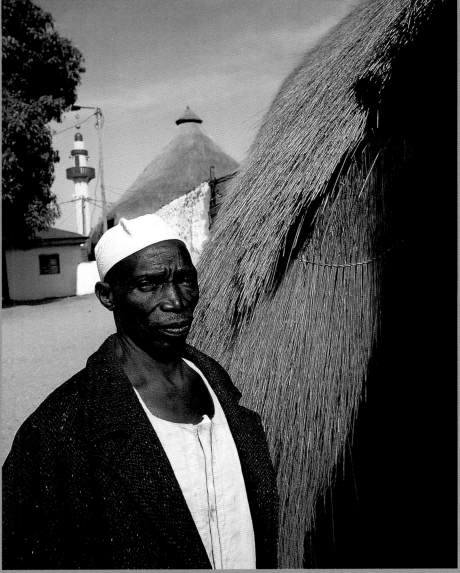

Nabusimake, COLOMBIA

Ngaoundéré, CAMEROON

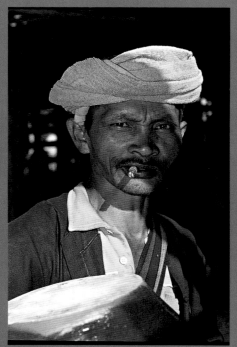

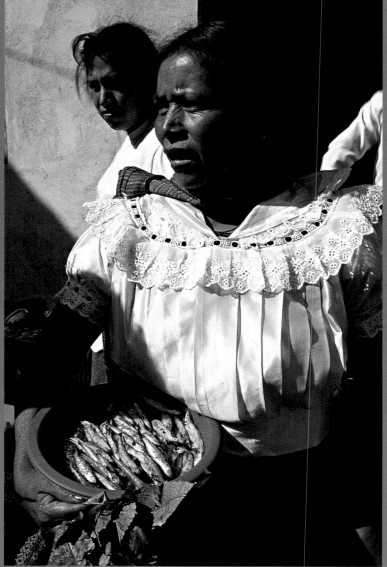

MYANMAR (formerly BURMA)

Pátzcuaro, MEXICO

Oh, fear not in a world like this,
And thou shalt know erelong,
Know how sublime a thing it is
To suffer and be strong.
Henry Wadsworth Longfellow

BELIEVE

Whether motivated by religion, nature, love, trust, or other influences, all humankind has the ability to believe or accept something as true, genuine, or real. People exhibit belief through kneeling, raising arms, turning faces to the sky, bowing heads, touching hands and heads, or dancing. These evidences are beautifully seen in worship as part of holy places both created and natural.

I have experienced many holy festivals. A favorite was in Nepal where the women spent two days praying to the setting sun and giving thanks. This was a solemn, peaceful ceremony and a refreshing pause from my travels.

Prayer is the soul's sincere desire,
Uttered or unexpressed …
James Montgomery

Antsirabe, MADAGASCAR

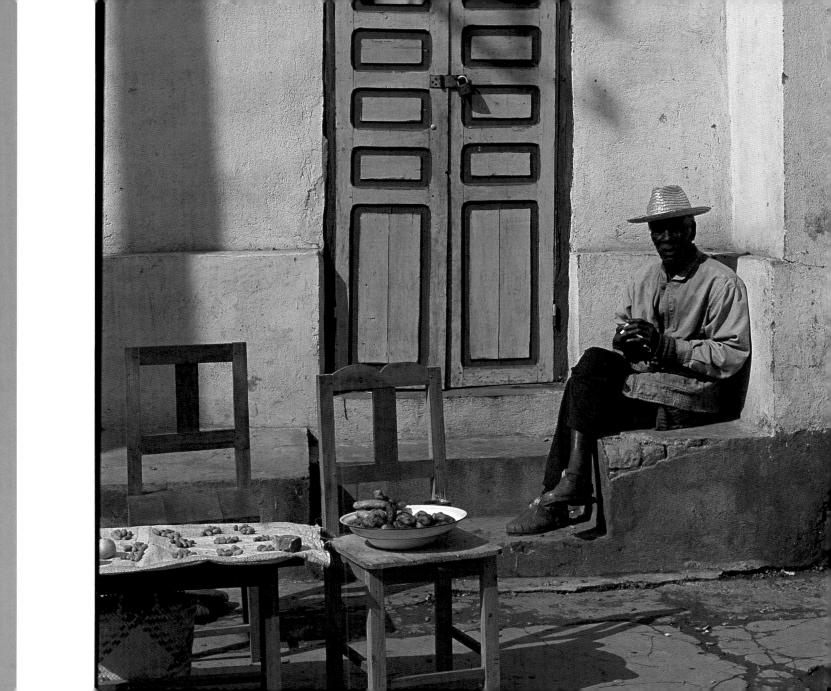

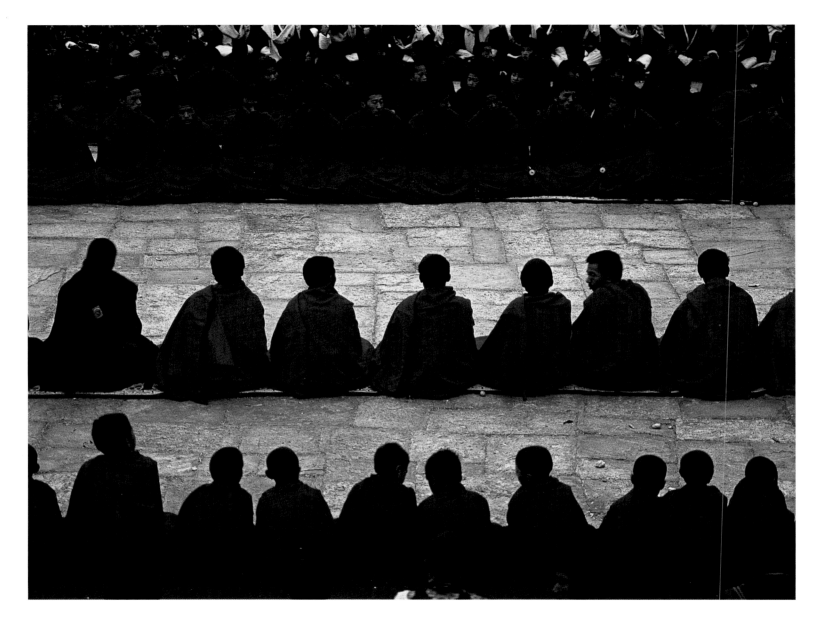

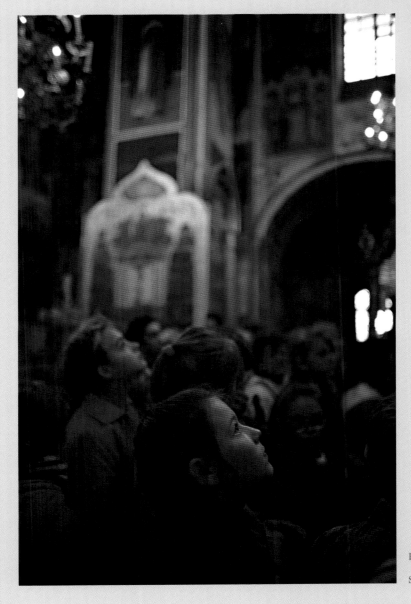

BELIEVE

Paro, BHUTAN

Suzdal, RUSSIA

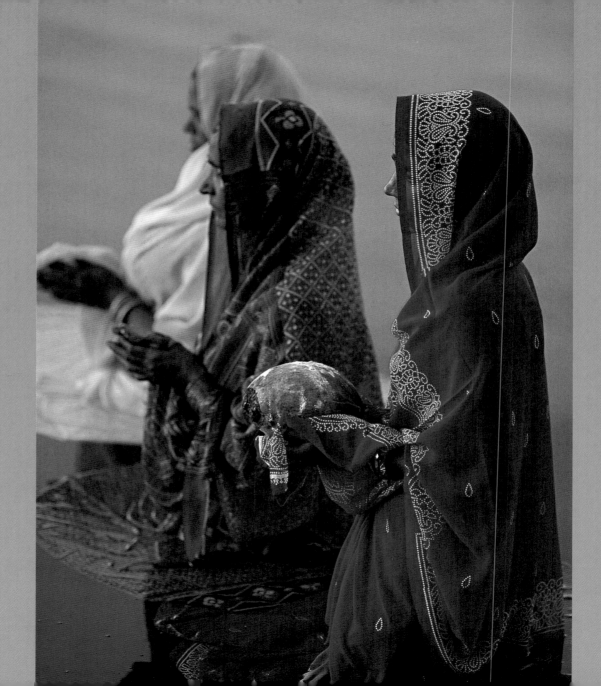

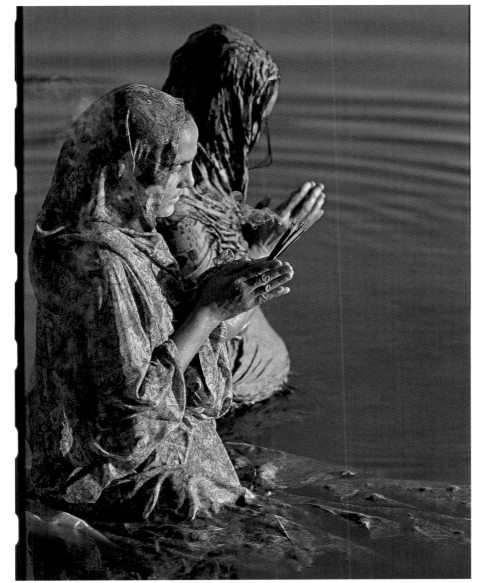

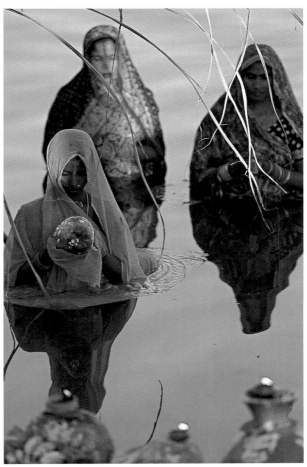

Janakpur, NEPAL

Tihama, YEMEN

GUATEMALA

Paro, BHUTAN

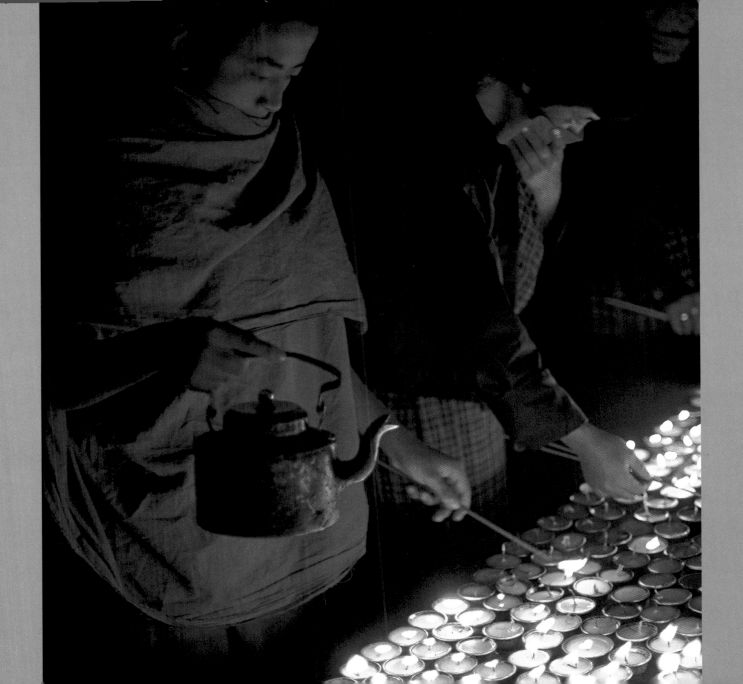

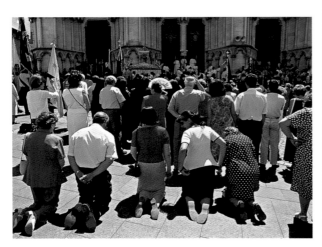

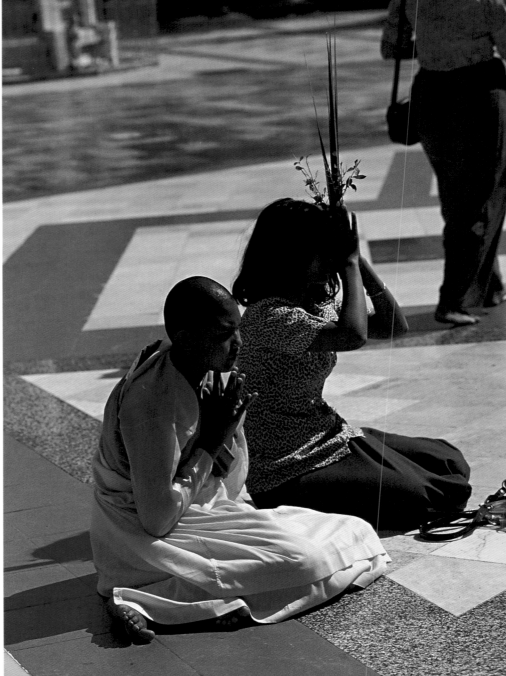

Cuenca, SPAIN

MYANMAR (formerly BURMA)

Prayer ardent opens heaven.
Edward Young

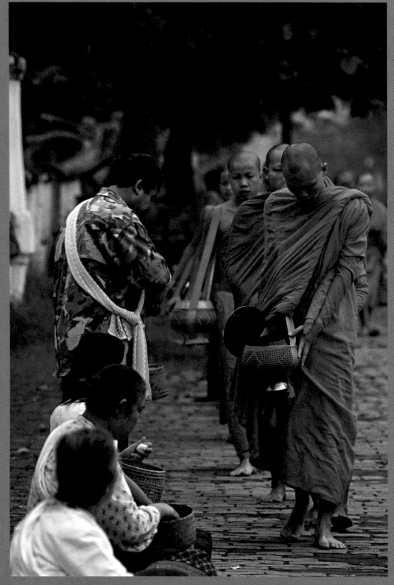

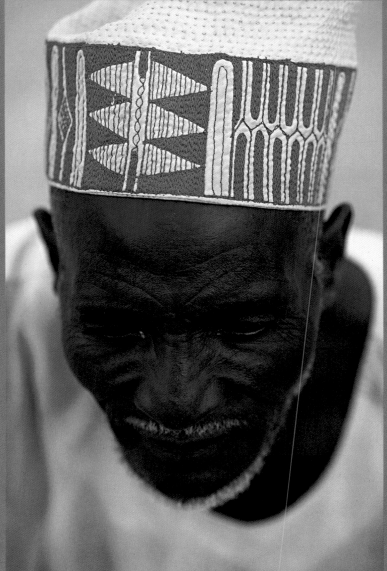

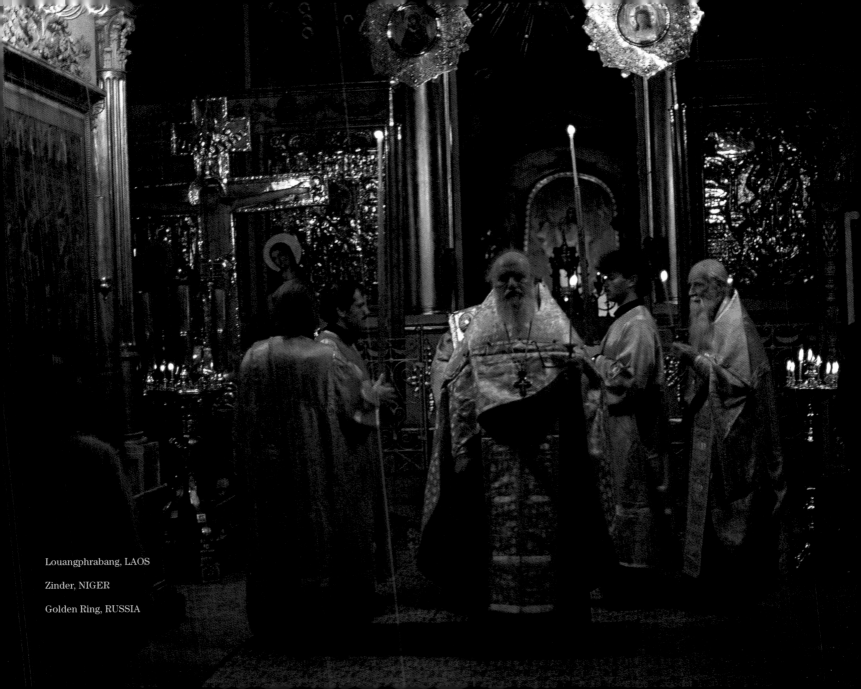

Louangphrabang, LAOS

Zinder, NIGER

Golden Ring, RUSSIA

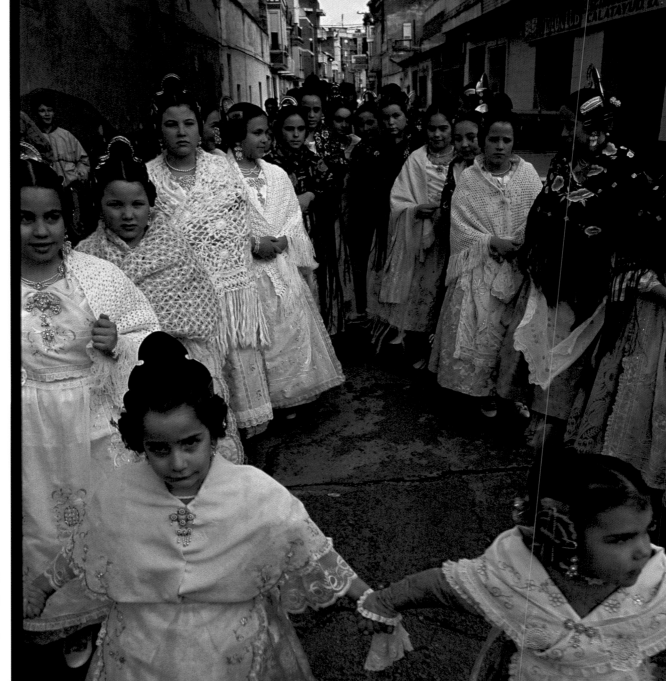

Valencia, SPAIN

JAPAN

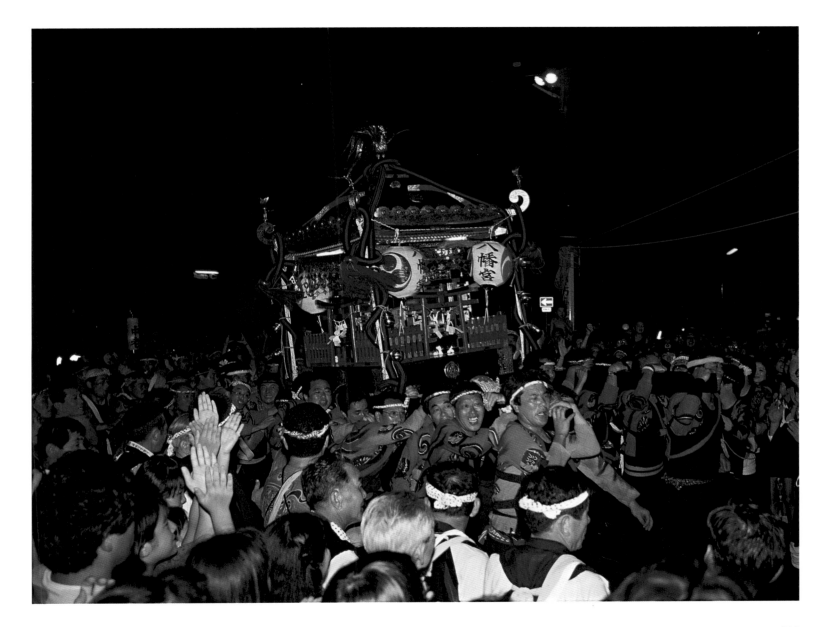

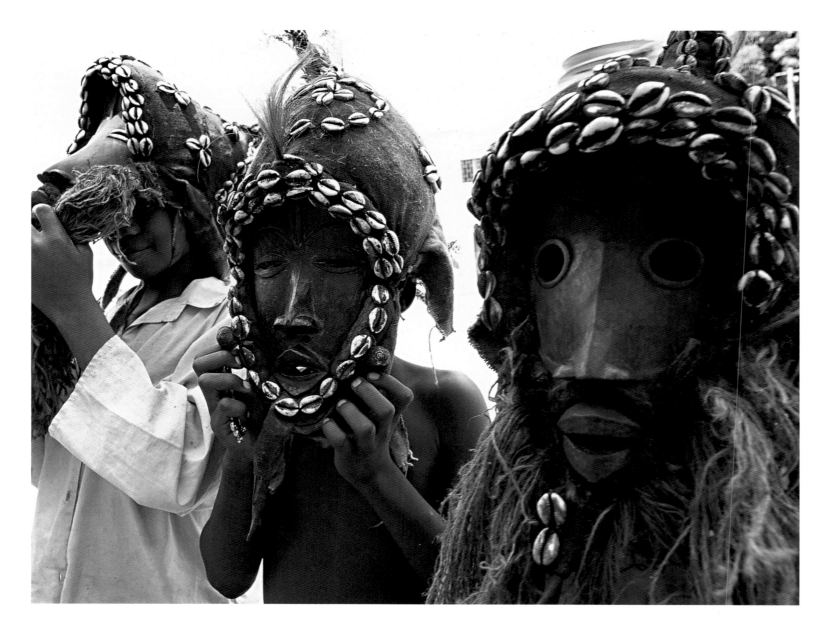

We are born believing.
A man bears beliefs,
as a tree bears beauty.
Ralph Waldo Emerson

Korhogo, IVORY COAST

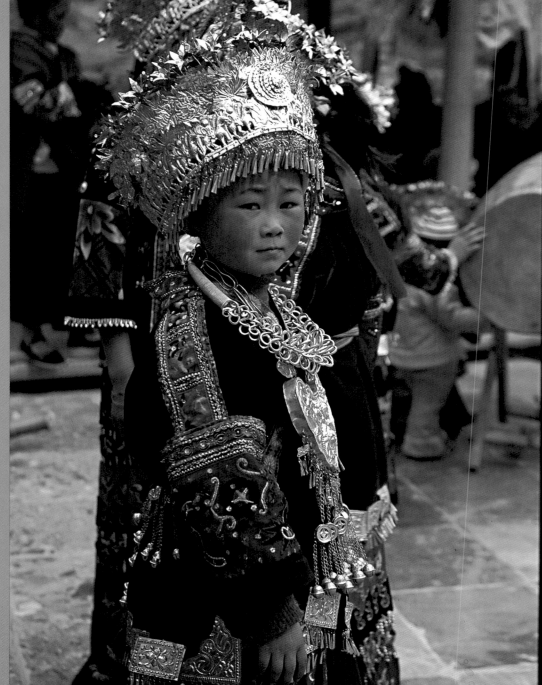

HUMANKIND

CHINA

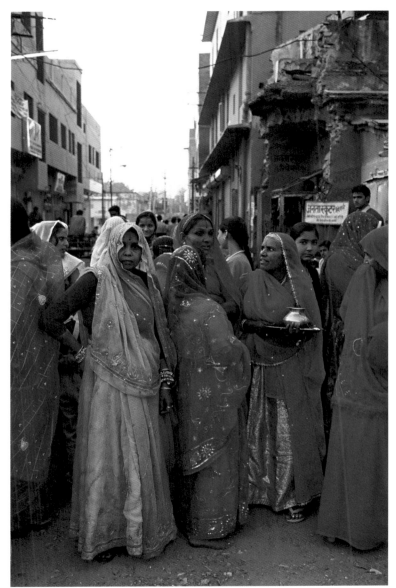

Jaipur, INDIA

SRI LANKA

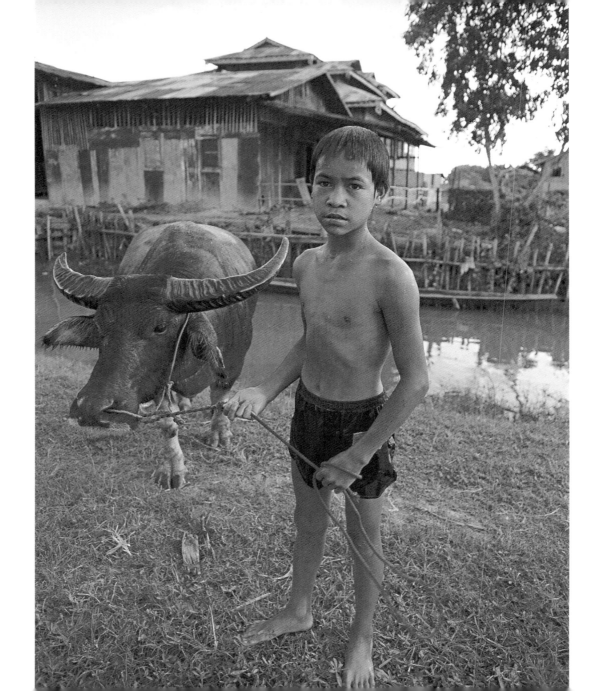

TRY

Trying evokes many expressions that involve anything from activities and movements to thoughts and examinations. Every person has his or her own way of trying. Sometimes it is influenced by experiences or ancient wisdom, and the actions related to trying are in some ways similar and also distinct among different countries.

This is the greatest effort in regard to trying—to understand each other and forge bridges of toler-ance. *Try* is a verb; as such, it requires action, and this action can evoke change toward a better world.

Trying is hard work when focused toward a common cause of understanding and balance. We must continue to try.

A man's feet should be planted in his country, but his eyes should survey the world.
George Santayana

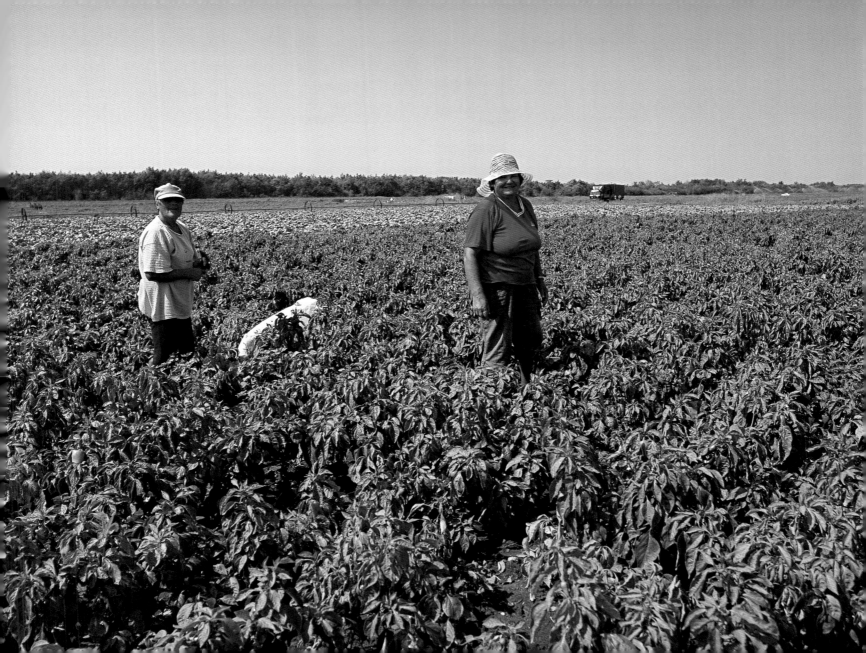

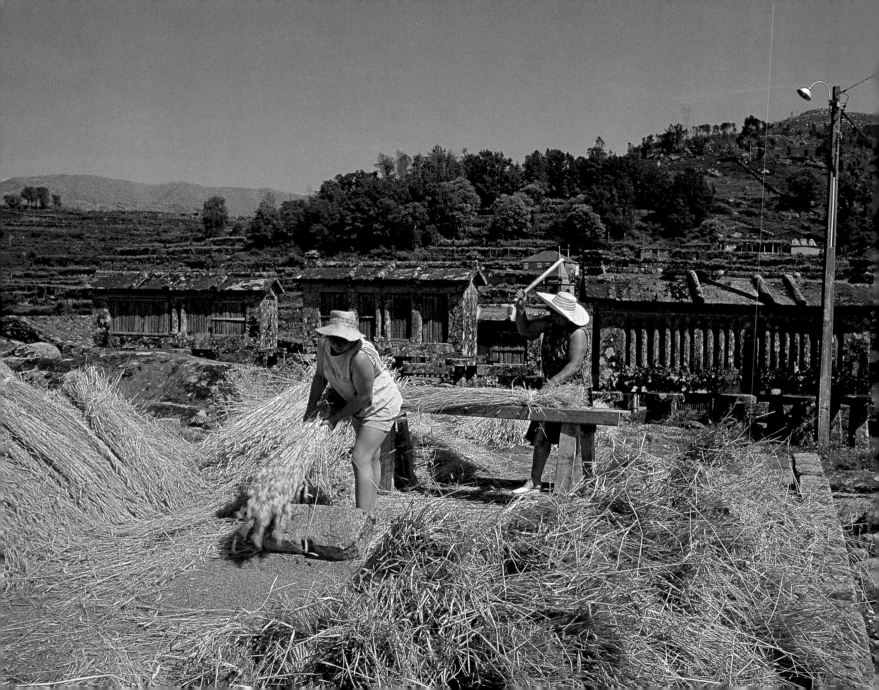

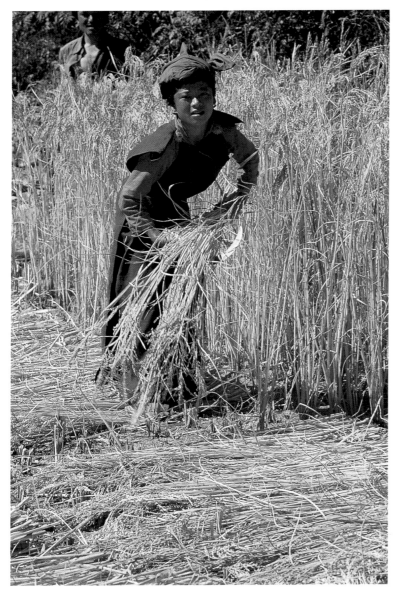

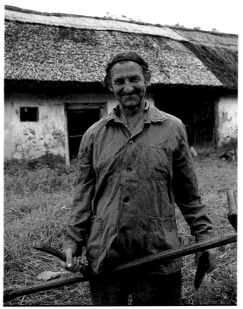

Lindoso, PORTUGAL

Paro, BHUTAN

HUNGARY

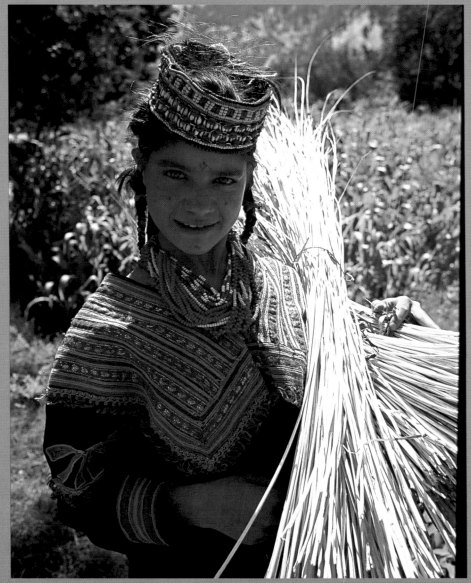

Kalash Valley, PAKISTAN

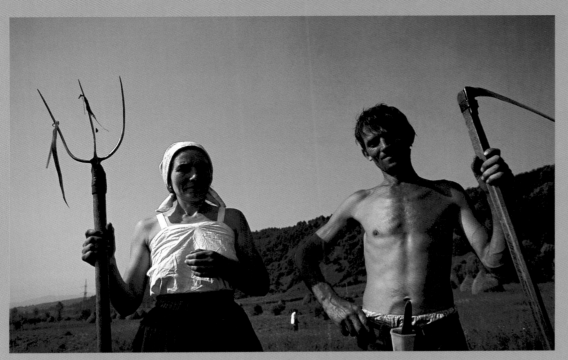

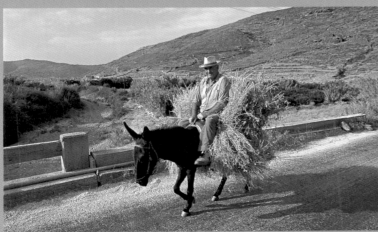

Maramures, ROMANIA

Tinos Island, GREECE

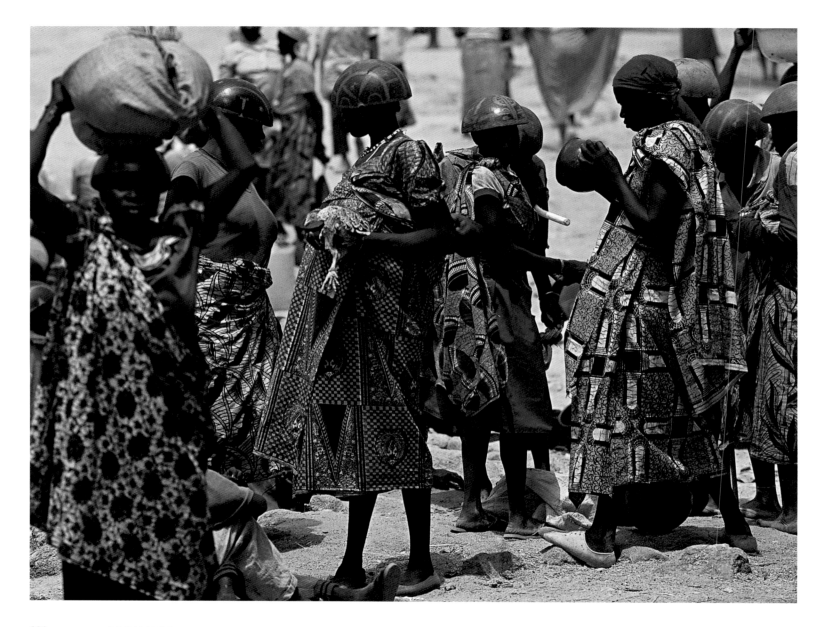

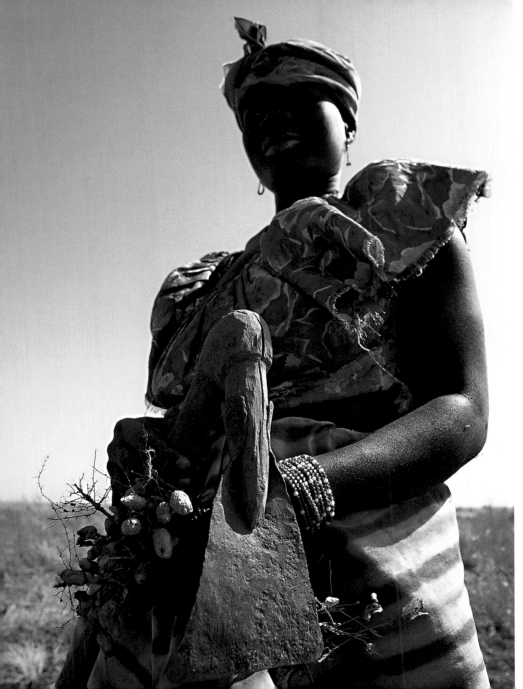

TRY

Work, and thou wilt bless the day
Ere the toil be done;
John Sullivan Dwight

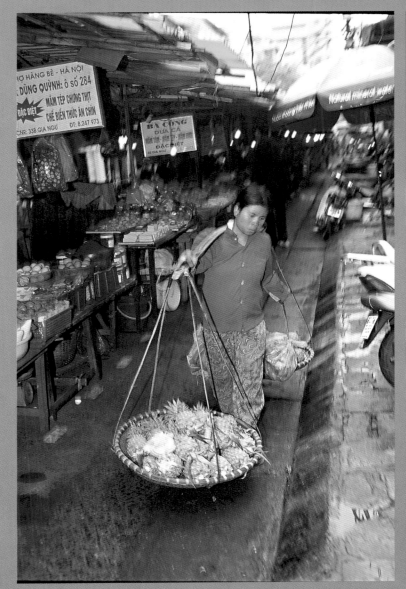
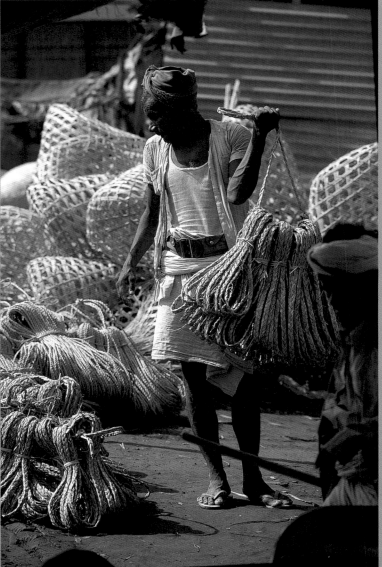

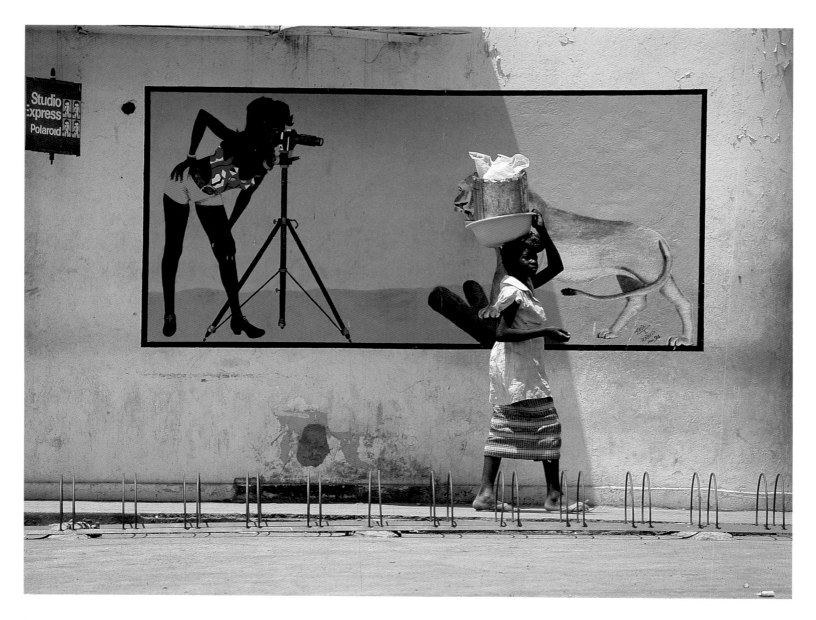

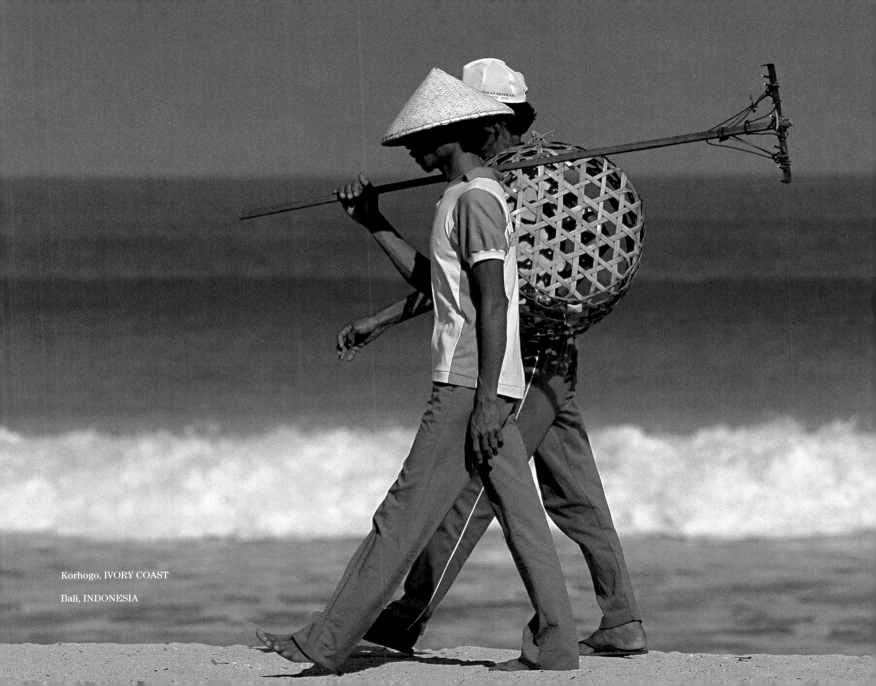

Korhogo, IVORY COAST

Bali, INDONESIA

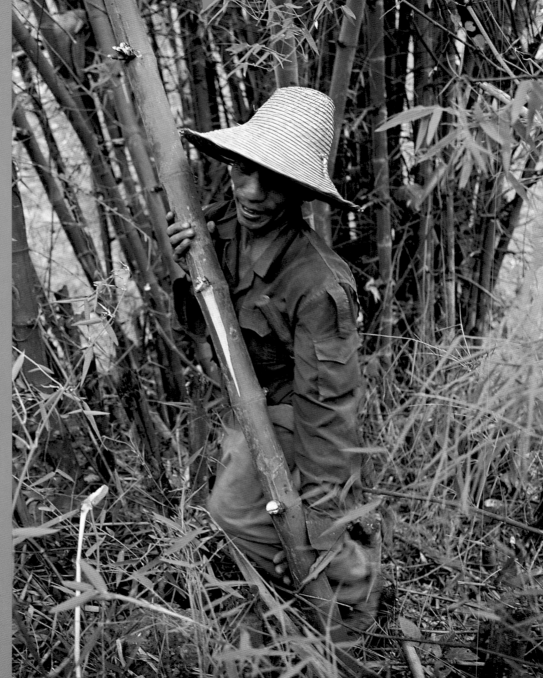

Yunan, CHINA

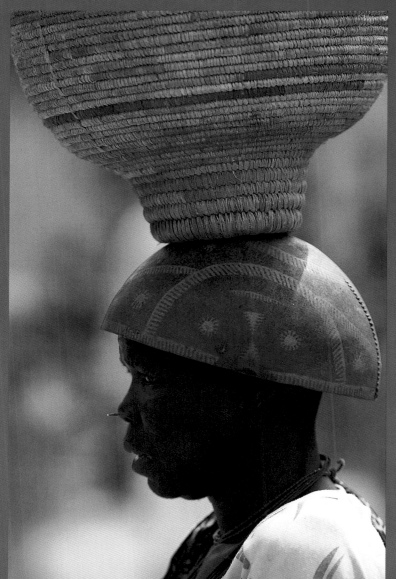

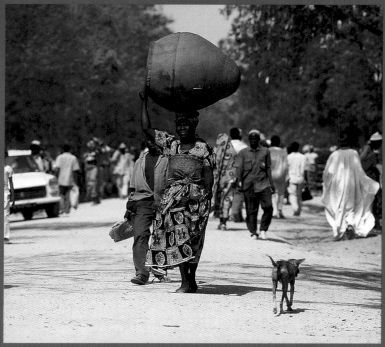

Tourou, CAMEROON

Mokolo, CAMEROON

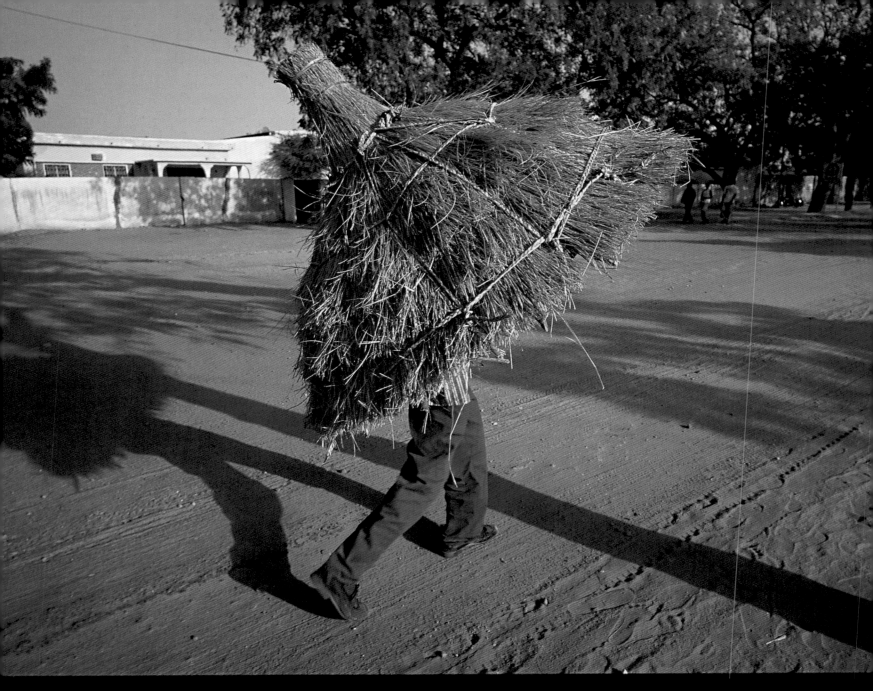

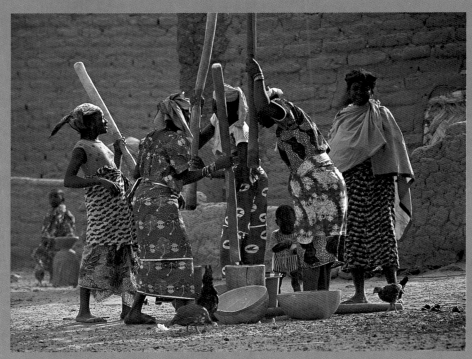

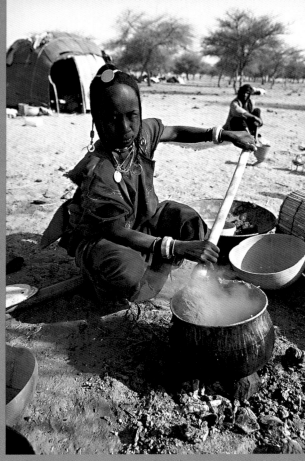

NIGER

BURKINA FASO

BURKINA FASO

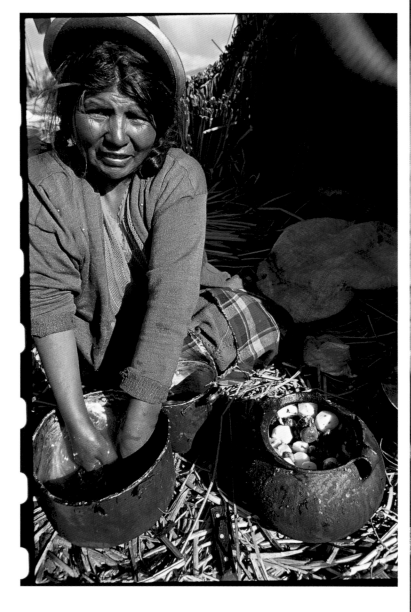

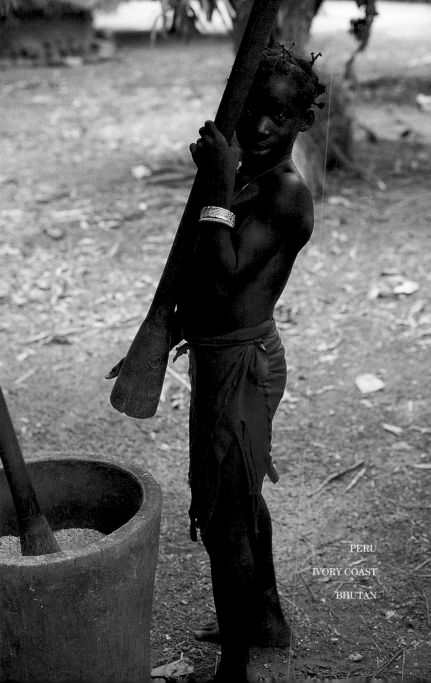

PERU

IVORY COAST

BHUTAN

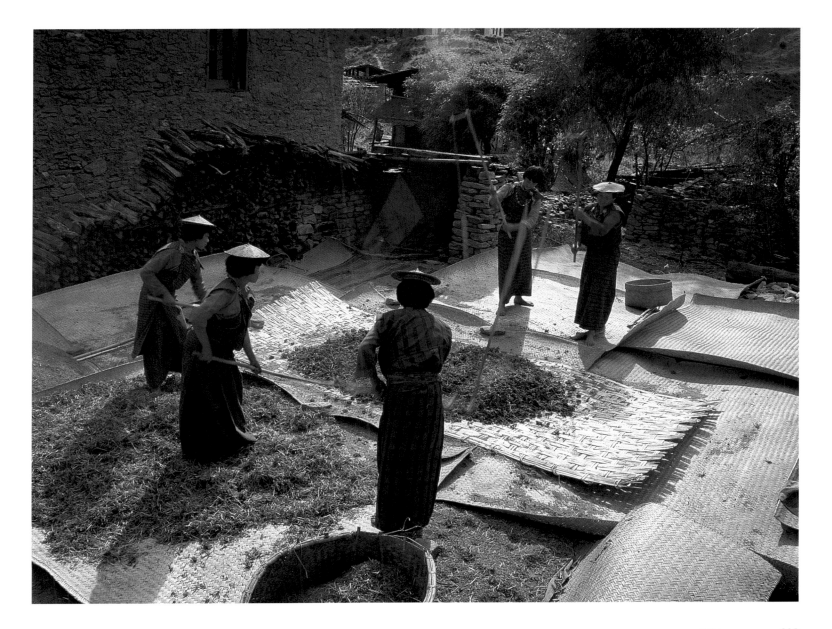

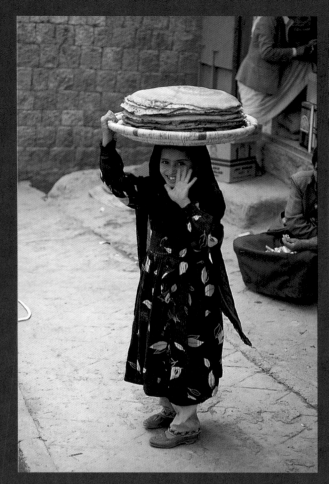

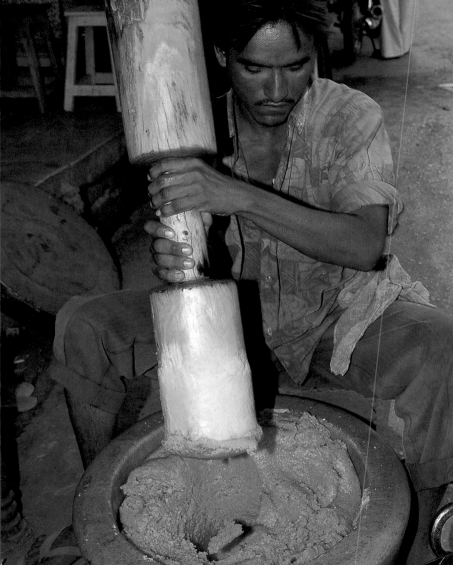

Hajja, YEMEN

INDIA

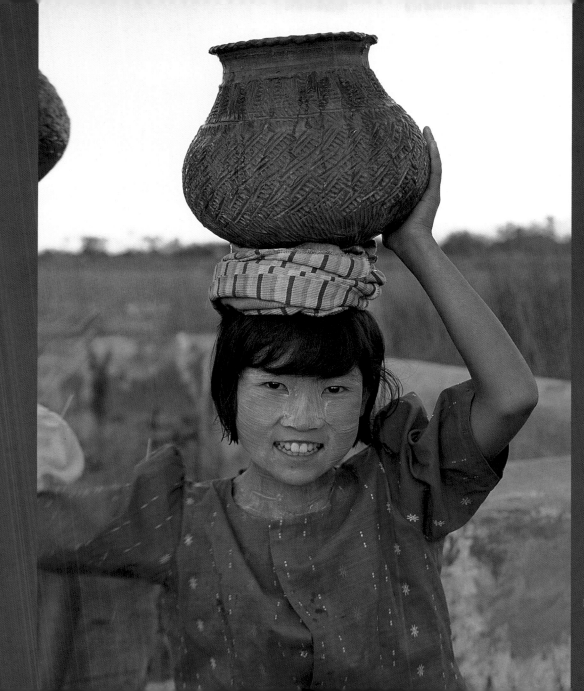

TRY

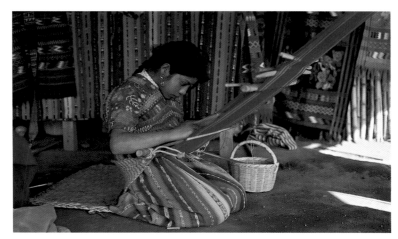

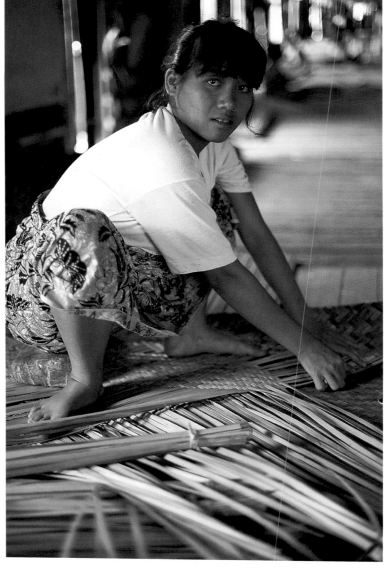

San Antonio Palopó,
GUATEMALA

VENEZUELA

Borneo Island, MALAYSIA

What people say you cannot do,
you try and find that you can.
Henry David Thoreau

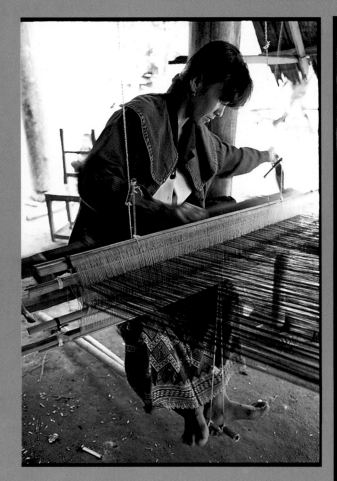

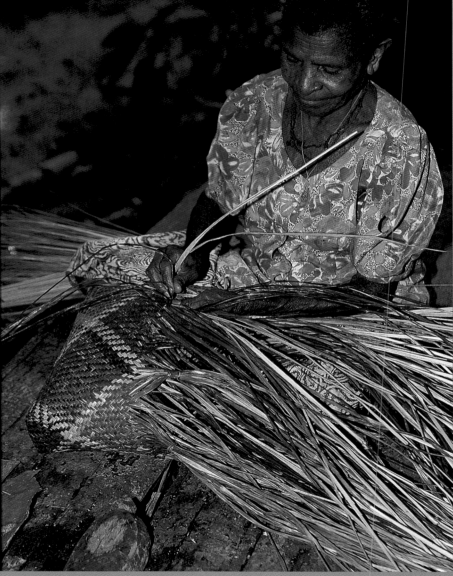

LAOS

Sepik village,
PAPUA NEW GUINEA

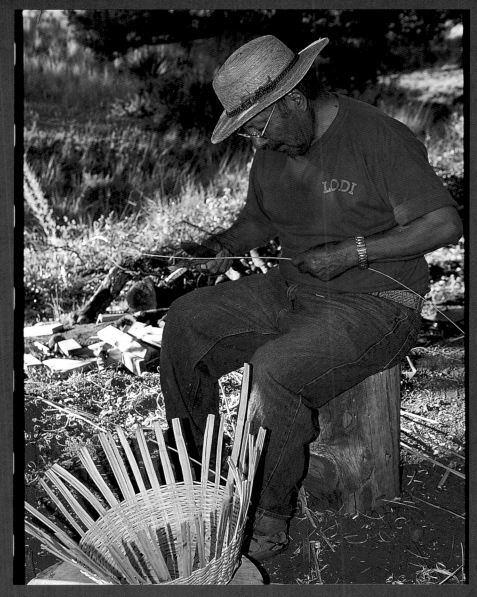

Arizona, UNITED STATES

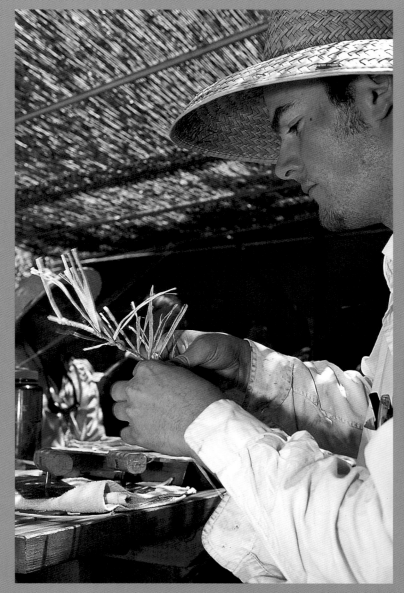
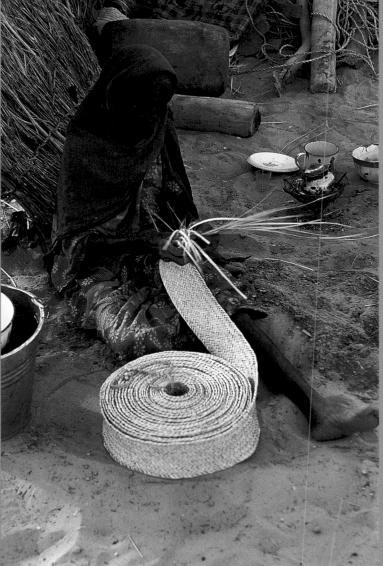

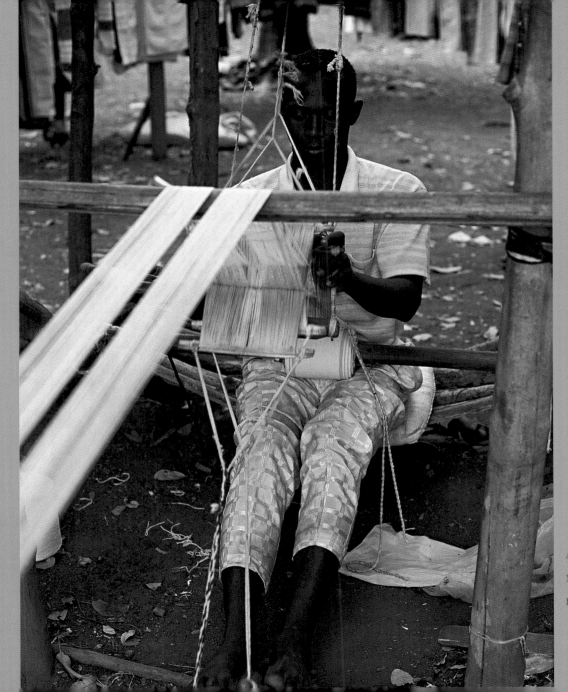

TRY

Arizona, UNITED STATES

Near Lake Chad, CHAD

IVORY COAST

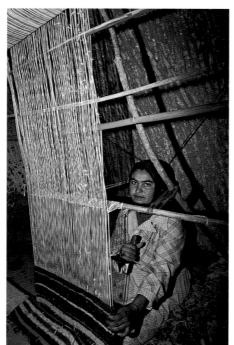

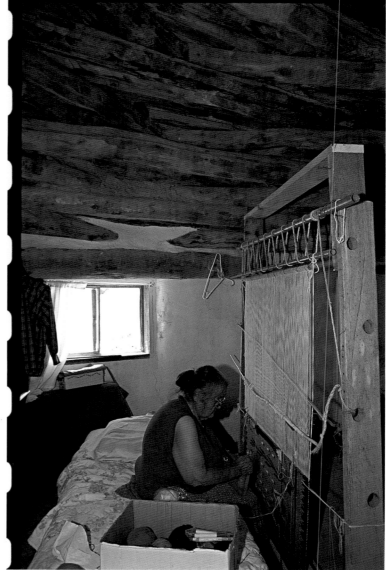

Matmata, TUNISIA

Near Ship Rock, UNITED STATES

Ardakan, IRAN

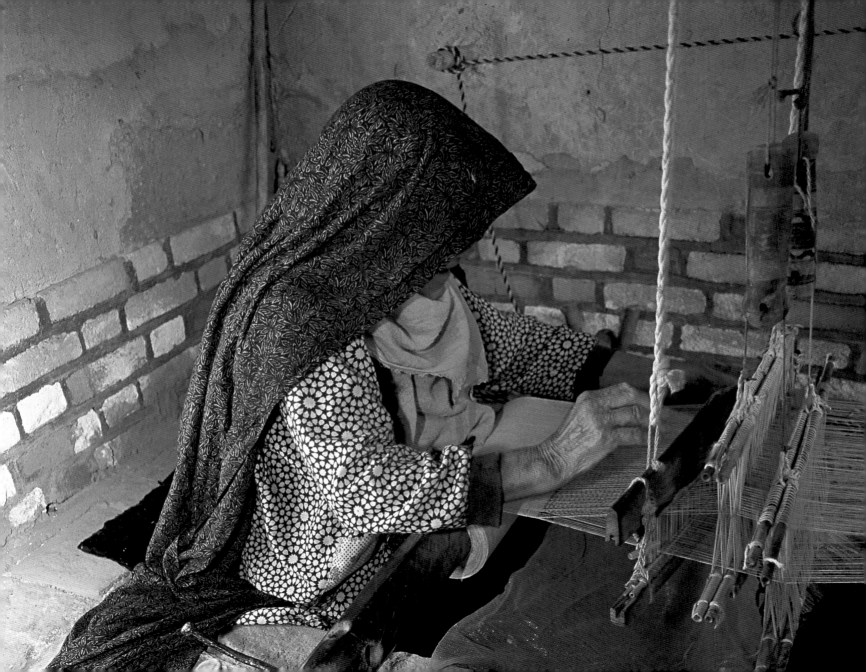

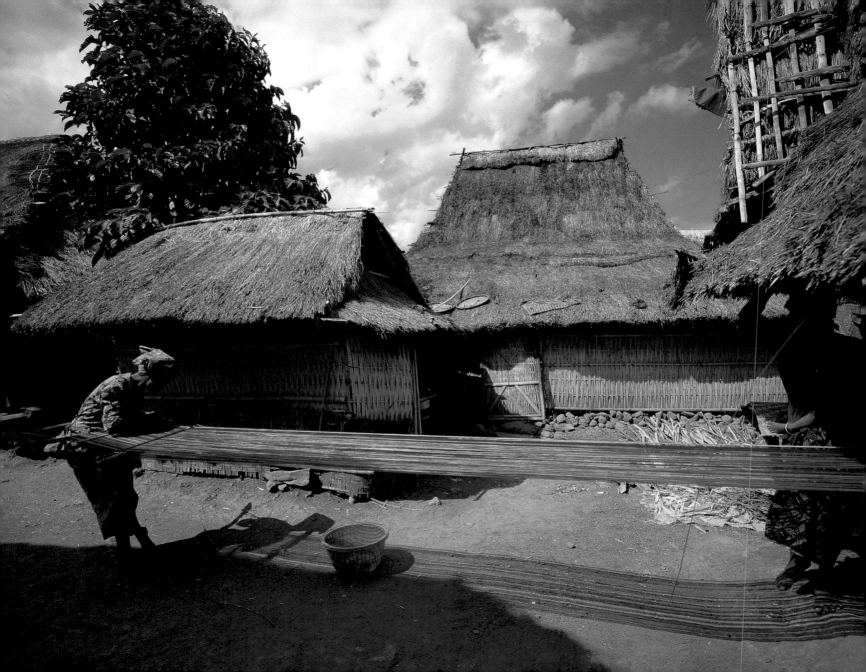

By the work one knows the workman.
Jean de La Fontaine

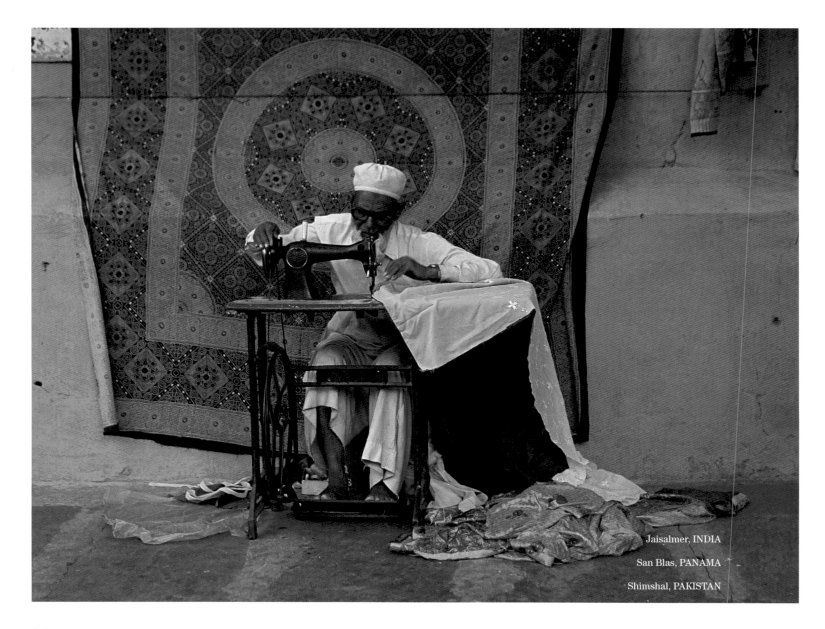

Jaisalmer, INDIA

San Blas, PANAMA

Shimshal, PAKISTAN

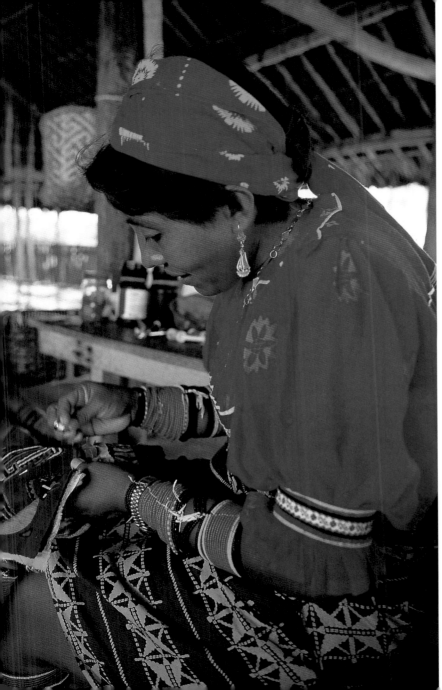
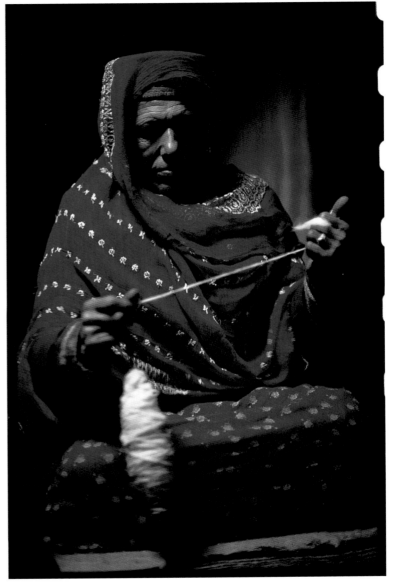

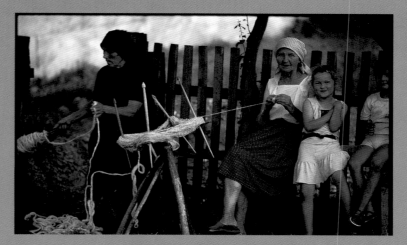

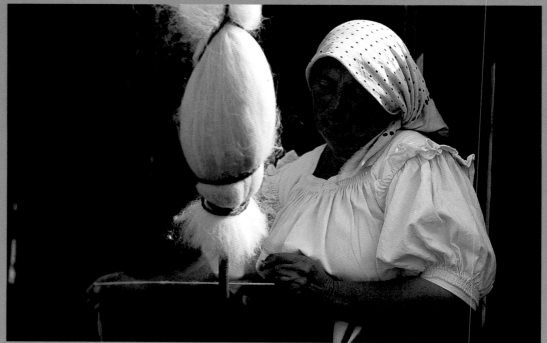

Maramures, ROMANIA

Maramures, ROMANIA

Lunenburg, CANADA

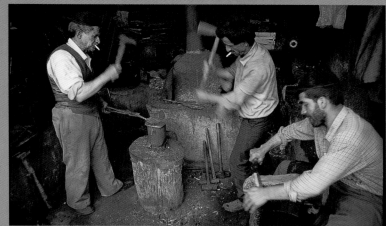

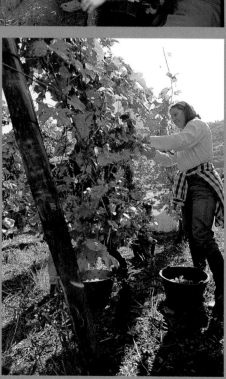

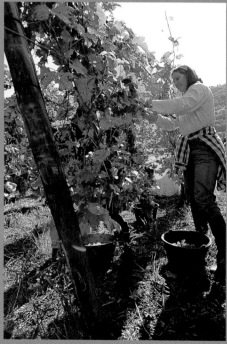

Masule, IRAN

Kaysersberg, FRANCE

Fakaha, IVORY COAST

Even in the meanest sorts of Labor, the whole soul of a man is composed into a kind of real harmony the instant he sets himself to work.
Thomas Carlyle

What unites us as human beings is the aspiration to make the world better, more compassionate, with less conflict, less hate and hardship, and with more tolerance and understanding.

Elie Wiesel

Arizona, UNITED STATES

Valledupar, COLOMBIA

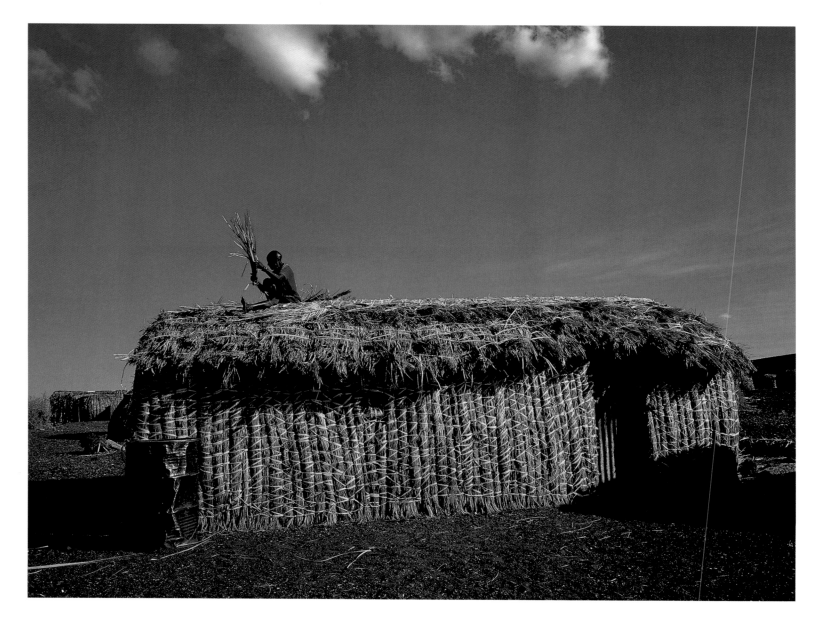

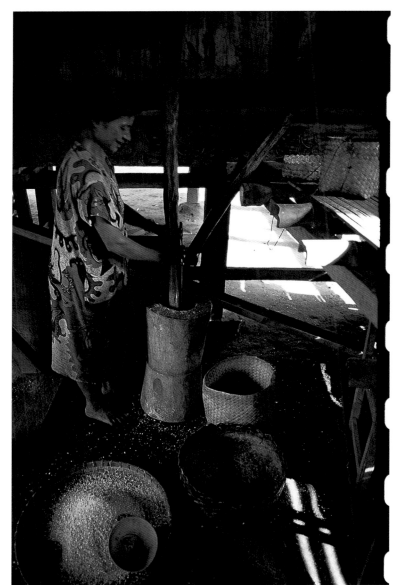

Turkana lakeside, KENYA

Flores, INDONESIA

Bretagne, FRANCE

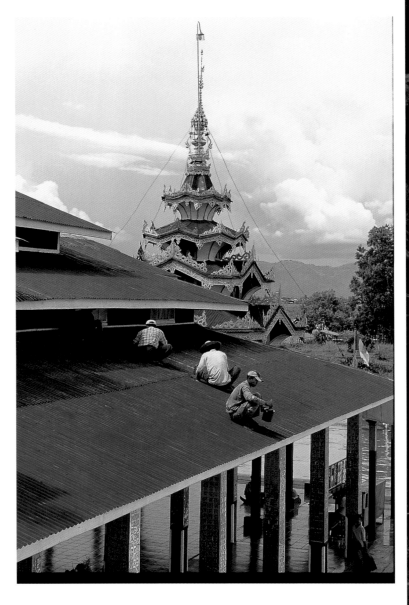

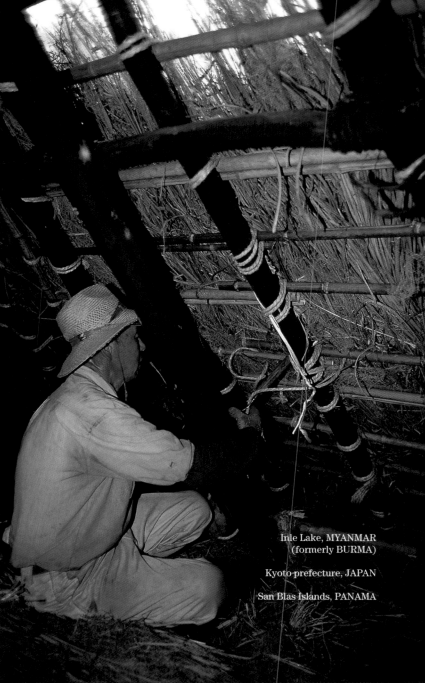

Inle Lake, MYANMAR
(formerly BURMA)

Kyoto prefecture, JAPAN

San Blas Islands, PANAMA

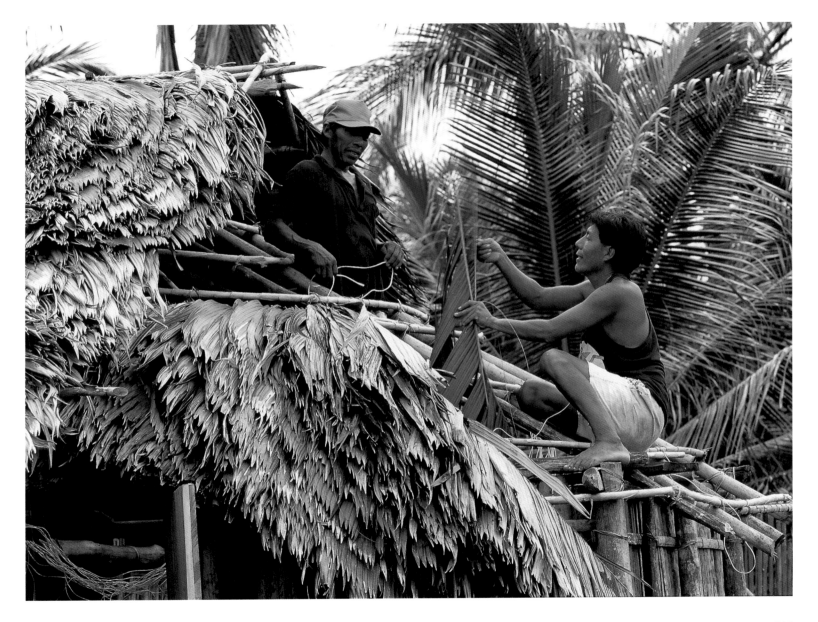

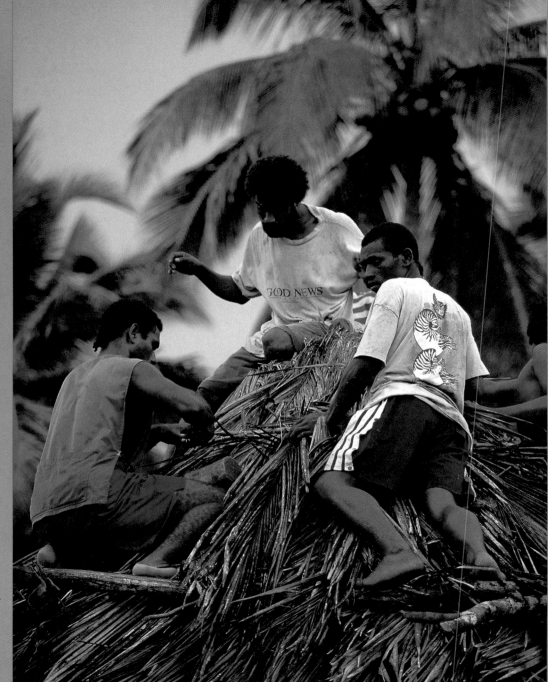

TRY

Jaisalmer, INDIA

Fujian, CHINA

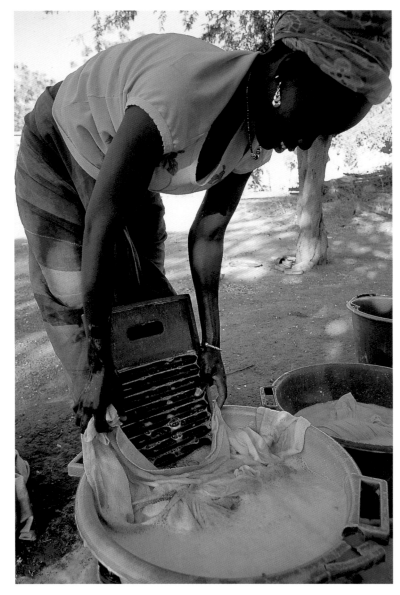

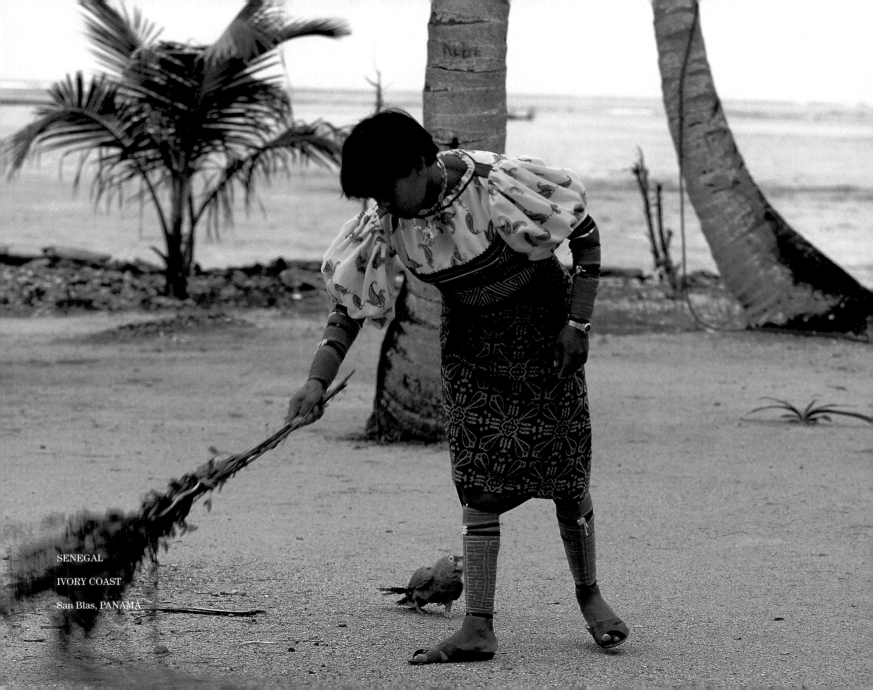

SENEGAL

IVORY COAST

San Blas, PANAMA

Natural abilities are like
natural plants;
they need pruning by study.
Sir Francis Bacon

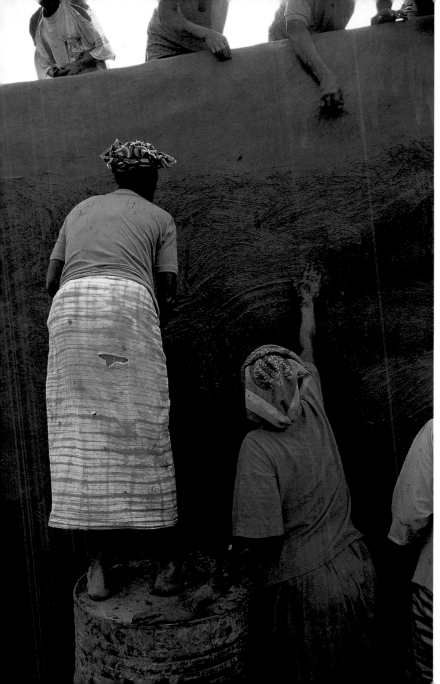

Tiébélé, BURKINA FASO

La Paz, BOLIVIA

Vlkolinec, SLOVAKIA

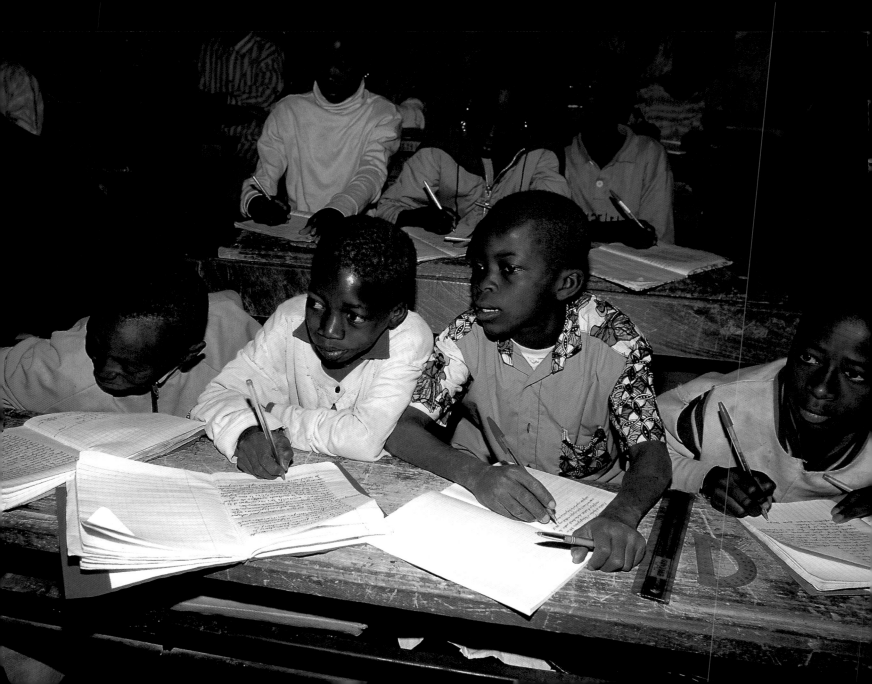

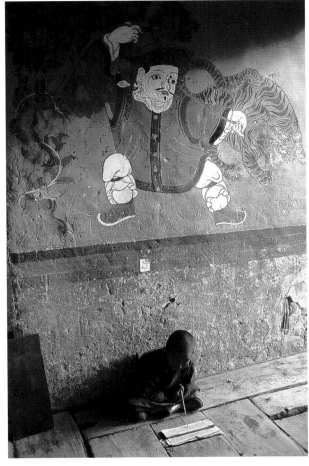

Po, BURKINA FASO

Lake Titicaca, PERU

Bumthang, BHUTAN

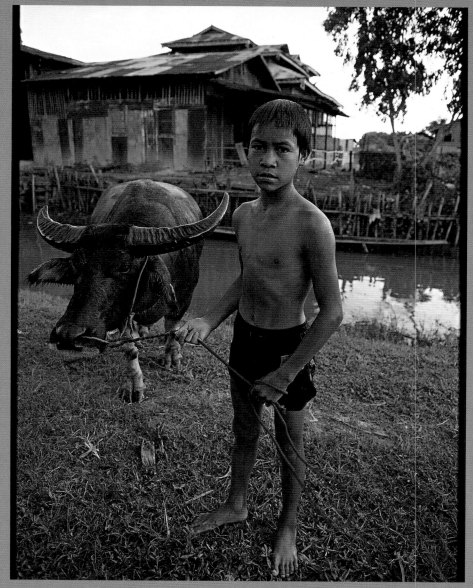

MYANMAR (formerly BURMA)

Oualata, MAURITANIA

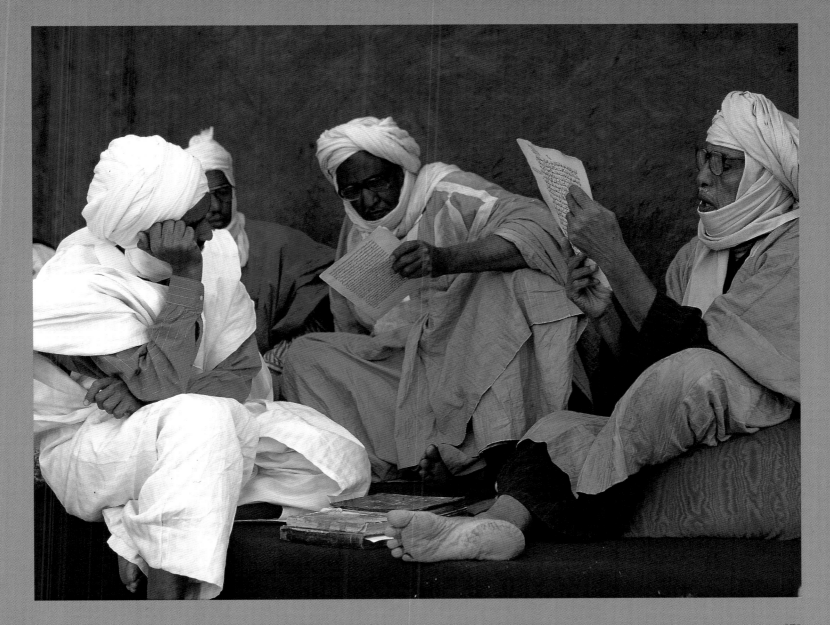

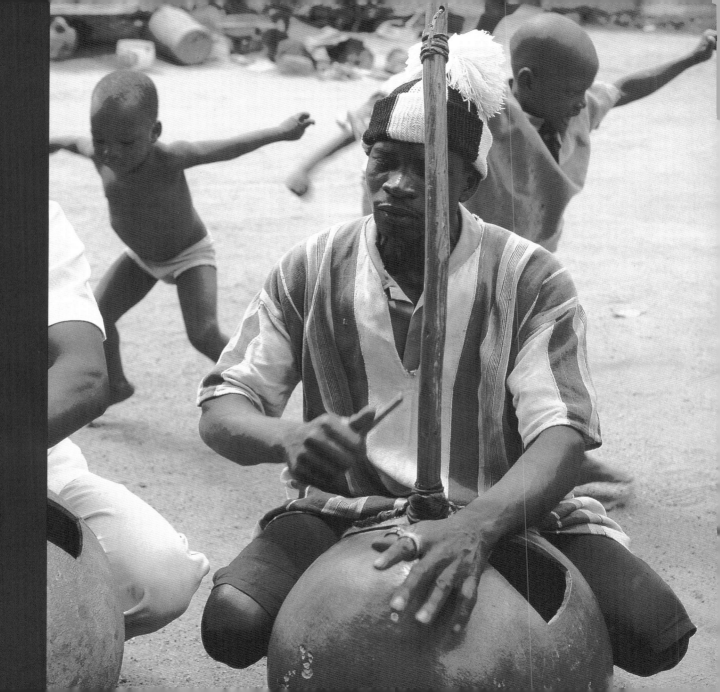

PLAY

No matter our age, we all want to go out and play. It is part of who we are and what we want to experience in our lives—a powerful expression of our wants, desires, and personalities. Playing represents freedom, rest, and energy.

Children are full of energy; watching their playful behaviors brings us cheer. When they are playing, children are geniuses. They contrive and make tools with anything. They play games like hide-and-seek with friends; they have sensibility and imagination. They involve friends, family, and pets.

When I see children playing, I see myself. I feel I am flying to a time from my past. It is a sweet feeling. We need more play.

We are never more fully alive, more completely ourselves, or more deeply engrossed in anything than when we are playing.

Charles Schaefer

Eastern Terai, NEPAL

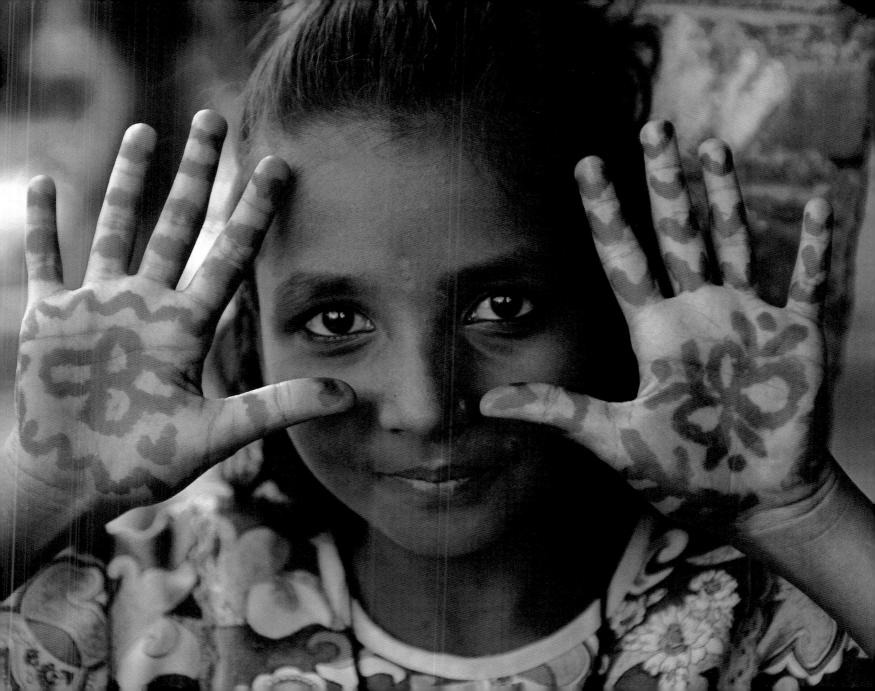

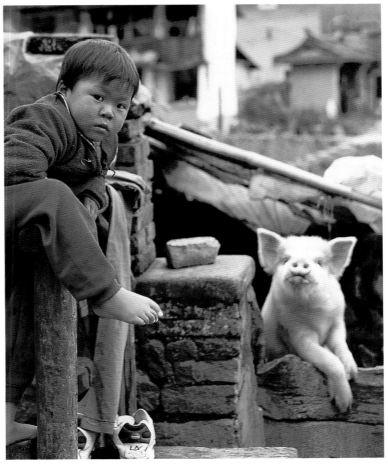

Antwerp, BELGIUM

Fujian, CHINA

Istanbul, TURKEY

Paris, FRANCE

New York, UNITED STATES

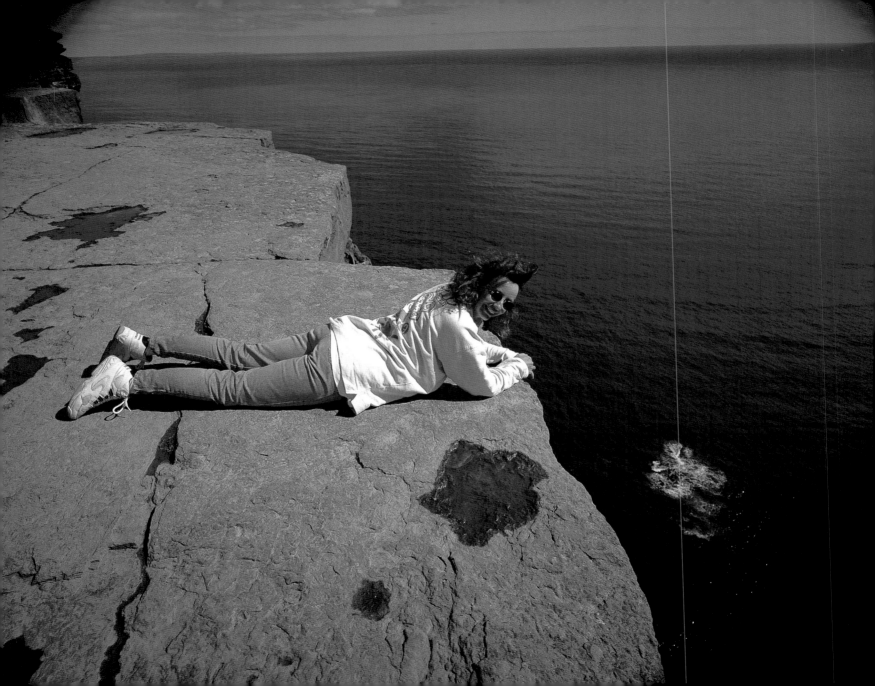

Unless each day can be looked back upon by an individual as one in which he has had some fun, some joy, some real satisfaction, that day is a loss.

Anonymous

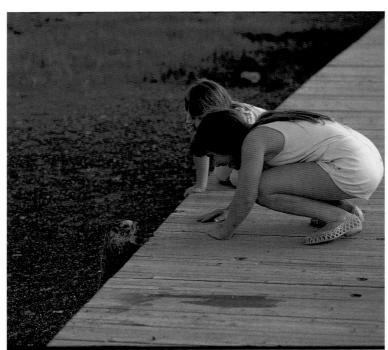

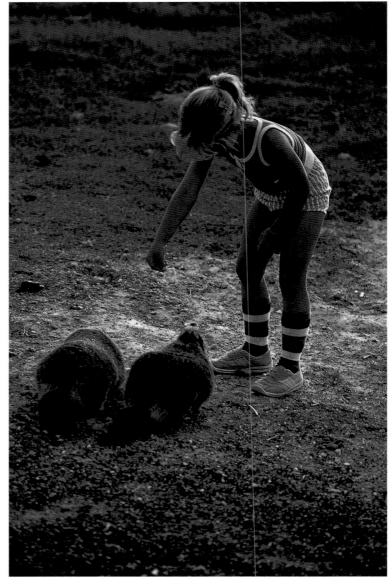

UNITED STATES

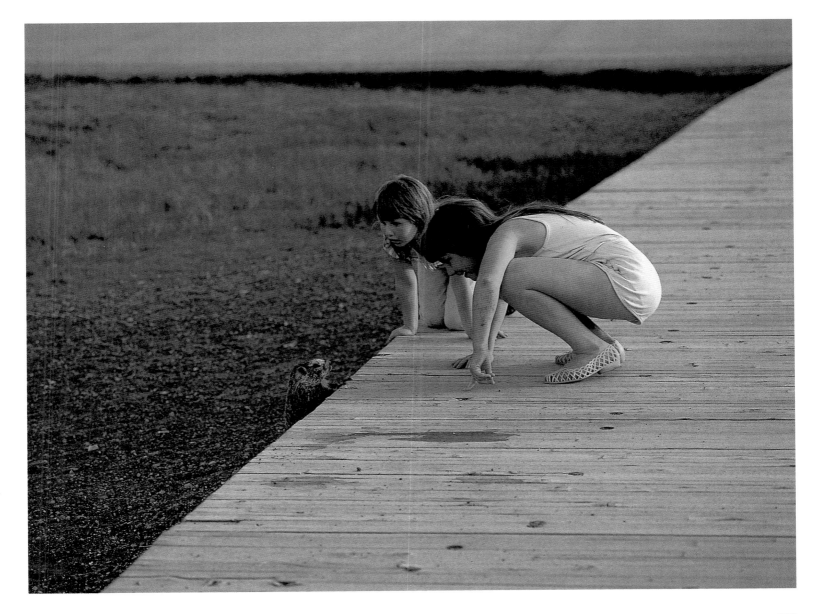

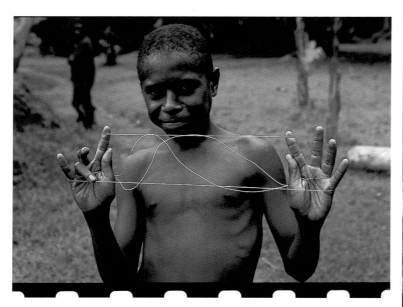

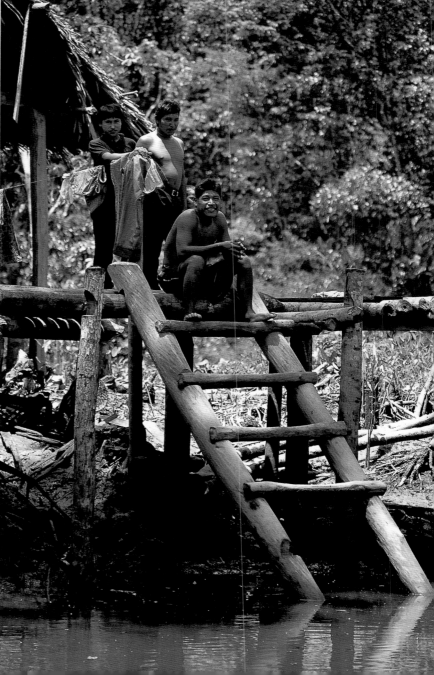

Sepik Village,
PAPUA NEW GUINEA

Orinoco Delta, VENEZUELA

Lisbon, PORTUGAL

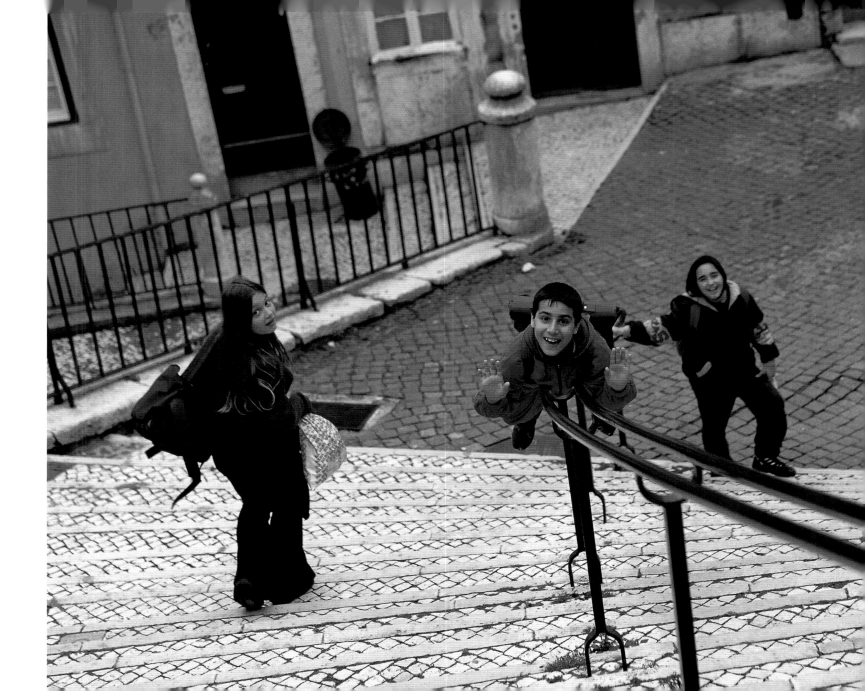

We don't stop playing because
we grow old; we grow old because
we stop playing.

Benjamin Franklin

Chiclayo, PERU

Janakpur, NEPAL

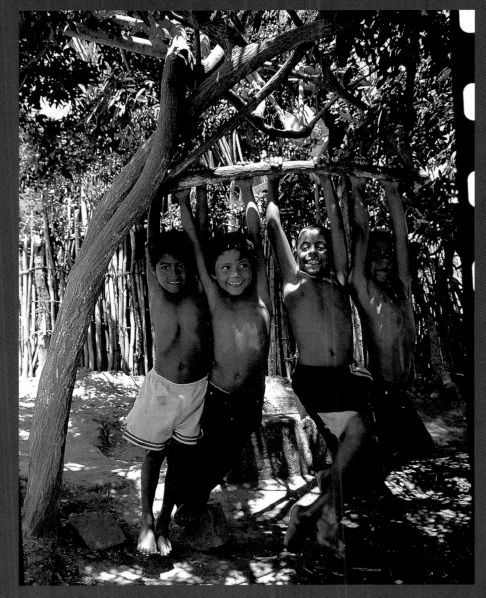

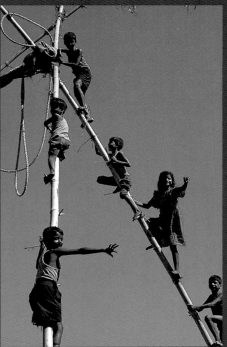

PLAY

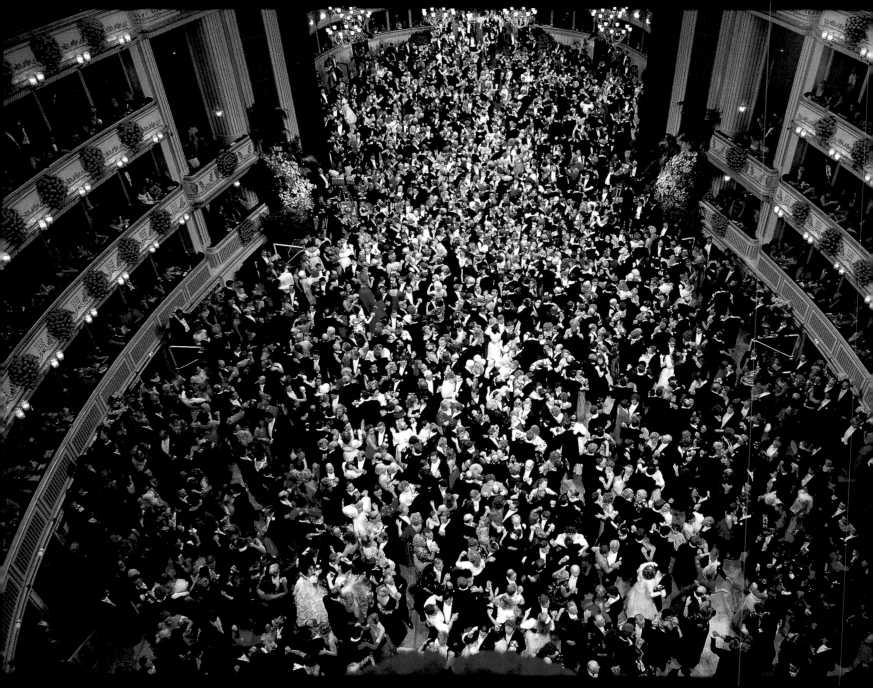

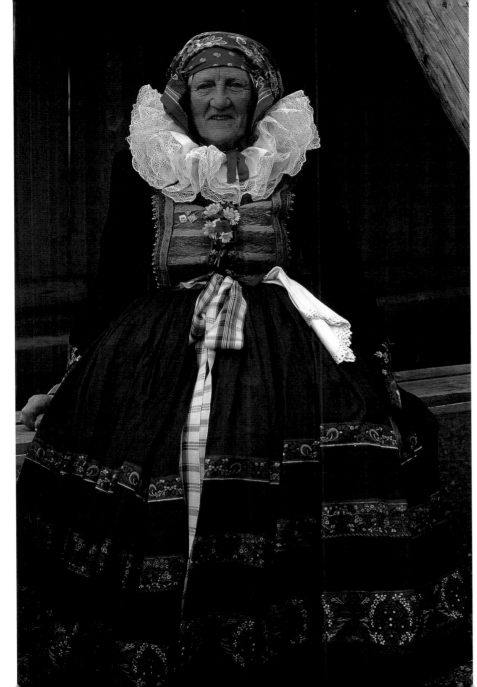

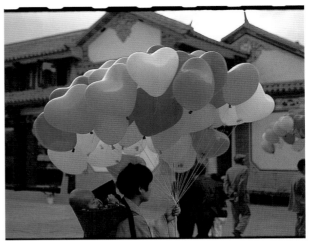

Vienna, AUSTRIA

CZECH REPUBLIC

Da Li, CHINA

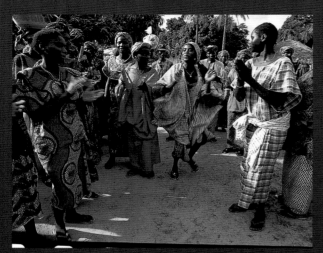

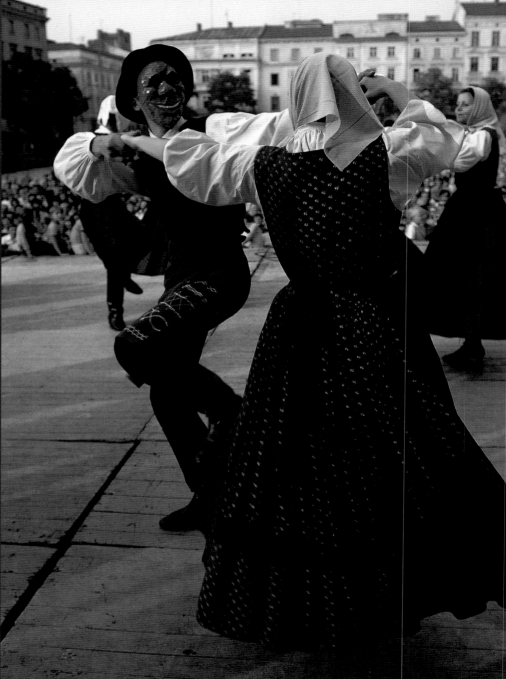

Casamance, SENEGAL

Kraków, POLAND

Dance is the hidden language of the soul.
Martha Graham

We are the music-makers,
We are the dreamers of dreams ...
Arthur William Edgar
O'Shaughnessy

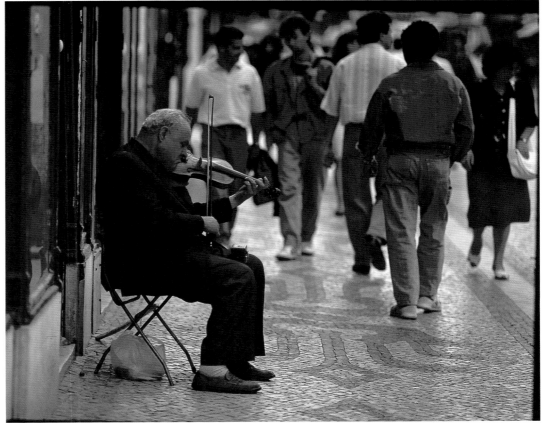

Caracas, VENEZUELA

Niofouin, IVORY COAST

Lisbon, PORTUGAL

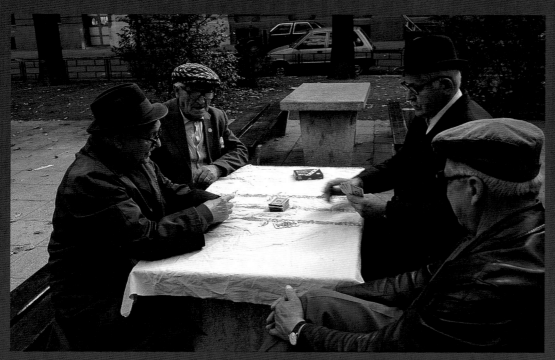

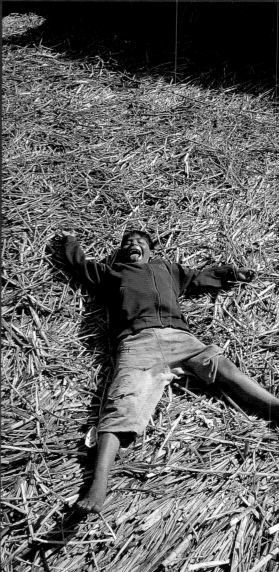

Budapest, HUNGARY

Lake Titicaca, PERU

Tryavna, BULGARIA

The band is playing somewhere, and somewhere hearts are light,
And somewhere men are laughing and somewhere children shout ...
Ernest Lawrence Thayer

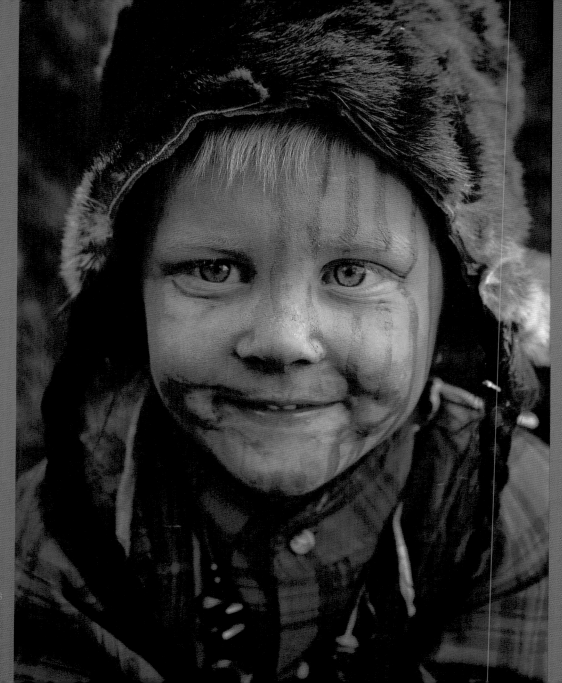

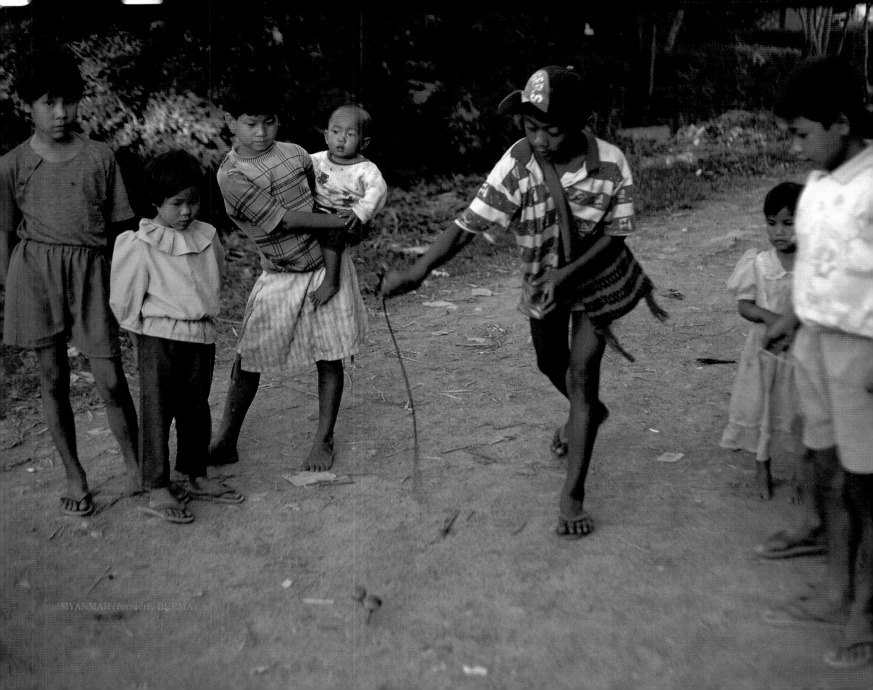

MYANMAR (formerly BURMA)

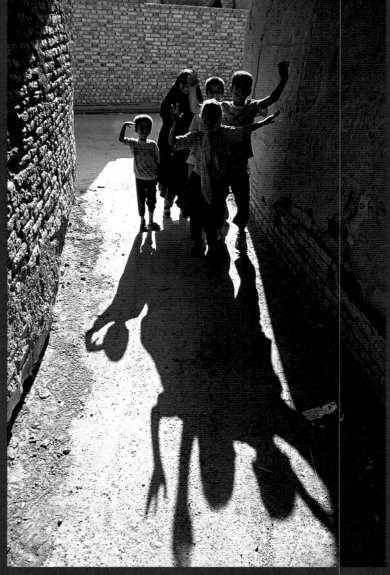

Four Corners, UNITED STATES

Ardakan, IRAN

UNITED STATES

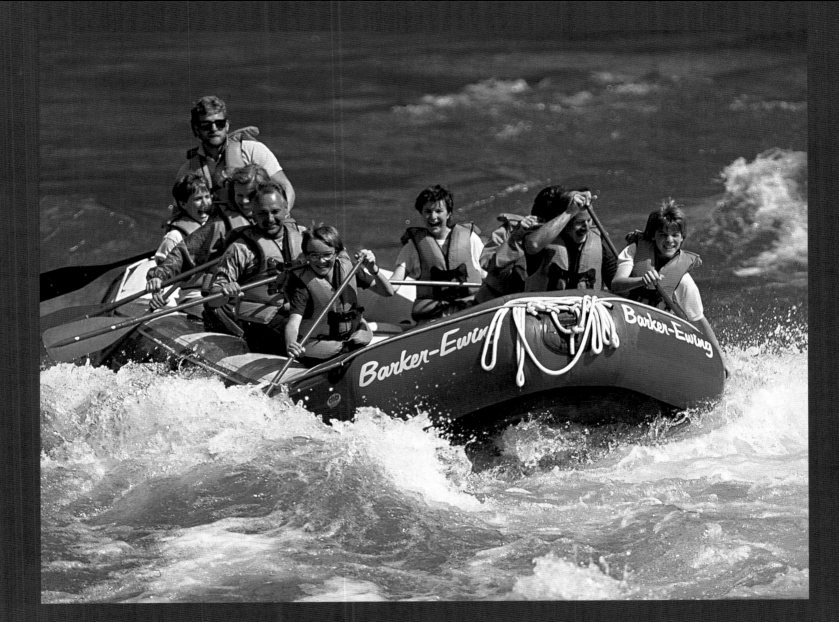

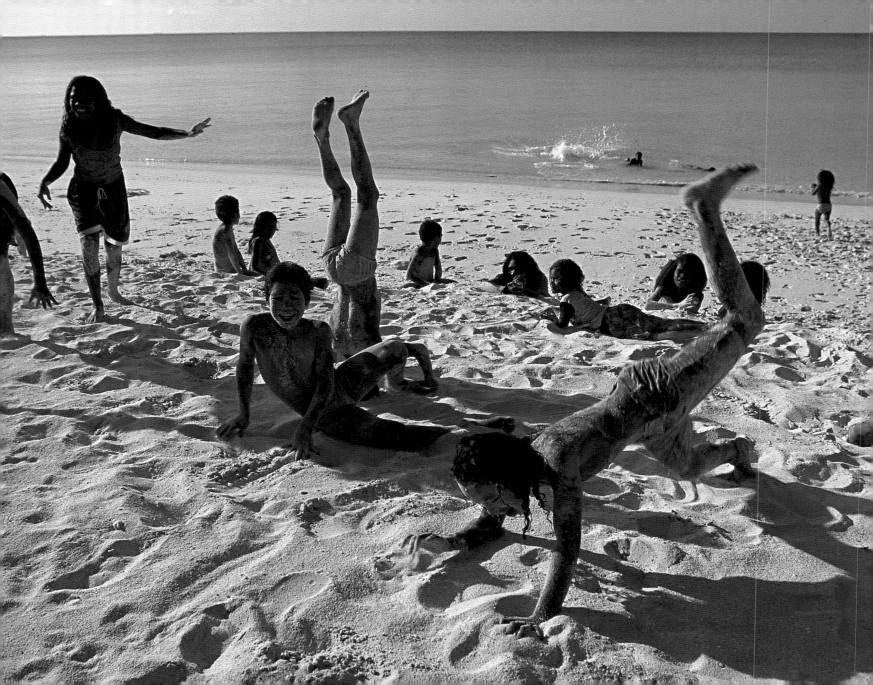

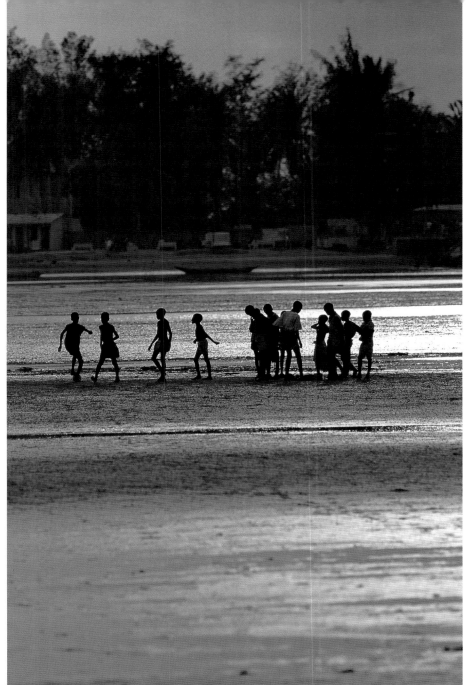

Ouvéa, NEW CALEDONIA

Joal-Fadiout, SENEGAL

ARUBA (Netherlands Antilles)

Happy the man, and happy he alone,
He, who can call to-day his own:
He who, secure within, can say,
To-morrow do thy worst, for
I have lived today.

John Dryden

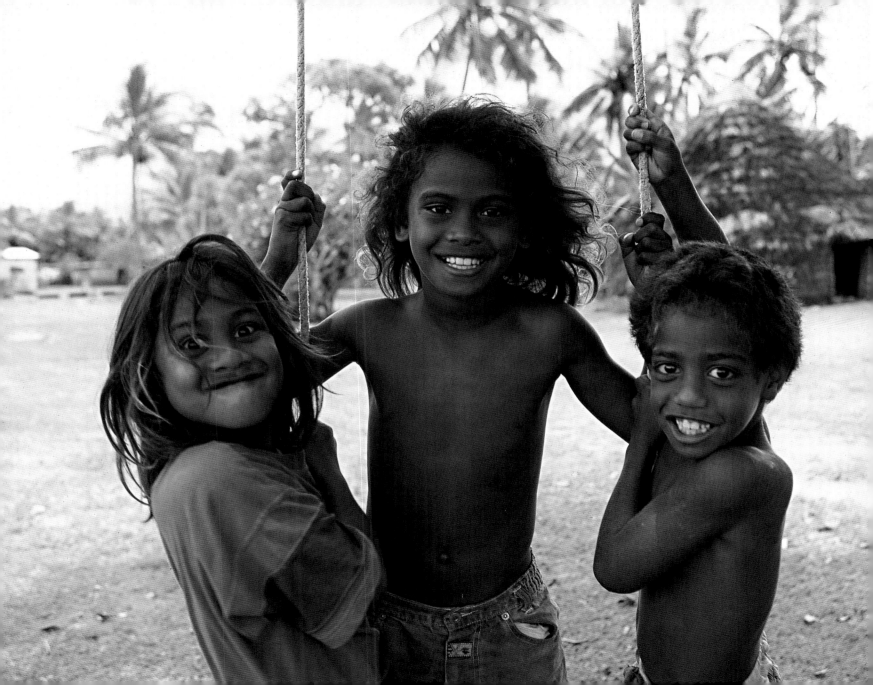

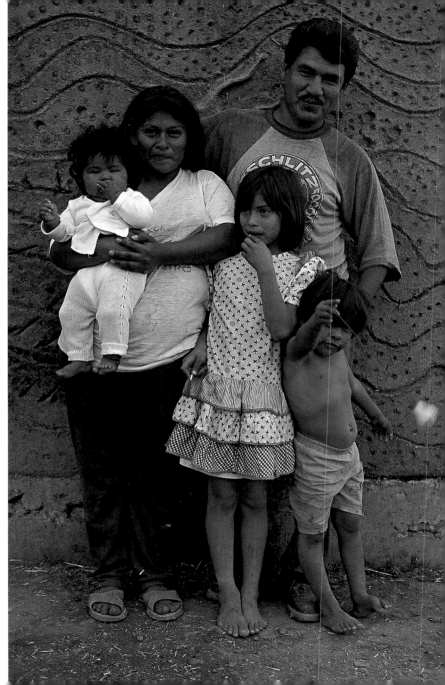

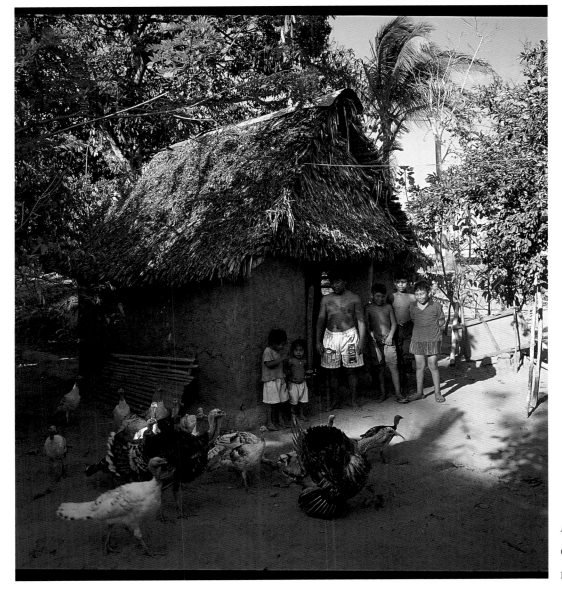

PLAY

Arizona, UNITED STATES

Ciudad Obregón, MEXICO

MEXICO

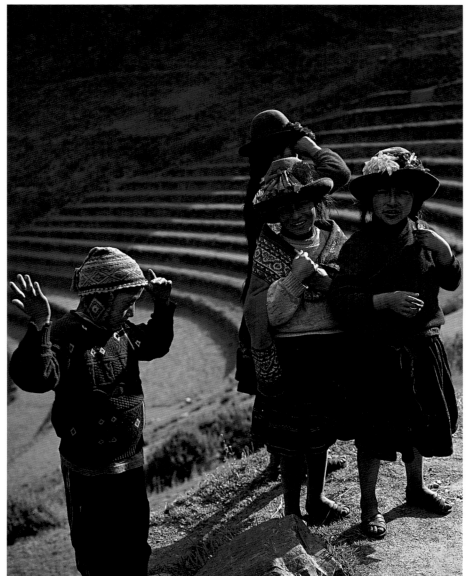

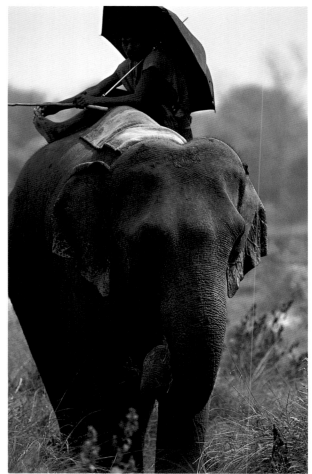

PERU

NEPAL

All animals, except man,
know that the principal business
of life is to enjoy it.
Samuel Butler

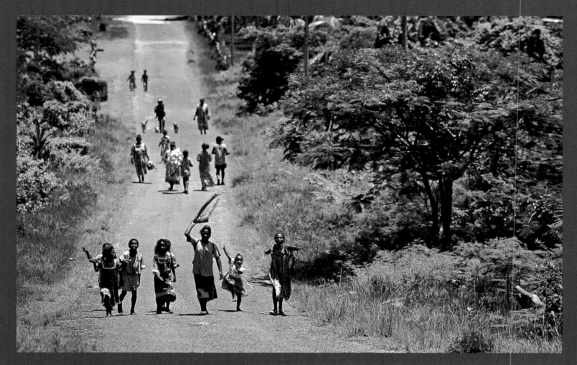

Lifou, NEW CALEDONIA

Four Corners, UNITED STATES

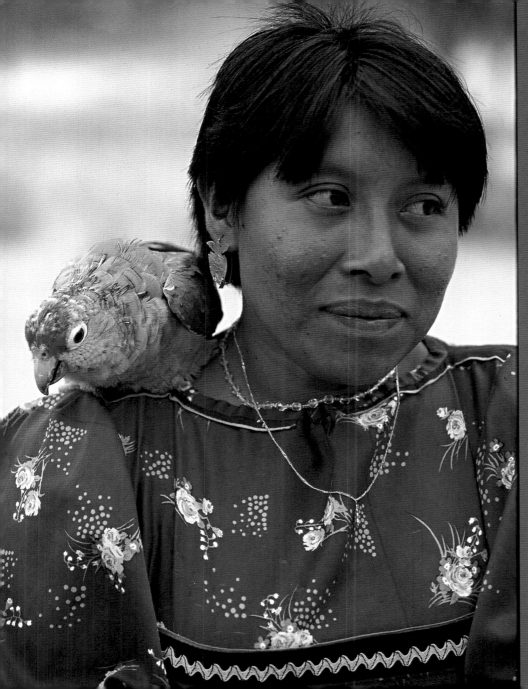

San Blas, PANAMA

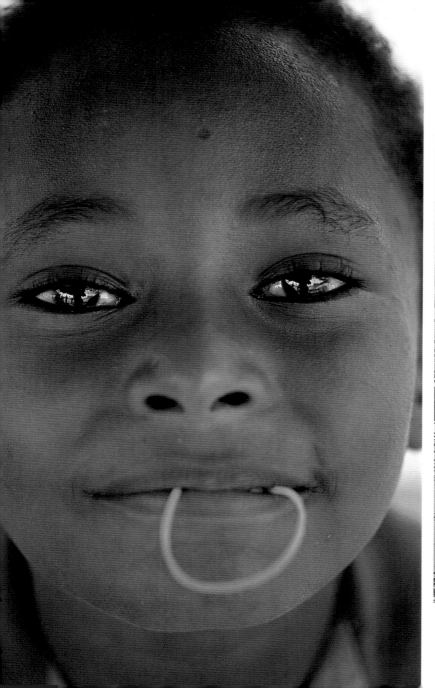
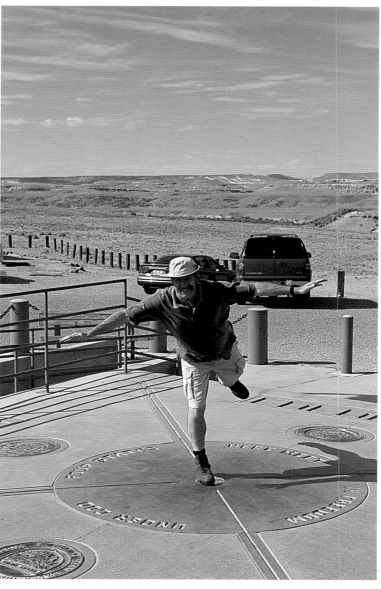

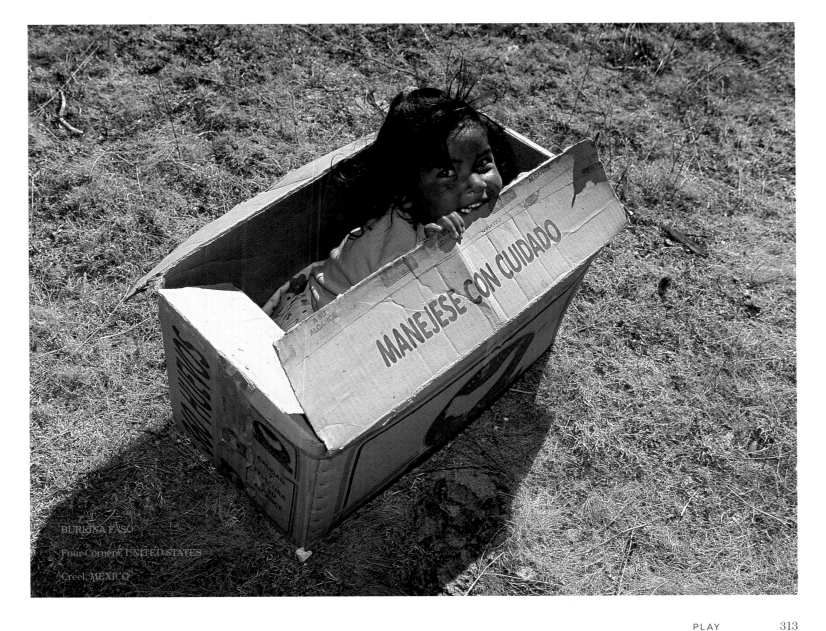

BURKINA FASO

Four Corners, UNITED STATES

Creel, MEXICO

A little work, a little play
To keep us going — and so good-day!

George Louis Palmel a
Busson Du Maurier

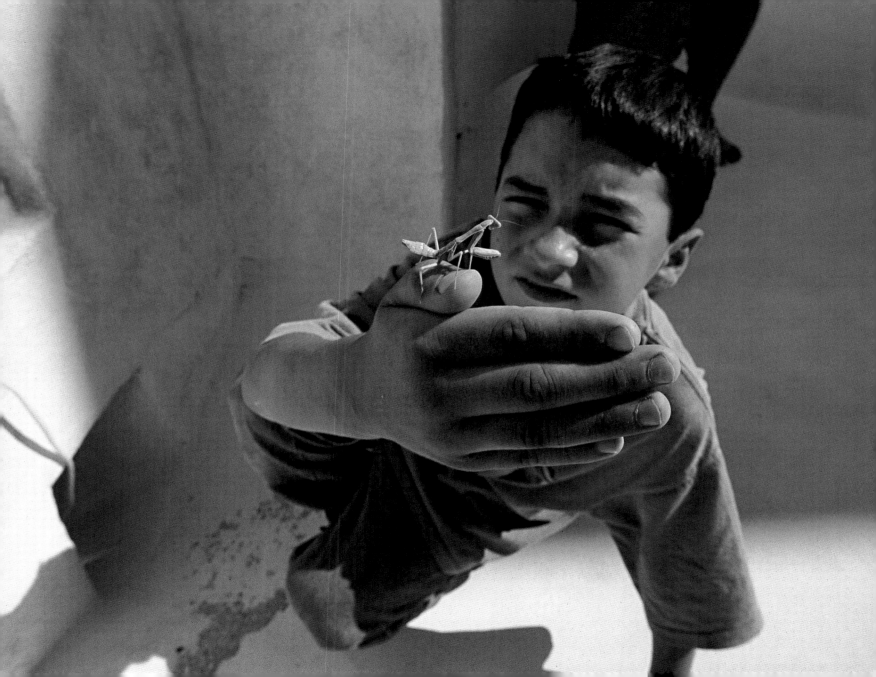

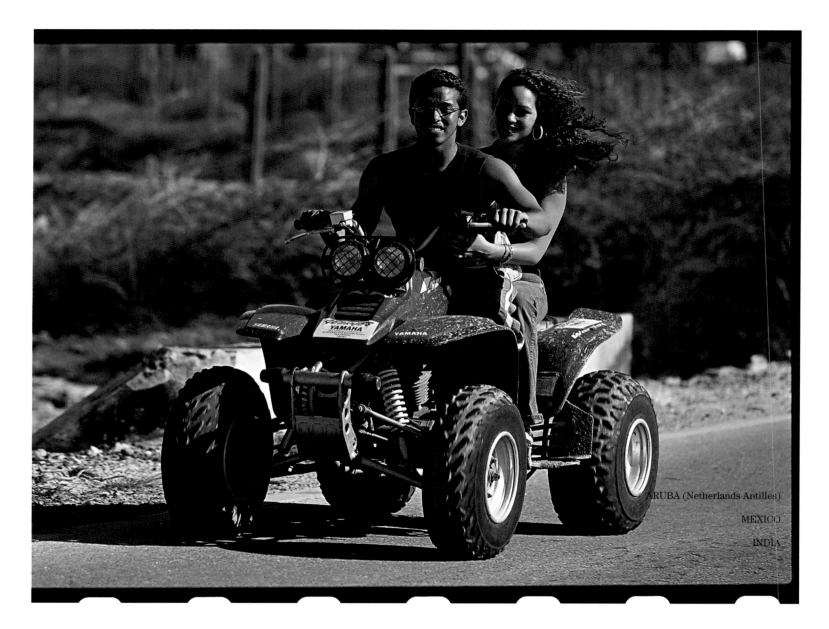

ARUBA (Netherlands Antilles)

MEXICO

INDIA

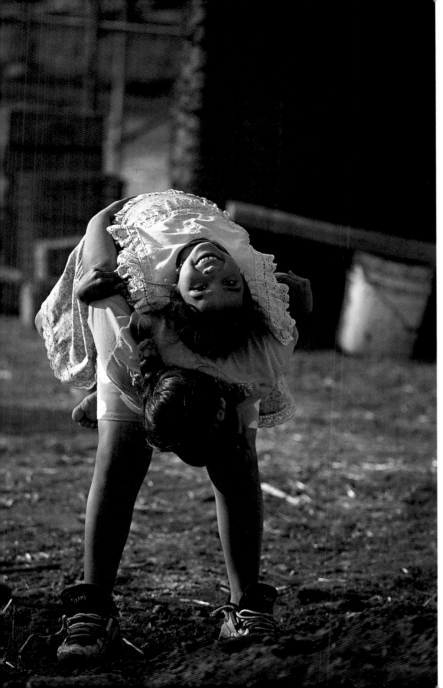
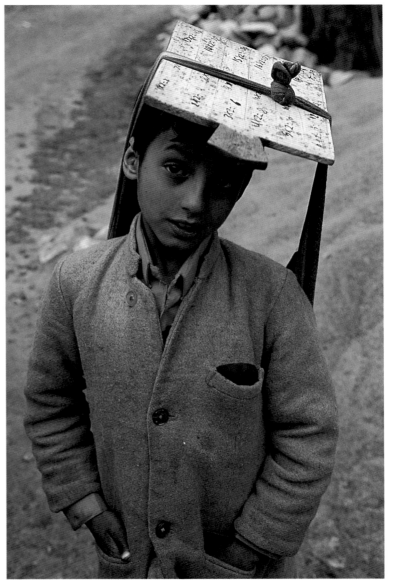

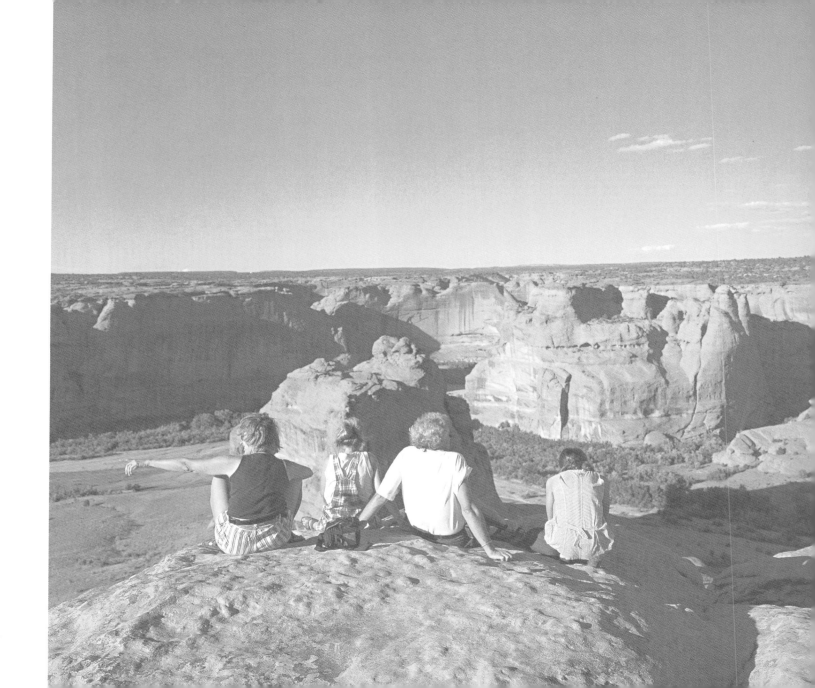

REST

Our lives rush by at a harried pace. If we are to savor life and share it, we need time to be still.

To be still is to rest from work—physically, mentally, and spiritually. It means to open your senses to the other layers of living that find you on your journey. "Be still" time is a sacred rest for the body, mind, and spirit whereby one can take time to listen to nature, to listen to your thoughts, to listen to your spirit, to listen to those around you.

The best time to experience this is in the early morning before the sun rises over the mountains.

Tired nature's sweet restorer, balmy sleep!
Edward Young

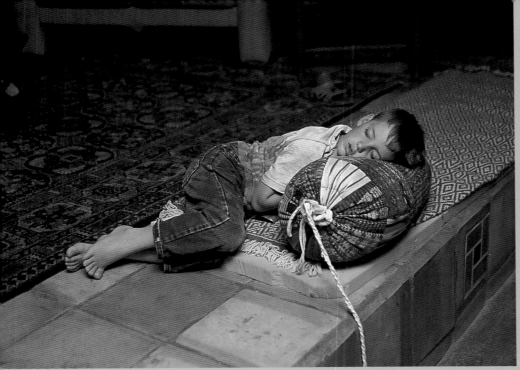

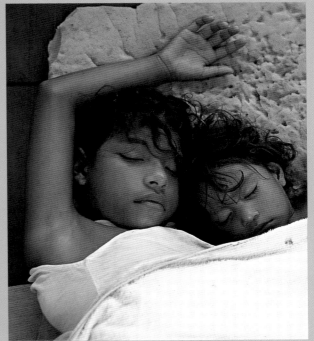

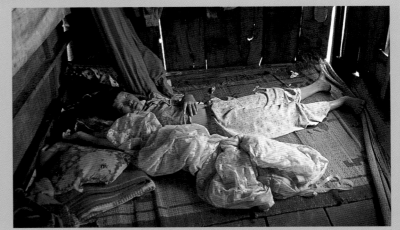

UNITED STATES

VENEZUELA

VIETNAM

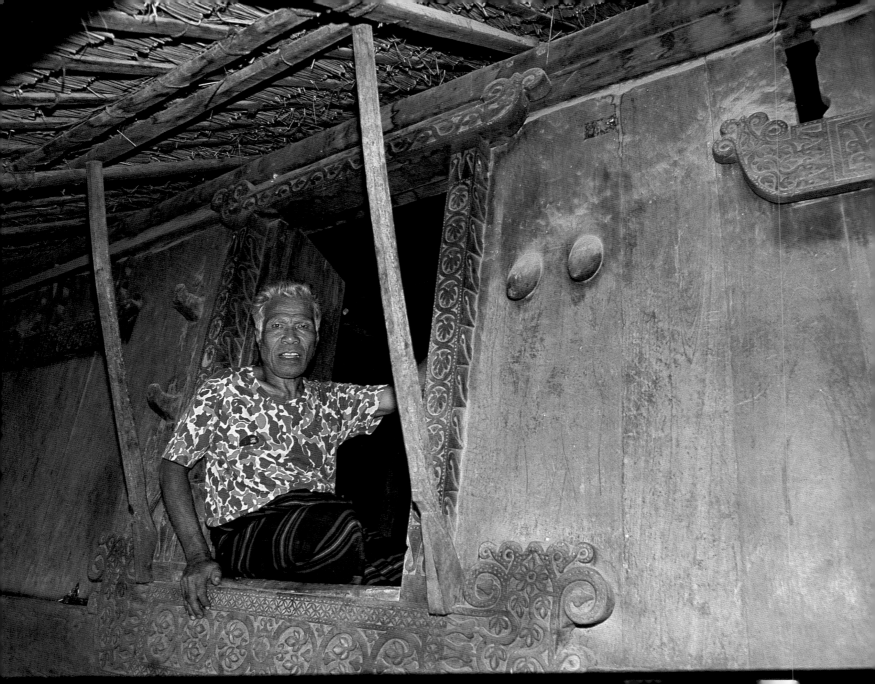

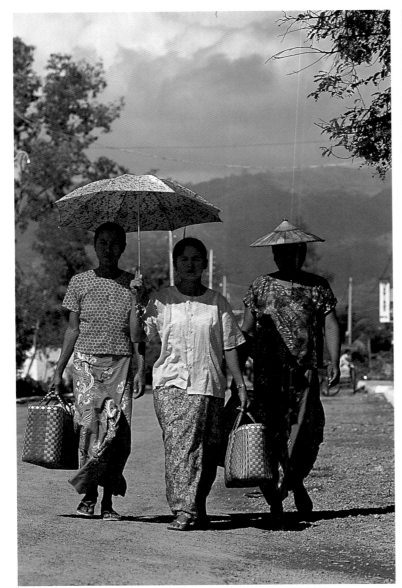

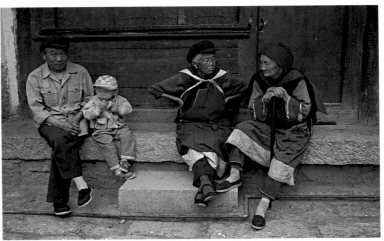

Wolowaru, INDONESIA

MYANMAR (formerly BURMA)

Lijiang, CHINA

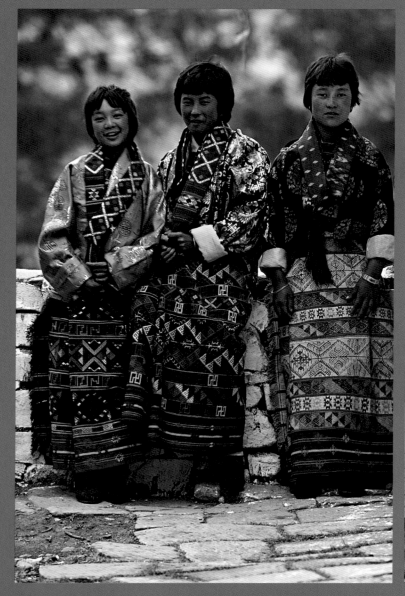

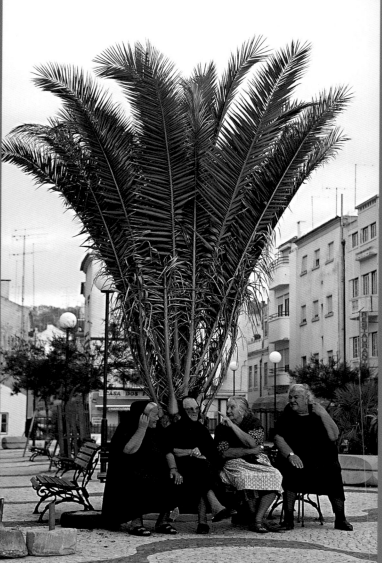

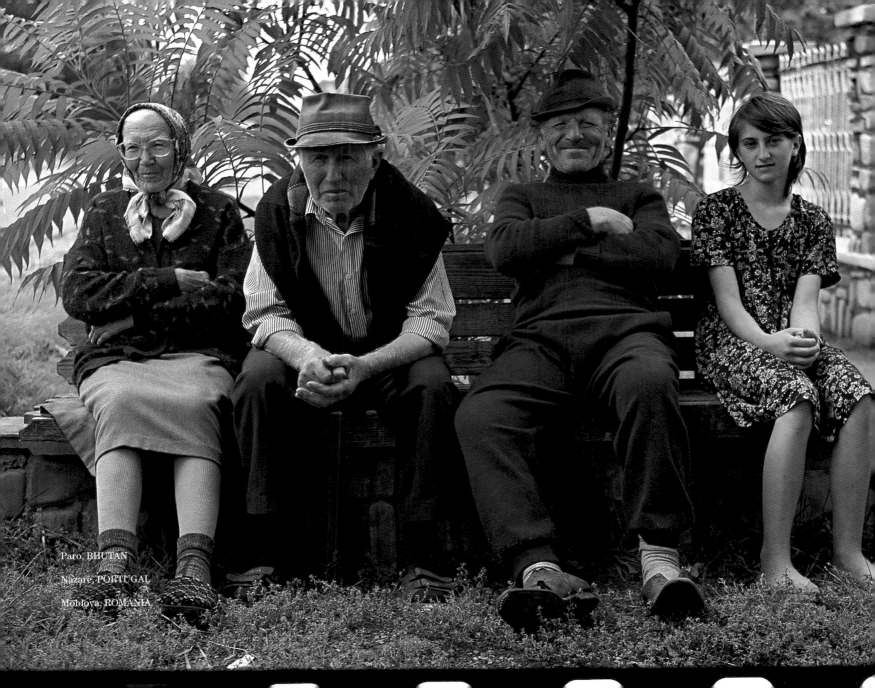

Paro, BHUTAN

Nazaré, PORTUGAL

Moldova, ROMANIA

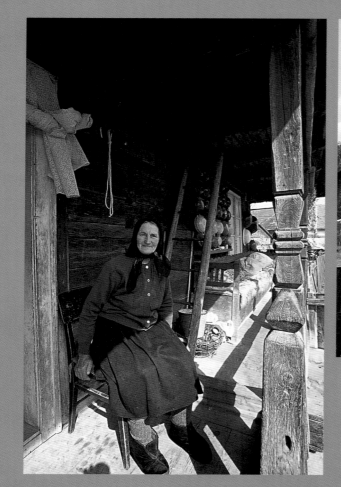

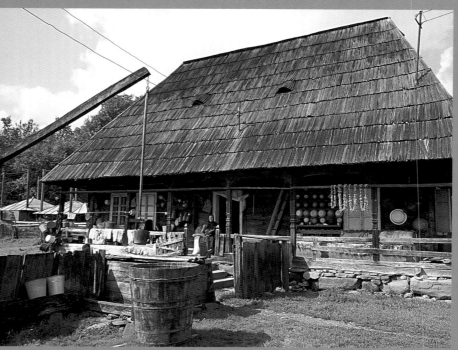

Maramures, ROMANIA

Maramures, ROMANIA

NEPAL

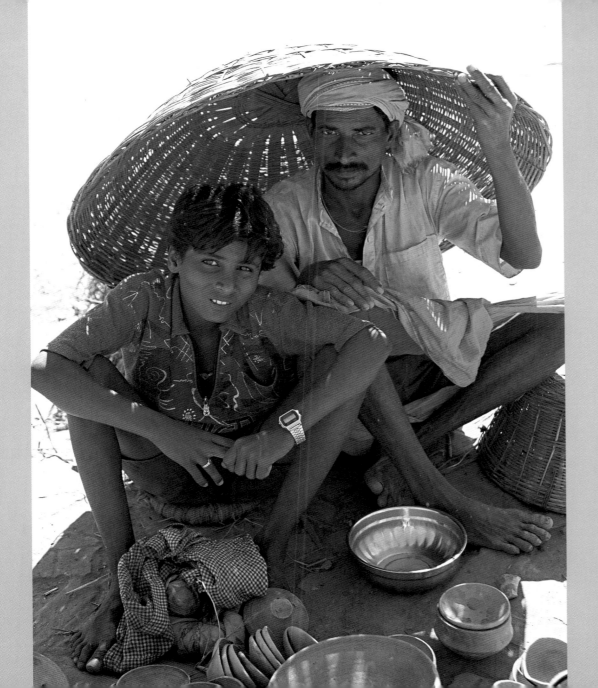

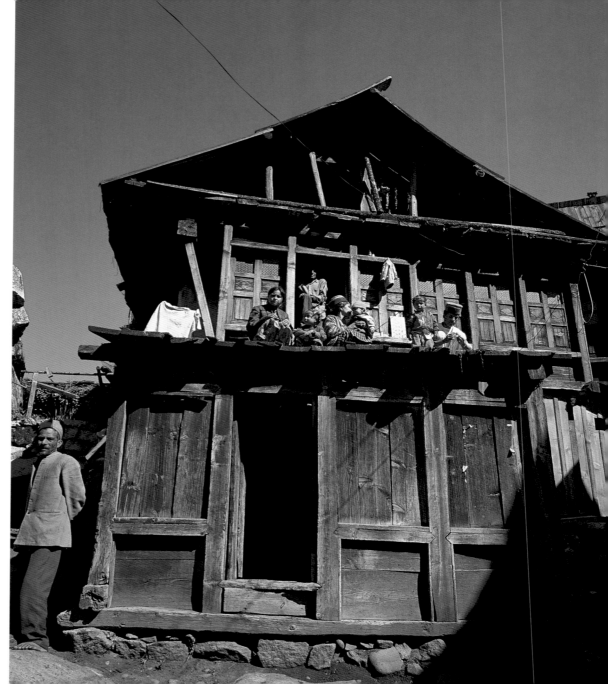

Kinnaur, INDIA

REST

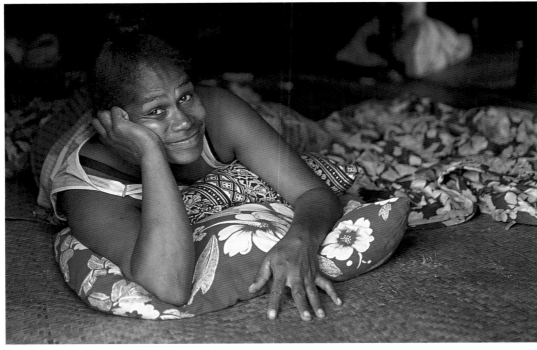

IRELAND

NEW CALEDONIA

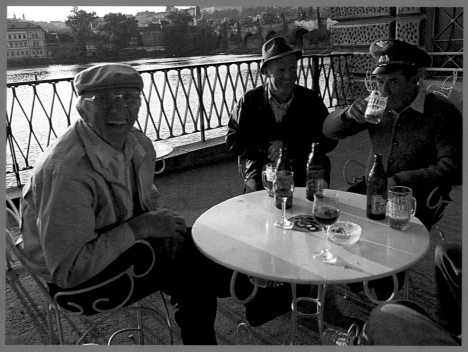

Prague, CZECH REPUBLIC

Santorini, GREECE

Lisbon, PORTUGAL

Rest is not idleness, and to lie sometimes on the grass on a summer day listening to the murmur of water, or watching the clouds float across the sky, is hardly a waste of time.
Sir John Lubbock

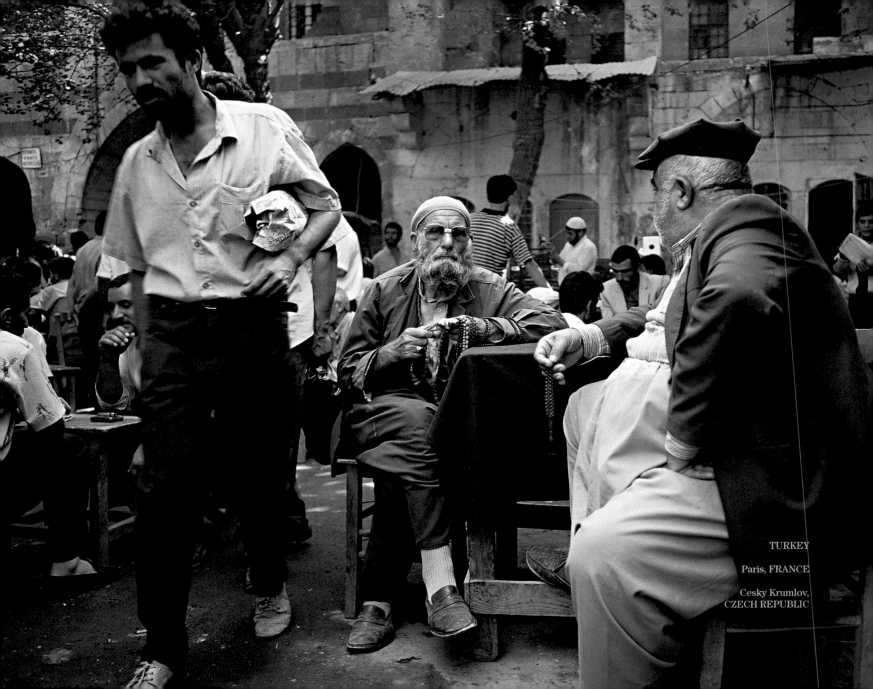

TURKEY

Paris, FRANCE

Cesky Krumlov,
CZECH REPUBLIC

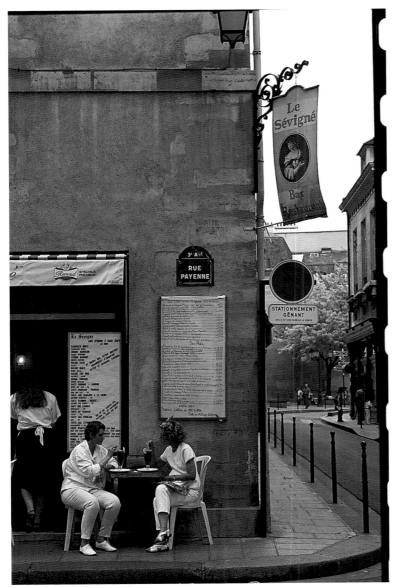

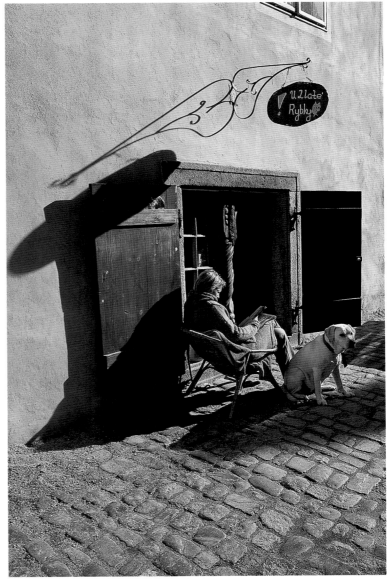

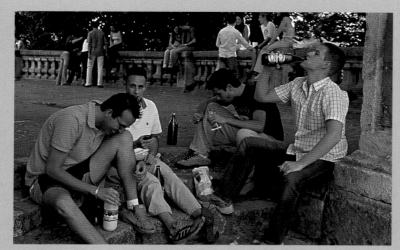

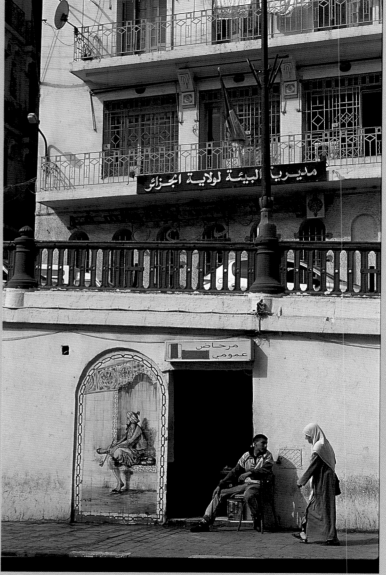

SPAIN

Alger, ALGERIA

Sometimes the most important thing in a whole day is the rest we take between two deep breaths...
Etty Hillesum

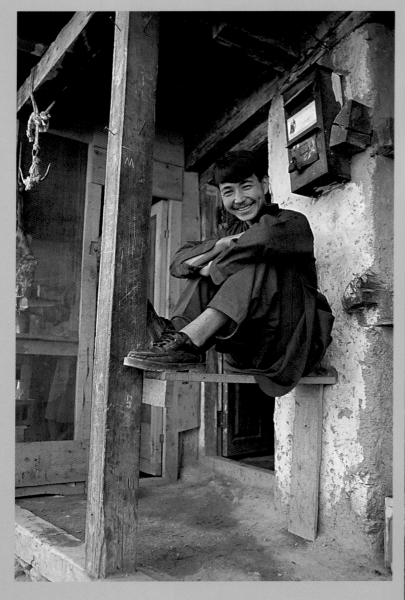

HUMANKIND

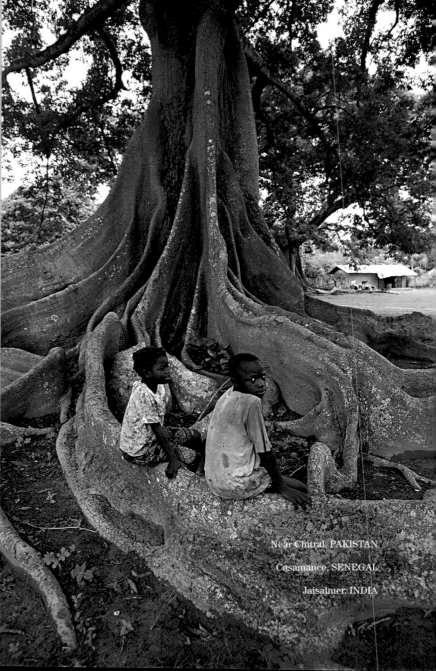

Near Chitral, PAKISTAN

Casamance, SENEGAL

Jaisalmer, INDIA

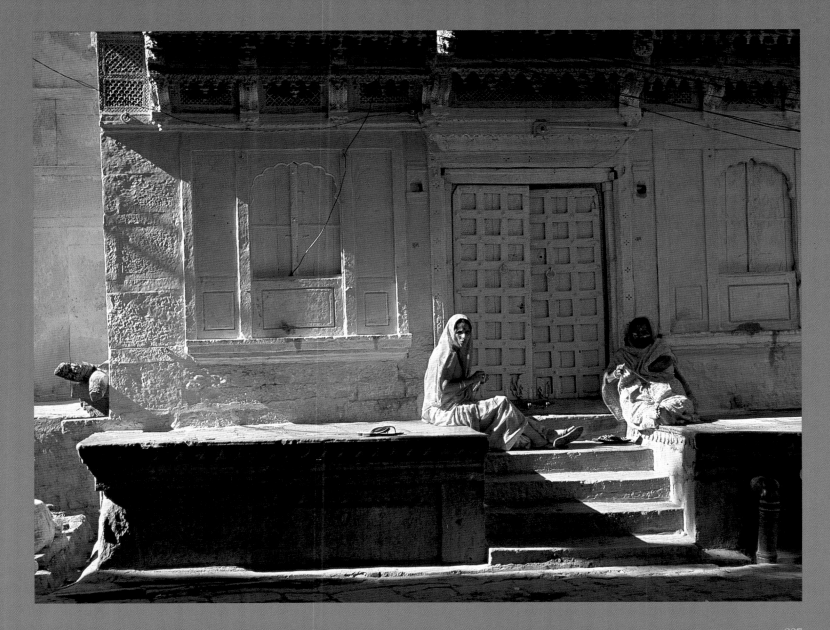

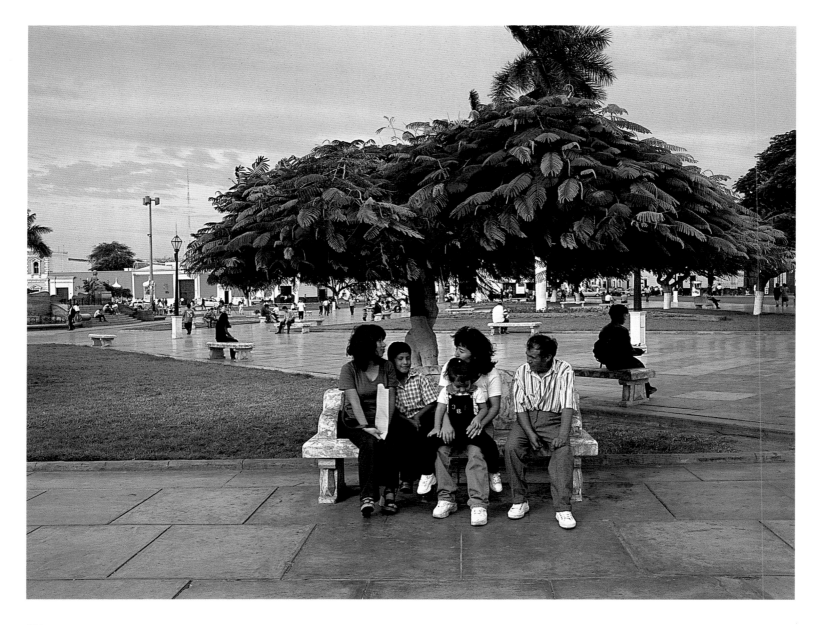

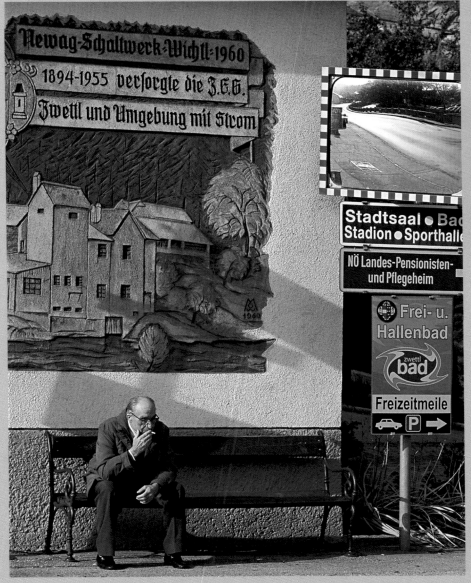

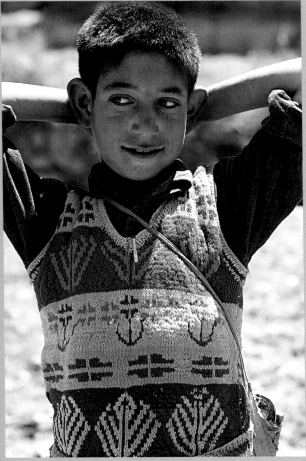

Trujillo, PERU

Zwettl, AUSTRIA

PAKISTAN

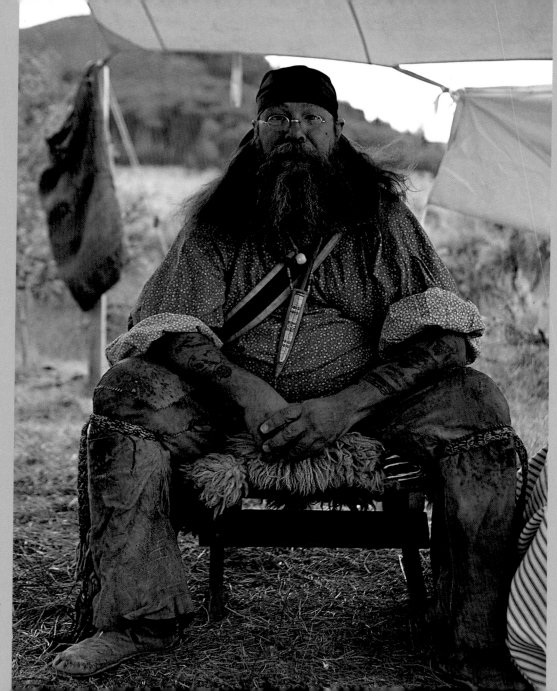

HUMANKIND

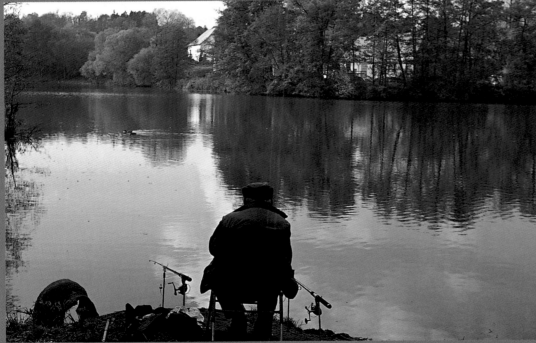

Michoacan, MEXICO

Jindrichüv Hradec,
CZECH REPUBLIC

"Never a day passes but that I do myself the honor to commune with some of nature's varied forms."

George Washington Carver

GHANA

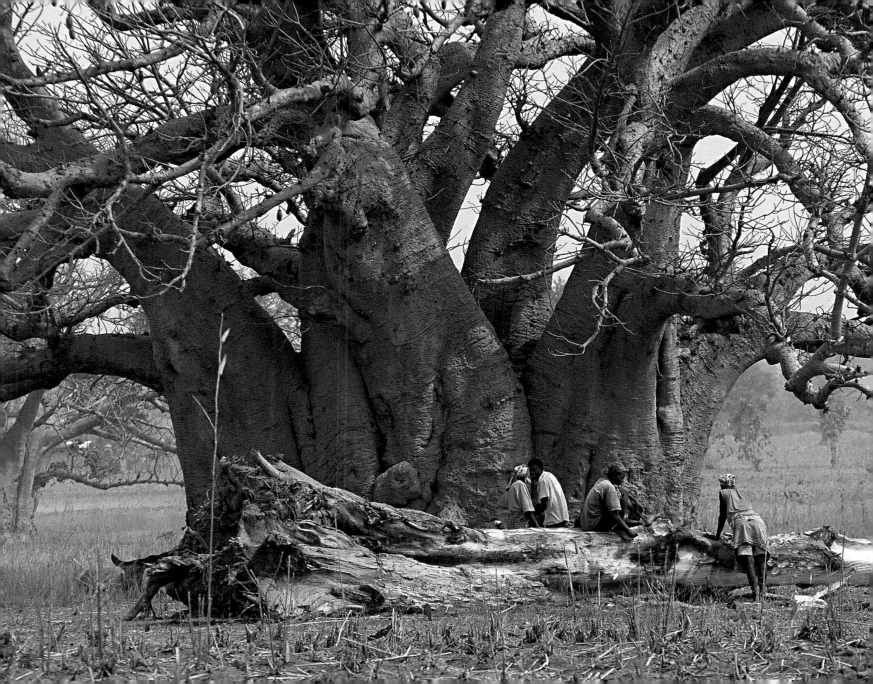

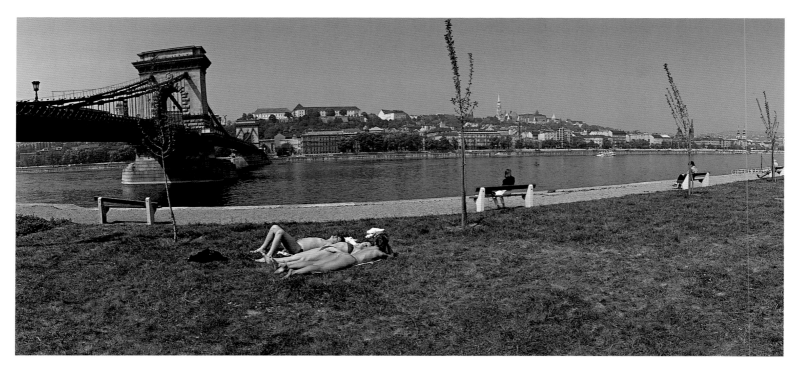

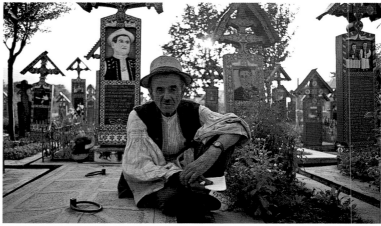

Budapest, HUNGARY

Maramures, ROMANIA

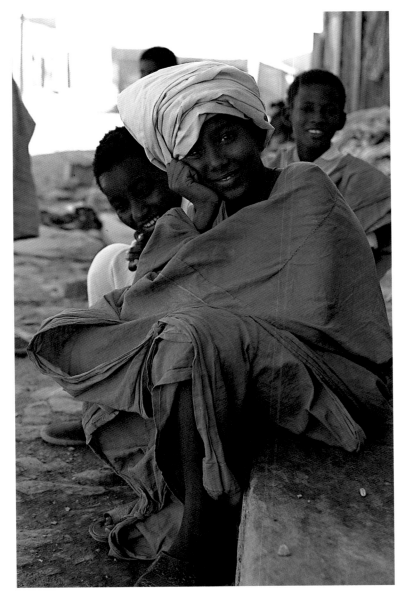

MAURITANIA

REST

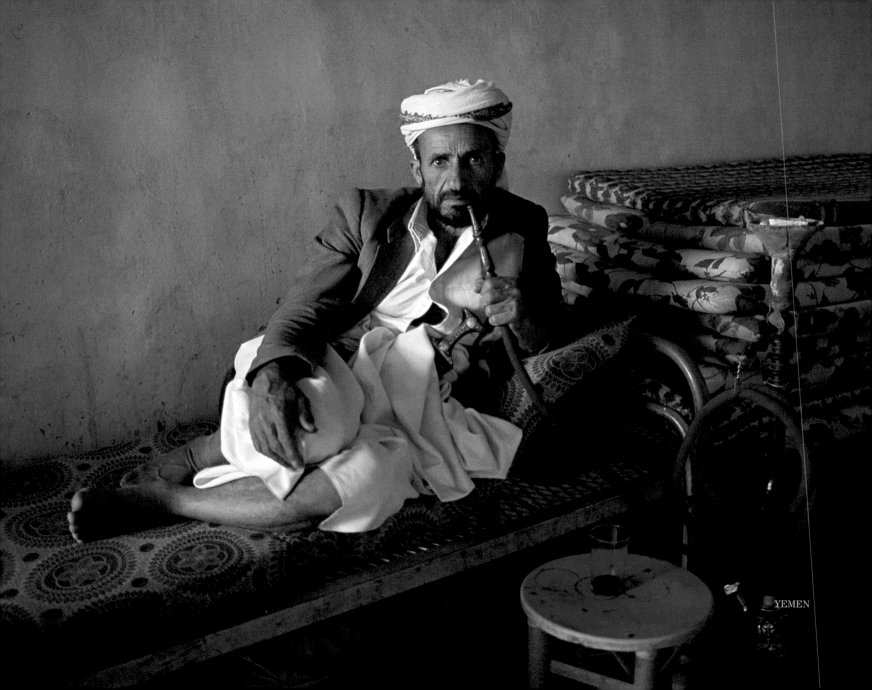

YEMEN

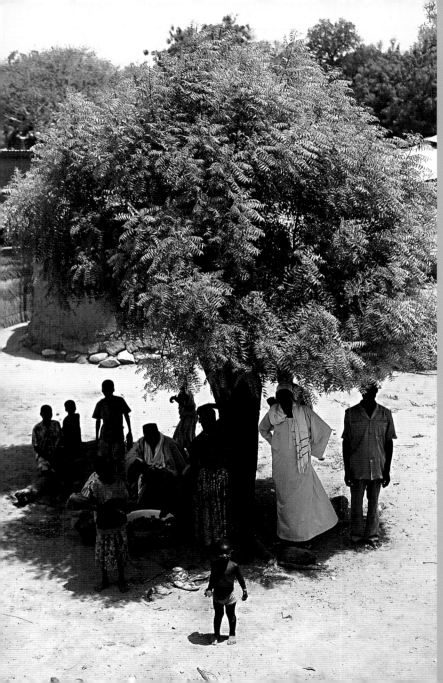

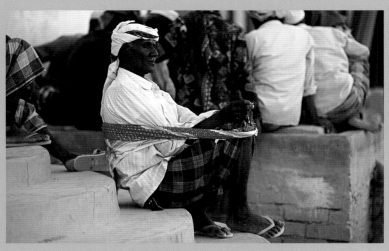

CHAD

YEMEN

Climb the mountains and get their good tidings. Nature's peace will flow into you as sunshine flows into trees. The winds will blow their own freshness into you... while cares will drop off like autumn leaves.

John Muir

Arizona, UNITED STATES

UNITED STATES

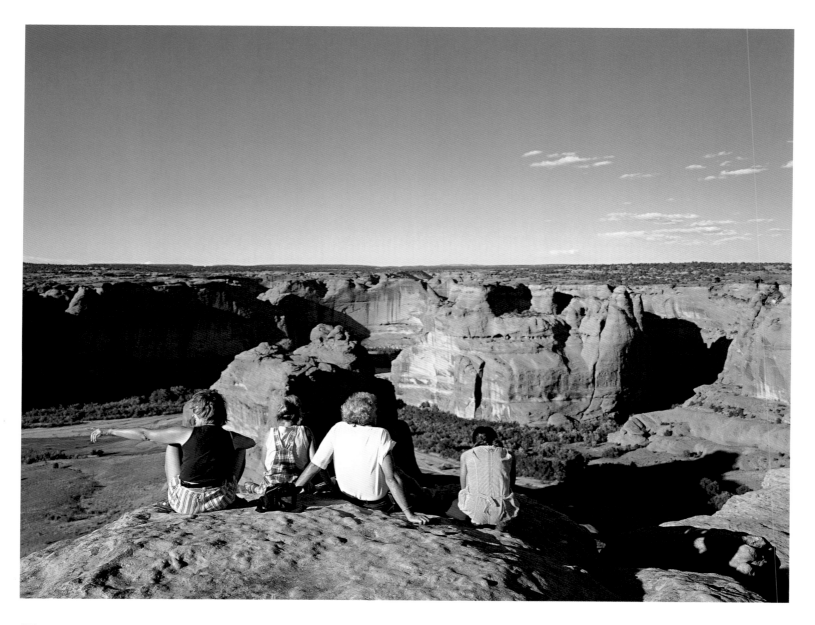

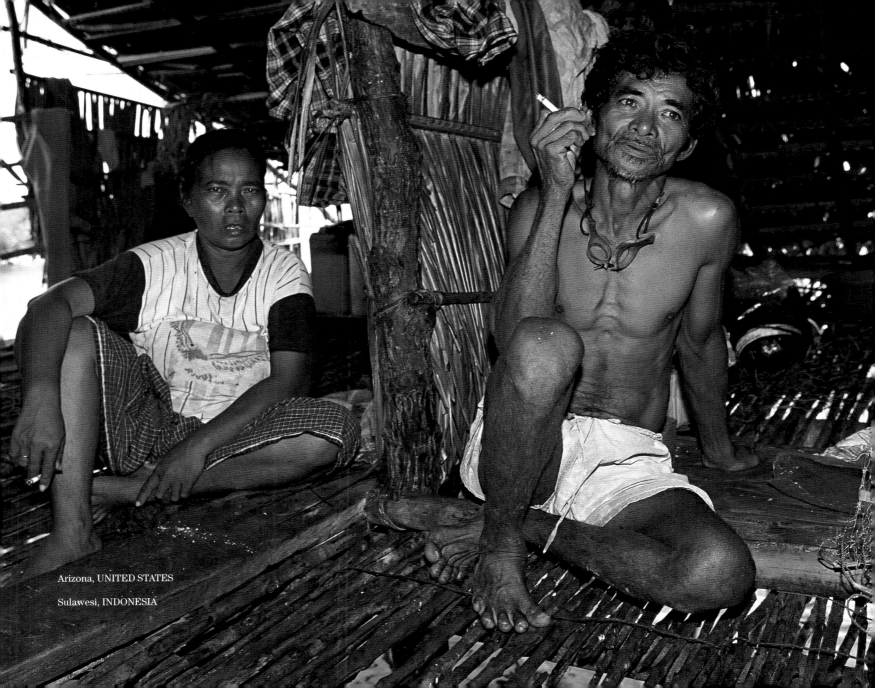

Arizona, UNITED STATES

Sulawesi, INDONESIA

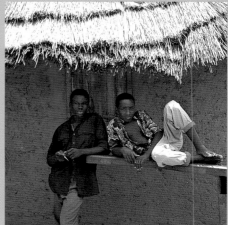

New York, UNITED STATES

Niamtougou, TOGO

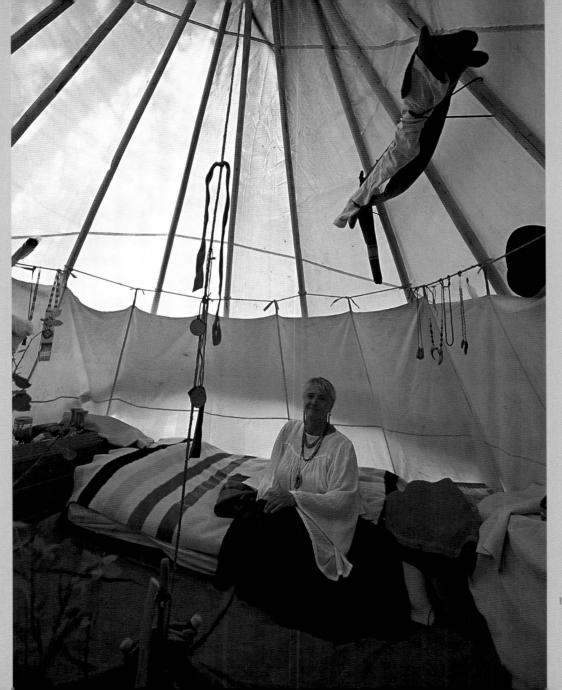

REST

UNITED STATES

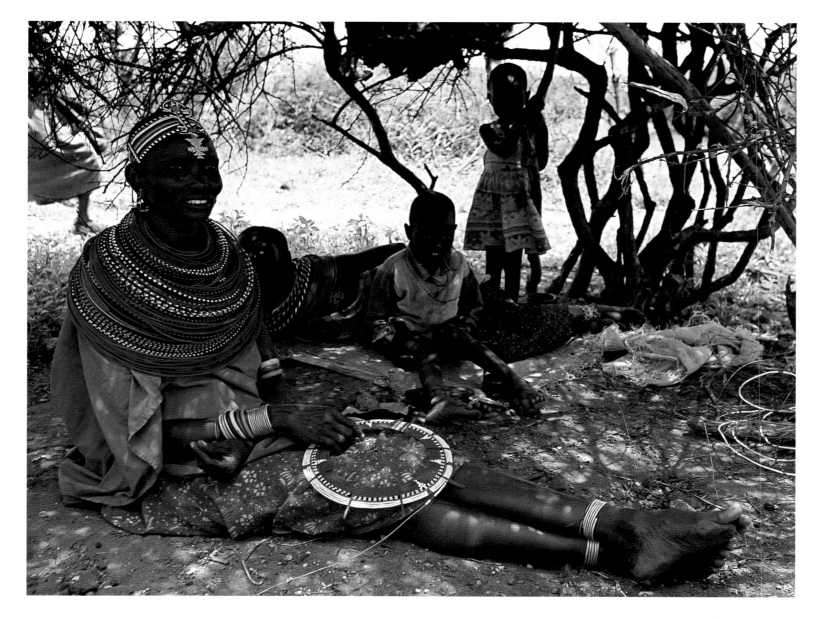

HUMANKIND

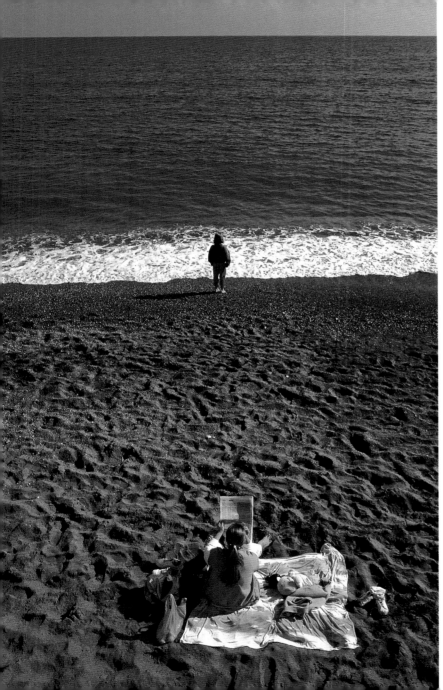

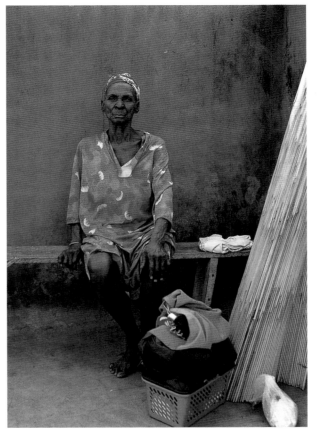

KENYA

SPAIN

GHANA

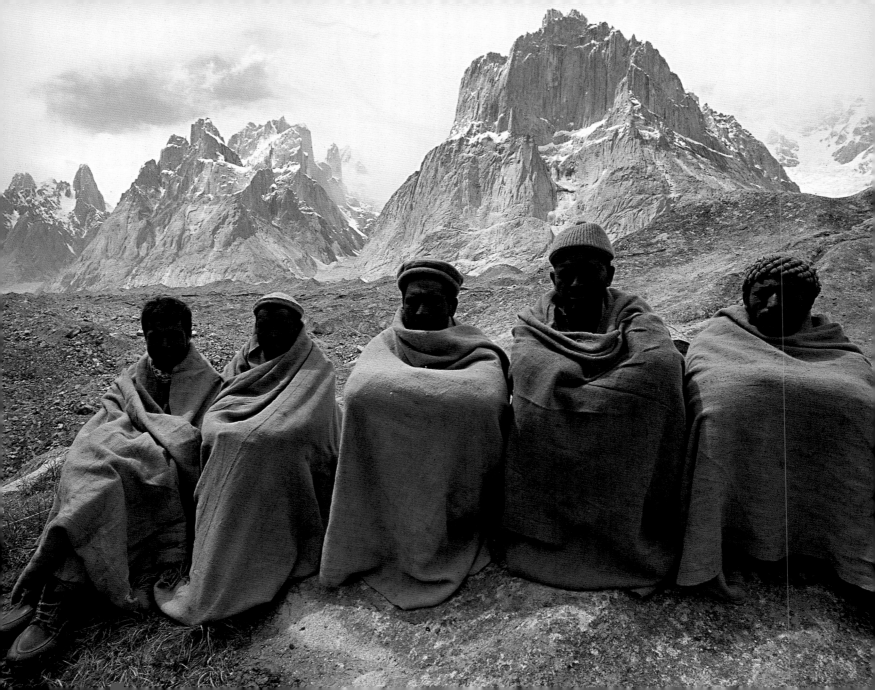

So shall thy rest strengthen thy labor, and so thy labor sweeten thy rest.

Francis Quarles

Karakoram Himalaya,
PAKISTAN

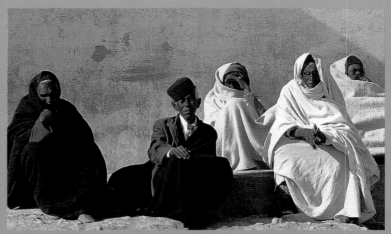

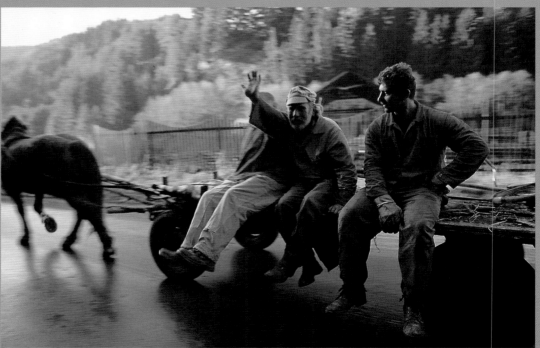

TUNISIA

SLOVAKIA

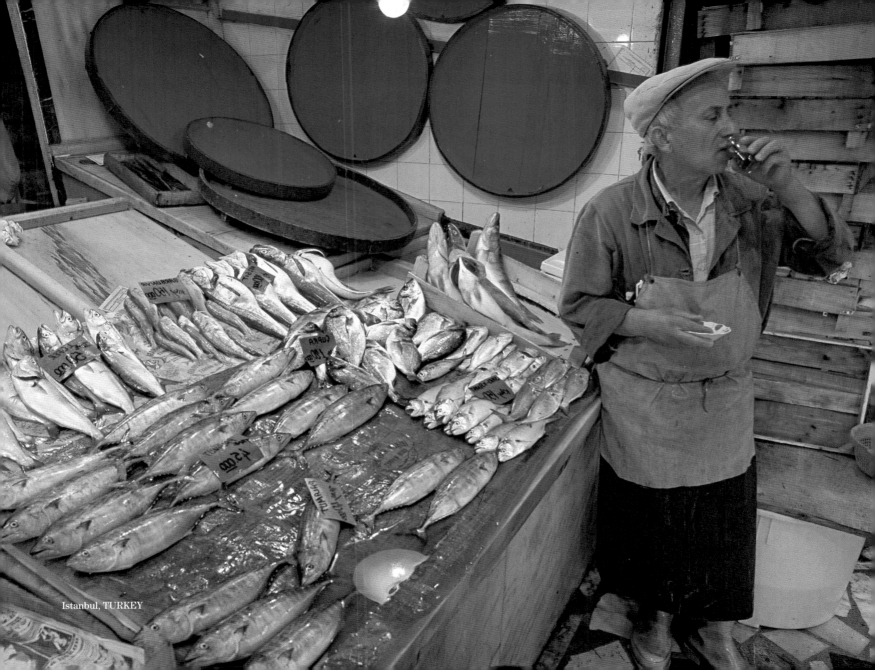

Istanbul, TURKEY

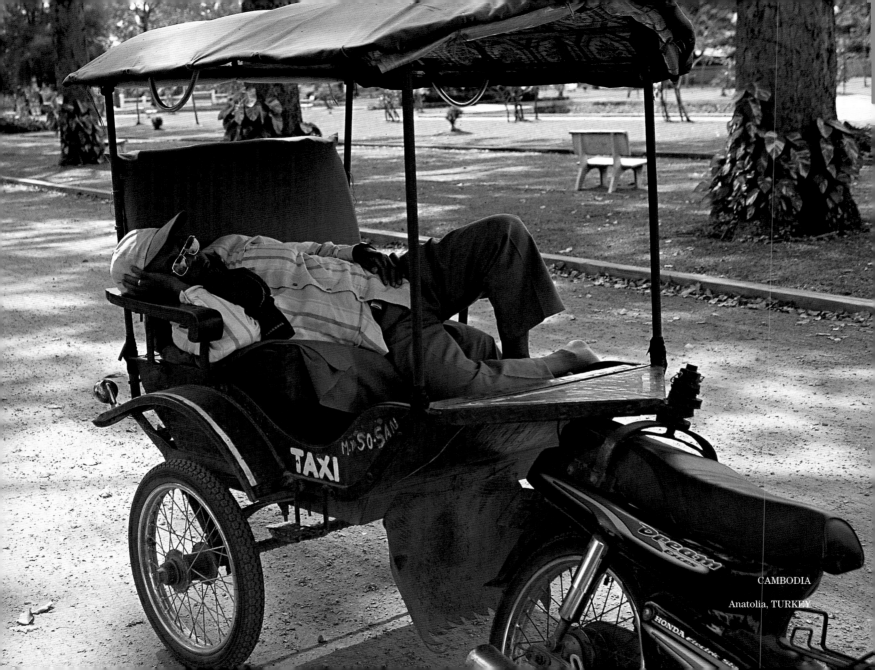

CAMBODIA

Anatolia, TURKEY

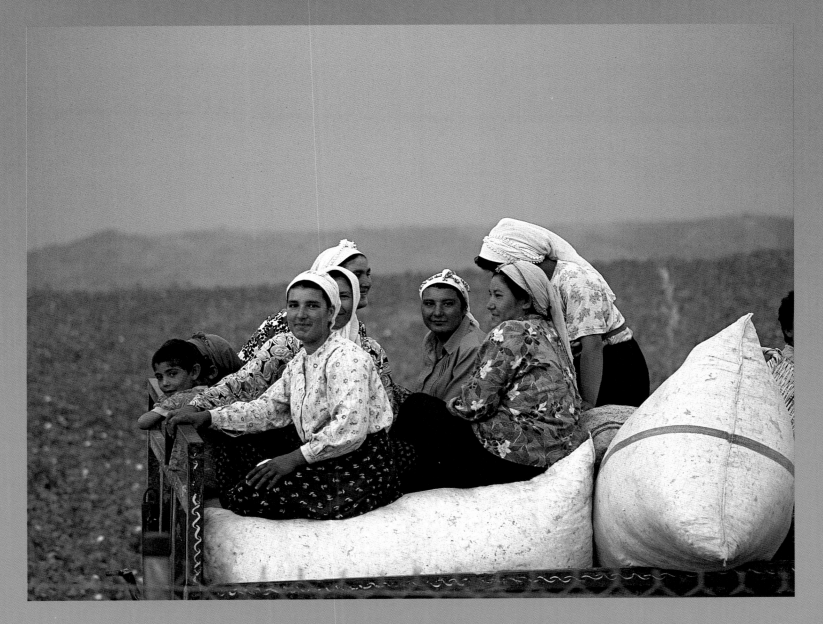

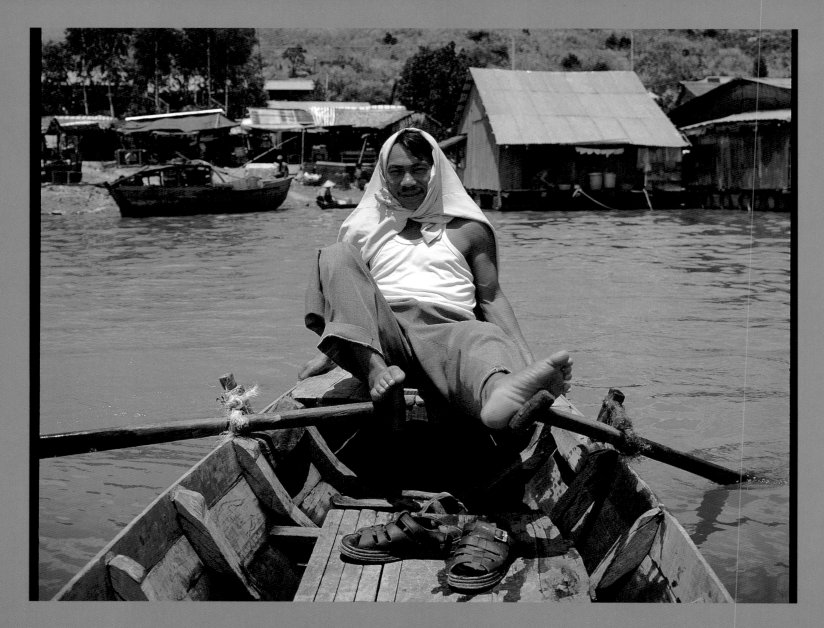

REST

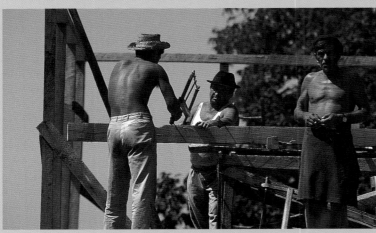

VIETNAM

Near Donegal, IRELAND

Transylvania, ROMANIA

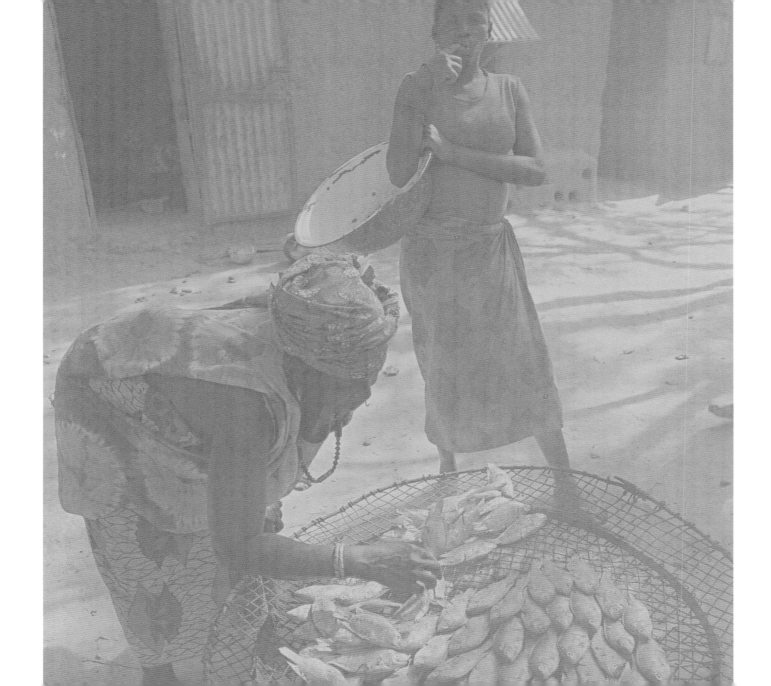

NEED

Need is the culmination of who we are as tenants on earth. Physical needs make us all alike, and the innermost needs of the soul connect us.

Every day on our emotional journey, we face the choice of whether to feed the souls of those around us or continue to selfishly overeat. Our emotional journey together fuels the world need to create positive change, reach understandings, and solve problems.

As individuals we are one. Together we are Humankind.

Here is bread, which strengthens man's heart, and therefore called the staff of life.
Matthew Henry

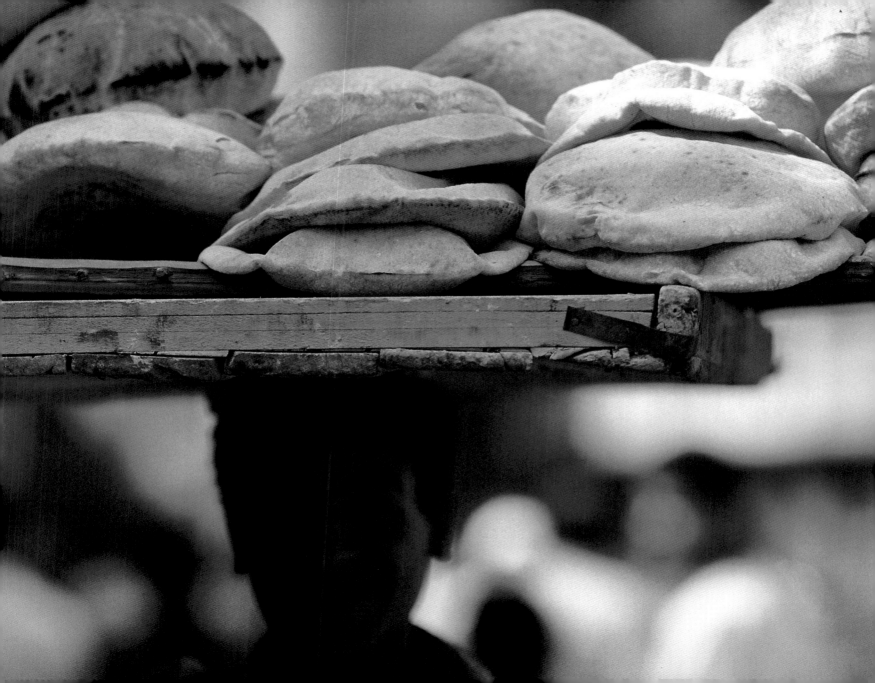

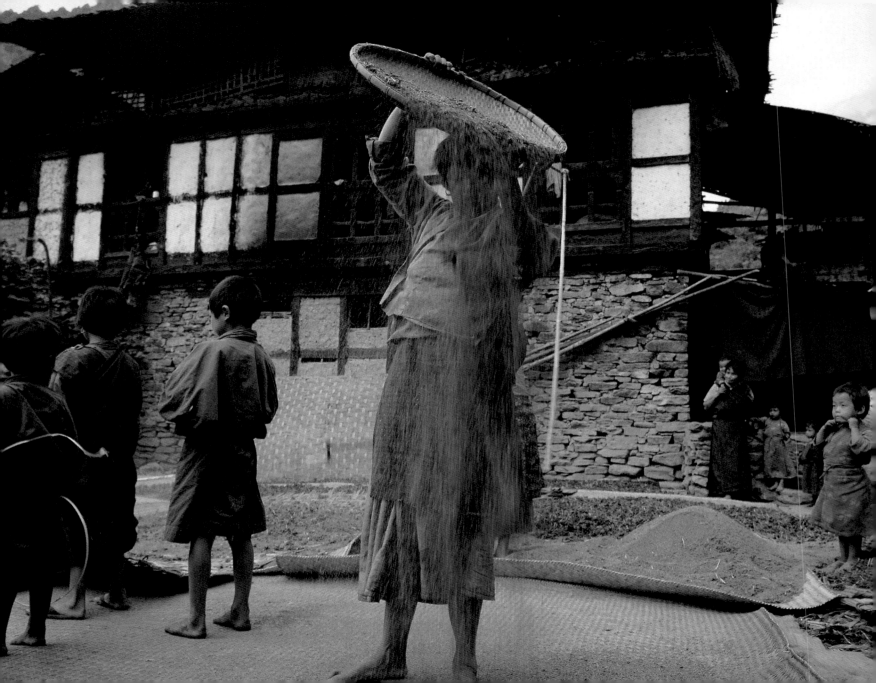

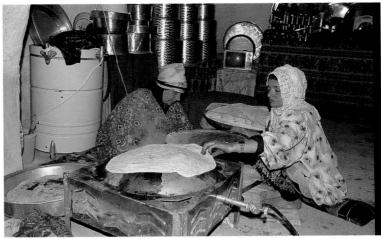

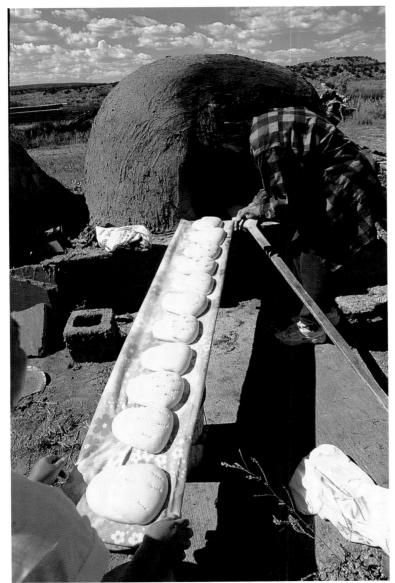

BHUTAN

UNITED STATES

SYRIA

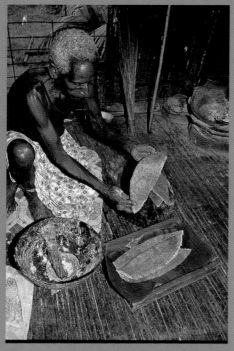

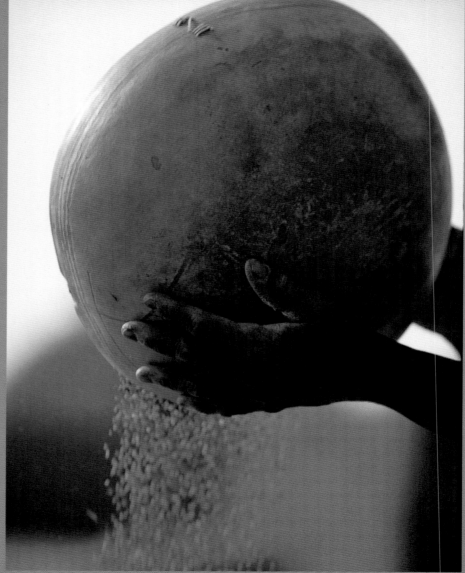

PAPUA NEW GUINEA

BURKINA FASO

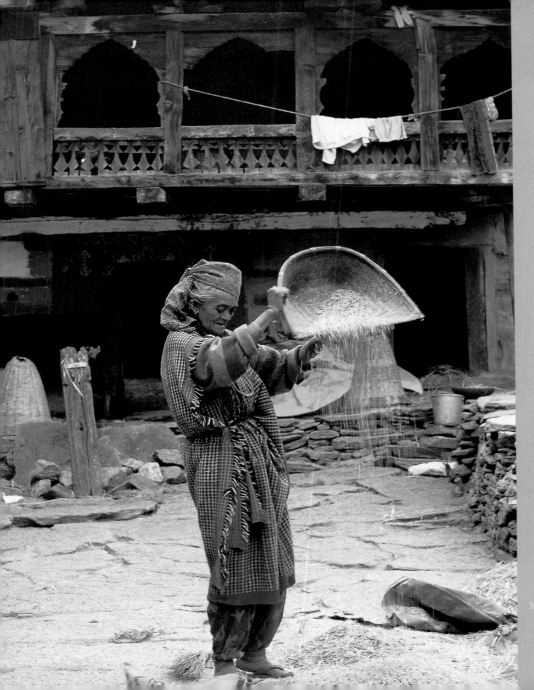

Manali, INDIA

NEED

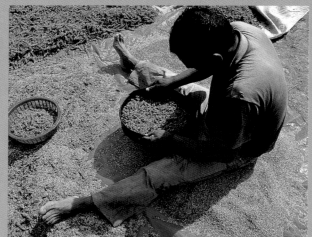

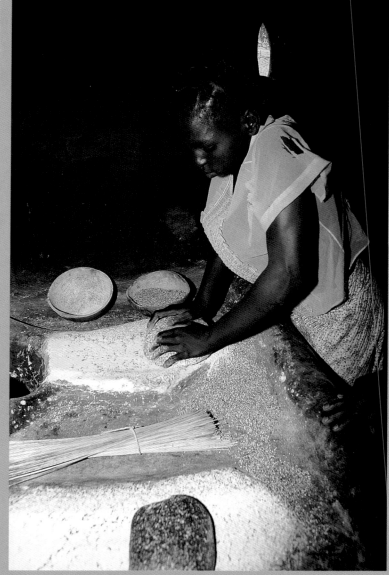

PERU

BURKINA FASO

In the sweat of thy face
shalt thou eat bread.
Genesis 3:19

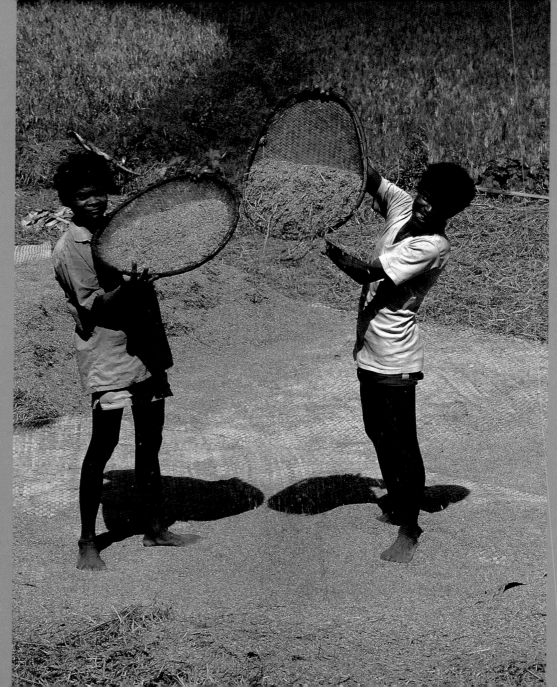

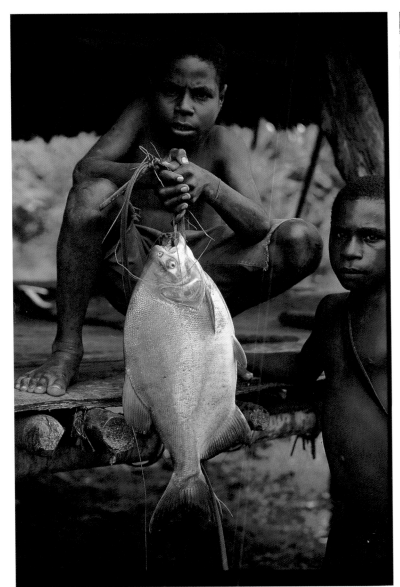

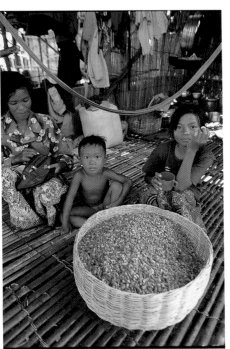

PAPUA NEW GUINEA

CAMBODIA

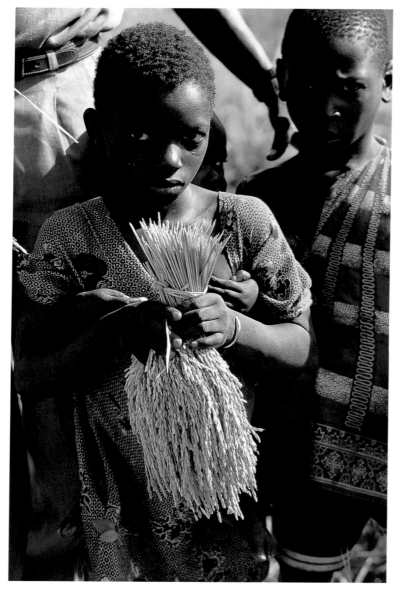

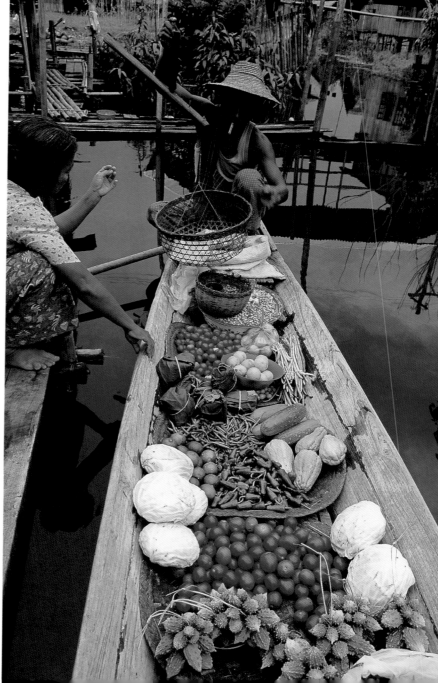

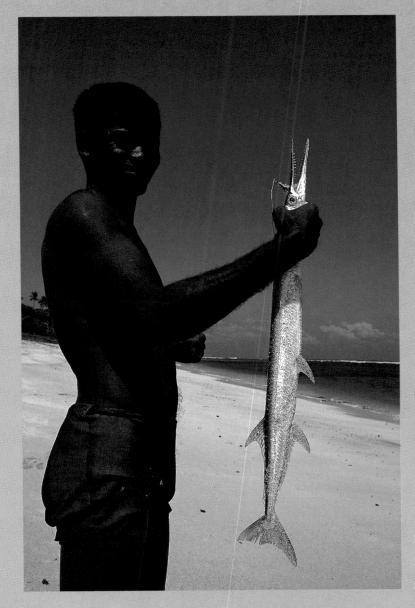

NEED

IVORY COAST

MYANMAR (formerly BURMA)

Sumba, INDONESIA

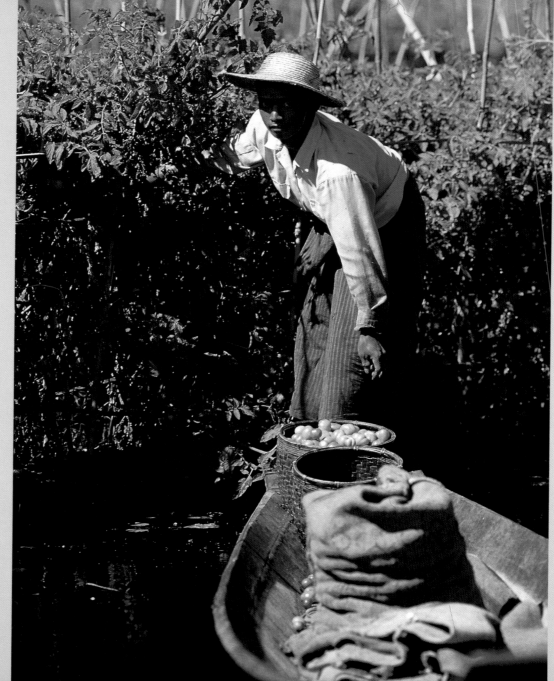

HUMANKIND

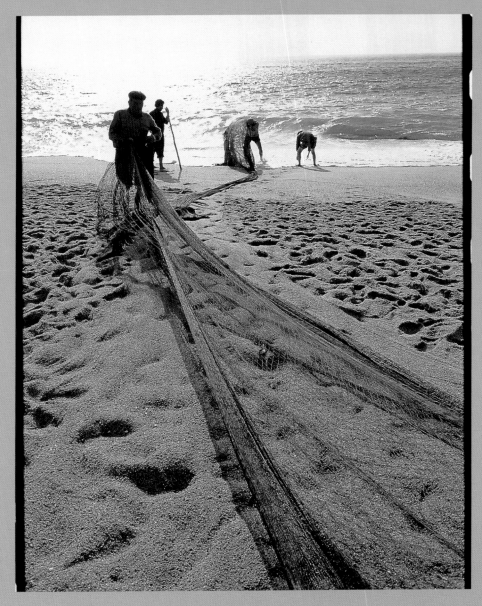

Nazare, PORTUGAL

He who comes first, eats first.
Eike von Repkow

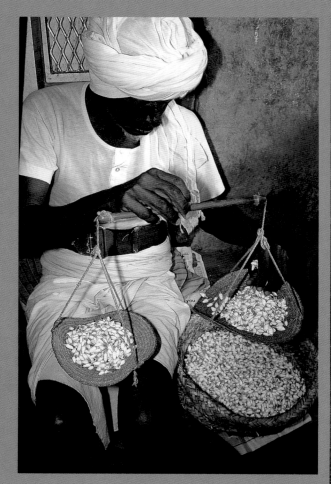

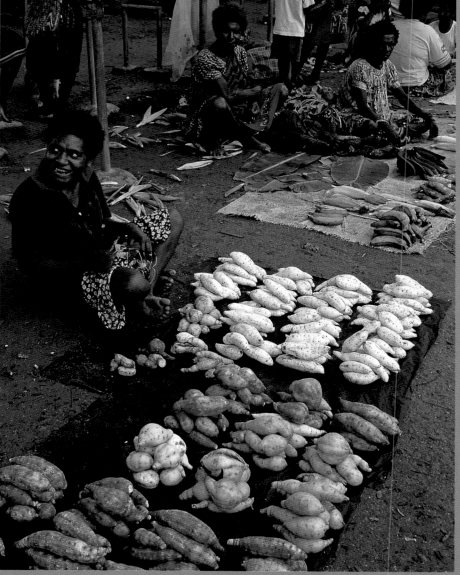

Bayt-al-Faqih, YEMEN

PAPUA NEW GUINEA

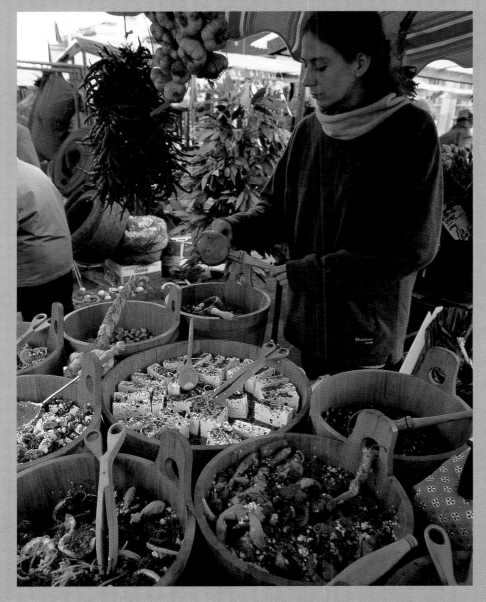

Moreton-in-Marsh, ENGLAND

NEED

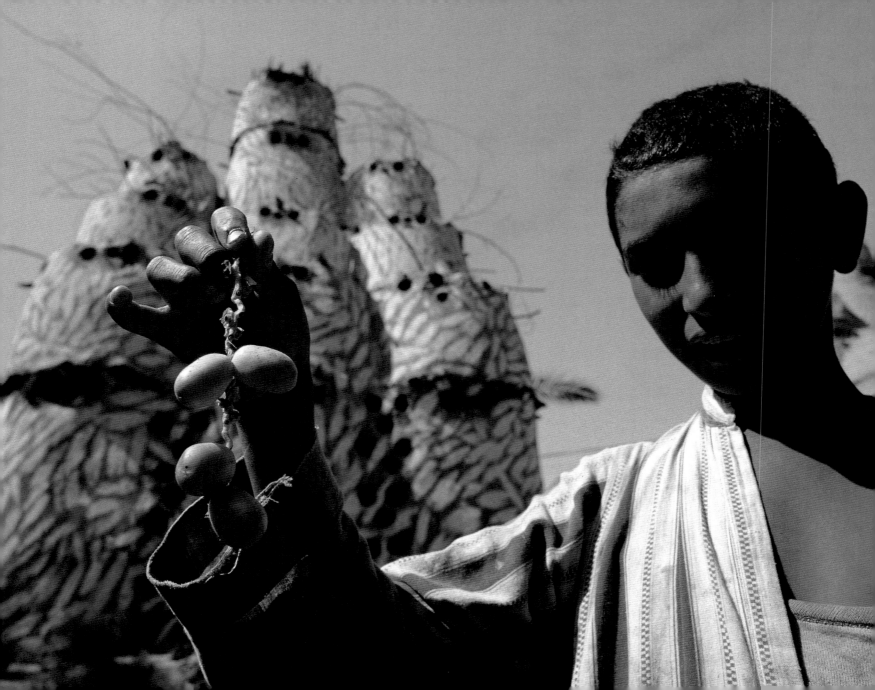

EYGPT

AUSTRIA

Tashkent, UZBEKISTAN

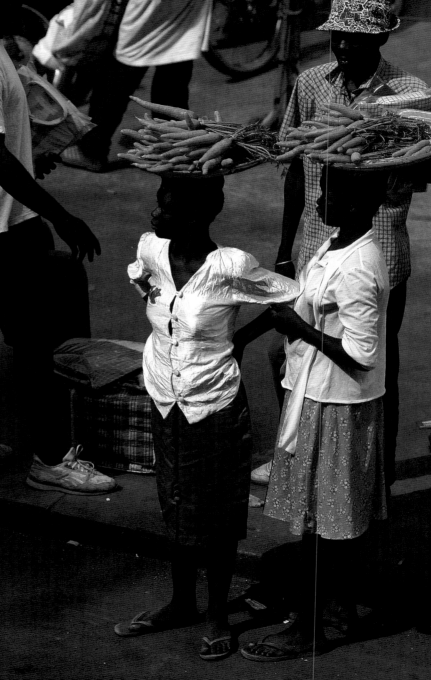

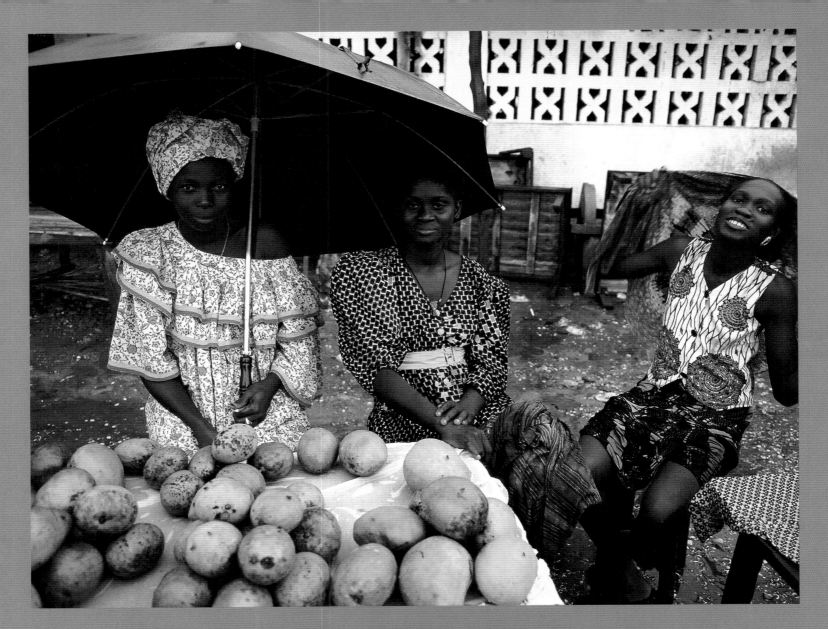

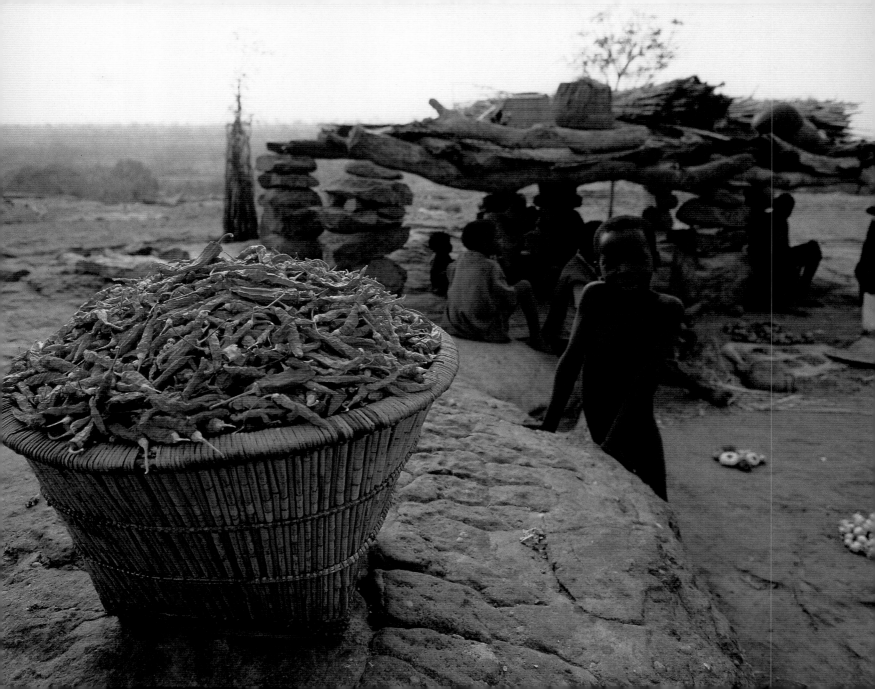

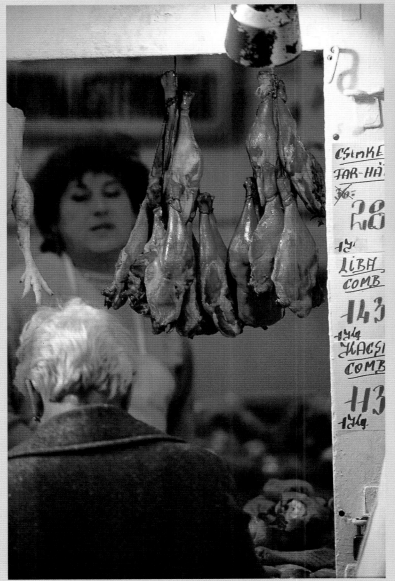

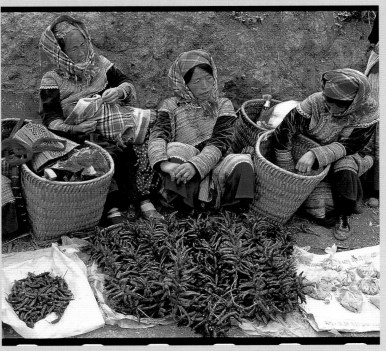

Djiguibombo, MALI

Budapest, HUNGARY

Northern VIETNAM

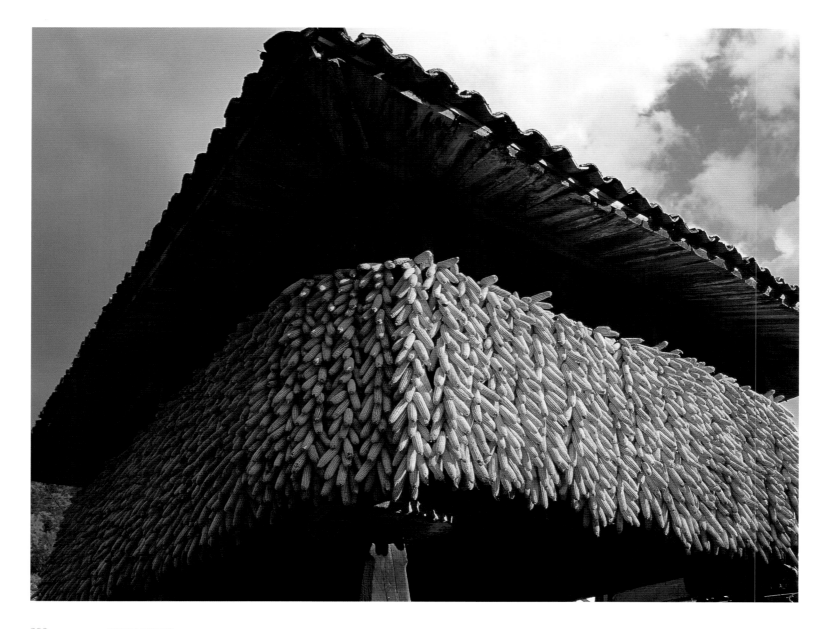

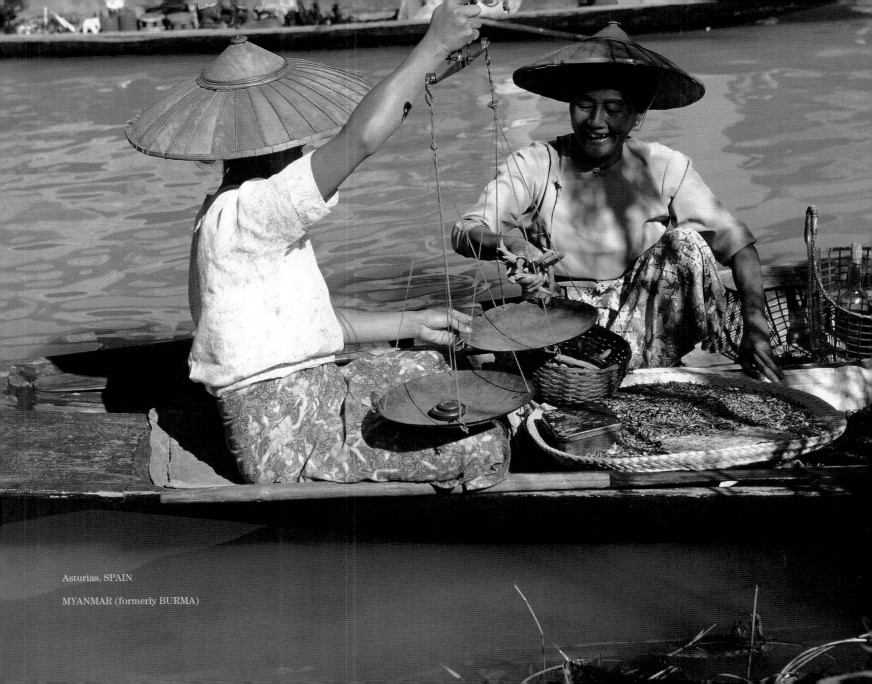

Asturias, SPAIN

MYANMAR (formerly BURMA)

To eat is a necessity…
La Rochefoucauld

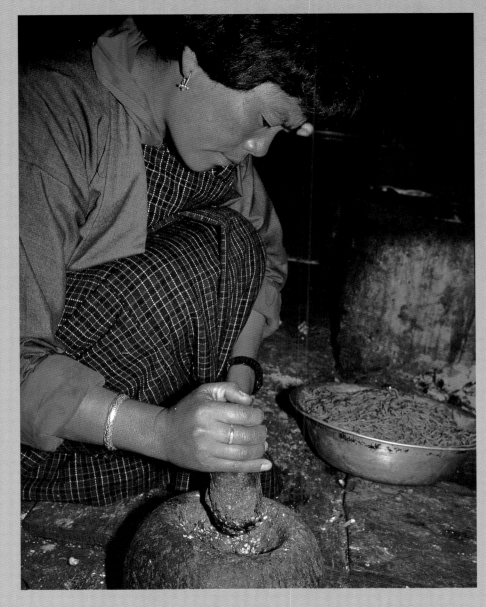

BHUTAN

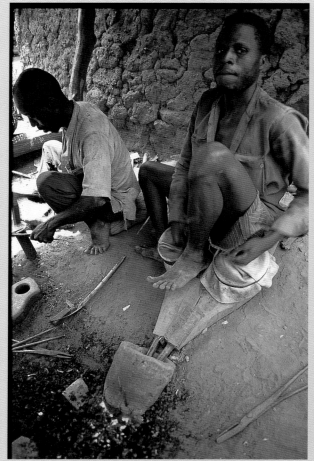

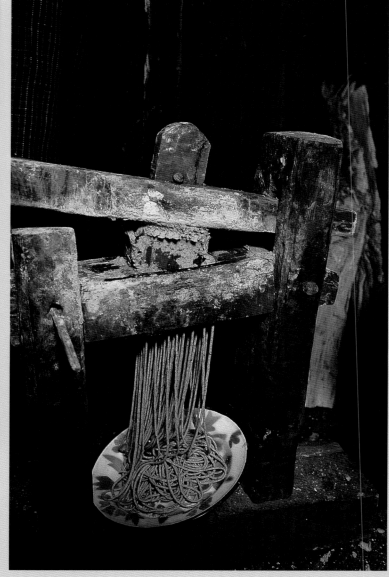

BURKINA FASO

BHUTAN

NIGER

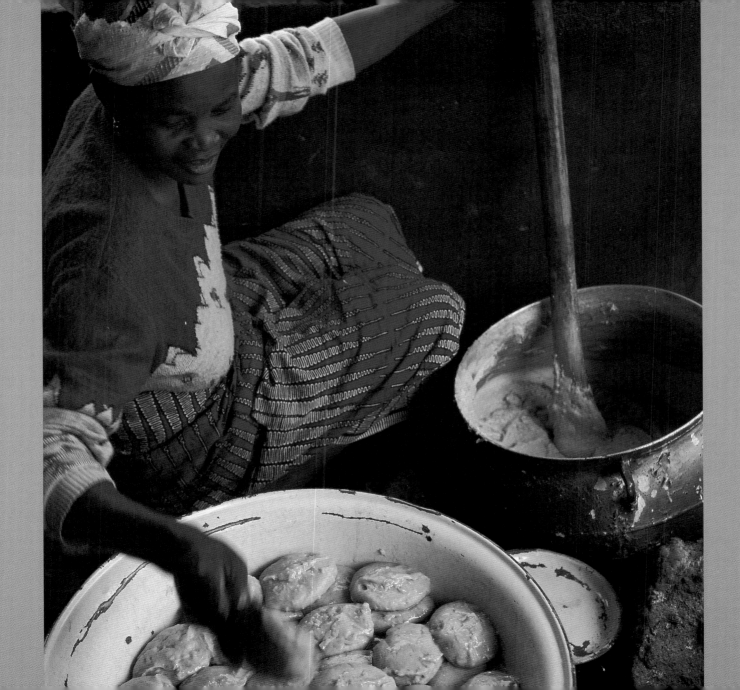

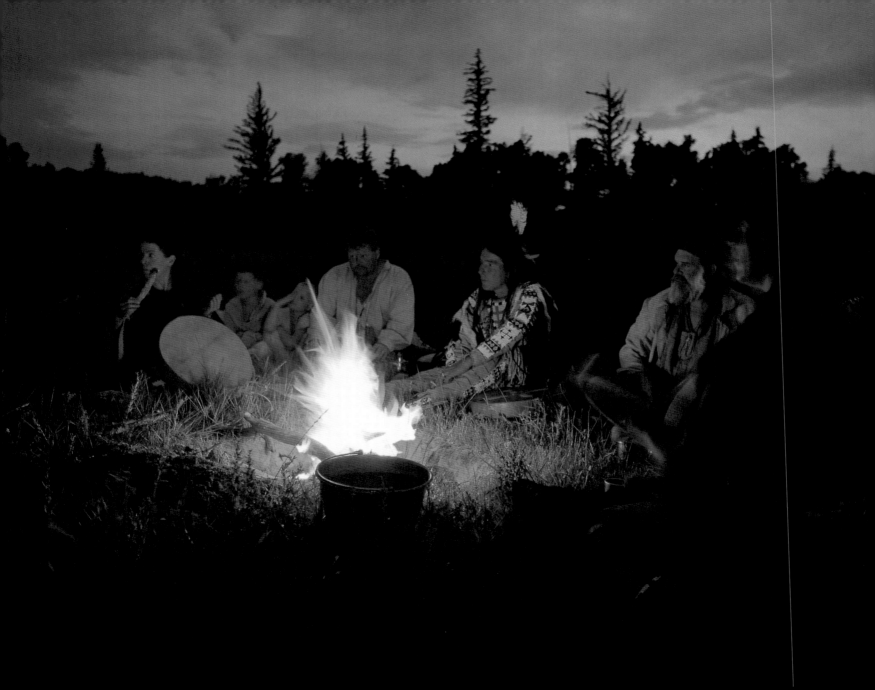

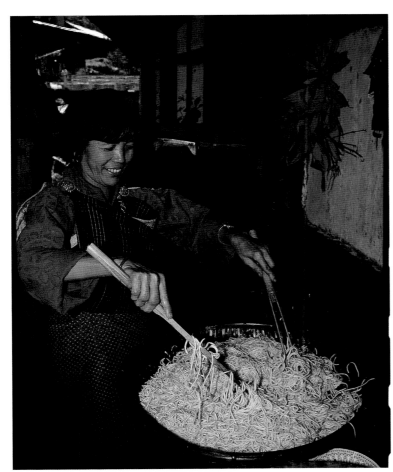

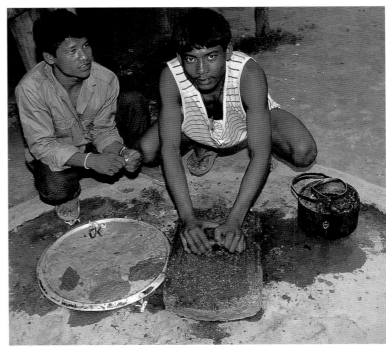

UNITED STATES

BHUTAN

NEPAL

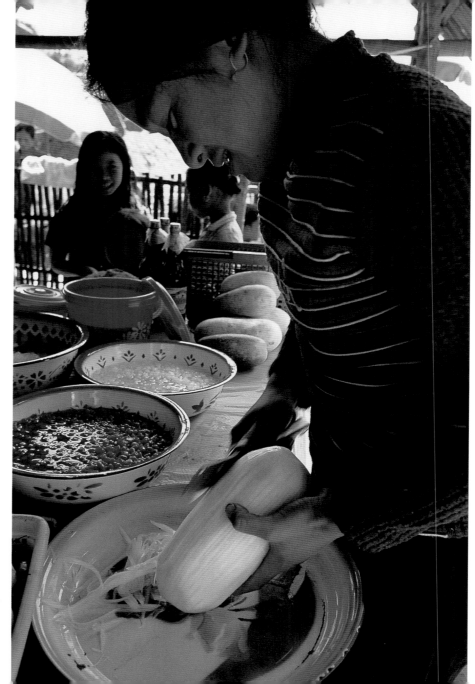

LAOS

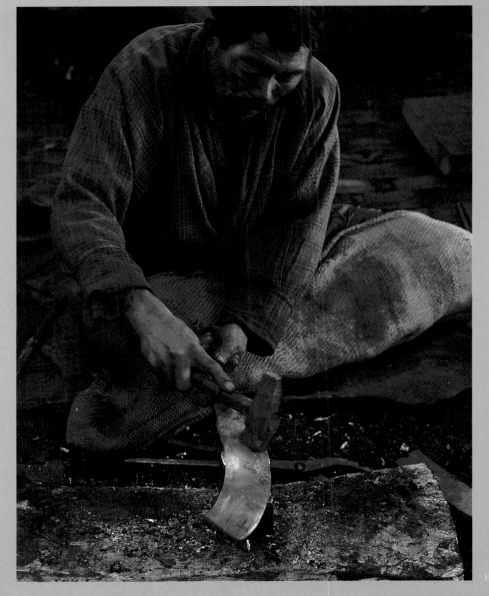

BHUTAN

NEED

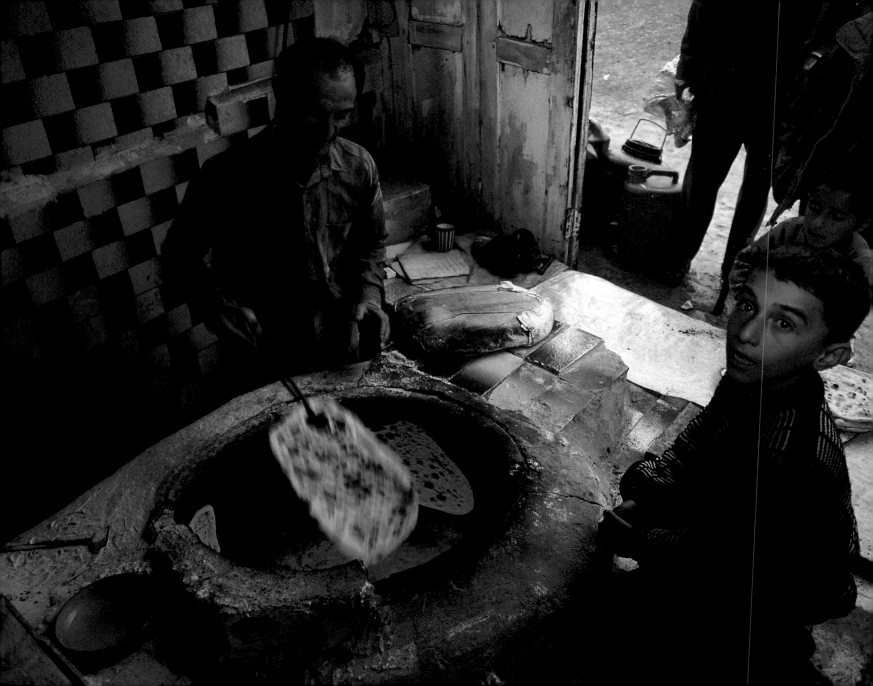

Food is our common ground, a universal experience.
James Beard

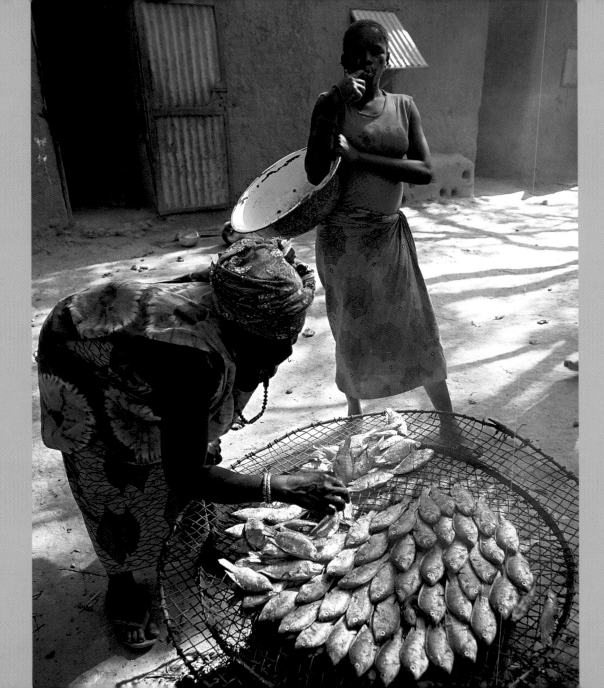

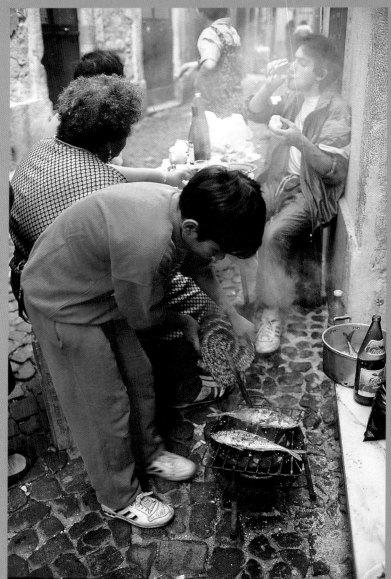

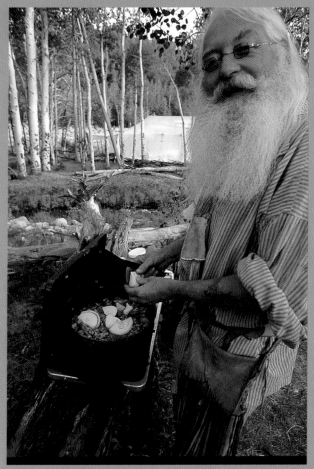

Mopti, MALI

Lisbon, PORTUGAL

UNITED STATES

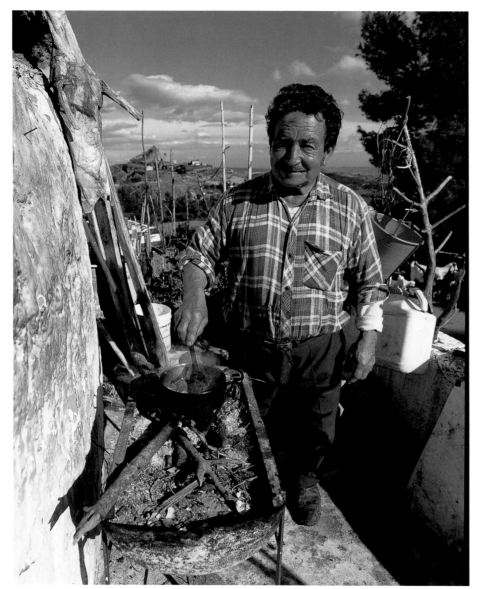

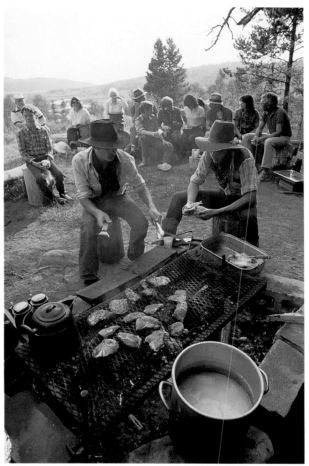

ITALY

UNITED STATES

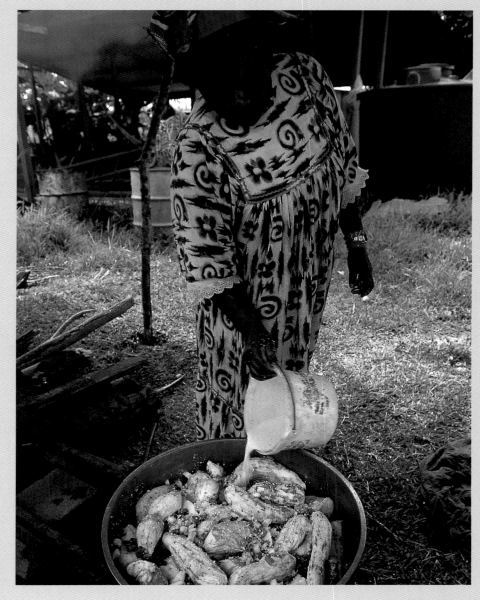

NEW CALEDONIA

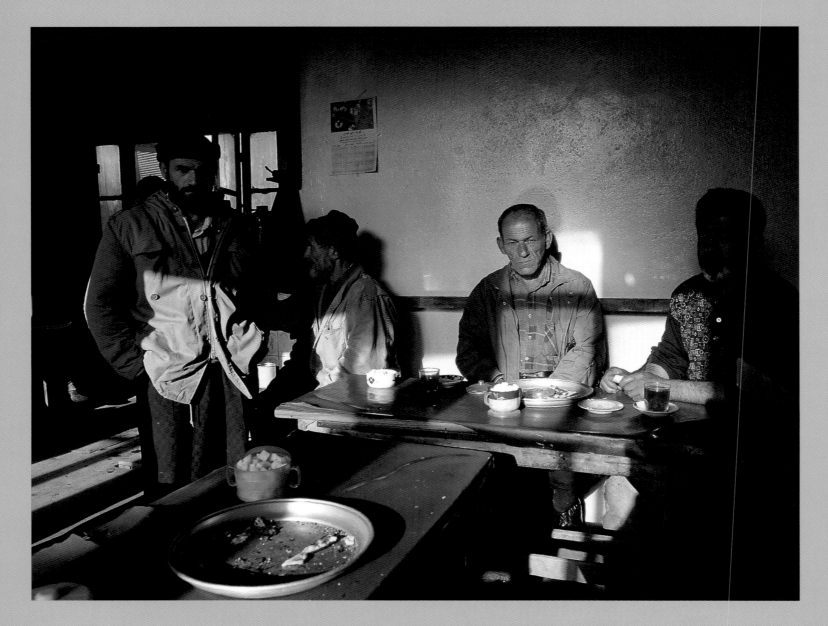

Nothing would be more tiresome than eating and drinking if God had not made them a pleasure as well as a necessity.
Voltaire

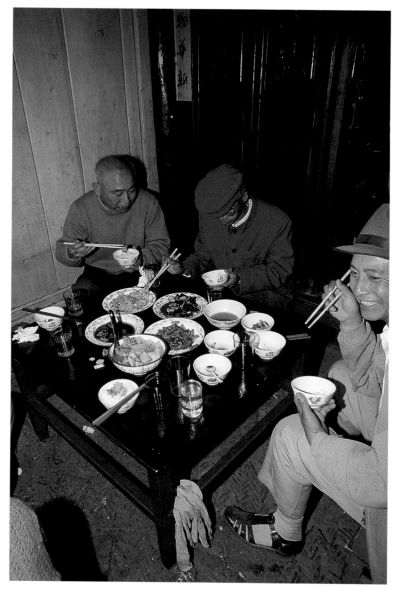

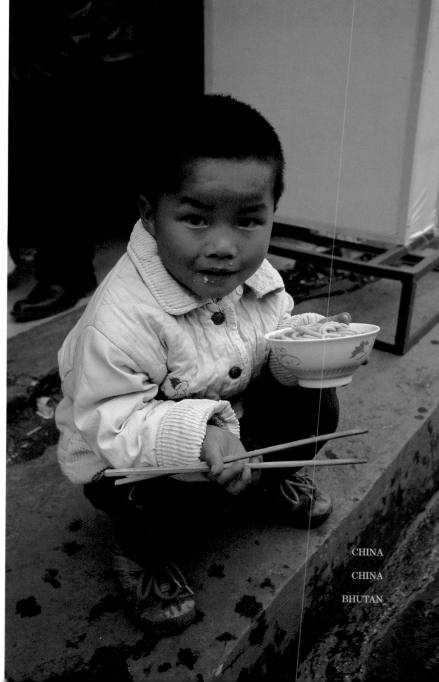

CHINA

CHINA

BHUTAN

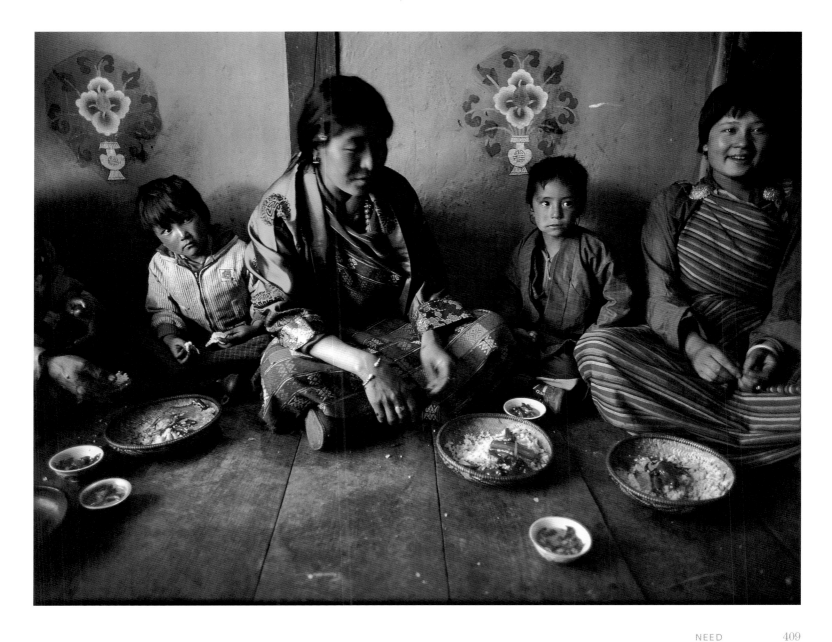

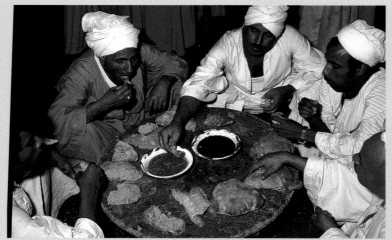

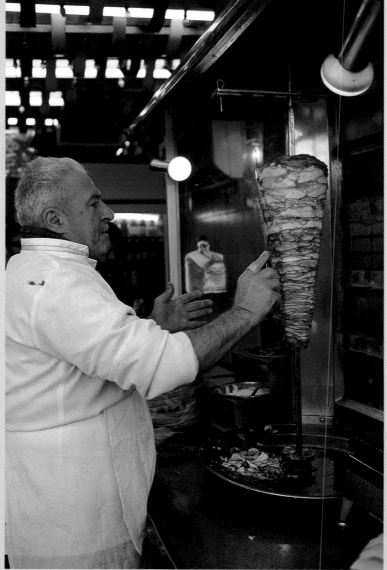

EGYPT

SYRIA

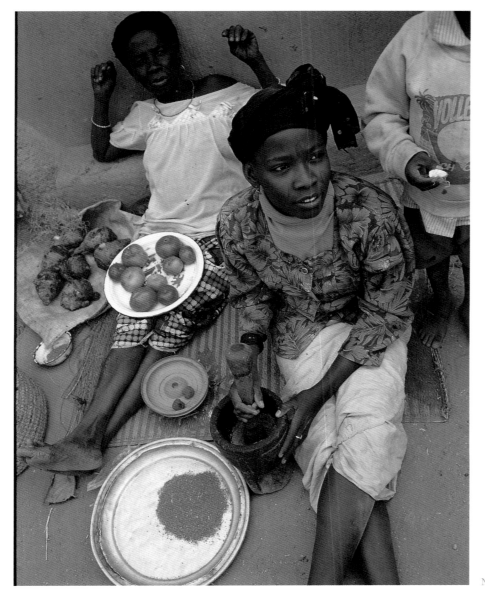

NIGER

NEED

Water is the best of all things.
Pindar

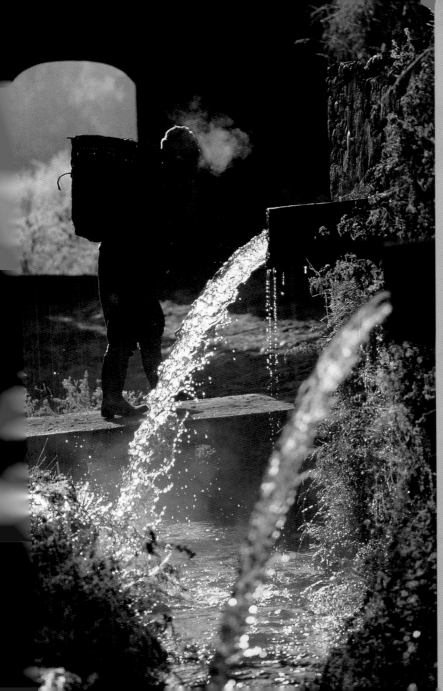
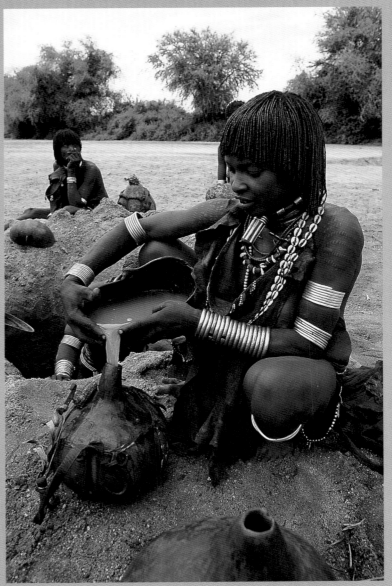

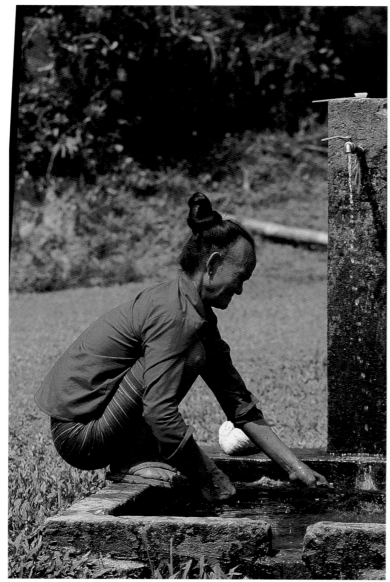

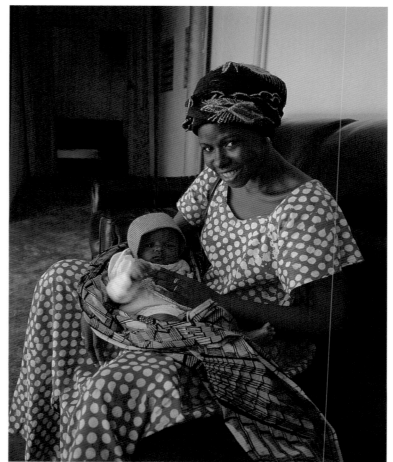

LAOS

BURKINA FASO

BHUTAN

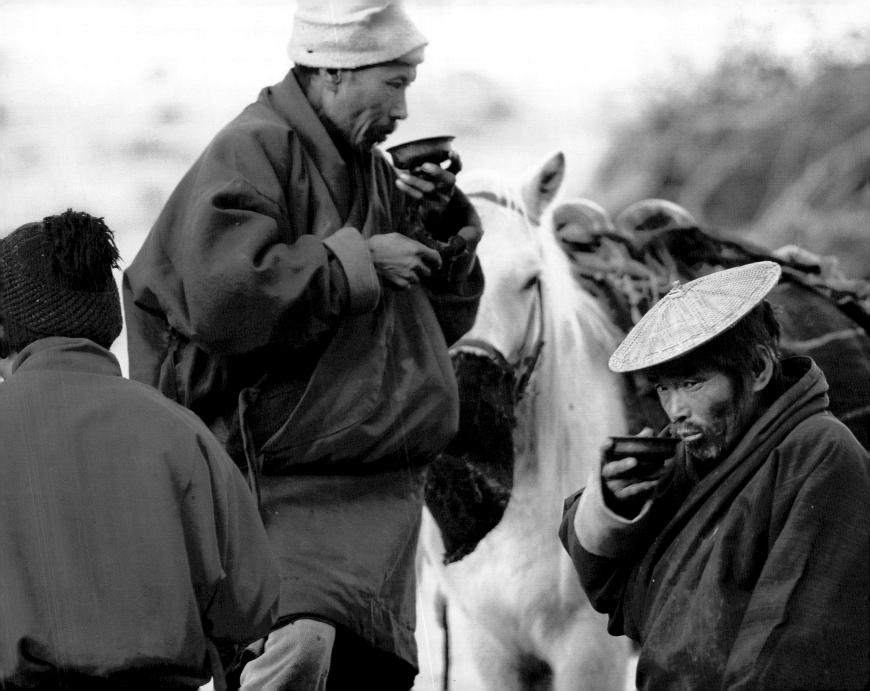

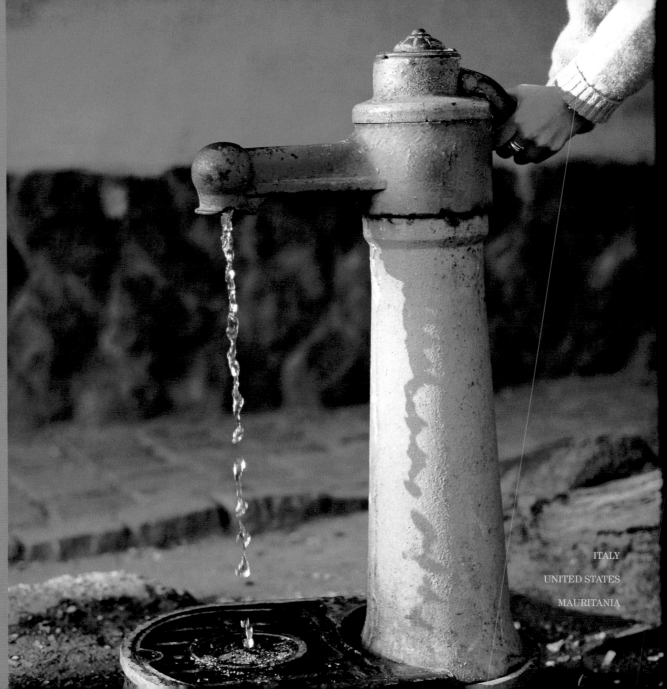

ITALY

UNITED STATES

MAURITANIA

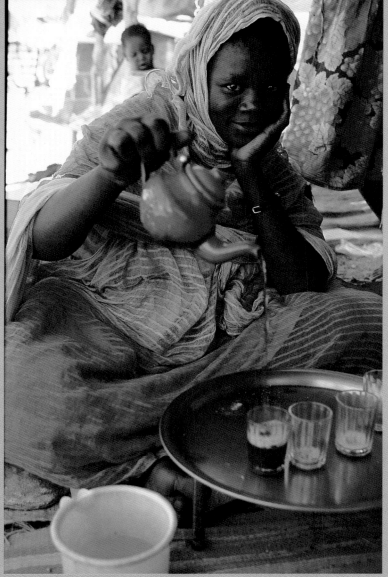

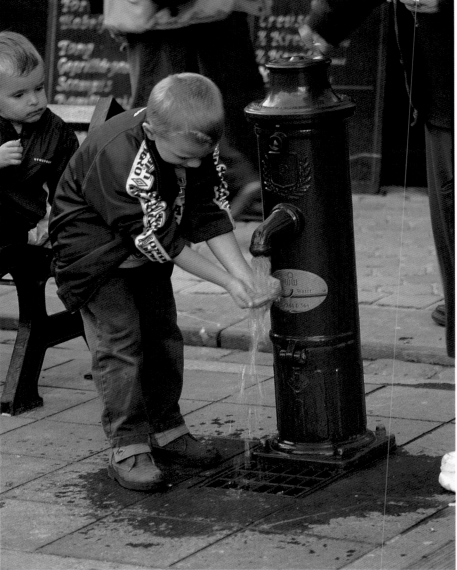

BELGIUM

BELGIUM

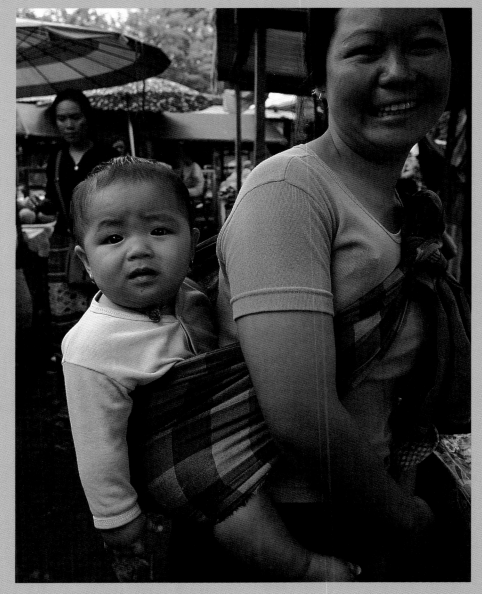

LAOS

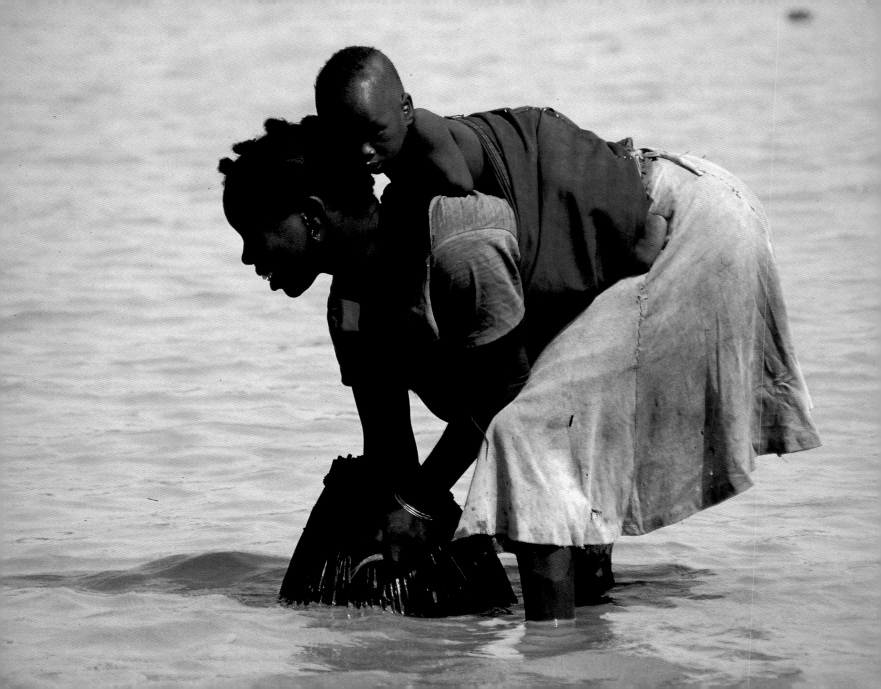

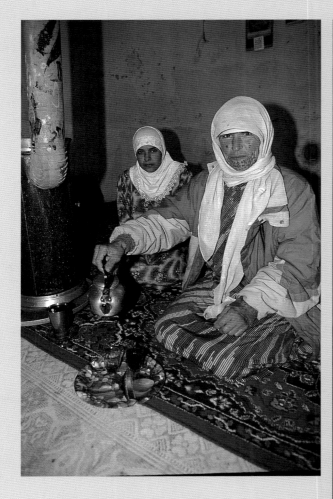

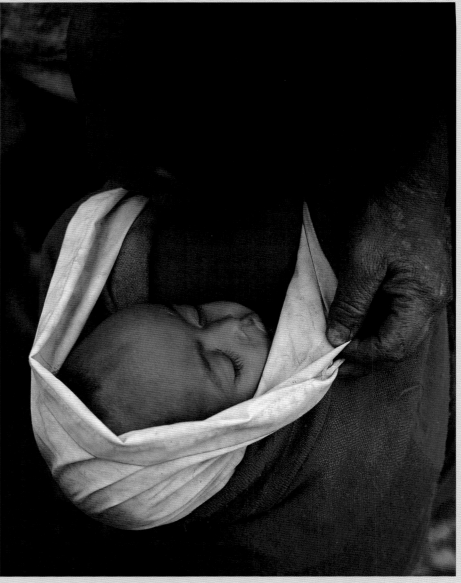

Sabou, BURKINA FASO

SYRIA

ETHIOPIA

Call it a clan, call it a network, call it a tribe, call it a family. Whatever you call it, whoever you are, you need one.
Jane Howard

Bangkok, THAILAND

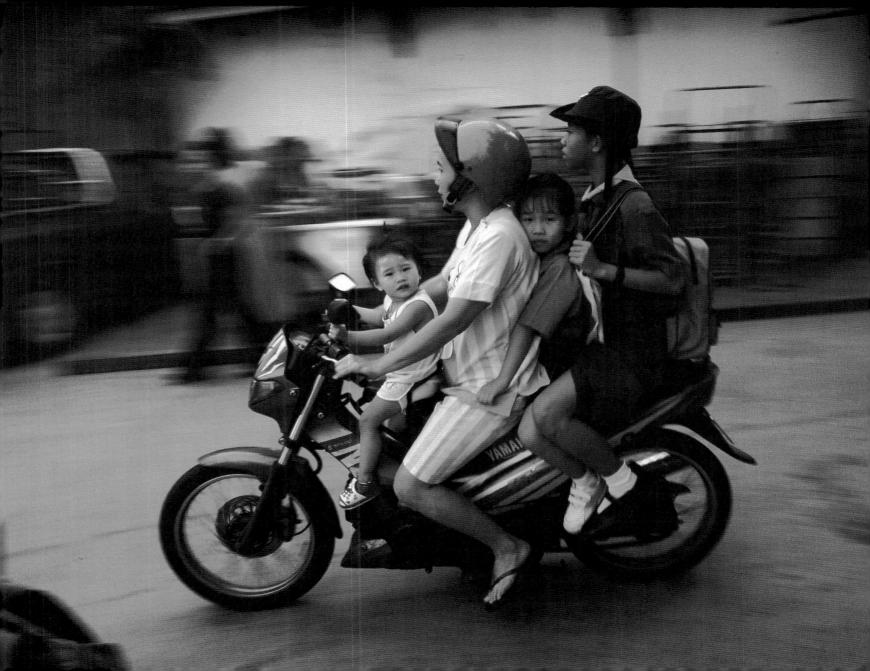

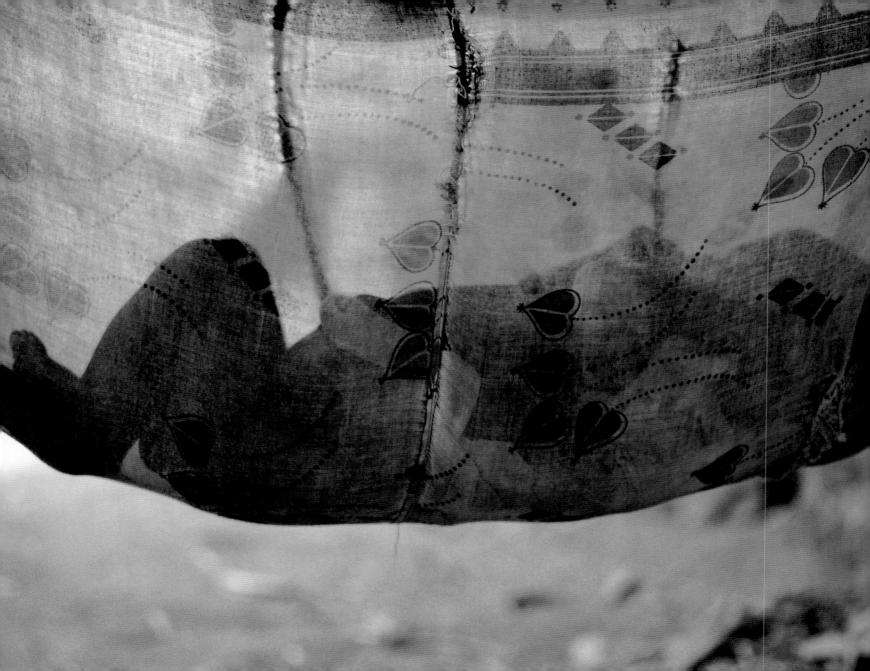

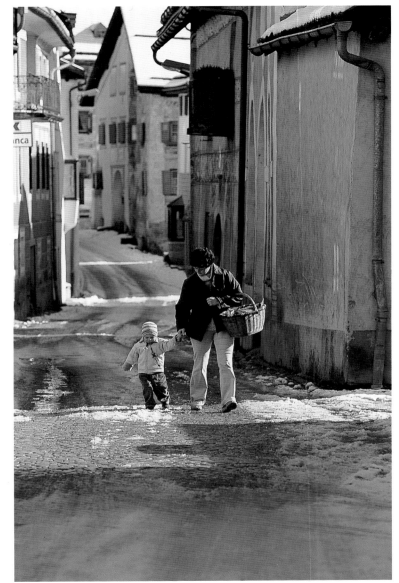

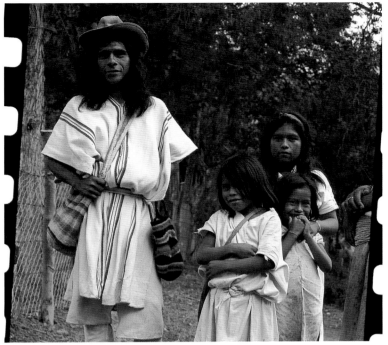

INDIA

Ardez, SWITZERLAND

Nabusimake, COLOMBIA

A comfortable house is a great source of happiness. It ranks immediately after health and a good conscience.
Sydney Smith

CURAÇAO (Dutch Colony)

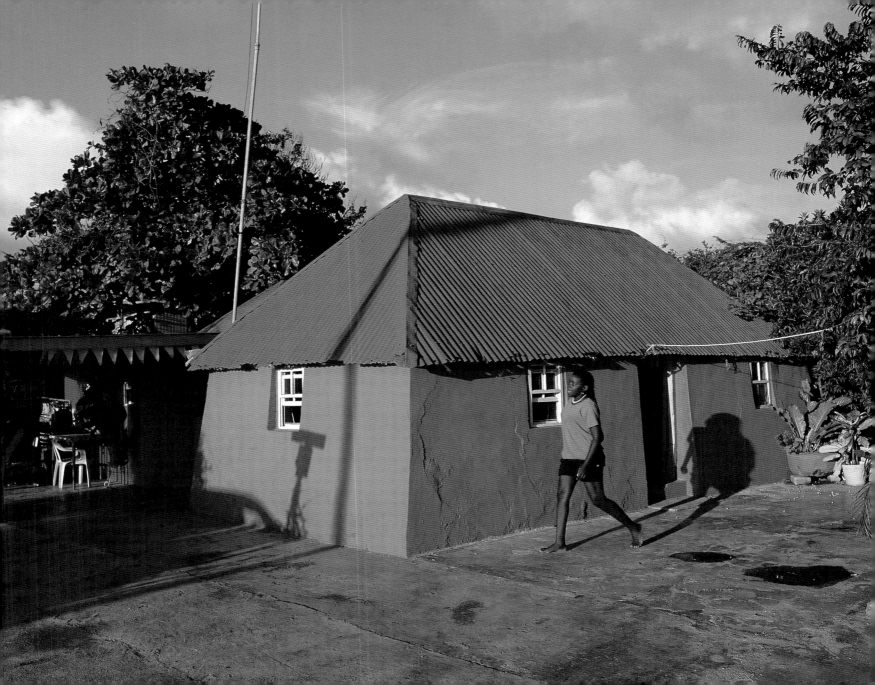

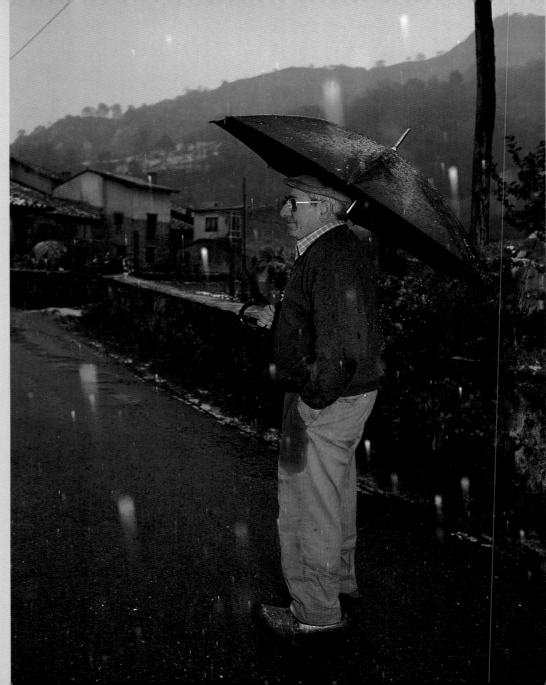

SPAIN

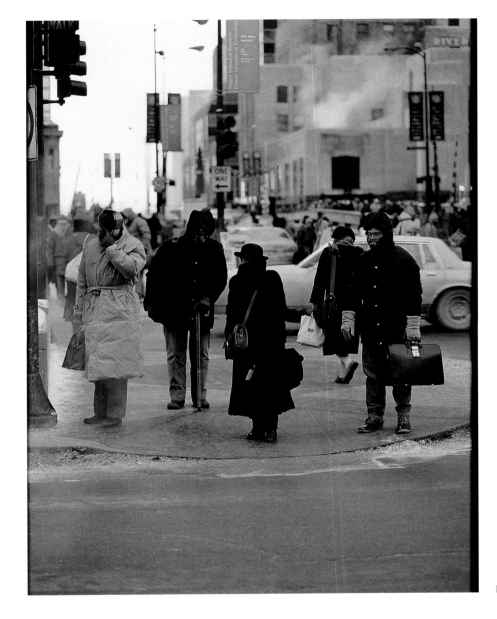

NEED

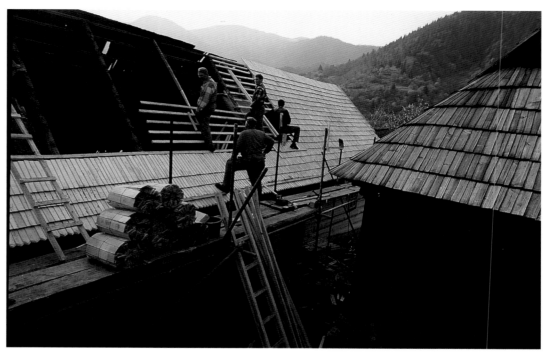

Vlkolinec, SLOVAKIA

Turkana, KENYA

Puglia, ITALY

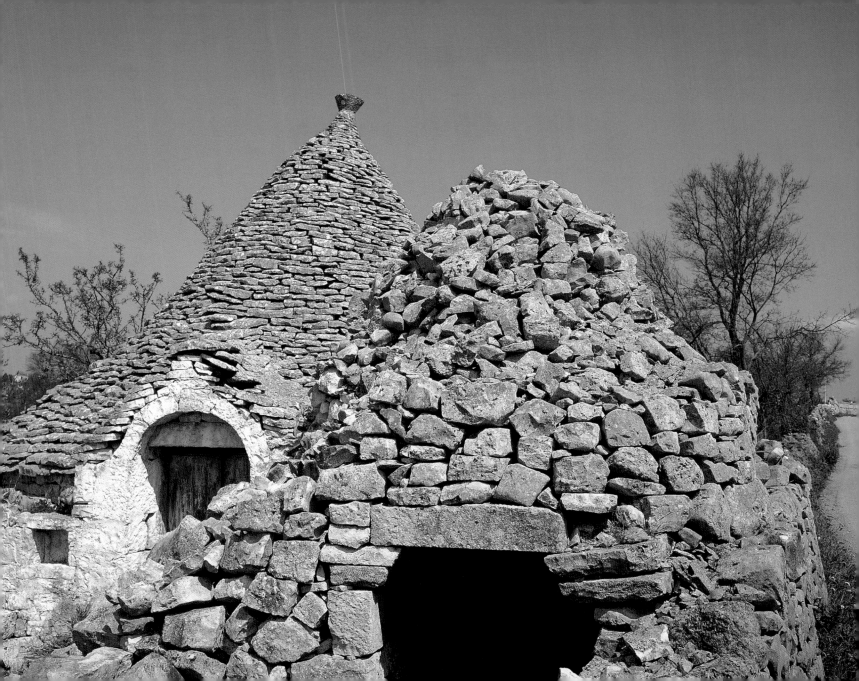

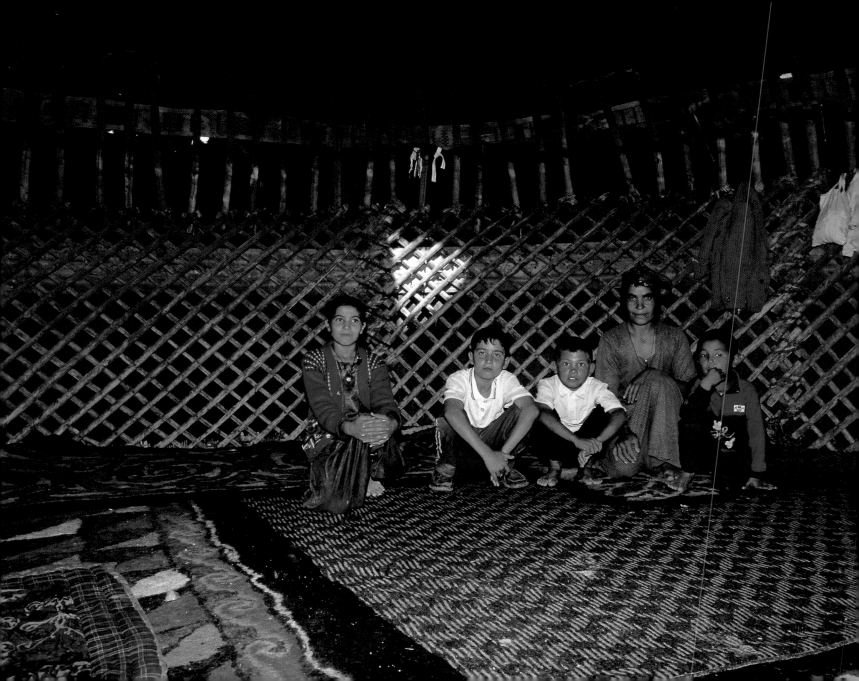

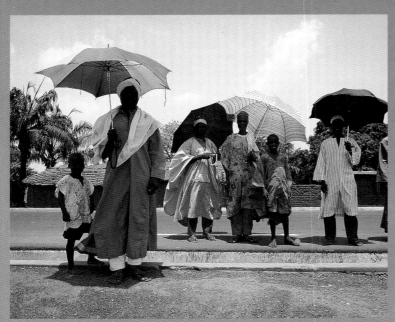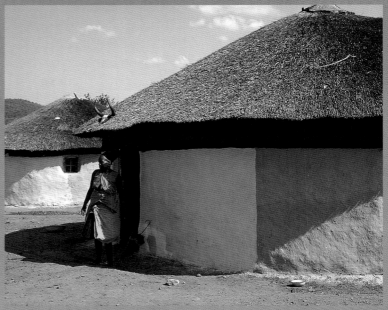

UZBEKISTAN

Niamtougou, TOGO

Natal, SOUTH AFRICA

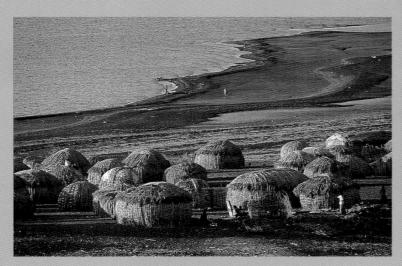

Turkana lakeside, KENYA

CURAÇAO (Dutch Colony)

High Plateau, MADAGASCAR

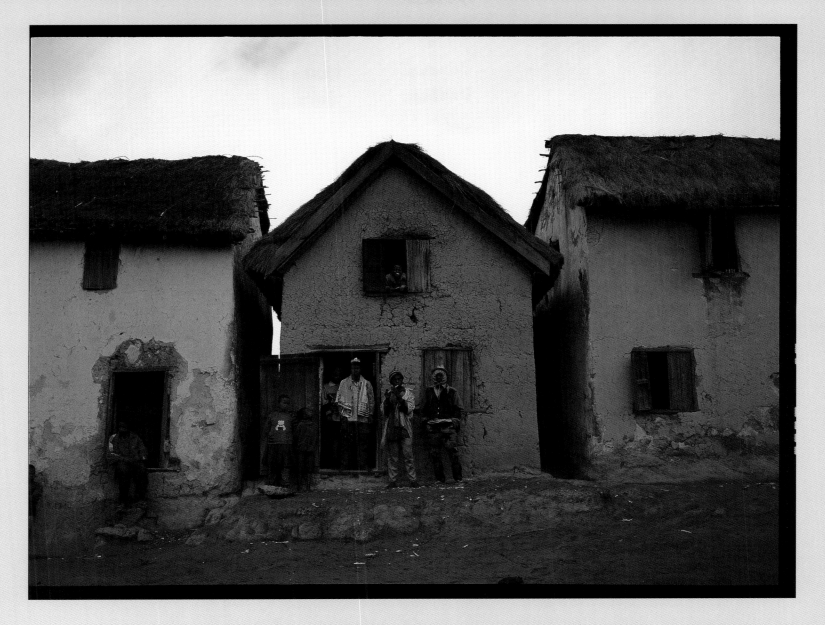

It takes a village to raise a child.
African Proverb

M'zab Valley, ALGERIA

Elvas, PORTUGAL

Cesky Krumlov,
CZECH REPUBLIC

Schwäbisch Hall, GERMANY

Know, first, who you are, and then adorn yourself accordingly.
Epictetus

Jaisalmer, INDIA

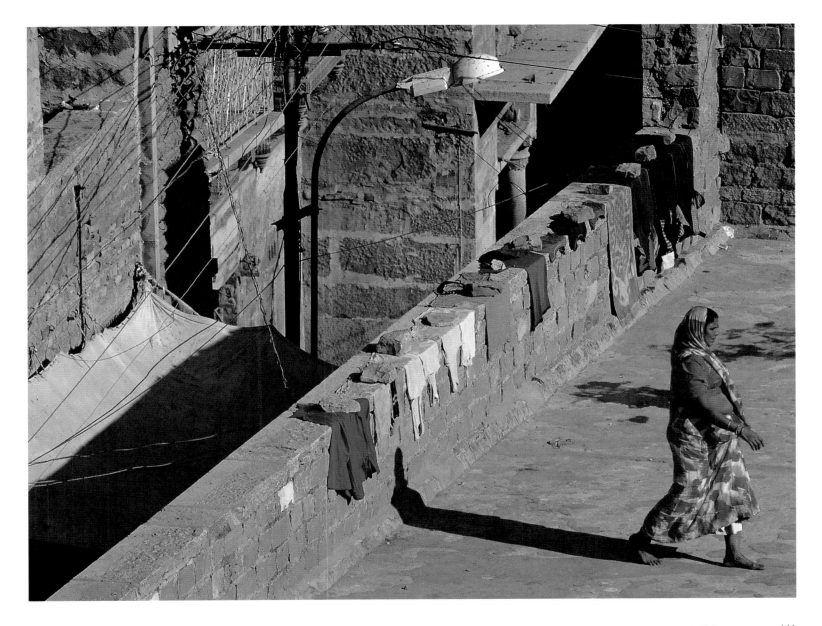

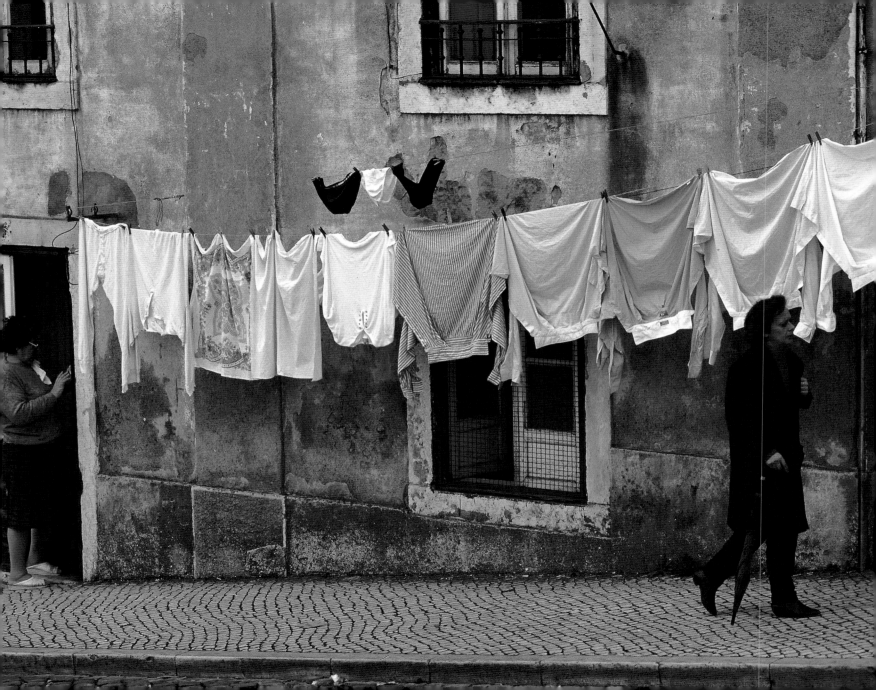

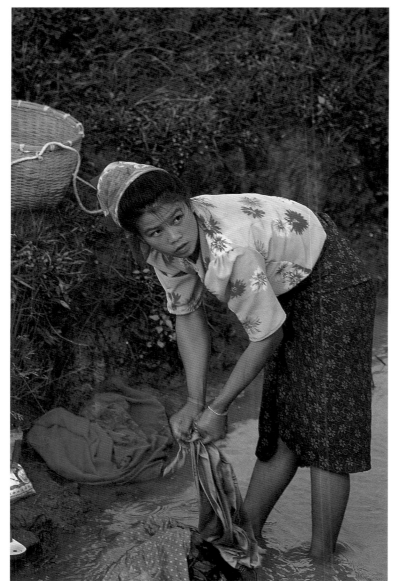

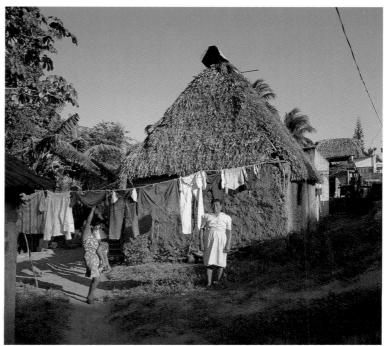

Lisbon, PORTUGAL

CHINA

Hidalgo, MEXICO

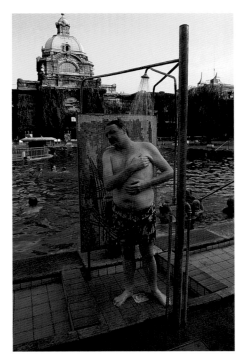

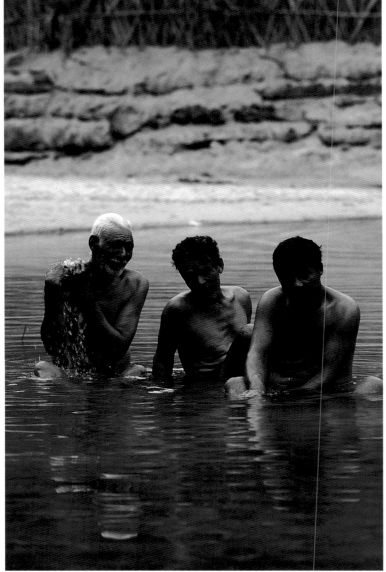

Budapest, HUNGARY

Nefta, TUNISIA

Oualata, MAURITANIA

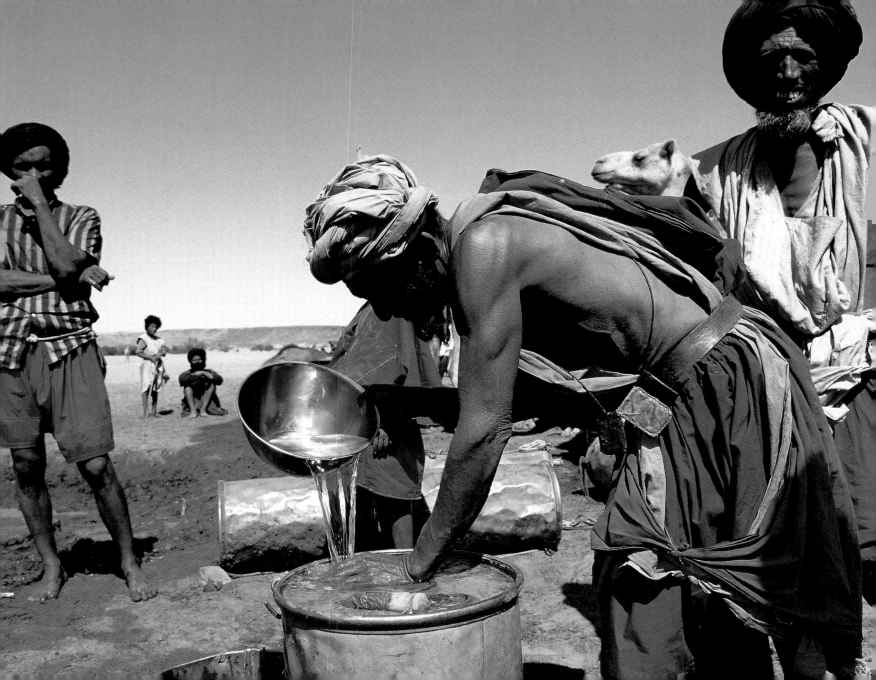

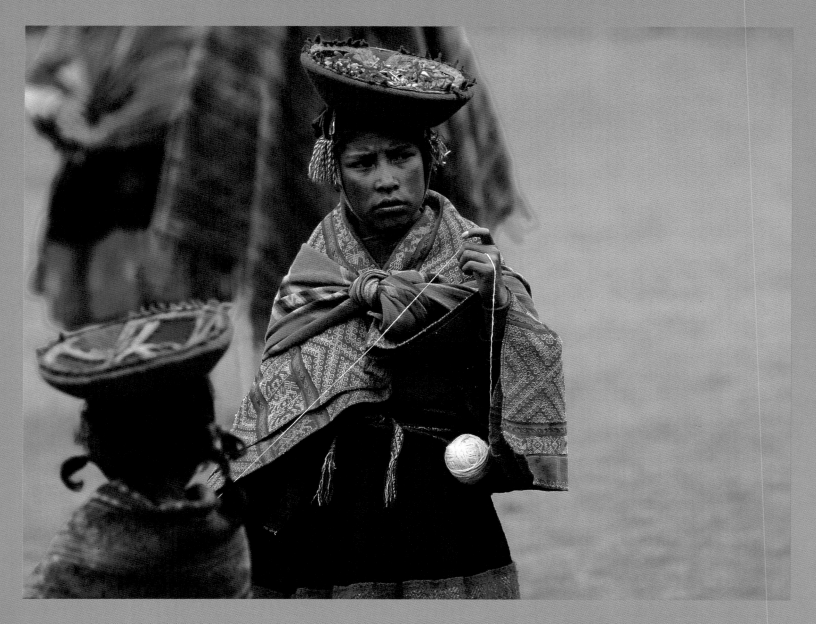

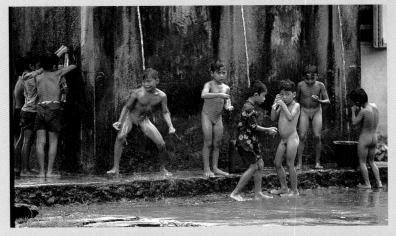

NEED

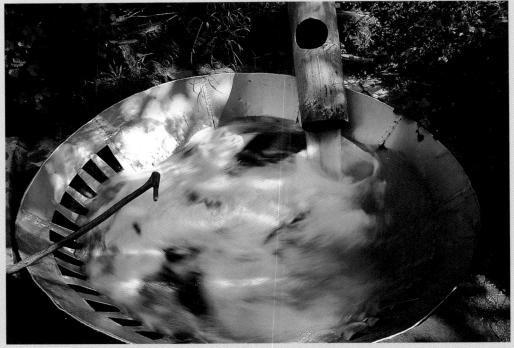

Wuillo, PERU

Nias, INDONESIA

Tryavna, BULGARIA

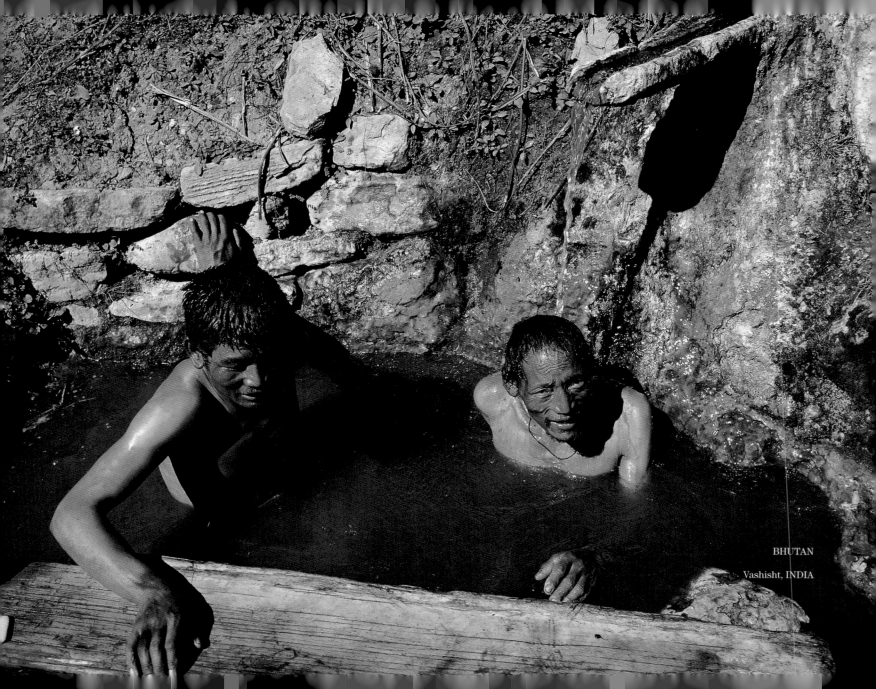

BHUTAN

Vashisht, INDIA

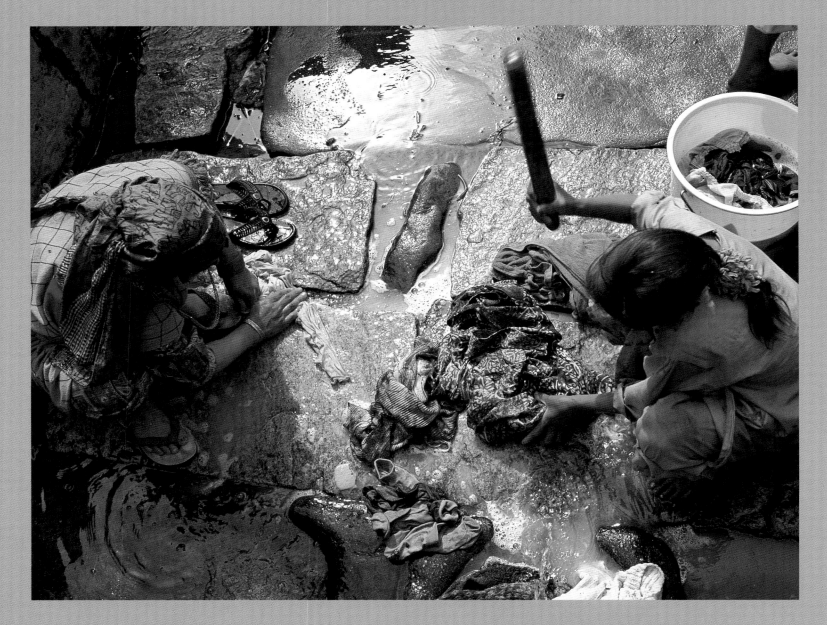

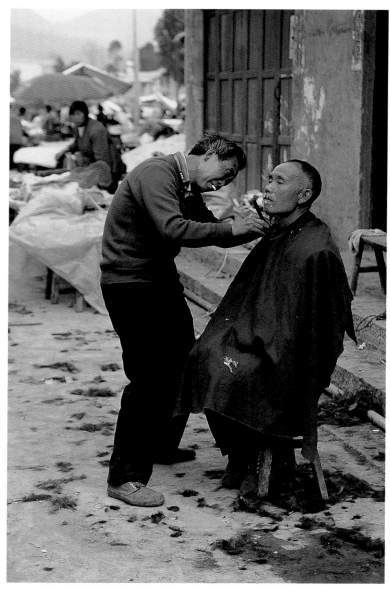

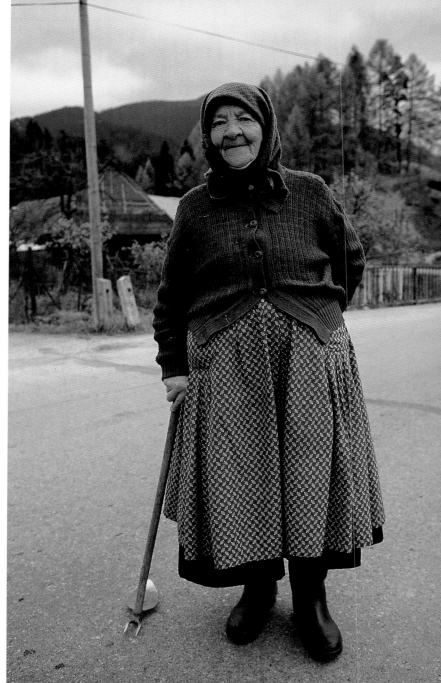

Beauty commonly produces love, but cleanliness preserves it.
Joseph Addison

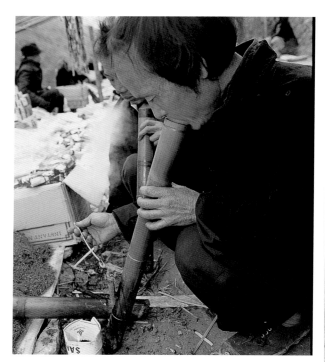

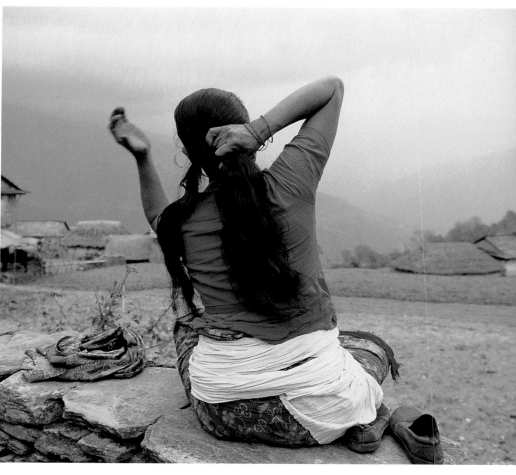

VIETNAM

Dhampus, NEPAL

Monsanto, PORTUGAL

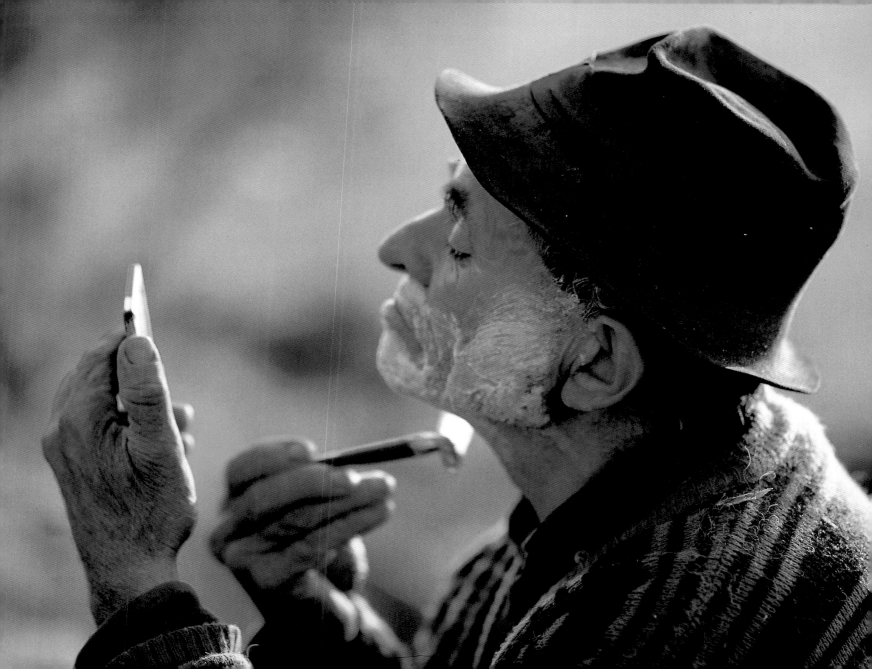

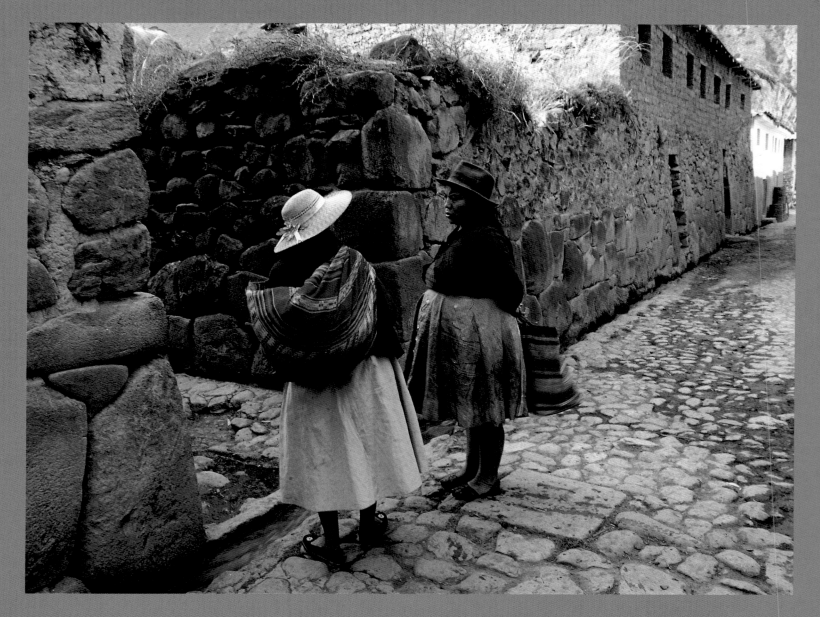

Nature loves nothing solitary, and always reaches out to something, as a support, which ever in the sincerest friend is most delightful. Cicero

Ollantaytambo, PERU

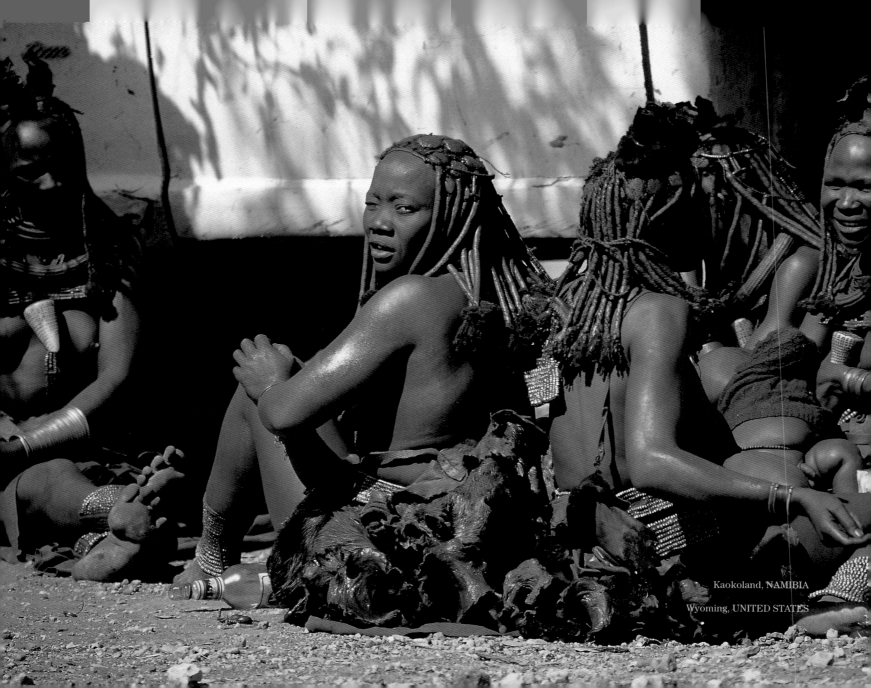

Kaokoland, NAMIBIA

Wyoming, UNITED STATES

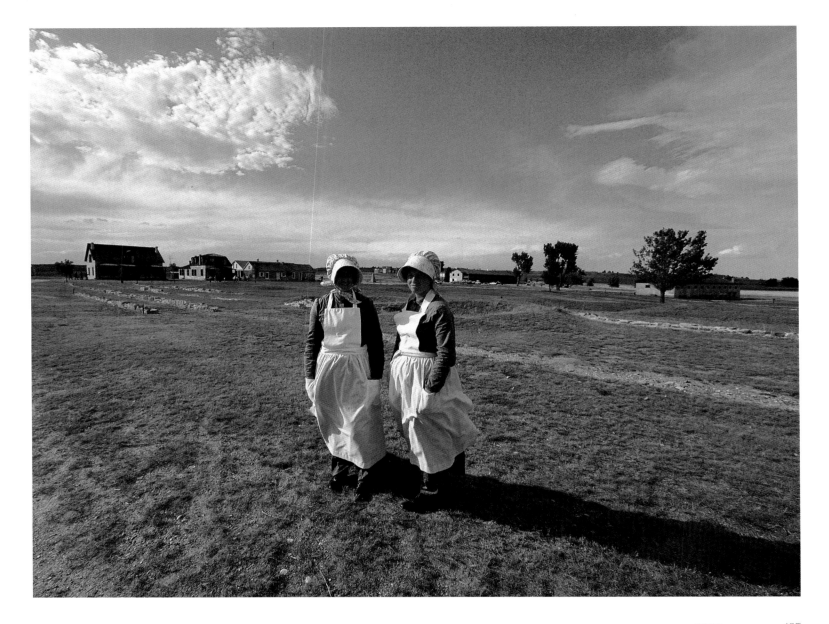

Budapest, HUNGARY

UNITED STATES

NEED

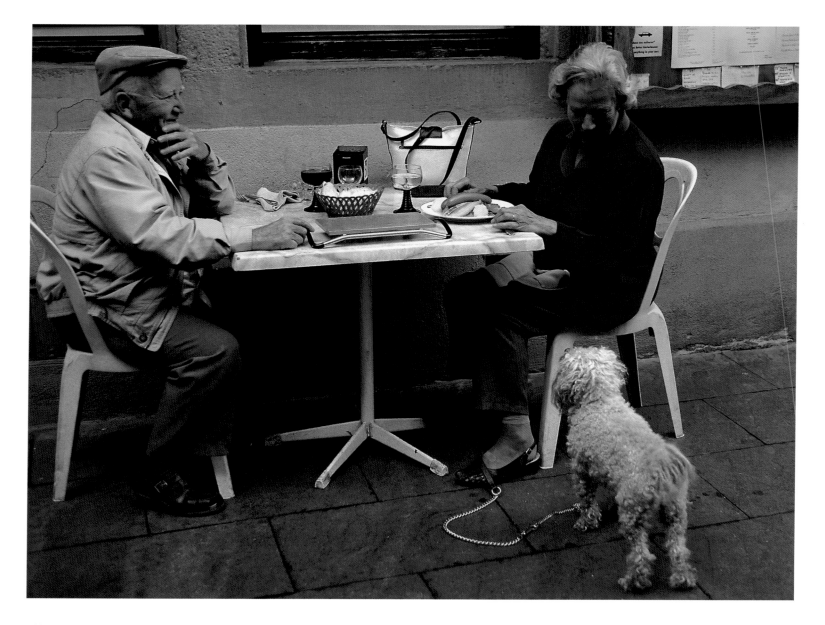

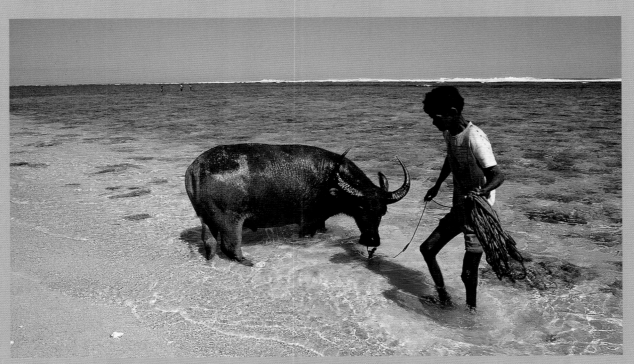

FRANCE

Sumba, INDONESIA

Arizona, UNITED STATES

Beauty is but the sensible image of the infinite. Like truth and justice, it lives within us; like virtue and the moral law, it is a companion of the soul.

George Bancroft

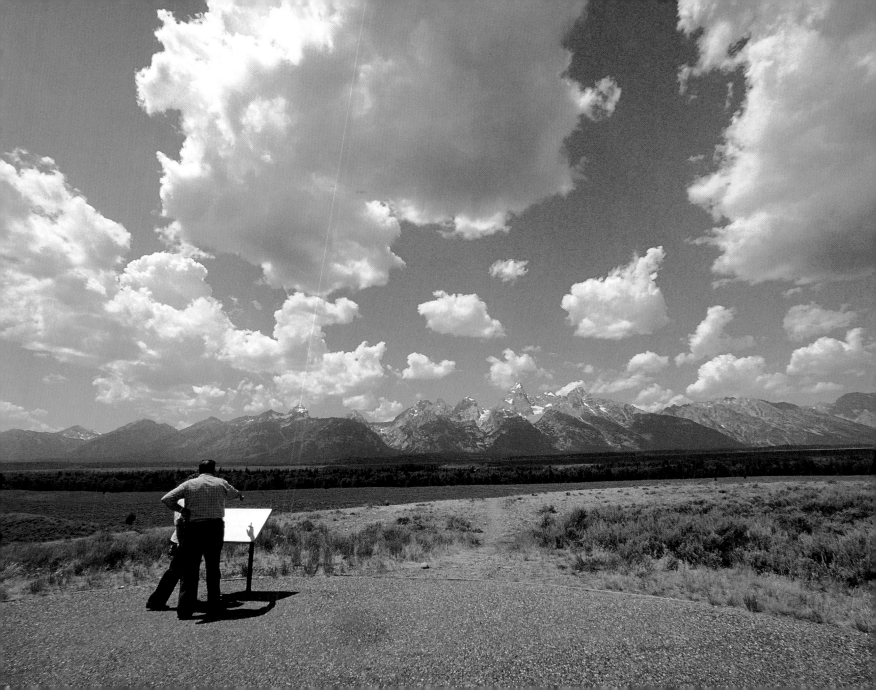

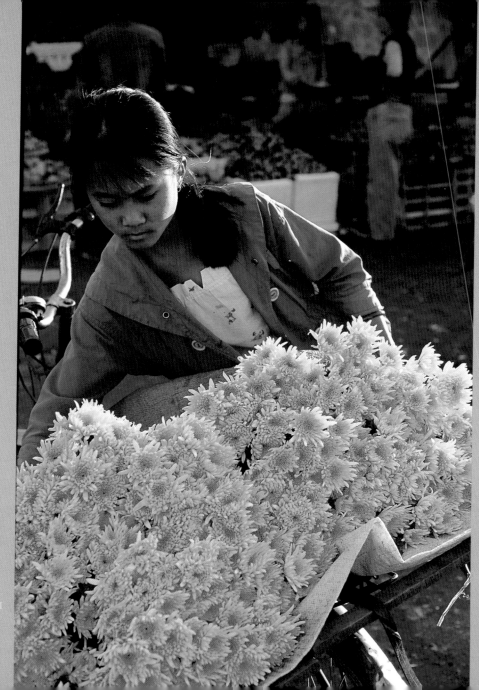

VIETNAM

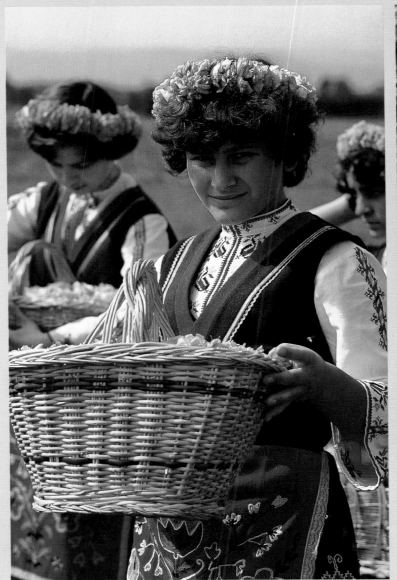

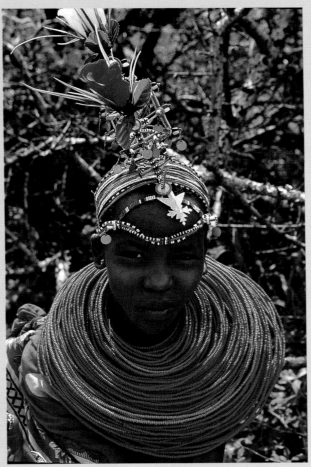

Kazanluk, BULGARIA

KENYA

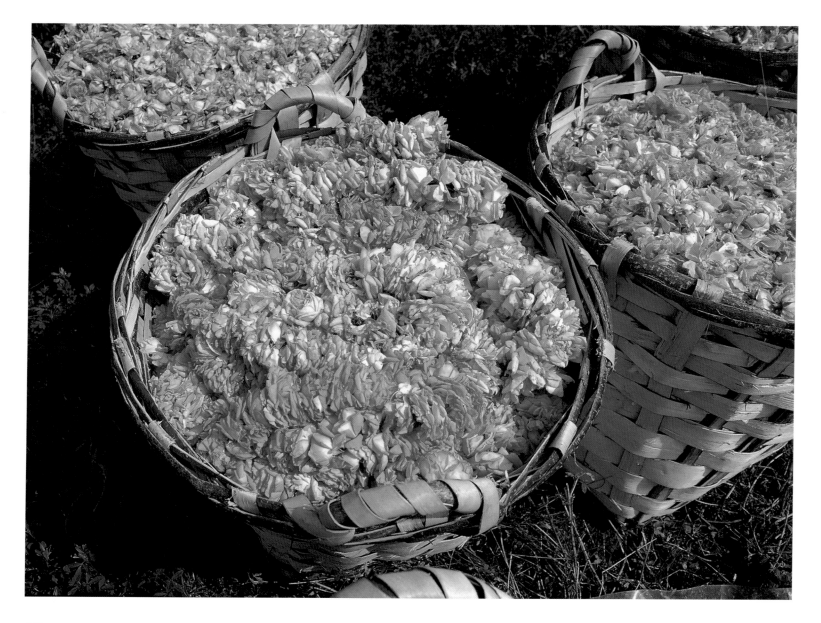

HUMANKIND

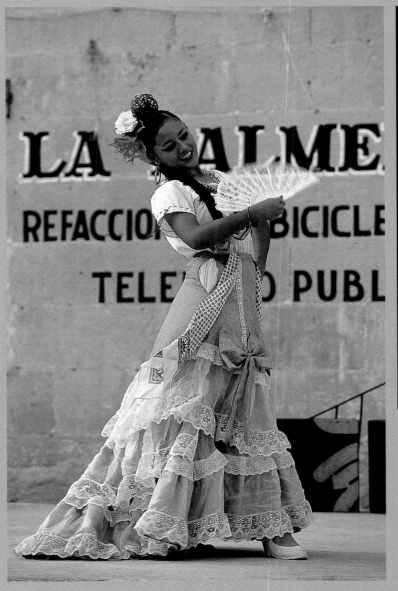

Kazanluk, BULGARIA

Jerez, MEXICO

CZECH REPUBLIC

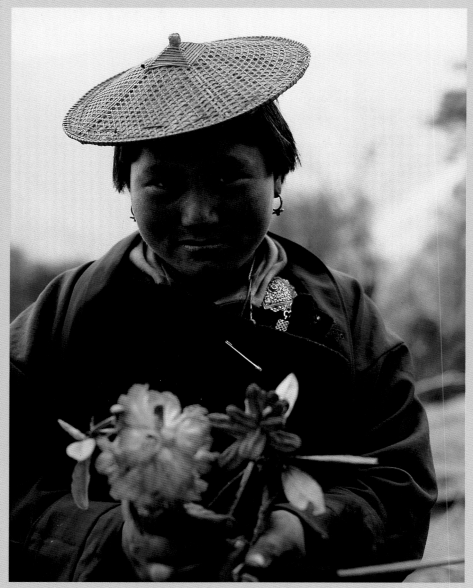

Wangdue Phodrang, BHUTAN

PAKISTAN

PERU

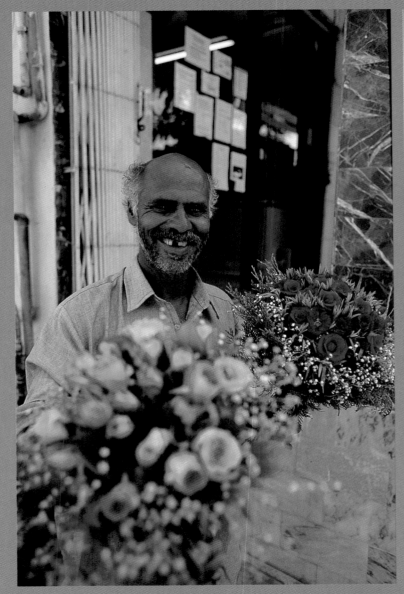
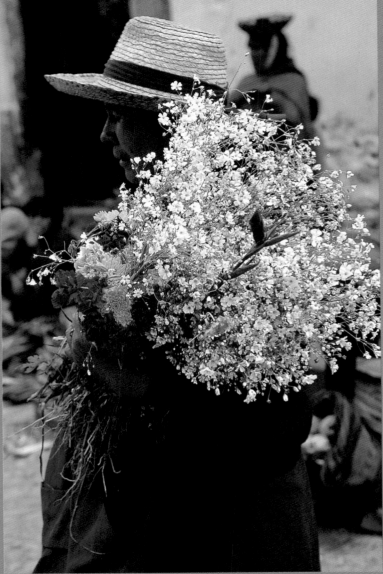

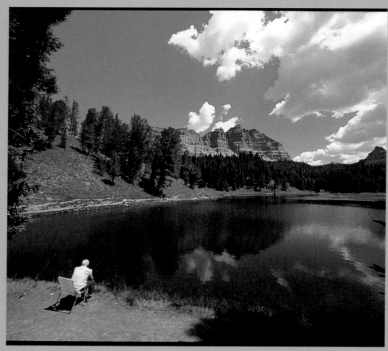

Wyoming, UNITED STATES

Hunza, PAKISTAN

KENYA

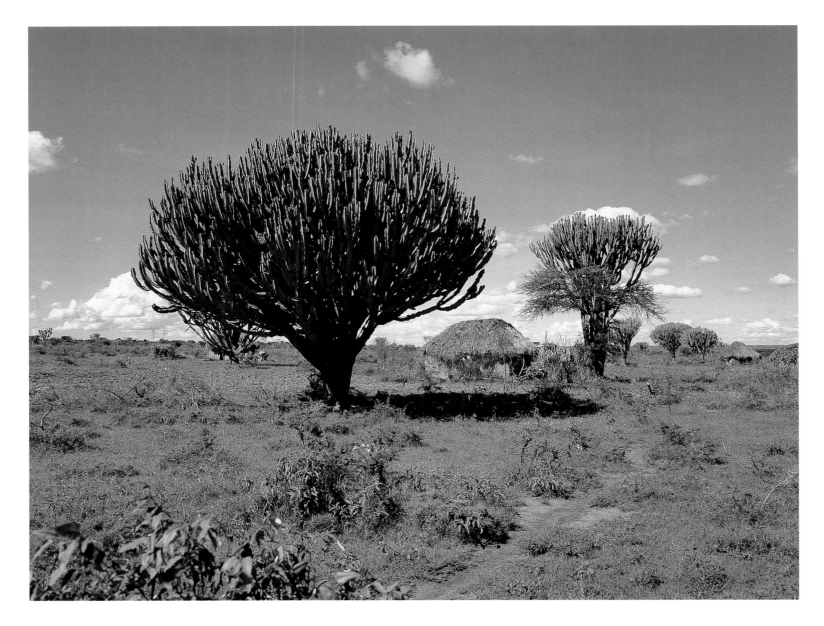

We may have different religions, different languages, different colored skin, but we all belong to one human race.

Kofi Annan